# Sound and Image

T0074815

*Sound and Image: Aesthetics and Practices* brings together international artist scholars to explore diverse sound and image practices, applying critical perspectives to interrogate and evaluate both the aesthetics and practices that underpin the audiovisual.

Contributions draw upon established discourses in electroacoustic music, media art history, film studies, critical theory and dance; framing and critiquing these arguments within the context of diverse audiovisual practices. The volume's interdisciplinary perspective contributes to the rich and evolving dialogue surrounding the audiovisual, demonstrating the value and significance of practice-informed theory, and theory derived from practice. The ideas and approaches explored within this book will find application in a wide range of contexts across the whole scope of audiovisuality, from visual music and experimental film, to narrative film and documentary, to live performance, sound design and into sonic art and electroacoustic music.

This book is ideal for artists, composers and researchers investigating theoretical positions and compositional practices which bring together sound and image.

**Andrew Knight-Hill** is a composer specialising in studio composed works, both sound-based electroacoustic and audiovisual. He is Senior Lecturer in Sound Design and Music Technology at the University of Greenwich, programme leader of Sound Design BA, director of the Loudspeaker Orchestra Concert Series and convenor of the annual SOUND/IMAGE conference.

# Sound Design

The Sound Design series takes a comprehensive and multidisciplinary view of the field of sound design across linear, interactive and embedded media and design contexts. Today's sound designers might work in film and video, installation and performance, auditory displays and interface design, electroacoustic composition and software applications, and beyond. These forms and practices continuously cross-pollinate and produce an ever-changing array of technologies and techniques for audiences and users, which the series aims to represent and foster.

**Series Editor**
Michael Filimowicz

**Titles in the Series**

**Foundations in Sound Design for Linear Media**
A Multidisciplinary Approach
*Edited by Michael Filimowicz*

**Foundations in Sound Design for Interactive Media**
A Multidisciplinary Approach
*Edited by Michael Filimowicz*

**Foundations in Sound Design for Embedded Media**
A Multidisciplinary Approach
*Edited by Michael Filimowicz*

**Sound and Image**
Aesthetics and Practices
*Edited by Andrew Knight-Hill*

For more information about this series, please visit: www.routledge.com/Sound-Design/book-series/SDS

# Sound and Image

## Aesthetics and Practices

**Edited by Andrew Knight-Hill**

Routledge
Taylor & Francis Group

LONDON AND NEW YORK

First published 2020
by Routledge
2 Park Square, Milton Park, Abingdon, Oxon OX14 4RN

and by Routledge
52 Vanderbilt Avenue, New York, NY 10017

*Routledge is an imprint of the Taylor & Francis Group, an informa business*

*British Library Cataloguing-in-Publication Data*
A catalogue record for this book is available from the British Library

*Library of Congress Cataloging-in-Publication Data*
Names: Knight-Hill, Andrew, editor.
Title: Sound and image : aesthetics and practices / edited by Andrew Knight-Hill.
Description: New York : Routledge, 2020. | Series: Sound design | Includes
    bibliographical references and index.
Identifiers: LCCN 2020001660 (print) | LCCN 2020001661 (ebook) |
    ISBN 9780367271473 (hardback) | ISBN 9780367271466 (paperback) |
    ISBN 9780429295102 (ebook)
Subjects: LCSH: Motion picture music—History and criticism. | Motion picture
    music—Philosophy and aesthetics. | Experimental films—History and criticism. |
    Mixed media (Music)—History and criticism.
Classification: LCC ML2075 .S674 2020 (print) | LCC ML2075 (ebook) |
    DDC 781.5/42—dc23
LC record available at https://lccn.loc.gov/2020001660
LC ebook record available at https://lccn.loc.gov/2020001661

ISBN: 978-0-367-27147-3 (hbk)
ISBN: 978-0-367-27146-6 (pbk)
ISBN: 978-0-429-29510-2 (ebk)

Typeset in Times New Roman
by Apex CoVantage, LLC

Visit the eResources: www.routledge.com/9780367271466

For Emma, Peter and Joan.

# Contents

# Contributors

**Roger Alsop,** PhD, is a composer, musician and mixed-media artist, focusing on developing interactive and collaborative approaches that enhance and exemplify the hybrid, genre-breaking nature of modern creativity. He supervises research students and teaches Interactive Art, Research Skills, Electronic Music and Mixed Media. His writing and artwork is presented internationally.

**Emilio Audissino** holds one PhD in visual and performing arts and one PhD in film studies. His interests are film analysis, screenwriting, film style and technique, comedy, horror and film sound and music. Notably, he is the author of *John Williams's Film Music* (2014) and *Film/Music Analysis* (2017). He is also an active screenwriter.

**Bret Battey,** PhD, is Professor of Audiovisual Composition at the Music, Technology, and Innovation Institute for Sonic Creativity at De Montfort University, Leicester, UK. He creates electronic, acoustic and audiovisual concert works and installations, with a focus on generative techniques. His website is www. BatHatMedia.com

**Myriam Boucher** is a video and sound artist based in Montreal (Canada). Her sensitive and polymorphic work concerns the intimate dialogue between sound and image in fixed videomusical form and live AV performance. Inspired by the natural environment, she creates audiovisual compositions from field recordings augmented by synthetic materials. The relationship between nature and humanity is central to her aesthetic. She is currently a stydying for a D.Mus. in videomusical composition at the Université de Montréal.

**Brigid Burke** is an Australian clarinet soloist, composer, performance artist, visual artist, video artist and educator whose creative practice explores the use of acoustic sound, contemporary new music, technology, visual arts, video, notation and improvisation to enable cross-media performances that are rich in aural and visual nuances.

**Simon Cummings,** PhD, is a composer, writer and researcher based in the Cotswolds. His music harnesses intricate algorithmic processes to create stochastic transformations between carefully defined musical behaviours. Cummings is an accomplished writer about contemporary music; he is the author of music blog 5:4 and is a contributor to numerous print and web journals.

**Matthew Galea,** PhD, is a hypermedia sculptor and researcher based at the Department of Digital Arts within the University of Malta. The focus of his practice and research lie in the intersections between media and disciplinarity within the arts, the notion of 'otherness' and sculpture through a hyperdisciplinary approach.

**Diego Garro,** PhD, worked in the UK as a university lecturer for twenty years researching electroacoustic music and audiovisual composition. His creative work has been presented internationally on many occasions and was awarded the first prize in two consecutive years at the Bourges International Competition of Electroacoustic Music and Sound Art (2004 and 2005).

**Sam Gillies** is an audiovisual artist with an interest in the function of noise as both a musical and communicative code in music and art. His work treads the line between the musically beautiful and ugly, creating alternating sound worlds of extreme fragility and overwhelming density. He is currently the Liz Rhodes Scholar in Musical Multimedia (PhD) at the University of Huddersfield.

**Louise Harris,** PhD, is an electronic and audiovisual composer and Senior Lecturer in Sonic and Audiovisual Practices at the University of Glasgow. She specialises in the creation and exploration of audiovisual relationships utilising electronic music, recorded sound and computer-generated visual environments. Louise's work encompasses fixed media, live performance and large-scale installation pieces, with a recent research strand specifically addressing Expanded Audiovisual Formats (EAF).

**Jim Hobbs** is an artist, lecturer and Programme Leader for the MA Digital Arts at the University of Greenwich, UK. He is a multimedia artist working across 16mm film, video, performance, installation, site-specific work, drawing, sculpture, sound and photography. His work has been exhibited internationally in museums, galleries and festivals.

**Joseph Hyde,** PhD, Professor of Music Bath Spa University, is interested in music's place in an interdisciplinary landscape. In particular, he has engaged with audiovisual performance and visual music since the mid-1990s, as an artist and a writer. He has undertaken a project on the unique musical notation used by Oskar Fischinger, and in his creative practice he has focused on the use of 'obsolete' technologies: cathode ray tubes, oscilloscopes and analogue (audio and video) synthesisers. Since 2009 he has run a symposium on visual music at Bath Spa, *Seeing Sound*.

**Jung In Jung,** PhD, is an interdisciplinary artist and researcher. She has presented her works at various international festivals and conferences such as Sonica, ISEA, xCoAx, ICLI, NEoN, MIVSC São Carlos Videodance, Athens Video Dance Project and Vivarium Festival. Currently, she is a R&D fellow at the research centre InGAME.

**Andrew Knight-Hill,** PhD, is a composer specialising in studio composed works, both sound-based electroacoustic and audiovisual. His works are composed with materials captured from the human and natural world, seeking to explore the beauty in everyday objects. He is particularly interested in how these materials are interpreted by audiences, and how these interpretations relate to our experience of the real and the virtual. He is Senior Lecturer in Sound Design and Music Technology at the University of Greenwich, programme leader of Sound Design BA, director of the Loudspeaker Orchestra Concert Series and convenor of the annual SOUND/IMAGE conference. His website is www. ahillav.co.uk

**Leyokki** is a weaver of "lines of flight". A film-maker, his work engages cinema as a musical practice, dealing with non-verbal meaning and movies made in realtime. His pieces, made through layers of compositing and chaotic algorithms, create a narration of shapes and textures.

**Cornelia Lund,** PhD, is an art and media theorist and curator living in Berlin with a focus on audiovisual artistic practices, documentary practices, design theory and de- and post-colonial theories. Since 2004, she has been co-director of fluctuating images (www.fluctuating-images.de), a platform for media art and design. Her publications include *Audio.Visual – On Visual Music and Related Media* (2009) and *The Audiovisual Breakthrough* (2015). For more information, please see: www. fluctuating-images.de/cornelia-lund-en

**Maura McDonnell,** PhD, is an award-winning visual music artist who has been involved in visual music since 1997. She is Assistant Professor at Trinity College, Dublin, and teaches a visual music module on the M.Phil. Music and Media Technologies course. Her doctoral thesis on visual music was completed in 2019.

**Celine Murillo,** PhD, defended a dissertation in 2008 about reference and repetition in Jim Jarmusch's films and has published *Le Cinéma de Jim Jarmusch. Un monde plus loin* (Paris: L'Harmattan, 2016). She works as a senior lecturer at the University of Paris 13 (Sorbonne Paris Cité).

**Mark Pedersen,** PhD, is a Melbourne-based interactive media artist. His work includes sound design for choreography, theatre, film, poetry and radio, interactive audio/visual installation and various solo and collaborative audio projects. His work has been presented at Dance Massive, ABC Radio National, Mesmerism Festival, International Symposium of Electronic Art, International Computer Music Conference and the Melbourne Festival.

**Jean Piché,** PhD, is a composer, professor and visual artist. He was one of the originators of the videomusic movement in the late 1980s. He taught at the Université de Montréal for many years and is actively engaged in theoretical and practical audiovisual research.

**Tom Reid,** PhD, is an emerging composer and academic researcher, having worked with performers such as the Riot Ensemble, New Music Players, Heath Quartet and London Sinfonietta. He graduated with a PhD in Musical Composition at the University of Sussex in 2017. For more information, please see: soundcloud.com/ tom-a-reid vimeo.com/tomreidcomposer

**Claudia Robles-Angel** is a new media artist whose work and research cover different aspects of visual and sonic art, extending from audiovisual fixed-media compositions to performances interacting with biomedical signals. She has been artist-in-residence in several outstanding institutions, for example at ZKM (Karlsruhe/ Germany), ICST (Zurich/Switzerland) and CMMAS (Morelia/Mexico).

**Daniel von Rüdiger,** PhD, is a documentary filmmaker, musician and lecturer. He studied Media Design as well as Communication Strategies and Iconic Research in Munich, Augsburg and Basel. He holds a PhD from the University of Art Linz for his artistic research on rhythm as the intermediary of audiovisual fusions.

**Philip Sanderson,** PhD, works with a range of media including moving image, sound and installation with a particular focus on the nature and dynamics of the audiovisual relationship. Philip has exhibited widely both in the UK and internationally and had a number of music CDs and LPs released. Philip has worked as a senior lecturer, gallery director, curator and reviewer.

**Julie Watkins,** PhD, worked as lead creative in prestigious post-production facilities in Soho and Manhattan before joining the University of Greenwich as a senior lecturer and founding the successful undergraduate degree in Film and Television and initiating a unique learning partnership with the BBC. She presents her research and visual music at international conferences.

# Preface

Bringing together artists, composers, academics and thinkers, this inherently inter-disciplinary volume integrates practice with critical reflection, seeking to negotiate the construction of robust frameworks of understanding that are thoroughly rooted in both acting upon and thinking about the aesthetics and practices of sound and image works.

The international scope of this collection is clear, with contributors from three continents and twelve countries. This is an international discipline that benefits greatly from the open exchange of people and ideas that the world can so often seem to devalue or neglect. Such fora are increasingly essential to foster engagement, collaboration, support and exchange between, often disparate and sometimes isolated, practitioners and thinkers.

The past twenty years has seen a marked increase in the proliferation of audio-visual artforms, facilitated by the catalyst of increasingly accessible technologies, faster computing potential and the explosion of audiovisual content that surrounds us. And yet the discussions and theoretical discourse around these practices still remains relatively nascent. A number of publications and edited volumes have emerged over the last ten years which have promised to engage with and explore artistic audiovisual practice. But while these volumes were often titled affirmatively, their reality often failed to reflect the rich diversity of sound and image practices in action, weighting their contributions rather heavily towards more traditional narra-tive forms, such as Hollywood film.

All contributors within this volume have shared their research as part of SOUND/IMAGE, a conference running annually since 2015 (Figure 0.1). This international colloquium seeks to catalyse both theoretical and practice research within audio-visual composition; an area that lies at the intersection of many different artistic practices and academic disciplines, and which embraces the many different forms of audiovisuality, from abstract experimental film, to installation, to performance, to narrative film analysis. Reflecting the spirit of the original conference, this volume embraces the multiplicities and potentialities at the intersection of these diverse dis-ciplines. Bringing together composers, filmmakers, animators, video artists, sound

**Figure 0.1**    SOUND/IMAGE19 Poster

artists, film theorists, sculptors, media artists, programmers, musicians, academics, curators, media theorists, dancers and installation artists; to explore sound and image phenomena collectively, in manifold forms, allows the transfusion of ideas and approaches across institutional divides and traditional subject boundaries.

A unique contribution of this book, therefore, is the genuine convergence of ideas and perspectives from across the spectrum of audiovisual practice. It is a book that truly seeks to resolve its promise to reflect both the aesthetics and practices of the diversity of artforms that engage, articulate and apply sound and image as

both artistic material and for philosophical enquiry. That practice and theory are so coherently imbricated throughout this volume is a testament to the strength of contemporary practice research; demonstrating the value and significance of practice-informed theory, and theory derived from practice. This is a field which draws upon established discourses in art history, film studies, electroacoustic music, critical theory, and thus the ideas and approaches in this book will find application in a wide range of contexts across the whole scope of audiovisuality, from visual music and experimental film, to narrative film and documentary, to live performance, sound design and composition for film, into sonic art and electroacoustic music.

The structure of this volume opens with contributions exploring wider aesthetic and philosophical concerns in relation to sound and image practice. While often concept-driven, these are always firmly grounded in relation to creative practices, suggesting frameworks and new paradigms for framing and considering the audiovisual.

Later chapters critically reflect upon individual artistic practices, revealing approaches and techniques of working with sound and image that have the potential to greatly benefit those seeking to understand the practice, whether as a critical thinker, 'audiovisuologist' or as a sound image composer/filmmaker/artist.

Each author makes a unique and valuable contribution to this volume, bridging both across and between the diverse subject fields and practices that make up the rich potential of audiovisuality. Their research reflects the manifold approaches and enquiries which interrogate the aesthetics and practices of sound and image; and, by extension, to the developing discourse of audiovisual practices.

--------------------

This edited collection would not have been possible without the support and encouragement of my colleagues in the School of Design at the University of Greenwich, particularly Professor Steven Kennedy, who has been an unwavering supporter of the SOUND/IMAGE project and of critically informed creative practice research; Professor Gregory Sporton, who believed in the potential of a young academic and who explicitly encouraged the development of a publication to reflect and recognise the valuable work being undertaken by those engaging with the SOUND/IMAGE conference.

It is also essential to thank Professor Leigh Landy who provided invaluable guidance and support as both my PhD supervisor and as director of the Institute for Sonic Creativity at De Montfort University; Professor Bret Battey, who's sensitivity for, and insight, into audiovisual practice are reflected in his beautiful and inspirational audiovisual compositions – works which drew me to study with him for Master's and PhD research at De Montfort University; and to Dr Diego Garro

who inspired my trajectory of fascination with the audiovisual, by sharing his own passion for and mastery of sound and image composition, opening up whole new worlds of enquiry to an enthusiasic undergraduate student.

Alongside of this I have been incredibly fortunate to have the unwavering support of my family; especially that of my wife Emma, who has been steadfast and graciously accepting of the demands that arise as a consequence of creating and organising the great many conference events which have developed, evolved and expanded over the past ten years into SOUND/IMAGE. Without this foundational support, it would not have been possible to create a platform which is able to inspire and attract leading researchers from around the world to contribute and to innovate in the area of sound and image research.

Finally, thanks must obviously go to all of the contributors of this volume, for their openness and generosity in engaging with and delivering the project, and in sharing their invaluable research within this collection.

Andrew Knight-Hill
November 2019

# Connected media, connected idioms
## The relationship between video and electroacoustic music from a composer's perspective

Diego Garro

## Editor's note

This chapter was originally presented at various international conferences between 2006–2008, but was never formally published. Its inclusion within this volume provides a permanent published record of the perspectives and ideas within and reflects the significant influence that the author had upon the editor as an undergraduate student, introducing him to the audiovisual.

This chapter is where this book began.

## Introduction

As the enabling technologies for creative work with digital audio now reside on the same computers as those used for video applications, composers have the, relatively affordable, opportunity to 'connect' these two digital-media in their creative endeavors. Yet, despite the facilitating role of software interfaces and the inheritance of past experiences in mapping musical gestures to the moving image, the inherent difficulty of an interconnected audiovisual 'idiom' soon becomes apparent. The exposition and development of such an idiom represents a stimulating, yet daunting, challenge for both audiences and composers.

Electroacoustic music communities have treasured and pioneered technological advances in electronic and digital media tools. Sound and Image practices may find benefit in seeking to extend into the audiovisual domain the powerful and distinctive traits of a form of art that originally based itself, historically, culturally and aesthetically, on the primacy of the ear.

Strategies adopted by a new breed of – sometimes self-taught – audiovisual composers are informed by their experiences as Electroacoustic composers, sound designers and sound artists, but their very actions also throw the acousmatic paradigm into question. We will leave the darkness of the concert room behind us and

reflect upon works articulated through the combination of shifting audible and visible morphologies.

Although this topic can be approached from the viewpoint of the connection between the two 'physical' digital media, it becomes apparent that simply connecting two media opens up several interesting questions, not only on the techniques and technologies, but, especially, questions on the 'connected idioms', notably how the sonic language and the language of the moving image relate to each other, and what (if any) new combined, integrated idiom they contribute to form. The authors position as a composer ensures that the following discussion is directed and informed by applied experience in practice.

A new trend has emerged within the electoacoustic community during the last twenty years: the combination of Electroacoustic Music soundtracks with video material to form audiovisual works in which the sound and images are more or less equally important. To illustrate the growing status of audiovisual composition within the Electroacoustic Music community I will cite a few historical precedents:

- The International Electroacoustic Music and Sonic Art Competitions of Bourges (www.imeb.net): this competition was founded in 1973 by Françoise Barrière and Christian Clozier and has been for many years one of the most important competitions in this field, certainly in Europe, attracting approximately 200 participants every year from 30 different countries. In the year 2001 for the first time the Bourges competition featured a category for multi-media works.
- The *Computer Music Journal* (MIT press), published since 1977, covers a wide range of topics related to digital audio signal processing and Electroacoustic Music. The first Video Anthology DVD, containing video works, was published in Winter 2003 as an accompanying disc to issue Vol. 27, Number 4 of the journal.
- The *Computer Music Journal* issue Vol. 29, Number 4, Winter 2005, was entirely dedicated to topics relevant to Visual Music. This issue also included a second Video Anthology DVD, with selected video works and video examples.
- The biannual Seeing Sound Conference/Festival, hosted by Joseph Hyde at Bath Spa University since 2009. An informal practice-led symposium exploring multimedia work which foregrounds the relationship between sound and image; exploring areas such as visual music, abstract cinema, experimental animation, audiovisual performance and installation practice through paper sessions, screenings, performances and installations, bringing together international artists and thinkers to discuss their work and the aesthetics of audiovisual practice.
- SOUND/IMAGE conference/festival hosted by Andrew Knight-Hill in Greenwich, running annually since 2015, bringing together international practitioners to share concepts and creative approaches to audiovisual composition in

concert with exhibitions, screenings and performances. Colliding the worlds of experimental filmmaking and multichannel eletroacoustic composition.

## Electroacoustic Music

For the sake of the ensuing discussion we should come, if at all possible, to an agreement of what constitutes 'Electroacoustic Music'. The reader can refer to many recent writings on the subject as well as a critical review of at least some seminal works from the repertoire (see, for example, Knight-Hill 2020). But in the immediate context, we can take a giant leap forward to consider the following definition:

> Electroacoustic Music is a form of art that is concerned with the technologically aided exploration of 'sound' in all its phenomenological aspects, and with the organisation of sonic material in time.

This definition follows closely Edgard Varèse's idea of Music as 'organised sounds'. Another definition could be:

> The structuring and the articulation of time with the materials of sound patterns, which is both technically enabled and aesthetically informed by the capabilities of electro-acoustic transducers (microphones, loudspeakers) and by the opportunity to access and manipulate sound spectra by means of electronic analog and digital technologies.
> (expanded from a definition of 'Absolute Music'
> by Brian Evans 2005)

Both these definitions are obviously incomplete, and they over-simplify a form of art which is complex, still evolving, and possibly still trying to define itself amongst the same tidal of globalised fragmentation that characterises all modern electronic arts (and perhaps all human endeavours).

Nevertheless, these definitions give us at least a starting point and some basic principles. More discursively, the concerns of Electroacoustic Music can be identified as follows:

- It has a concern with the 'discovery' of sound (recording, synthesis, processing).
- It is a time-based form of art, hence concerned with the evolution and organisation of sounds in time. This raises typical issues of all time-based media such as structure, balance, articulation, progression, direction, etc.
- It uses technology to 'augment' composers' and performers' control of sound material and audiences' experience of sound stimuli in an artistic context.

- It assumes the 'primacy of the ear' promoted by members of the French school of Musique Concrète (Pierre Schaeffer and others) in the 1950s. This is a cultural attitude both for composers and for listeners. For composers, because they use their hearing ability as primary informant when they 'compose the sound' in the studio and when they 'compose with sound'. For listeners, because in most cases they rely only on their hearing ability (no visual clues) to understand the artistic message in the music. The primacy of the ear is at the core of what we may label the 'acousmatic paradigm' of Electroacoustic Music culture.
- It draws together creators and audiences who share a deep fascination with the material of the acoustic space surrounding all of us. Not just the 'music' but, rather the 'sound of it'.

These elements are important because they give us some clues on how to relate to the body of works for electroacoustic sounds and video discussed in this chapter.

## The art of visible light – Visual Music

Electroacoustic Music developed alongside innovations and progress in audio technology, the realisation of a quest for a medium of artistic expression that utilised sounds freed from the expectations and cultural references of 'music', as we knew it, until the beginning of the 20th century. We could trace a similar path in the development of a non-narrative language of the moving image. In Germany, for example, pioneering film-makers such as Walter Ruttman, Viking Eggeling and Hans Richter developed a type of experimental cinema that articulated abstract shapes moving over time. Oskar Fischinger worked for over 30 years on this type of filmic language and is considered by many the father of this type of filmmaking, choreographing abstraction in connection with musical form (Evans 2005).

Experimental cinema of this kind is considered innovative, but was in effect a re-mediated version of practices that date back a couple of centuries further in time, to the pioneers of 'Visual Music'.

> Visual Music can be defined as time-based visual imagery that establishes a temporal architecture in a way similar to 'absolute' music. It is typically non-narrative and non-representational (although it need not be either). Visual Music can be accompanied by sound but can also be silent.
>
> (Evans 2005)

Visual Music precedes even film. Early examples of gas-lamp Colour Organs date back to the 18th century. Colour organs were instruments that projected coloured light under the control of an organ-like keyboard and were used

to provide a visual accompaniment to music performances (Peacock 1988). Such instruments became increasingly sophisticated, in terms of technology, control and visual sophistication, especially with the advent of electricity, but they responded to the same aesthetic quest as their predecessors. Interestingly, there has been a resurgence of interest in Visual Music with exhibitions, screenings and museum galleries in major cities in North America and Europe (see www.iotacenter.org and www.centerforvisualmusic. org for information and catalogues of works in the field, now available on DVDs[1]).

## Convergences

Media art histories of recent years may depict a parallel development of languages of sonic arts, with Electroacoustic Music at the forefront of this movement, and languages of the moving image with Visual Music and experimental non-narrative cinematography on the other side. We can see such a parallel development as an anticipation of an encounter between these disciplines, facilitated by certain key convergences:

### Convergence in the type of media

Both the 'art of sound' and the 'art of visible light' are time-based media. They engage the viewer/listener in a revisited and augmented experience of chronometric time, accomplished through articulation of their time-varying stimuli (audible and visible respectively).

### Technological convergence

Both the 'art of sound' and the 'art of visible light' can inhabit the digital domain, hence their materials can be stored and manipulated by computers. Nowadays the same relatively 'inexpensive' desktop computer and even laptops can handle digital audio and, with more difficulty, digital video data. In the solitary reclusion of the music project studio, enabling tools for digital audio-video experimentation reside in the same workstations used for modern computer-music endeavours. It is an opportunity that has been staring at Electroacoustic Music composers for the last 10 years.

### Artistic and idiomatic convergences

Both the 'art of sound' and the 'art of visible light' developed a language that is very experimental, often abstract and breaks away from historically established forms (classical music, figurative art), concentrating on the exploration of the basic matter in the respective media and in the construction of temporal articulations of that matter for artistic purpose (see, for example, Whitney 1960).

## Mapping between sound and images

Strategies to combine sound and images have been the subject of study and experimentation for centuries, from Isaac Newton and his correspondences colour-pitch, through the inventors of the colour organs down to the creators of modern music visualiser software such as those supported by iTunes, Windows Media Player and WinAmp (Collopy 2000). Furthermore, psychologists of cognition have been intrigued since the beginning of the 20th century by so-called synaesthesic correspondences correspondences, within which stimuli in one sense modality is transposed, to a different modality (for example, in some individuals certain sounds are perceived with an strong sense of certain taste/flavours).

Many strategies of mapping audio and visual have concentrated on seeking to establish normative mappings between sound pitches and colour hues, in an attempt to create a 'colour harmony/disharmony' that can be related to musical consonance/dissonance. Fred Collopy provides a compendium of possible 'correspondences' between music and images (see for example a summary of the various 'colour scales' developed by thinkers and practitioners over three centuries to associate normatively certain pitches in the tempered scale with certain colour hues [Collopy 2001]).

However, prescriptive mapping techniques, such as colour-scales, quickly become grossly inadequate once the palette of sound and visual material at a composers' disposal expands. If models for correspondences are to be sought, they need to account for more complex phenomenoloies of audio and video stimuli, far beyond simplistic mappings between, for example, musical pitch and colour hue, or sound loudness and image brightness.

Let us, for a start, introduce a taxonomy of phenomenological parameters of the moving image and of sound, that we may consider a deeper mapping strategy between the two media.[2]

### *Phenomenological parameters of the moving image*

- *Colour* – hue, saturation, value (brightness).
- *Shapes* – geometry, size.
- *Surface texture*.
- *Granularity* – single objects, groups/aggregates, clusters, clouds.
- *Position/Movement* – trajectory, speed, acceleration in the (virtual) 2-D or 3-D space recreated on the projection screen.
- *Surrogacy* – links to reality, how 'recognisable' and how representational visual objects are.

## *Phenomenological parameters of sound*

- *Spectrum* – pitch, frequencies, harmonics, spectral focus.
- *Amplitude envelope* – energy profile.
- *Granularity* – individually discernible sound grains, sequences, aggregates, streams, granular synthesis/reconstruction.
- *Spatial behaviour* – position, trajectory, speed, acceleration in the 2-D or 3-D virtual acoustic space recreated in a stereo or surround sound field.
- *Surrogacy* – links to reality, how 'recognisable' and how representational our sound objects are.

We can not forget that we are dealing with two time-based media. Therefore, all these preceding parameters must be considered, not just in their absolute values at certain points in time or in averages, but should instead be considered as time-varying entities with individual temporal trajectories.

An audiovisual language can be thus constructed using association strategies relating one or more parameters of audio material to one or more parameters of the visual, including the profile of their behaviour in time. Some of these associations are more naturally justifiable than others (Jones and Nevile 2005: 56). For instance, a mapping between sound frequencies and the size of corresponding visual objects may take into account the fact that objects of smaller size are likely to produce sounds that resonate at higher frequencies. In another example, a mapping strongly rooted on the physics of the stimuli can be established between the amplitude of a sound and the brightness of the associated imagery whereby louder sounds correspond to brighter images, on the basis of the fact that both loudness and brightness are related to the intensity (energy per unit of time and surface) of the respective phenomenon.

The viability and the laws of sound-to-image mappings can represent a fascinating field of research and experimentation. However, with regards to the desirability and the use for creative purposes of, more or less strict, parametric mapping, opinions may vary dramatically between different artists and viewers. On this matter, two interesting viewpoints:

> The principle of synergy, i.e. that the whole is greater than the sum of its parts, is fundamental to the nature of complex interactive dynamic sound and light system and their resulting forms.
>
> (Pellegrino 1983: 208)

> A direct, synaesthesic mapping of music's most basic parameters (pitch, loudness and so forth) fails to capture the expressive vision of great works of music,

which depend more directly on multi-dimensional interplay of tension and resolution.

(extrapolated from John Whitney's idea of 'complementarity' between music and visual arts [Alves 2005: 46])

## From 'mapping' to 'composing'

The "multi-dimensional interplay of tension and resolution" mentioned by Alves indicates an angle of analysis creativity that is richer than parametric mapping, albeit less rigorous, because the articulation of tension-release is indeed a more useful compositional paradigm than any, more or less formalised, mapping between audio and video material.

Instead of pursuing strict parametric mapping of audio into video or vice versa, composers can aim at the formulation of a more complex 'language' based on the articulation of sensory and emotional responses to artistically devised stimuli.

Roger B. Dannemberg observed that composers may opt for connections between sound and moving image that, because they are based on explicit mapping, operate at very superficial levels. He advocates links between the two dimensions that are not obvious, but are somewhat hidden within the texture of the work, at a deeper level. Audiences may grasp intuitively the existence of a link and feel an emotional connection with the work, while the subtlety of this link allows the viewer to relate to the soundtrack and the video track as separate entities, as well to the resulting 'Gestalt' of the combination, thus finding the work more interesting and worth repeated visits (Dannemberg 2005: 26).

A beautiful example of such approach can be found in Dennis H. Miller's work *Residue* (1999) (Figure 1.1). At the onset of this audiovisual composition a moving, semi-transparent cubic solid, textured with shifting red vapours, is associated with long, ringing inharmonic tones on top of which sharp reverberated sounds – resembling magnified echoes of water drops in a vast cavern – occasionally appear. The association between the cube and the related sounds cannot be described in parametrical mapping terms and, in fact, seems at first rather arbitrary. However, the viewer is quickly transported into an audiovisual discourse that is surprisingly coherent and aesthetically enchanting. It is clear that those images and sounds 'work well' together although we are not able to explain why, certainly not in terms of parametric mapping. A closer analysis of this work, and others by the same author, reveals that it is the articulation in time of the initial, deliberate, audiovisual association that makes the associations so convincing: we do not know why the red cube is paired with inharmonic drones at the very onset of *Residue* but, once that audiovisual statement is made, it is then articulated in such a compelling way – by means of alternating repetitions, variations, developments – that the

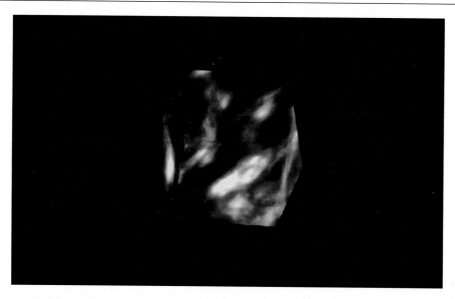

**Figure 1.1** Still from the opening sequence of *Residue* by Dennis H. Miller.

sound-to-image associations become very quickly self-explanatory even without any formal mapping.

Normative mapping approaches to the correspondence between audio and video material can be aesthetically hazardous for composers of Electroacoustic Music. Modern music in general, and Sonic Art in particular, can be very complex, featuring lush sonic textures full of details, spectral and spatial information for the listener to decode and make (artistic) sense of (Dannemberg 2005: 27–28). The listening process, for most works from the Electroacoustic Music repertoire, require repeated, attentive visits and this is often part of the unspoken 'contract' between sound artists and their audiences.

When composers engage with audiovisual media they may follow normative approaches and pair complex sound worlds with equally complex visual elements, as a natural extension of the richness and intensity that characterise their musical language. Such an approach would almost inevitably result in artistic redundancy, overloading the viewers' attention, overestimating their ability to decode the vast amounts of densely articulated material across both domains as they attempt to understand the creative message carried by the combined two. A mantra that all educators repeat so often to their student-composers working with sound and images: 'less is more'.

This is not to deny complexity. But to recognise that it must be situated within a framework and context which substantiates it. The reader will find that in most successful audiovisual compositions, complex passages are interspersed with moments

of release; the viewer's focus thus moves from global entities with high internal activity (tension), to local entities at lower internal activity (release).[3]

## Electroacoustics, video and reality

Issues of sonic and narrative coherence brought upon by the use of recognisable 'real' sounds in Electroacoustic Music are magnified when recognisable imagery is also used in combination with the sounds. There is an enormous creative potential when composers utilise material that, thanks to their representational value, call upon very tangible associations and cultural responses from the audiences. For instance, a generic inharmonic sound can be perceived as a rather abstract object and can acquire a variety of aesthetic connotations depending on the (sonic) context it is immersed in. A particularly recognisable inharmonic sound, for example, a church bell, might function in a similarly reduced way,[4] however, such sound is more likely to conjure images and memories of church, faith, religious ritual, spirituality, call, wedding, funeral, mass, joy, mourning, etc. depending on the particular experience – and possibly state of mind – of a particular listener. The dramaturgical implications are very potent and can be used to enhance the 'theatre' of a piece, or even as a primary compositional and interpretational paradigm of the work itself (Jonathan Harvey's *Mortuos Plango, Vivos Voco* is a case in point).

We can construct works that are recognisably 'about something' that is easily understood (Rudi 2005: 37) or use illusory references to a chunk of reality that the viewer can relate to through more or less deep reflection[5]. These are obviously compositional choices that reflect the artistic intention of the work. This aspect is particularly interesting because it bridges the audiovisual art discussed in this chapter with the cinematography it often strives to separate from. The availability, and affordability, of digital camcorders exerts on audiovisual composers an attraction as irresistible as that posed by microphones to electroacousticians, to access an entire universe of material that can be used for artistic expression. This is inevitably reflected within a body of work that applies elements of audio and video material captured from reality to articulate discourses that are not necessarily, or not entirely, based on narratives and which often attempt to transcend reality itself. In these pieces, the viewer is often informed of the poetic intention of the work via text credits at the beginning of the film or through printed programme notes. However, although such works use cinematographic techniques, they are not 'film' in the traditional sense of the word, and nor are they documentaries, although they feature, sometimes extensively, recognisable material filmed with a video camera. Their concrete nature foregrounds their cultural and historical settings which reinforce their audiovisual impact and, vice versa. The sophistication

of their audiovisual design may augment the poignancy and the drama implied by the subject matter and its poetic framework. Steve Bird and other researchers at Keele University are working towards a form of audiovisual composition that he calls 'Electroacoustic Cinema' and it's based on the paradigm that "both audio and video are of equal importance and that their relationship must always be synergetic" (Bird 2006). This paradigm is also reinforced by the belief that any form of audiovisual art, even the non-narrative and non-representational ones, should not disregard one and a half centuries of experience in cinematography.

## Conclusion

In this chapter we have cruised swiftly through the historical and aesthetic settings within which the 'art of sound' and the 'art of visible light' have developed during the last century. This, however incomplete excursus, allowed us to consider some convergences in: type of media, technologies and in aesthetics and idiomatic references. These convergences have facilitated, within the Electroacoustic community, an engagement with audiovisual composition, a artform in which parametric audiovisual mapping can provide some interesting, albeit not necessarily comprehensive, strategies for the design and the organisation of material in time. More often however, composers wish to go beyond the 'connection of two media' and venture in the murkier, yet more fascinating, business of engaging with the 'connection of two idioms'. The filmic language, with more than a century and a half of cinematographic heritage, provides an additional creative dimension accessible via modern video cameras which can be used to capture material from the real world as part of the compositional process.

Within the Electroacoustic community, a new breed of, sometimes self-taught, audiovisual composers are operating on the basis of their experience of sound designers and sound artists. However, extending their practices into the combined audiovideo media they also throw the acousmatic paradigm into question. The fact that such a challenge happened without much of a stir, and was embraced by the traditional establishments of Electroacoustic Music (IMEB–Bourges, *Computer Music Journal*, universities around the world and other centres and institutions), is perhaps an indication that this expansion was somewhat inevitable.

## Notes

1 Editor's Note: A disk-based distribution format for film and video content.
2 Some of these concepts are borrowed and extended from Denis Smalley's discussion on Spectro-morphology, which is a highly regarded piece of writing among Electroacousticians (Smalley 1986).
3 The works of Bret Battey are prime examples of excellence in this area, see, for example, cMatrix10 (2004) and Autarkeia/Aggregatum (2006).

4 The process of 'abstracting' a recognisable sound object from its realistic connotation and concen-
 trate solely on its sonic qualities was named 'reduced listening' by Musique Concrète pioneer Pierre
 Schaeffer.
5 See, for example, my own work Pointes Precaires (2004).

## References

Alves, B. (2005) Digital Harmony of Sound and Light. *Computer Music Journal*. 29(4). pp. 45–54.
Autarkeia/Aggregatum (2006) [VISUAL MUSIC] Bret Battey.
cMatrix10 (2004) [VISUAL MUSIC] Bret Battey.
Collopy, F. (2000) Colour, Form and Motion. *Leonardo*. 33(5). pp. 355–360.
Collopy, F. (2001) *Rhythmic Light* [Website]. Available online: http://rhythmiclight.com/archives/ideas/
 correspondences.html [Last Accessed 31/09/05].
*Computer Music Journal*. 29(4, Winter 2005). [VISUAL MUSIC].
Dannemberg, R. (2005) Interactive Visual Music: A Personal Perspective. *Computer Music Journal*. 29(4).
 pp. 25–35.
Evans, B. (2005) Foundations of a Visual Music. *Computer Music Journal*. 29(4). pp. 11–24.
Eve's Solace (2005) [VISUAL MUSIC] Steve Bird.
Jones, R.; Nevile, B. (2005) Creating Visual Music in Jitter: Approaches and Techniques. *Computer Music
 Journal*. 29(4). pp. 55–70.
Knight-Hill, A. (2020) Electroacoustic Music: An Art of Sound. In: M. Filimowicz (ed.) *Foundations of
 Sound Design for Linear Media*. New York: Routledge.
Mortuos Plango, Vivos Voco (1980) [MUSIC] Jonathan Harvey.
Peacock, K. (1988) Instruments to Perform Colour-Music: Two Centuries of Technological Experimenta-
 tion. *Leonardo*. 21(4). pp. 397–406.
Pellegrino, R. (1983) *The Electronic Arts of Sounds and Light*. New York: Van Nostrand Reinhold
 International.
Pointes Precaires (2004) [VISUAL MUSIC] Diego Garro.
Residue (1999) [VISUAL MUSIC] Dennis H. Miller – 0:00 to 1:50, dur 1:50.
Rudi, J. (2005) Computer Music Video: A Composer's Perspective. *Computer Music Journal*. 29(4).
 pp. 36–44.
Smalley, D. (1986) Spectro-Morphology and Structuring Processes. In: S. Emmerson (ed.) *The Language
 of Electroacoustic Music*. Basingstoke: Macmillan Press.
video example no.3 (2003) [VISUAL MUSIC] Brian Evans.
Whitney, J. (1960) Moving Pictures and Electronic Music. *Die Reihe*. 7. pp. 61–71.

# Sound/image relations in videomusic
## A typological proposition

Myriam Boucher and Jean Piché

## Introduction: another typology?

Having worked in the videomusic form for a number of years, we felt the need to examine how visuals linked to music operate on the receptive level. What role do the relational linkage of music and moving images play in the expressivity of a work? Beyond the tools used, how is this expression built and articulated? Where does its meaning reside? Our typology is a step towards understanding why videomusical discourse is, precisely, *discursive*.

Arising from visual music, video art and experimental cinema, videomusic started from the studio practices of electroacoustic music in the late 1980s. The term *videomusic* was coined[1] to describe a hybrid artform sitting halfway between music and video. A foundational aspect of videomusic is that sound and image were produced with an almost identical time-based technology, using a similar workflow. In both the analogue and digital domains, the compositional processes used in electroacoustic music were easily transposable to the production of moving imagery, putting forth the idea of a *musical writing of the image*. The thought processes inherent in electroacoustic music and timeline-based work environments opened up a large reservoir of relational possibilities.

In this hybrid form, sound and image are blended in a unified perceptual space, where the aesthetic experience is driven primarily by the musical. For the *viewer-listener*,[2] the meaning of this experience is found in the relations between the musical and the visual materials. Sound drives image as image drives sound, even though the two are intertwined in ways that are not primarily mimetic.

Our approach is phenomenological. We wish to identify the moments in an audiovisual flux that give rise to a dialogic interaction of sound and image and understand what role this interaction plays in the audiovisual experience. This interaction goes from the very simple to the highly complex, given that the pure act of presenting

a sound and an image together will trigger a desire in the viewer-listener to make sense of the association, even if there isn't an obvious one. On the one hand, we are interested in metaphors, imagination, memory and sensations, and on the other, we consider physical signal coherence. Some relations are identified as *technical* (using parametric criteria), others as *physical* (taking advantage of our knowledge of the physical world) and yet some others are anchored in complex metaphorical links where coherent meaning is assigned by the viewer-listener. Further, directionality, gesture, kinetic energy and morphology are central components for assigning types of sound/image relation.

The viewer-listener likely does not care for nor need this level of typological precision. But for composers,[3] putting words on what is happening in the audiovisual discourse can richly expand its reach. Being aware of the variety of possible relationships can only help deepen the engagement with the works. The ultimate objective of our study is to enrich audiovisual practices by refining the vocabulary to describe it.

## Methodology and previous work

Most studies in film theory discuss sound as it relates to dialogues, musical accompaniment, ambient background and sound effects.[4] While compelling for analysing the functional role of sound in a classical narrative context, much of the writing rests on the assumption that sound and music are at the service of the images and the story being told. But since our enquiry starts from the point of view of the composer who often makes the visuals, we took some key concepts of film theory and adapted them to reflect our desire to understand the role of sound and music in a non-support role.

From film theory, we retained the ideas of *synchresis* (Chion 1994) and *diegesis* (Souriau 1951). Synchresis addresses *time* and the synchronicity of sound and image events and diegesis concerns the *context*, i.e. the space and the universe proposed by the work. We adopted the terms as the two main classes of relational descriptors of our typology. In addition, we propose a specific symbol for each descriptor. These symbols can be used for the end of graphical representation for the analysis of a videomusic work.

In close connection with our research, Coulter (2010) proposes a theoretical framework for the analysis of the media pair electroacoustic music and moving images. His study is also based on the writings of Chion (1994) and proposes to describe: 1) the pair of media (audio/video) on a continuum going from representational to abstract and 2) the structural relations between each media, on a continuum from homogeneous to heterogeneous. The authors suggest that relations can be formalised under isomorphic, concomitant and heterogeneous determinants. Although the notions of referential, abstract, homogeneity and heterogeneity are addressed in our research, they are not the main components on which our typology is based.

The study of Basanta (2012) also served as a reference. In his article, the author takes the models proposed by Chion (1994) and Coulter (2010) a step further. His study is based on the development of different types of synchresis through an analysis of light/sound relations in light-centred installation. Basanta's approach, like ours, seeks to establish a link between compositional strategies and perceivable results. Our typologies both aim to highlight the relations within the audiovisual composition, its dynamics, its discourse and the perceptual meaning of an audio-visual object. The notable difference lies in extending synchresis and, especially, in the visual material chosen as the model: light vs. moving image. This implies significant differences, particularly in regards to the notion of diegesis and the role played by the content of the image within the relational perception of the sound/image coupling.

We were also interested in the congruence association model (CAM), as articulated by Cohen (2015), Ireland (2018) and a number of other scholars. The CAM is an offshoot of congruence studies in cognitive psychology which, among other things, examines the contribution of music to informing and supporting the narrative drive of audiovisual experiences like cinema and video games. For obvious reasons, the concept of congruence/incongruence – (un)fitting/(in)appropriate – is germane to the nature of sound/image relations and we will find an application of the term as one of the diegetic descriptors of our typology. However, considering that in videomusic the audiovisual discourse shifts towards abstraction and escapes traditional storytelling, the perception of (in)congruence rests on more uncertain ground. The emotional response to what seems 'right' and what seems 'wrong' is not as easily circumscribed.

Finally, our proposal is esthesis-based and non-prescriptive, focusing on the reception and perception of the stimuli. Gestalt theory[5] (Koffka 1935; Enns 2004; Madary 2016) helped us understand how we perceive sound and image when they are presented together to form an *audiovisual object*. The audiovisual object is the smallest atomic unit of analysis we use.

From our own work and that of others, we selected relevant examples to illustrate each descriptor of synchresis and diegesis. We tried to reach across all aesthetics of videomusic, from the fully abstract to the quasi-representational. We willfully excluded music videos (in the commercial acceptance of the term) since music videos are usually *made to order* as a specific cross-media carrier for the music it uses, paradoxically inversing the usual hierarchy in the media-predominance present in narrative film. We wanted to ascertain the examples we chose were true to the balanced presence of sound and image that is typically the *raison d'être* of videomusic. We also limited our choices to music content that is pertinent to the definition we propose of the videomusic form, which is that the writing of both media issues from the experimental tradition of working with the plasticity of materials.[6]

## Audiovisual objects

An audiovisual object is formed by the fusion of a media pair in the viewer-listener's mind. Audiovisual objects act as the smallest components of audiovisual discourse, like sound objects are the main constituents of electroacoustic music or musical chords form the backbone of harmonic progressions.

Based on humans' shared experience of the physical world, some instances of audiovisual objects are clear. For example, the sound and sight of a bursting balloon leave no doubt in our minds that what we heard and saw was caused by the same physical event. Our senses, memory and experience also contribute to identifying the object. Strongly source-bound associations can take place outside strict time coherence when physical forces at play are known and part of our daily experience. For instance, the crumbling of a piece of paper or the scraping of boots on the ground.

These examples apply to objects which are known to the viewer-listener. However, these objects seldom constitute the sound/image pairs used in videomusic, where the works are usually inhabited by non-representational forms, both sonic and visual. The concept of audiovisual object is therefore extended to include any sound/image association that the viewer-listener instinctively accepts as perceptually bound.

Audiovisual objects are often bound according to agglutination principles. These principles, ordinarily applied to vision, are at play in audiovisual perception due to our ability to evaluate and connect cross-modal stimuli (Fahlenbrach 2005). As is well known, the sum of two parts is different than the addition of their individual features (Koffka 1935). The object of our analysis is thus the relationship between the two and how this relationship affects our identification of an audiovisual object. The sensation of unity of sound and image happens in the mind, not in the eye and the ear.

We are interested in the primary tendency of the brain to group audiovisual stimuli according to their similar nature if they are visually and aurally connected via kinetic, morphologic or semantic characteristics. In fact, the principles of grouping[7] in Gestalt theory suggest that humans order their experiences in a manner that is regular, orderly, symmetrical and simple. In order to form a unified percept, the mind simplifies the stimuli and satisfies the desire to establish relationships.

An audiovisual object is therefore perceived when the shape and timing of visual and sound stimuli are perceptually bound, triggering a mental schema for interpreting the two stimuli as one. This perceived object can usually be characterised as *true to life* and believable. The synchretic relation – happening in the same time frame and having a singular isomorphic composition (Coulter 2010) – makes the object a perceivable unit.

However, sound and image need not happen at the precise same moment nor be purely isomorphic for the synchretic effect to take place. There is a plausible range of variability in both media that not only allows the binding effect to happen but may

indeed make the relationship stronger. This state of uncertainty pulls the viewer-listener into a personal and metaphorical understanding of the composer's intention and likely explains the wealth of experiences that can be carried with abstracted audiovisual forms.

## Segmentation: audiovisual units

Our analysis method is partly inspired by Stéphane Roy's functional analysis (2003), which is based on discrete semantic functions that explain the role played by *sound units* in a work of electroacoustic music. From this approach, we keep the idea of semantic units, but the object of our analysis is relational rather than functional.

To analyse sound/image relations, we segment the work into *audiovisual units*. An audiovisual unit (hereafter AVU) is a segment of variable duration (instantaneous, short, medium or long) that carries at least one perceptible sound/image relation that:

- has a minimum of perceptual salience in the form of the work;
- possesses well-defined kineto-morphological properties that make it discernable from other units in a given context;
- plays a significant role in a larger discursive entity.

Given that different relations may overlap within a work, AVUs can be assembled vertically and horizontally. An AVU can itself be a container for other AVUs down to the level of the audiovisual object. The level of analysis is a function of the complexity of the audiovisual flux. Many AVUs containing synchretic relations can happen simultaneously. On the other hand, diegetic relations are based on the scene of occurrence or on the nature of the world that is articulated by their presence. Therefore, we suggest there can only be a single diegetic relation at a time and it applies to the highest level of analysis.

The division of the audiovisual flux into AVUs is also conditioned by Gestalt principles and the receptive behaviours[8] of the viewer-listener. Receptive behaviours participate actively in constructing the perceived experience of a work. When studying the phenomenon, these behaviours condition the way a work will be segmented. This is why the application of our typology is not systematic: it is by nature interpretive.

Our objective is to provide tools for understanding the wholeness of a work of videomusic, based on a poetic and abstracted reading of reality. We do not provide explanations for what functions well and not so well in an association of music and image. We give identifiers to argue a case, whatever that case may be. Indeed, our thinking is essentially guided by the idea that the discourse of a work corresponds

to a specific way of arranging syntactic relations. In that sense, AVUs are the main building blocks that articulate the videomusical discourse.

## Synchresis

*Synchresis* is a term introduced by Chion and refers to the "spontaneous and irresistible weld produced between a particular auditory phenomenon and visual phenomenon when they occur at the same time" (Chion 1994: 63). However, this association is not totally automatic and depends on the meaning and context of occurrence. Thus, the variable simultaneity of occurrence, conditions our perception in terms of what is *welded* and leaves much room for interpretation.

In our interpretation of synchresis, the effect does not directly imply that the sound issues *from* the image/action seen. When visual and sound elements are combined and organised with a musical intent, realism, as it relates to causality, is not a primary concern, for both the composer and the viewer-listener. A *meta-narrative* audiovisual discourse is not in itself concerned with realism. The *audiovisual contract*[9] (Chion 1994) is still signed by the viewer-listener because s/he accepts that a plausible rendering of reality (as in representational cinema) is not what is being proposed. In other words, synchretic relations can and do exist outside causal links between sound and image/action.[10] Our comprehension of synchresis extends to encompass all situations where a viewer-listener can accept the suitability (as opposed to the believability) of a time-based association of sound and image.

## Synchresis: descriptors

Synchresis happens when an auditory event and a visual event:

- occur at the same time;
- occur in a short time interval so that they are perceived as belonging to the same object;
- are directly associated in a physically recognisable object;
- progress morphologically at the same perceptual speed with coherent shared directional dynamics;
- or unfold at a predictable periodicity or as a singular repeated pattern.

Generally, a synchretic relation qualifies isolated sound/image elements but many synchretic relations can be present simultaneously. The concomitance of many audiovisual objects, each with its synchretic relation, is very similar to vertical music writing (harmony, figure/background, the compound timbre of multiple instruments, etc.). It is also important to understand that synchresis occurs on an

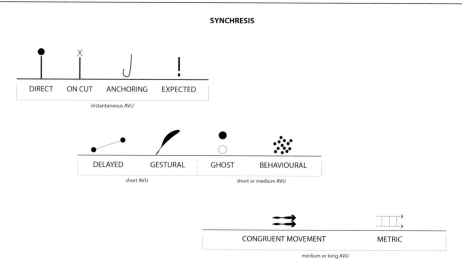

**Figure 2.1**  Synchresis descriptors.

Note: See the Appendix for examples.

elastic scale: it can be instantaneous or deferred up to a time period within which the viewer-listener can still unequivocally associate the two stimuli.

We identified ten types of synchresis: direct, on cut, anchoring, expected, delayed, gestural, ghost, behavioural, congruent movement and metric (see Figure 2.1). We will briefly describe each descriptor and provide pertinent examples of its various embodiments.

## Direct synchresis (instantaneous AVU)

Immediate synchronicity between a sound element and an image element. A hammer strikes a surface producing a sharp sound. A white dot pops briefly on screen accompanied by a short beep sound (Video 2.1). Direct synchresis concerns an object that is visible in the image. Sound and image are bound by their simultaneity, not by whether they are recognisable objects (Video 2.2). A slap in the face with a church bell sound is still direct synchresis even if the association is not believable.

## On cut synchresis (instantaneous AVU)

The simultaneous and abrupt change of sound and image in a simple straight cut edit. For example, an impact sound, sudden change of chord or of timbre happens with the change of scene or a sudden change of point of view on the same scene (Video 2.3).

Cuts can be prepared and anticipated. For example, the sound increases in volume and the image is cut at its peak amplitude.

### Anchoring synchresis (instantaneous AVU)

Anchoring synchresis occurs when, after a time span of asynchronous behaviour or apparent independence of sound and image evolution, there is a *falling together* of both media, leading to a sentiment of togetherness and the perception that audiovisual bonding is achieved. An anchor point is an unequivocal point of convergence of media pairs (Video 2.4).

### Expected synchresis (instantaneous AVU)

There is a significant event in the image while there is no change in the sound or there is a significant event in the sound while there is no change in the image. This type of synchresis can create a compelling surprise effect by breaking expectations of continuity (Video 2.5).

### Delayed synchresis (short AVU)

This relation appears when there is an association of image and sound taking place at a deferred time. This association is not always clear and its identification is dependent on the viewer-listener's attention and cognitive biases. It is related to expected synchresis in that a change in the image is not immediately accompanied by a change in sound. Delayed synchresis happens when concordance is re-established by an appropriate audio event that happens later and thus resolves the unfulfilled expectation of change (Video 2.6). In traditional film editing, *L-cut* and *J-cut* edits[11] are a special case of delayed synchresis.

### Gestural synchresis (short AVU)

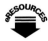

This relation is associated with the directional evolution of the sound/image coupling in a single audiovisual object. It is dependent on similar kineto-morphological characteristics of both sound and image, such as acceleration/deceleration, dynamic progression, direction, movement and energy. Forms on the screen move in a way that is congruent with the continuous sound and could believably be the source of the sound. Gestural synchresis happens when, directly or metaphorically, the movement in the image and in the sound follows the same "energy-motion trajectory" (Smalley 1997: 111) (Video 2.7).

### Ghost synchresis (short or medium AVU)

A visual object is seen as the forefront and is a predominant component of the scene, but it does not have a perceptible correspondence in the music; the visual object is silent. Conversely, a forefront musical figure that is very important in the audio flux is not associated by a significant figure in the image; the sonic object is invisible. Independence between image and sound components makes it possible to emphasise one element over the other. For example, ghost synchresis can underline a visual rhythmic pattern while there is no rhythmic element in the sound, or highlight a visual detail that musically interacts with the sound but not in a synchronous way (Video 2.8).

### Behavioural synchresis (short or medium AVU)

The audiovisual unit contains meeting points between image and sound, but not systematically. Convergence does not obligatorily happen at the same time, but the sound and image have strong morphological correspondences. An image of flying birds does not need to have the sound of the same number of flapping wings (Video 2.9). There is no need to have perfect synchronicity between sound and image to associate them as the same object (Video 2.10).

### Congruent movement synchresis (medium or long AVU)

Congruent movement synchresis is manifest in the pairing of objects that progress at the same perceived speed, rate of change and direction. Unlike gestural synchresis, it does not carry morphological correspondences between image and sound. In other words, the image is not perceived as the *source of* the sound but is associated with the sound by its comparable drive or momentum (Videos 2.11 and 2.12).

### Metric synchresis (medium or long AVU)

Measured and periodic, image and sound are linked by their common time base. The denominator is the beat per minute to frame per second (BPM/FPS) ratio. By multiplicative processes, patterns can vary independently in image and sound but the denominating period remains the same. Metric synchresis also concerns periodic (predictable) synchronisation between a sound and an image, based on pattern recognition (Videos 2.13, 2.14, and 2.15).

## Diegesis

> [E]very film, as soon as it is projected, installs a universe.
>
> (Souriau 1951: 232)

Borrowing the term *diegesis* from ancient Greek philosophy and applying it to film theory, Étienne Souriau introduced the term in 1951 and re-defined it as "everything that is thought to happen according to the fiction presented by the film; everything that this fiction would imply if we supposed it to be true" (Souriau 1951: 240). Diegesis is characterised not only by "all that is taken into consideration as represented by the film" but also by "the kind of reality assumed by the meaning of the film" (Souriau 1951: 237). A few years later, Souriau widened the definition by saying that diegesis assimilates "all that belongs [. . .] to the supposed world or the proposed world of the film" (Souriau 1953: 7).

Souriau's analysis is closely associated with narrative storytelling. The diegetic world he describes is a fictive world but a world that has a *likely* quality. In other words, from the spectator's view, enough cues, recognisable objects and characters are given to ensure the believability of the story. If the fiction is well built and acted out, the spectator can be convinced that the story *could* happen in real life.

In the case of abstracted audiovisuals, this acceptance cannot be elicited in the same manner, given the relative absence of representational cues from real life. To address this quandary, we will use a deviation of the term *meta-narrative*, distinct from its post-modern acceptation (Lyotard 1979). The meta-narrative of abstracted audiovisuals is the overarching meaning of a work, even if this meaning is largely fabricated in the mind of the viewer-listener. The diegesis of this world establishes a coherent spatiotemporal universe populated by sound and moving images.

The supposed or proposed world is built using criteria of size, speed, colour, shape, texture, affect and emotion. All sounds and images then constitute the supposed or proposed world. Diegesis does not imply that sound and image be complementary or similar. The mere fact that sound and image are presented together triggers a diegetic relation. Indeed, the human mind "needs to establish a coherent link in a process of simultaneity" (Kröpfl 2007: 90). Even in radical incongruence, our mind still attempts to make sense and produce meaning.

The terms *intra-diegetic* and *extra-diegetic*[12] (Genette 1972), commonly used in film theory for categorising sound, seem problematic to us. We prefer to talk about different types of diegesis, ranging from the physicality of the link between sound and image to the affect generated by it. Diegesis is *where* audiovisual relations happen.

For example, a videomusic work containing slow ocean waves with sounds of a solo violin presents a dual space of occurrence, but the combination creates a new unified *where* that attempts to resolve the incongruence. The diegetic relation in such a case is based on affect and would be qualified as *sublimated* diegesis. The relation doesn't happen because of the ocean or the violin, but because of them being presented together.

Another example could be a work based on direct relations between sound and image. A low-pitched sound triggers a red circle, a high-pitched sound triggers a blue

triangle. The internal laws of this presentation constitute a diegetic relation which is driven by its cross-modal logic. If we hear a low sound, we expect to see a red circle. A viewer-listener having understood the nature of the proposed world will anticipate and accept an interpolation of red/blue to circle/triangle as the pitch rises.

## Diegesis: descriptors

Diegesis occurs on a relatively longer scale than synchresis: the AVU carrying the diegetic relation can be medium or long. Diegetic relations are concerned about the whole, i.e. all the elements seen/heard in a scene. As explained earlier, since there can only be one fictive proposed universe at a time, there can only be one diegetic relation in a given top-level segment.

We identified seven types of diegesis: direct, synthetic, musical, parametric, incongruent, sublimated and monomedia (see Figure 2.2).

### Direct diegesis (medium or long AVU)

Takes place when the sound is associated with the real sound of an object in the image or of the scene. Related to origin: the sound comes from the visual scene and uses our knowledge of the physical world to identify the relation. Direct diegesis concerns images/sounds coming from the real world (for example, a recording of fire) or representing the real world (for example, in a 3D scene). Sound can be *on-screen* (the source of the sound heard is visible in the image) or *off-screen* (the source of the sound is not visible but could be – a camera movement could make it appear) (Chion 1994) (Videos 2.16 and 2.17).

### Synthetic diegesis (medium or long AVU)

There is a strong concordance between visual and sound materials. Synthetic diegesis concerns abstract images and sounds (i.e. not representing the real world). Abstract images don't have a specific sound but they have kineto-morphological

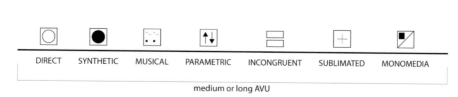

**Figure 2.2** Diegesis descriptors.

Note: See the Appendix for examples.

features that indicate their appropriateness to the sounds they are presented with. It includes rhythm, grain (textures), oscillation (*allure*), melodic profile and profiles of mass (Schaeffer 1966). Synthetic diegesis can be likened to a sound design approach applied to a musical context (Videos 2.18 and 2.19).

### Musical diegesis (medium or long AVU)

The sound/image relationship is drawn by the music itself (pitch, rhythm, etc.). The composition is guided by a musical structure. In this case, the image seems like a visual representation of the music, or vice versa. It is a visual representation of the musical elements of the music, not the physical parameters of the sound. This type of diegesis was often used in early visual music works such as Fischinger's *An Optical Poem* (1938) (Videos 2.20 and 2.21).

### Parametric diegesis (medium or long AVU)

Parametric diegesis harnesses the parametric values of one media (colour, blob tracking for visual/pitch, loudness and timbre for sound) scales them and remaps them directly onto the other media to provide a visualisation of sound or a sonification of images.

In *image-to-sound* or *sound-to-image* conversion, optical sound allowed for a direct analogue translation between sound and image as a form of technical and aesthetic synthesis. The foundations for linking auditory and visual phenomena are intimately tied to the materiality and operative possibilities of media technologies. For example, in *Test Pattern [no 8]* (Ryoji Ikeda 2015), the visual is generated from the audio buffer (sound-to-image conversion).

*Visualisation* and *sonification* use transmutability, which relies on the premise that any kind of input data can be algorithmically visualised or sonified (mapping). This process embodies a mapped isomorphy operating through cross-media parametric mapping (Coulter 2010: 30–31) (Videos 2.22 and 2.23).

### Incongruent diegesis (medium or long AVU)

The sound and image fluxes are contradictory, dissimilar and heterogeneous. They appear independent in their movement, evocation and morphology. Incongruent diegesis is not, as in the CAM model, about the emotional affect that can be triggered when heterogeneous media are presented together.

In incongruent diegesis, the connection between sound and image does not appear to exist at all. The antagonistic cohabitation remains and is not resolved. It is like an encounter between two different musics, one to be seen and the other to be heard (Xenakis 2008, cited in Basanta 2012: 12). Even if we do perceive connections (as we actively look for sense and meaning), those will happen on random accidental synch

points. Given enough time, we will finally fail to reveal any underlying volition for the material to be perceived as living in the same universe (Videos 2.24 and 2.25).

This type of diegesis is usually attributable to either an error in composition or, in less frequent occurrences, to the ultimate purpose of the work. As an example (admittedly not videomusical) of the former, Merce Cunningham and John Cage (see *Roaratorio* 1983) made a point of avoiding any perceivable connection between dancers and the music in their collaborations. Keeping dance and music on independent tracks, coinciding at performance time but without pre-planned correspondence, was the esthetic principle espoused by the work (Kriegsman 1986).

### Sublimated diegesis (medium or long AVU)

Sublimated diegesis appears when the sound/image relation elevates an audiovisual unit to a role similar to that of congruent music in narrative cinema. It unequivocally abandons any physical relationship between the sound and image but forges a strong primary emotional link. The music is not limited to an accompaniment mode; it merges into the meta-narrative frame and gives rise to emotions by contextualising the images. The image/sound relationship offers a reading angle, a sublimation, raising the image/sound relation beyond the physical manifestation of what is heard and seen. Its affect is a sensation of unity outside credible kineto-morphological links (Videos 2.26 and 2.27).

Sublimated diegesis does not imply that the emotions carried by both media are congruent. For example, a happy banjo soundtrack over a train derailment will give rise to a new affect and most likely a new interpretation of what is seen and heard. The difference with incongruent diegesis is that there is a meaningful link to be made between sound and image, even if they refer to vastly different emotional content.

### Monomedia diegesis (medium or long AVU)

Monomedia diegesis happens when the image is without sound or sound is without the image. Any obvious linkage between image and sound is, by definition, removed. However, monomedia diegesis is highly context dependent. For the monomedia diegetic relation to exist there only needs to be an *expectation* by the viewer-listener to be presented with both sound and image. If one of the media is missing the sound/image relation is still present. It rests on the expectation of the medium to be present and is, therefore, a powerful meaning generator. It is a strong marker of tension when transitioning from another type of diegesis (Video 2.28).

## Future work

From this outline, we hope to have presented convincing analytical tools for the development of audiovisual practices. It is our hope that our attempt will be of use for understanding some of the building blocks of abstract(ed) audiovisuality.

To move forward with our coupling theory of image/sound and to expand on the present typological proposals, we hope to explore a possible analysis method. This method will study the discursive elements to understand the sound/image relations of the meta-narrative in a larger context. We experience a work of videomusic as a succession of elements, and the ordering of these elements drives the overall experience. The analysis method should afford the possibility to notate a videomusic work in a representational score and to model the guiding forces that define its meaning. So far, we have admittedly created a simple catalogue of effects, albeit a catalogue that is bound to be enriched and augmented in the future.

It is important to keep in mind the organisational insights and intuitions involved in composing musical moving imagery. In the absence of narrative as a leading sustainer of experience, we are left with more questions than answers. In a way, we arrive at the same crossroad previously visited by the *Traité des objets musicaux* (Schaeffer 1966). Once we have built tools to name phenomena, we can identify and classify them but we still cannot understand why they have the effect they do. Accounting for the behaviour of two complex streams of interdependent stimuli is daunting indeed.

## Acknowledgements

This work is supported by the generous assistance of the Social Sciences and Humanities Research Council (CRSH). Many thanks to Marie Gaudreau and Pierre-Luc Lecours for their invaluable support. All translations from French are ours. All images © Boucher and Piché.

## Notes

1 Tom Sherman and Jean Piché, informal discussions ca. 1986–1989.
2 In this text, a *viewer-listener* is understood to be the receiver of any audiovisual information where what is heard is equally important as what is seen.
3 We use the title *composer* for the artist who creates videomusic works.
4 See (Genette 1972; Altman 1992; Chion 1994; La Rochelle et al. 2002; Pisano 2004; Murch 2005).
5 Gestalt psychology maintains that the mind forms a global whole with self-organising tendencies, and describes how humans tend to organise elements into groups when certain principles are applied.
6 We acknowledge that this is a difficult line to draw, given the blurring of boundaries between vernacular and experimental practices in the last decades.
7 For our purpose, we retain the principles of common fate, common region, proximity, unified connectedness, continuation, past experience, closure, figure/ground (multi-stability), meaningfulness (familiarity), regularity, similarity (invariance), symmetry and synchrony.
8 See François Delalande (1998). The author describes three types of listening behaviours: taxonomic listening, empathic listening and figurativisation.
9 "The audiovisual relationship is not natural but rather a sort of symbolic pact to which the audio-spectator agrees when she or he considers the elements of sound and image to be participating in one and the same entity or world" (Chion 1994: 222).

10 In order to make the distinction clearer, we will use the term *diegesis* to talk about relations that are perceptively credible as the *origins* of the sound.

11 Also known as *split-edits*, where the sound changes a short time after or ahead of a scene change, with the effect of enhancing continuity.

12 *Intra-diegetic* sound has its source on-screen – it is part of the story. While the *extra-diegetic* sound is a sound which does not have a source on-screen – it has been added in.

# References

Altman, R. (1992) *Sound Theory, Sound Practice*. New York: Routledge.

Basanta, A. (2012) Shades of Synchresis: A Proposed Framework for the Classification of Audiovisual Relations in Sound-and-Light Media Installations, Meaning and Meaningfulness in Electroacoustic Music. *Proceedings of the Electroacoustic Music Studies Conference*, Stockholm, June.

Chion, M. (1994) *Audio-Vision: Sound on Screen* (trans. French W. Murch; C. Gorbman). New York: Columbia University Press.

Cohen, A.J. (2015) Congruence-Association Model and Experiments in Film Music: Toward Interdisciplinary. *Music and the Moving Image*. 8(2). pp. 5–24.

Coulter, J. (2010) Electroacoustic Music with Moving Images: The Art of Media Pairing. *Organised Sound*. 15(1). pp. 26–34.

Delalande, F. (1998) Music Analysis and Reception Behaviours: Sommeil by Pierre Henry. *Journal of New Music Research*. 27(1–2). pp. 13–66.

Enns, J.T. (2004) *The Thinking Eye, the Seeing Brain: Explorations in Visual Cognition*. New York: W.W. Norton & Company.

Fahlenbrach, K. (2005) Aesthetics and Audiovisual Metaphors in Media Perception. *CLCWeb: Comparative Literature and Culture*. 7(4). https://doi.org/10.7771/1481-4374.1280 [Last Accessed 10/11/19].

Genette, G. (1972) *Figures III*. Paris: Seuil.

Ireland, D. (2018) Interrogating (In)congruence: The Incongruent Perspective. In: D. Ireland (ed.) *Identifying and Interpreting Incongruent Film Music*. Cham: Palgrave Macmillan.

Koffka, K. (1935) *Principles of Gestalt Psychology*. London: Routledge.

Kriegsman, A.M. (2011 [1986]) Inspired Roaratorio in N.Y. *The Washington Post*, [online] 8 October. Available online: www.washingtonpost.com/archive/lifestyle/1986/10/08/inspired-roaratorio-in-ny/ca1b2c89-9b05-4e20-97c6-f66d51b01aa6/?noredirect=on&utm_term=.55aa5c5c2647 [Last Accessed 10/11/19].

Kröpfl, F. (2007) Integrating Sound and Visual Image as Artform. In: F. Barriére and C. Clozier (eds.) *Audition and Vision in the Creation in Electroacoustic Music: 2004–2005*. Bourges: Institut international de musique électroacoustique de Bourges, VII, pp. 89–90.

La Rochelle, R., et al. (2002) *Écouter le cinéma*. Montréal: 400 coups.

Lyotard, J.F. (1979) *La condition postmoderne: Rapport sur le savoir*. Paris: Minuit.

Madary, M. (2016) *Visual Phenomenology*. Cambridge: MIT Press.

Murch, W. (2005) Walter Murch. *The Transom Review*, [online]. 5(1). Available online: https://transom.org/2005/walter-murch/ [Last Accessed 09/11/19].

Pisano, G. (2004) *Une archéologie du cinéma sonore*. Paris: CNRS.

Roy, S. (2003) *L'analyse des musiques électroacoustiques: Modèles et propositions*. Paris: L'Harmattan.

Schaeffer, P. (1966) *Traité des objets musicaux: Essai interdisciplines*. Paris: Éditions du Seuil.

Smalley, D. (1997) Spectromorphology: Explaining Sound-Shapes. *Organised Sound*. 2(2). pp. 107–126.

Souriau, E. (1951) La structure de l'univers filmique et le vocabulaire de la filmologie. *Revue internationale de filmologie*. 7–8. pp. 231–240.

Souriau, E. (1953) *L'univers filmique*. Paris: Flammarion.

Xenakis, I. (2008) Music and Architecture: Architectural Projects, Texts and Realizations. In: S. Kanach (ed.) *Iannis Xenakis Series* (1). Hillsdale, NY: Pendragon Press.

## Works

An Optical Poem (1938) [VISUAL MUSIC] Oskar Fischinger. Metro-Goldwyn-Mayer.
Roaratorio (1983) [CHOREOGRAPHY] Merce Cunningham and John Cage.
Test Pattern [n° 8] (2015) [INSTALLATION] Ryoji Ikeda.

## Appendix (video files examples – edited excerpts)

*01_DirectSynchresis*
Storm (2015) [VIDEOMUSIC] Myriam Boucher and Pierre-Luc Lecours.

*02_OnCutSynchresis*
Dolmens (paNi intiyA) (1996) [VIDEOMUSIC] Jean Piché.
See at 0:03.

*03_AnchoringSynchresis*
Cités (2015) [VIDEOMUSIC] Myriam Boucher.
See at 0:24.

*04_ExpectedSynchresis*
Threshing in the Palace of Light (2017–18) [VIDEOMUSIC] Jean Piché.
See at 0:25.

*05–1_DelayedSynchresis*
Spin (1998) [VIDEOMUSIC] Jean Piché.
See at 0:08.

*05–2_DelayedSynchresis*
Nuées (2016) [VIDEOMUSIC] Myriam Boucher.
See the saxophone baryton at 0:02 and the appearance of the bird at 0:05.

*06_GesturalSynchresis*
Mimic (2012) [EXPERIMENTAL VIDEO] Lucio Arese and Yu Miyashita.

*07_GhostSynchresis*
Bharat (2002) [VIDEOMUSIC] Jean Piché.

*08–1_BehaviouralSynchresis*
Nuées (2016) [VIDEOMUSIC] Myriam Boucher.

*08–2_BehaviouralSynchresis*
Vertiges (2018) [VIDEOMUSIC] Myriam Boucher.

*09–1_CongruentMovementSynchresis*
Storm (2015) [VIDEOMUSIC] Myriam Boucher and Pierre-Luc Lecours.

*09–2_CongruentMovementSynchresis*
Sieves (2005) [VIDEOMUSIC] Jean Piché.

*10–1_MetricSynchresis*
Ghostly (2013) [VIDEOMUSIC] Maxime Corbeil-Perron.

*10–2_MetricSynchresis*
Express (2001) [VIDEOMUSIC] Jean Piché.

*11–1_DirectDiegesis*
Vagues (2017) [VIDEOMUSIC] Myriam Boucher.

*11–2_DirectDiegesis*
Combustion (2011) [VIDEOMUSIC] Renaud Hallée.

*12–1_SyntheticDiegesis*
Storm (2015) [VIDEOMUSIC] Myriam Boucher and Pierre-Luc Lecours.

*12–2_SyntheticDiegesis*
Flux (2010) [VIDEOMUSIC] Candas Sisman.

*13–1_ MusicalDiegesis*
Forest and Trees (2011) [VIDEOMUSIC] Keita Onishi.

*13–2_ MusicalDiegesis*
Congruence (2009) [VIDEOMUSIC] Christoph Eggener and Fabian Schulz.

*14–1_ParametricDiegesis*
Musical Sonification of Brain Activity (2012) [AUDIOVISUAL STUDY] Roger Dumas.

*14–2_ParametricDiegesis*
Oscilloscope Music – Pictures from Sound (2016) [AUDIOVISUAL DEMO] Techmoan.

*14–3_ParametricDiegesis*
Virtual ANS: Image to Sound Conversion (2013) [AUDIOVISUAL DEMO] Alexander Zolotov.

*15–1_IncongruentDiegesis*
Roaratorio at BAM (1986) [CHOREOGRAPHY] Merce Cunningham and John Cage.

*15–2_IncongruentDiegesis*
Incongruent Diegesis: Example [VIDEOMUSIC] Jean Piché.

*16–1_SublimatedDiegesis*
Empty Spaces #10 (2019) [VIDEOMUSIC] Myriam Boucher.

*16–2_SublimatedDiegesis*
Spin (2001) [VIDEOMUSIC] Jean Piché.

*17_MonomediaDiegesis*
Recommencements (2020) [VIDEOMUSIC] Myriam Boucher.

# The question of form in visual music

Maura McDonnell

## Introduction

The question of form in visual music is complex because artistic impulses, styles and formal characteristics from visual art and music are jointly combined in an artistic fashion that is not reducible simply to either visual form, musical form, or to a one-to-one correspondence. The category of visual music itself is the first formal and structural element of visual music. This category refers to the totality of a visual music art as a unique form of art-making. It also refers to the major principle operating in the art, which is the unity of visual art and music that is expressed by artists and that takes place in the temporal unfolding of the visual music in the work of art. As a multi-sensory art-making, the major components of the artistic means of expression of both seeing and hearing are pooled together and unified by the artistic expressiveness operating in the visual music work. The expression at work in visual music is thus a unity that is derived from a combination of two arts; two disciplines; two knowledge areas; two histories; two sensory modes; two mediums and two sets of means. The formal content in visual music emerges from the operation of all these dualities as well as from the artist's own knowledge, subjective assemblage, use and understanding of their chosen means of expression. The tools, processes and methods that are available to create a visual music work have evolved historically and contribute to the way that the art evolves as an art form but also contributes to the types of formal content in the work. Wassily Kandinsky (1866–1944) assigned a very prominent role to the artist's choice of means, form and content as well as the artist's choice of the means of expressing that content as essential and important factors for a work of art, and it is from this premise that the author will discuss the issue of form in visual music in this chapter. In visual music then, the artist contributes to the form-making and form-perceiving to be had in the work by how they understand what unifies the musical or sonic with the visual part and by what means

they will choose to create the visual music. The means and forms of expression in art and music have of course developed over time, but it is of significance to note that the contemporary practice of this combined art form, now commonly referred to as 'visual music', evolved in conjunction with major shifts that occurred in art and music over the twentieth century in particular.

By way of context, one area that that the author would like to address in this chapter is the impact of the various conceptions of form that emerged historically from the separate and distinct knowledge starting points. The techniques and methods from historical processes have become readily available and accessible as means, tools and methods for creating contemporary visual music works in the contemporary technologies available to artists. For example, the following different historical starting points demonstrate the diversity of contributions to the field of visual music: the use of mathematical knowledge to devise proportioned scale of colour in analogy with the geometric proportions of a music scale; the emergence of abstraction in painting that sought out the language and expression of music to explain the new content of painting (for example, Victor Eggeling, Wassily Kandinsky and Paul Klee); the experiments with the mass communication technologies of film, television and video (for example, Hans Richter and John Whitney) for the purposes of making new artistic tools to create integrated art works of music, sound and image. From out of these developments, visual music as a distinct artistic activity emerged. Another important aspect in the historical evolution of visual music and art in general is the issue of art boundary. The boundaries that separated art domains, such as art domain specific artistic languages, art domain specific techniques, processes and skills, as well as access to making art with technological means seems to have been loosened over the twentieth century and in some ways has dissipated in the twenty-first century as a result of the evolution of the technological tools and techniques that have grown and evolved from the capability of the computer to record, store, process and playback images and sounds together. The computer as an instrument that presents the reproductions of information in the form of images and sounds has within it the capacity to facilitate multi-sensory design and to facilitate an infinite permutation of form in the content and relation of images and sounds.

The overarching theme of this chapter is based on the premise that form in visual music is led by the artists' desire to work with the means of expression that is available to them and to develop form and content from the means. Today, musicians can use their knowledge of programming to create their own unique versions of visual music mappings (for example, Stephan Malonowski) and painters can use their knowledge of abstract expressionism to create a unity of artistic expression between abstract animations and music (for example, Jean Detheux). Thus, this chapter considers form in visual music to be always a type of question and enquiry into the artistic means. The following subtopics are addressed: the geometries of tone and sound made visible; the relation of form to the means of expression; basic

formal elements; musical means of expression for visual forms; the independent and autonomous means of expression; from the artistic need to create new forms for expression; universal language of form; light as a material and a means of expression in time; exploring music with visual formations; and, finally, the process of making facilitates the emergence of form.

## Geometries of tone and sound made visible

An older tradition influencing twentieth-century visual music comes from natural scientific experiments that attempted a classification of colour derived from a colour-tone analogy dating back to Sir Isaac Newton, and prior to this, to the ancient Greek Pythagoreans. The attempt to correlate mathematically colour and sound has a long history. The colour-organ tradition of the nineteenth and twentieth century arose out of colour-tone analogies (Mason 1958; Gage 1999; Peacock 1988). This history, however, will not be examined in detail here, as it has been examined elsewhere (Fransseen 1991; Collopy 2004; Darrigol 2010a, 2010b; Jewanski 2010; McDonnell 1998, 2013, 2019). This history demonstrates that colour was conceived of as having the same mathematical and physical basis in geometric harmonic laws. Thus it was envisaged that colour could be arranged in colour scales and performed like music, creating harmonious colour arrangements. This colour-tone analogy approach has evolved in contemporary practice to the creation of content in which visual forms and/or music are devised through some sort of analogical and associative process between the visual and music part(s). In this approach, authors devise a system of mapping between visual and music elements. Bret Battey and Rajmil Fischman (2013) refer to this as a 'note-to-visual-object linkage' approach.

Alongside this colour-tone and mapping approach to visual music, there has also been a consistent exploration of artistic content that endeavours to create a simultaneous image and sound through some form of mediation that enables the simultaneity. Scientific experimentation was able to demonstrate that sounds did exhibit consistent geometric relations and behaviours in relation to the physics of sound and pitched tones and that these geometries could be presented as visual patterns. Ernest Florens Friedrich Chladni's (1756–1827) acoustic experiments with sound vibrations on plates, sand and a violin bow yielded what he referred to as 'tone figures'. A geometric visual form manifested itself at different pitches. Hans Jenny (1904–1972) invented the '*Tonoscope*' based on attaching oscillators to frequency generators to research the structure and dynamics of sound waves and vibrations in what he called 'Cymatics'. He demonstrated the periodicity, movement and emergence of patterned-figuration formations with sound and called these visual geometric forms 'sonorous figures'. This approach to creating a mathematically based content is an important strand of visual music's history, what one could call an approach that is

based on the geometry of music made visible. Much of the filmmaker John Whitney's (1917–1995) work was based on exploring the mathematical ratios of harmony from music in visual form and also, at times, in sonic form where he generated synthetic sounds on the optical track of film by means of a system of pendulums. In his later computer work, he created time-varying geometric visual forms using computers with the assistance of computer programmers. He noted a phenomenon in these forms where "differential resonant actions of aggregate pixel patterns, generated by computer, resemble the actions of harmony in music" (Whitney 1994: 47). He describes these as arising from 'harmonic pixel phenomena'. He dealt with this topic in detail in his study of *Digital Harmony – On the Complementarity of Music and Visual Art*' (ibid.). Several contemporary artists have continued to work and extend Whitney's digital harmony ideas, for example, Lewis Sykes and Ben Lycett's *The Augmented Tonoscope* set of audiovisual performance works, where they "attempt to show a deeper connection between what is seen by making the audible visible. By looking for similar qualities to the vibrations that generate sound in the visual domain, they try to create an amalgam of the audio and visual where there is a more literal 'harmony'" (Seeingsound 2013). Another geometric approach to making a connection between visual and music were the film experiments with synthetic sound by means of film. Oskar Fischinger (1900–1967) referred to the shapes that he prepared by drawing, and then photographed on to the optical part of the filmstrip, as '*Klingende Ornamente*' (Fischinger 1932), 'sounding ornaments', and created a series of film experiments 'Tönende Ornamente (Ornament Sound)' exploring these ideas. László Moholy-Nagy (1895–1946) explored similar ornament approaches to synthetic sound by means of film in his *Tönendes* ABC/ABC in Sound (1933). Moholy-Nagy's film has only recently been found in the BFI archives and restored, after being missing for eighty years. Norman McLaren (1914–1987) explored the capability of film to draft intricate sound-to-image connections through the precise drawing of shapes and figures on both the optical and visible part of the filmstrip. He referred to these synthetic sounds as 'animated sound' (McLaren 1953: 224). He used extensive cinematic and animation means to create these synchronised images, and forms with sounds. Interestingly, however, McLaren also took a mathematical geometrical approach to the control of motion, pace and speed of visual elements in animation, noting the harmonic structure of relationships of motion.

## Relation of form to the means of expression

Mathematically correlated sounds-to-images and images-to-sounds, however, do not explain the selection or creative use or artistic combination of the means of expression of such 'objects' in visual music or the relation of the objects to the means of expression. Form relates the content and the means of expression that comes from

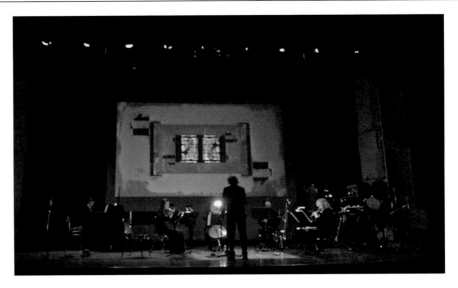

**Figure 3.1**   Ensemble Parallax's music performance of Pierre Boulez's *Dérive* 1, 2019, with visuals by Maura McDonnell.

the artist's processes and structuring of the means and content. Form then refers to the artistic and means based processes that an artist uses to create the art work.

Typically a visual music work of art today comprises two works of art – the visual art and the music art. Both of these arts are brought together in a dynamic combination. Through the visual part of the work, the two arts are conceived of as a unity and presented as a unity, just as music and dance are conceived of as a unity and the dance performance brings the two together. Cinema art is also a more complex unity that brings together acting, dialogue, music, sound and film images. A characteristic feature of visual music, however, is that it is brought to life through its 'live' performance and presentation to an audience, which can be in a music concert, or in an art installation, or in a film screening. Following is a still of a presentation of a visual music visual from the author's composition of a video for live performance by Ensemble Parallax of Pierre Boulez's music composition '*Dérive* 1' (see Figure 3.1), in a music concert setting. Many visual music artists present their work this way.

## Basic formal elements

Since visual music enables an artist to share the means of expression from the basic formal elements belonging to both visual art and music, the visual music artist, at the outset of creating a work, chooses the visual elements and the means of expression with which they will work. This sets the scene for the work and acts as the ground

for the image component just as in music composition a music composer chooses the sounds and instruments out of which the music is constructed. The ground of the image operates in every good work of visual music art, and it can be observed from the very first instant of experiencing a visual music work. This is because the forms, colours and style of treatment of the images over time and their way of relating to the music part are declared in the first few frames of the work, and one can grasp, almost immediately, that these belong to the totality of the work. The rest of the work provides the trajectory of the transformations and appearances of these formal elements over the course of the work's presentation.

The basic formal elements in art are also constantly evolving and changing as the art develops in its practice, processes and techniques. In tonal music, for instance, the major formal elements of music have a long history of development and evolution. The musical note, the sound, the *concrète* sound, the timbre, the melody, the harmony, the rhythm, the totality of each piece are some of the basic elements of music and they are well known. The note carries an aesthetic value in how it is used in a melody or with sound or in a composition. No one note has more value than another, it is rather an already formed formal element (von Hildebrand 1984: 368). The representation in music, however, is different to the imitative types of representation that were and are possible in a visual art. In music, representation is linked to expression and has a direct relationship to the world of the senses (ibid., 366). The expression takes place in the way of handling the basic elements. The basic elements of music are used to construct and represent the expressive possibilities that musical sound brings to human experience and are used to construct musical sounds in the totality of a musical work. That which is expressed is linked to life, emotion, beauty, drama and well-formed sensory experience. The art of music has built up a whole language of expressiveness in relation to formal elements and means of expression to employ in the musical work. Some of the means of expression employed in a musical work of art are tempo, staccato, smoothness, legato, crescendo, diminuendo, height of notes, major and minor keys (ibid., 372), tremolo, vibrato, intonation, phrasing, accents and many more. More recent means of expression are the sound object, listening to sound, moving sound through aural space.

In a visual art work that incorporates a pictorial surface, the basic elements of the art of creating a picture are also well known, such as the object, the figure, the still life, the landscape and so forth. The means of expression employed in the visual art work are the line, the colours, the shape, tints and shades of colour, light and shade, the foreground and background, the size, the position, the composition, the smoothness, the texture. In painting up until the turn of the twentieth century, these basic elements and the means of expression served the same function as they represented external objects of apprehension. Even if that object was being used for symbolic purposes, it was still a recognisable object. Forms comprised correct relations of figure and ground, spatial perspective, light, shade, volume, proportion and were filled

with the correct colours and colour relations occupying the content of the figures and objects. This ensured that colour acted consistently across all forms in the particular space and also related correctly to the space in terms of hue, light, shadow, tint, shade, volume, depth and proximity. For example, the skin-tone colour on a bodily part of a figure had to match across all the parts of the body and similarly the skin-tone colour of several figures in a scene had to be consistent with the light and depth of the scene. In the imitative and representational style of painting, the visual impression goes beyond sense impression to apprehend the external objects of the artistic content, whether it is a landscape, a figurative work or a still life.

From the beginning of the twentieth century, however, painting increasingly turned towards finding new forms and means of expression in the content of painting. Forms may have initially been recognisable and stayed close to natural and recognisable shapes, but the content inside these forms and the strict adherence to imitation had shifted even before the emergence of abstraction in painting. This can be found, for example, in impressionist and cubist painting. Wassily Kandinsky (1866–1944) is one of the first painters to dispense with the recognisable external form of an object as the fundamental basic element of the pictorial surface. The philosopher Michel Henri (1922–2002) assigns Kandinsky's contribution to the development of art as being revolutionary because Kandinsky redefined the themes and the reality of painting by making the content and the means of expression serve interior and invisible realities. The means of the painting such as its forms and colours are also invisible, as the means now expresses the invisible content, "These means must now be understood as 'internal' in their meaning and ultimately as 'invisible' in their true reality" (Henri 1988, 2005, 2008: 10). Thus the external forms had a significance beyond appearance. Now the form and forms themselves, chosen by the artist, were the content and basic formal elements of the pictorial surface. The means of expression now served to create new forms and formal elements. In addition, new types of means of expression explore invisible qualities in a similar vein to the expressive means in music such as tempo, force, changing dynamics of form and colour.

## Musical means of expression for visual forms

Music provided a language and compositional devices in some instances for both finding and creating new means and forms of expression in painting and new ways to work with existing means of expression for the creation of form on the pictorial surface. Music provided not only a new avenue for painting to explore its own material but also a new way to describe the processes that were being used to create these new forms of expression in painting. For example, the painter Paul Klee (1879–1940) looked to formal music structures and music compositional forms both to solve the problem of description and to invent means of expression for creating

forms in painting. Klee was interested in creating forms that could depict the idea of the transformation of a form through a series of growth cycles, a phenomenon he had observed in nature (Klee 1923). He borrowed the conceptual compositional language of the musical forms of the fugue and polyphony to explore this idea of growth and to thus articulate and craft groupings of visual elements. For example, the main formal element in Klee's painting *Fugue in Red* (1921) consists of specific forms that are presented in simultaneous groups of similar shaped forms which, in their arrangement as a group and in their internal makeup, have a consistent and similar treatment of colour, tint and shade. The content – which is the main formal element – acts like a leading theme in the painting just as the leading theme of the melody in a fugue is declared on one music instrument. Each form in the painting carries the theme into its content, but because the shape, or the size and orientation of the grouping of graduated colour are different, these variations suggest the movement of the theme across many forms, just as the leading melody in one music instrument is passed along to another music instrument.

Will Grohmann identifies and suggests that the four shapes (jug, kidney, circle and rectangle) are analogous to musical themes and replies (see Figure 3.2):

> We might see theme, reply, theme in the third, and reply in the fourth part. The changing pitch would then lie in the changing character of the forms, the development of the theme in the development of colour. . . . A logical gradation of colour plays itself out in logically interrelated shapes.
>
> (Grohmann 1954 in Maur 1999: 55)

The totality of the work consists of the simultaneous merging and separating of these forms into a unified composition of many voices (Düchting 2004: 71).

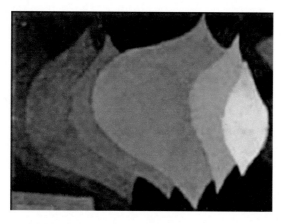

**Figure 3.2**  Detail of one of the shapes with colour gradations from Paul Klee, *Fugue in Red* (1921).

## The independent and autonomous means of expression

Arnold Schoenberg's (1874–1951) development of an atonal system of organising tones and his 'emancipation of dissonance' (Schoenberg 1926) in music alerted Kandinsky to new possibilities for the means and forms of expression in the content of painting. Kandinsky saw in this musical composer an artist choosing a form in music from his need to express something new with music, such as the invention of a twelve-tone row system of tone organisation in order to express his need to explore music beyond tonality. Schoenberg made the form fit his need to create a new type of music content. Kandinsky himself was interested in the use and application of colour in painting and in his earlier works had approached colour from a theoretical, geometrical and scientific point of view, examining the rules of colour and applying these in his paintings. After encountering Schoenberg's music, Kandinsky was struck by the independence and autonomy of the musical tone that was now organised around Schoenberg's own formal system. Kandinsky was inspired to assign a similar independence to the role of colour in painting so that colour could be an autonomous and resonant object in itself and also could contribute to formal elements by adding an emotional and affective quality to them and to the relationships between forms in the space of the painting. Such an approach to the use and application of colour in painting was less reliant on a mechanical or theoretical basis to inform the use of colour and more reliant on the artist's own sense of how the colour could be used to create resonances for the viewer.

A colour could now be a formal element in its own right and it had the power to inform the shape and appearance of the form to be created and how the colour is to occupy that form. Colour and form were now given the status of independent, autonomous elements in the space of the painting, comparable to the autonomy and independence given to the musical tone in Schoenberg's atonal music. It is understandable, then, that one of the terms Kandinsky devised to describe the autonomy and independence of the colours and forms and their relating to each was 'sounds' (Kandinsky 1912). 'Sounds' described the type of resonating relationship that takes place between the forms and colours. Each form, in other words, has its own particular content in analogy with how each instrument in music has its own particular timbre.

The organisation of music by means of its tonality and by well-known formal elements and means of expression such as a musical note, musical scales, melody, timbre, the harmony and the rhythm expanded in the twentieth century, into other types of musical organisation and structure. Musical sound not only came from music instruments but also from the recording and manipulation of recorded sounds, the playback of sound through loudspeakers and the synthesis and manipulation of electronic sounds generated from oscillators. Such developments had profound implications for what were now constituted as the forms and means of expression in music and have been discussed elsewhere (such as Battey and Fischman 2013;

Emmerson 2018). The independent and autonomous means of expression both in sound and image for painting and music were expanding over the course of the twentieth century. For example, abstract painting evolved an art that is linked to the independence and autonomy of the artists subjectivity as being the instigator of the expression in the art work and electroacoustic music facilitated the independence of sound and listening as being the main starting point for music expression.

## Form from the artistic need to create new forms of expression

Kandinsky laid emphasis on the unique role of the individual artist in the creation of form and content. Composition, in the hands of an artist, becomes a formal structuring agent that is more suitable to these new types of paintings and so was a new structural agent and a new means of expression. Compositional decisions could now focus on what colours to explore, what forms to create and where is the best fit for the role of the colour and form in the painting. According to Kandinsky (1911–1912), it was the artist's artistic sense and the artist's 'inner necessity' that was the main bearer and determinator of the aesthetic value of the elements and means of expression that was best fit to decide what forms the painting should contain and how the forms were to be created. He thus moved the axis of formal analysis and art production away from a reliance on pre-determined scientific and methodological justifications of a new technique or content that was prevalent in his time in favour of giving a more prominent determination to the artist's own decision-making about the forms of expression they devised with their chosen means of expression. What this revolutionised for art was that there were an infinite variety of possible permutations of form for the content of art and each artist contributes in a unique way to the creation of form. In a short article written for the 1911 edition of the *Blaue Reiter* pamphlet about an exhibition of his and other painters' works, Kandinsky explains the exhibiting artist's approach to form:

> We do not seek to propagate any one precise and special form; rather, we aim to show by means of the variety of forms represented how the inner wishes of the artist are embodied in manifold ways.
> (Kandinsky 1911–1912, in Lindsey et al. 1982: 113)

Such an approach enabled an artist to move beyond the conventions of the time and to create something new. Roger Fry also tried to explain to a public that was critical of the new forms and content in the paintings of the early twentieth century what the artist was doing in relation to form, remarking:

> Now, these artists do not seek to give what can, after all, be but a pale reflex of actual appearance, but to arouse conviction of a new and definite reality. They

do not seek to imitate form, but to create form; not to imitate life, but to find
an equivalent for life.

(Fry 1912: 26)

The forms thus created through the artists' working with their means of expression
whose forms were conceived and crafted through artistic decision-making processes
were a new type of reality. A reality that might be considered to be closer to the sort
of experience one encounters with a music work. Kandinsky preferred to use the
term 'non-objective' painting rather than 'abstract', because he was concerned that
the term 'abstract' did not convey the concreteness of the realities of the forms and
structures in the painting content. The painting and its forms had both an internal
reality and an external content that served that internal reality. The internal reality
is led by the artists' creation of form with their chosen means of expression and
by the capability of the viewer to grasp both the internal and external meanings of
the form and content of the painting. Painting was not just a subjective expression
but had the potential to communicate at the level of the human beings' capacity to
understand internal meaning through external forms and content.

The legacy of Kandinsky's contribution in making colour and form have a freer
role in the work of art in a similar manner to Schoenberg's 'emancipation of dis-
sonance' was that colour and form were linked to the artist's subjective, individual
decision-making and creative approach rather than to any system or external model-
ling of form-making. This was a type of free form expression, but one that conveyed
the concrete nature of the reality of the artist's representation. Today, in much visual
art and music practice, there are no constraints on subject matter, style and form-
making, indeed such freedom of form-making means that an artist can explore the
form-making potential of machines. With increased computational and information
processing capabilities of digital technologies, the reproduction of images and music
into machine languages has opened up even more, the possibilities for an infinite
variety of forms and means of expression in art.

## Universal language of form

From the 1920s onwards, artists started to use cinematic means to devise and explore
more visual forms and means of expression. The medium of film and its 'temporal
component' (Elder 2008: 447) facilitated what Viking Eggeling (1880–1925) and Hans
Richter (1888–1976) had started to explore in scroll paintings, that is, the articula-
tion of movement in time and the construction of polyphonic forms. Richter used
the boundary of the projected screen – the 4:3 aspect ratio area of the space of the
projection – as a formal element in itself. The visual surface of the viewing screen area
was the fundamental whole to which all the visual elements appearing on this surface

related. How the parts and whole related in this screen space was explored by him and also by his contemporary Eggeling. For Eggeling, the relations of part to whole took place in the unfolding of a particular form that evolved like music in time on the space of the surface. These visual elements "serve as instruments the film is played on" (Elder 2008: 447). Using rhythm as a formal element to assist in the unfolding, the form contained with it both the space and the means for the rhythmic articulation of its parts. Eggeling referred to his form of expression as *Kontrast-Analogie*. Here, figures are analogous when they resemble each other and are in contrast when they are the opposite of each other. Lazlo Moholy-Nagy (1895–1946), who also experimented with film and light plays, referred to Eggeling's forms as being first linked to the complexities of musical composition but then gradually became their own drama of forms (Moholy-Nagy, trans. Seligman 1996 in Elder 2008: 447). Eggeling had already spent considerable time in his painting practice articulating a theory of a universal language of abstract form. Andersson *et al.* explains that Eggeling was influenced by the philosopher Henri Bergson's distinction between the experience of lived time and objective measurable clock time and that "it was the hope of Eggeling to recreate '*la durée*', the flow of the present, through the cinematic medium. Through reduction he wanted to create a universal language" (Andersson et al. 2010: 37). Eggeling writes, "Artist's richness is not to be found in an arbitrary innovation, but in formal transformation of the most simple motifs" (ibid.). Eggeling and Richter wrote a pamphlet *Universelle Sprachte* together in 1920 as a manifesto on their now shared ideas of a concept of the universal language of form.

## Light as a material and a means of expression in time

The basic element of film, of course, was projected light. This was something that Eggeling considered to be an important formal element in the new style of film that both Richter and himself were exploring. Working with the formal potential of light with cinema, nonetheless, was complex. Eggeling still sought a logical deductive relation of the forms. The parts of a form acted like subsections of a group, in which the sequence of the subsections kept a sense of continuity with its group or its species over time. The formations explored symmetry, contrast and analogy. Around the time of his film *Symphonie Diagonale* he wrote and referred to this process as a form of visual dynamism (Elder 2008: 446) (see Figure 3.3).

Prior to film, however, light had already been used as an artistic material to explore visual music relations, and this is still the case in contemporary practice. Light evolved as the physical and expressive material in various forms of projection art, that is not based on the art and medium of film as cinema. Lumia art, kinetic art, light-plays and colour-light music projections are all based on harnessing, for artistic purposes, the power of the action of light and its 'behaviour' through reflection,

**Figure 3.3**   Frames from Viking Eggeling's film *Symphonie Diagonale* (1925).

refraction and projection. Thomas Wilfred's (1889–1968) *lumia* compositions were conceived of as a form of silent visual music and the lumia forms that were created in his compositions – ephemeral formations of reflected and refracted coloured light – were considered compositions because they could be performed repeatedly with the same effects, with each composition being a unique light-art work. The activity and behaviour of the transformations of the intensity and colours of the light forms projected onto the viewing screen exhibit an analogous transformational and changing form as sounds do in a music composition. The movement of the objects and mechanisms of his device enable the forms to interconnect, merge, separate, change and transform in a dynamic interplay of colour tints, shades and intensities of light and evolving shapes and forms. His colour discs were the basis of these forms and, through the process and mechanisation of the devices which he invented to perform his lumia art, they structured the output of the lumia forms. To play a different composition, one used a different disc. Wilfred provided the lumia artist with three means of added expressiveness to the light-art performance; these were form, motion and colour (Collopy 2000). Again, Wilfred referred to the playing of these compositions as being something to be learned – to score the changes at the right time to produce the intended compositional result. In today's VJ and video-cueing software, the playback of images and sounds can be controlled in the performance, so that a liveness is created but it can be repeated with practice to ensure that images and sounds appear at the correct cue points of the performance.

Forms, then, are not always linked to a shape in space but to an emergence of a shape or form in time. These are temporal forms, fleeting, fragments, bits and pieces of colour, line and texture that can suggest natural and new forms.

## Exploring music with visual formations

One way in which a visual music artist today can choose to craft visual forms is to follow in Klee's footsteps and focus on finding the visual means of expression in

visual form of the formal and expressive elements of musicianship. There is no one way to do this. The possibilities for such exploration are as wide as the possibilities are for creating unique music compositions, animations, films or paintings. There are many artists who work in this vein. However, two contemporary artists, Jean Detheux and Stephen Malinowski, will be mentioned as they demonstrate different styles and meaningful conceptions of music and visual elements in their work. Malinowski focuses on the visualising of music's characteristics such as its tonality, timbre, tuning, music intervals and elements of a music score and translates these into systematic visual forms that encode not only the basic elements of music but also music's expressiveness (Malinowski n.d.).

Malinowski creates animations that directly express such musical characteristics, such as his visualisations of Johann Sebastian Bach's *Toccata and Fugue in D minor* (see Figure 3.4) in which he shares his approach to creating the music animation based on a visual conception of the musical form of the fugue. He creates a visual pattern for musical qualities such as a mordent, a falling scale, a rising scale and a note being alternated with another note and combines these to form the fugal thematic material in visual form.

Detheux focuses on the expressiveness of music in visual form and uses a different approach and style to Malinowski. Detheux creates complex multi-faceted imagery worlds that are in constant flux. Detheux's visual forms in his abstract films often do not have any recognisable shape about them but are suggestive of shapes and forms and textures in fleeting moments. The means of expression for Detheux come from invisible forces such as rapid changes of multiple visual elements, where each visual element has its own timeline of rapid changes and rapid motions. This rapid change of multiple visual elements makes it hard to grasp any sort of defined form at all. One becomes immersed in an experience of immediacy and intense present time. The visual elements are in a constant process of change. This is a result, as Detheux states in the progamme note for his 2005 film *Liaisons* (2007), of an "intense meditation on

**Figure 3.4** Stephen Malinowski, documentation of his music animation 'name' motifs. L-R: The mordent, the rising and falling scale, and the alternation of a note that moves with one that stays put are combined to form the theme of the fugue.

Source: Malinowski 1996.

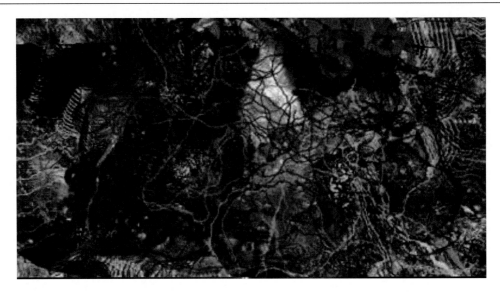

**Figure 3.5**  Frame from *Liasons* (2005) by Jean Detheux.

a world in constant renewal, where every form that emerges is immediately engulfed by the next one" (Detheux 2007). This can be demonstrated by even looking at any single frame from one of his films, for example from the film *Liaisons* (2005) (see Figure 3.5).

The complex imagery comprises a multiplicity of forms, lines, spaces, darkness, light, tiny fragments, motifs and clusters that behave and act in what has become a recognisable style and treatment and means of expression in Detheux's work. The variety of processes of changes and the variety of speeds of those changes brings a dimension of dramatic tension into the unfolding of the images. Detheux is aware that, as an artist, he is involved in a form of 'sense-giving' that images and music can bring to our human experience (Detheux 2013). Detheux notes the positive and exciting challenges of working with music and images; his visual treatments have some parallels with the meaningfulness of music that he focuses on, such as the multi-faceted nature of musical events happening simultaneously on many levels and so in making the connection with images. He raises the question, "What does (one make) the images talk/dance to/with? The melody, the bass, the beat, the accompaniment, what?" (ibid.).

## The process of making facilitates the emergence of form

Several artists talk of forms emerging in the techniques and processes of making including the author and Jean Detheux (2013). Forms can be discovered through the process of making. Direct film technique films are an example of a very fluid

and painterly form of form that emerges in time in the making and experience of the work. The artist's hand is present in the moulding of the images, processes and the techniques used. A contemporary example of a live performance filmmaker is Pierre Hébert, who himself uses the phrase 'Only the hand' (Hébert n.d.) in relation to a series of performances and video installations he created where he used a 'by hand' technique for forms on film, live in the time of the music performance. The forms are drawn by hand onto the film strip and projected simultaneously as they are forming. In the medium of paint, the artist Mark Rowan-Hull paints his paintings live as a music is being performed by live musicians. He calls these paintings 'performance paintings' (Rowan-Hull n.d.). The forms here are created in response to the artist's interaction with the live music performance and with his own performance in front of a live audience. Of course, there are many computer processes and devices that can be arranged to generate live visual content with a music performance or live visual content that is created from the data coming from a music performance. Live-coding is such an example, whereby forms are coded in real-time and adjusted in real-time through the live typing and adjusting of code.

It was, however, Len Lye (1901–1980) who really understood the possibilities of an emergence of form as being a fundamental aspect of the temporal and spatial dynamics of the rendering of visual forms in film. The idea of movement was at the core of all his artistic work in various mediums, such as kinetic sculptures, abstract animations, films, paintings.[1] In a co-authored article in 1935, Lye and Riding declare that the language of cinema is movement. They thus conceived of movement as a language and a medium. Movement creates the form.

> In film, movement is the most significant meaningful aspect of form, but there is a problem here because to think in terms of a shape of a form is to take something that is already fixed in its truth or literal meaning, and not a product of its movement.
>
> (Lye and Riding 1935: 40)

Thus, Lye and Riding suggest that it is of importance to think of shape as having arisen in the film *as a result* of an after-life of a movement. Therefore, "the result of movement is form" (Lye and Riding 1935: 39).

## Conclusion

The music element in the visual music work plays a dual role. It acts as a large-scale formal structure in itself for the totality of the work and as a starting point for the conception of the visual formal elements in relation to music elements operating in the work. Music that has been orchestrated and scored for music instruments might

suggest that the visual element align itself closely to the musicianship elements of the music, such as notes, music instrument sounds, rhythms, melodies and harmonies. Electroacoustic and electronic music might suggest that the visual element align itself with the perceptual aspects of the sonic texture of electronic sounds. What is common, nonetheless, in either approaches to music and visual is that the musical qualities of the sound that are operating in the music have become an intrinsic part of the artistic elements of the visual composition. They contribute to the overall artistic expression and means of expression used by the visual artist and thus to the overall impression of the final art work in its presentation.

Sonic textures from electronic and electroacoustic music provide many possible formal elements and a means of expression for creating visual images. Many of these elements can be grasped sonically and visually through the hearing of the sounds. A sound might suggest a particular movement, or direction, or velocity, or a fast-paced stuttering or a long-duration gliding sound. The sounds themselves can suggest physical phenomenon and evoke associations to describe these evocations such as shapes, colours and textures. It is these aspects of the sound that can become the basis of deciding what the formal elements are and what can be expressed with them for the visual part of a visual music work. A musical score may not be present for most electroacoustic music. Nevertheless, some of the gestural aspects of the sounds in the work, such as its height, its rising and falling, its speed and rate of change, its transformation, its appearance and disappearance, its layering, merging and separation can be experienced and noted. This can become the basis of devising equivalent formal visual elements that are expressed in similar ways, or in a counterpoint-type relationship with the music. A rich source of practice in the visual music related fields of audiovisual composition takes place with electroacoustic music at the centre of the work, for example, in the work of many authors writing in this volume and others. Examples are Diego Garro, Dennis H. Miller, Jean Piché, Joseph Hyde, Myriam Boucher, Bret Battey's visual music work, the collaborators Tim Howle and Nick Cope's 'electroacoustic movies' and many of the author's own visual music works and collaborations.

## Note

1  See McDonnell 2019 for a deeper exposition.

## Bibliography

Andresson, L.G.; Sundholm, J.; Widding, A.S. (2010) Viking Eggeling and the Quest for Universal Language. In: *A History of Swedish Experimental Film Culture: From Early Animation to Video Art*. Stockholm: Mediehistoriskt arkiv.

Battey, B.; Fischman, R. (2013) Convergence of Time and Space: The Practice of Visual Music from an Electroacoustic Music Perspective. In: Y. Kaduri (ed.) *The Oxford Handbook of Sound and Image in Western Art*. Oxford: Oxford University Press.

Collopy, F. (2000) Color, Form, and Motion: Dimensions of a Musical Art of Light. *Leonardo*. 33(5). pp. 355–360.

Collopy, F. (2004) *Three Centuries of Color Scales*. Available online: http://rhythmiclight.com/1998/archives/ideas/colorscales.html [Last Accessed 11/12/18].

Darrigol, O. (2010a) The Analogy between Light and Sound in the History of Optics from the Ancient Greeks to Isaac Newton: Part 1. *Centaurus*. 52(2). pp. 117–155.

Darrigol, O. (2010b) The Analogy between Light and Sound in the History of Optics from the Ancient Greeks to Isaac Newton: Part 2. *Centaurus*. 52(3). pp. 206–257.

Detheux, J. (2013 [2007]) Liaisons, Programme Note. In: D.H. Miller (dir.) *Visual Music Marathon*. Available online: http://t-m-a.de/cynetart/archive/cynetart07/programmubersicht/visuals-music/?lang=en [Last Accessed 07/06/19].

Detheux, J. (2013) Neither Fischinger Nor McLaren, Visual Music in a Different key. *Animation Studies 2.0*, [online]. Available online: https://blog.animationstudies.org/?p=346 [Last Accessed 07/06/19].

Düchting (2004) *Paul Klee: Painting Music*. Munich, Berlin, London, New York: Prestel Verlag.

Eggeling, V.; Richter, H. (1920) *Universelle Sprachte*. Pamphlet.

Elder, R.B. (2010 [2008]) *Harmony and Dissent: Film and Avant-Garde Art Movements in the Early Twentieth Century*. Wilfred Laurier University Press.

Emmerson, S. (2018) Introduction: Music Practice: Reaching Out with Technology. In: S. Emmerson (ed.) *The Routledge Research Companion to Electronic Music: Reaching Out with Technology*. Oxon, New York: Routledge.

Fischinger, O. (1932) Klingende Ornamente. *Deutsche Allgemeine Zeitung, Kraft Und Stoff*. No. 30, 28 July 1932. (English translation: Sounding Ornaments). Available online: www.centerforvisualmusic.org/Fischinger/SoundOrnaments.htm [Last Accessed 07/06/19].

Fransseen, M. (1991) The Ocular Harpsichord of Louis-Bertrand Castel: The Science and Aesthetics of an Eighteenth-Century *Cause Célebre*. *Tractrix Yearbook for the History of Science Medicine Technology and Mathematics*. 3. pp. 15–77.

Fry, R. (1912) The French Group. *Second Post-Impressionist Exhibition*. London: Grafton Galleries. Available online: https://bibliothequenumerique.inha.fr/viewer/35311/?offset=#page=20&viewer=picture&o=search&n=0&q=visual%20music [Last Accessed 07/06/19].

Gage, J. (2006 [1999/2000]) *Colour and Meaning: Art, Science and Symbolism*. London: Thames & Hudson.

Grohmann, W. (1954) *Paul Klee*. New York: Harry N. Abrams.

Hébert, P. (n.d.) *Only by Hand (Performances)*. Available online: https://pierrehebert.com/en/performance/only-the-hand/ [Last Accessed 07/06/19].

Henri, M. (2005 [1988]) *Seeing the Invisible: On Kandinsky* (trans. S. Davidson, 2008). London and New York: Continuum.

Jewanski, J. (2010) Color-Tone Analogies: A Systematic Presentation of the Principles of Correspondence. In: S. Daniels; S. Naumann (eds.) *Audiovisuology: Compendium: An Interdisciplinary Survey of Audiovisual Culture*. Cologne: Verlag der Buchhandlung Walther König. pp. 339–347.

Kandinsky, W. (1982 [1911–1912]) On the Spiritual in Art. In: K.C. Lindsey; P. Vergo (eds.) *Kandinsky: Complete Writings on Art*. Boston: G.K. Hall.

Kandinsky, W. (1982 [1912]) Sounds. In: K.C. Lindsey; P. Vergo (eds.) *Kandinsky: Complete Writings on Art*. Boston: G.K. Hall.

Klee, P. (1973 [1923]) The Nature of Nature. In: J. Spiller (ed.) and H. Norden (trans.) *Paul Klee: Notebooks. Vol.2: The Nature of Nature*. London: Lund Humphries.

Lye, L.; Riding, L. (1935) Film-Making. *Epilogue*. I. pp. 231–235.

Malinowski, S. (1996) Johann Sebastian Bach Toccata and Fugue in D minor Organ. *Music Animation Machine, Second Demonstration Reel – 1996*. Available online: www.musanim.com/pdf/ViewersGuide-MAM1996.pdf [Last Accessed 07/06/19].

Malinowski, S. (n.d.) *My Music Visualization Manifesto*. Available online: www.musanim.com/all/manifesto.html [Last Accessed 07/06/19].

Mason, W. (1958) Father Castel and His Color Clavecin. *The Journal of Aesthetics and Art Criticism*. 17(1). pp. 103–116.

Maur, K. (1999) *The Sound of Painting: Music in Modern Art*. Pegasus Library Munich. London: Prestel.

McDonnell, M. (1998) *An Analysis of the Concept of Harmony in the Audiovisual Composition 'Towards One'*. Unpublished Master's Thesis, Trinity College, Dublin, Ireland.

McDonnell, M. (2013) Visual Music: The Colour Tone Analogy and Beyond. *Paper presented at the Seeing Sound Symposium 2013*, Bath Spa University, 23–24 November.

McDonnell, M. (2019) *Finding Visual Music in Its Twentieth Century History*. PhD Thesis, Trinity College, Dublin.

McLaren, N. (1953) Notes on Animated Sound. *The Quarterly of Film Radio and Television*. 7(3, Spring). University of California Press. pp. 223–229.

Peacock, K. (1988) Instruments to Perform Color-Music: Two Centuries of Technological Experimentation. *Leonardo*. 21(4). pp. 397–406.

Rowan-Hull, M. (n.d.) *Performance Paintings*. Available online: www.rowan-hull.com/ [Last Accessed 07/06/19].

Schoenberg, A. (1975 [1926]) Opinion or Insight? In: L. Stein (ed.) and L. Black (trans.) *Style and Idea: Selected Writings of Arnold Schoenberg*. New York: St. Martin's Press; London: Faber & Faber.

Seeingsound (2013) Performances. *Presented at Seeing Sound Symposium, 2013*, Bath Spa University, 23–24 November. Available online: www.seeingsound.co.uk/seeing-sound-2013/2013-performances/ [Last Accessed 07/06/19].

Whitney, J. (1994) To Paint on Water: The Audiovisual Duet of Complementarity. *Computer Music Journal*. 18(3). pp. 45–52.

von Hildebrand, D. (2018 [1984]) *Aesthetics* (Vol. 2, 368, ed. and trans. Crosby, et al.). Ohio: The Hildebrand Project.

# Audiovisual spaces
## Spatiality, experience and potentiality in audiovisual composition

**Andrew Knight-Hill**

## Introduction

At the outset it is vital to assert clearly that this chapter is not primarily concerned with panoramic space – the spatial positioning or movement of sounds within a stereo or multichannel sound field – but with perceptual space, and the use of spatial concepts and metaphors as frameworks or drivers for audiovisual composition.

It is an attempt to reconceptualise sound and image relationships, not as oppositional strands of media which entwine themselves around one another, but as complementary dimensions of a unified audiovisual space. Applying spatial concepts from a variety of disciplines, this chapter seeks to set out a framework within which we can recontextualise audiovisual works and access new understandings about them.

> [We seek] the moment where their combination begins to sing out [. . .] where audiovisual correspondences dissolve and turn instantaneously into audiovisual music.
>
> (Sergei Eisenstein in Robertson 2009: 201)

## Temporal frameworks

Tools of creation for audiovisual and electroacoustic works tend to foreground the temporal. Both digital audio workstations and offline video editors proffer an array of simultaneous systems of measurement, each dividing continuous temporal flow into discrete units – a metricisation of materials. The adoption of waveform visualisation for sound materials further prioritises temporal information over that of spectral makeup, and thus a time-based understanding of materials is again foregrounded.[1] This process flattens the materials of audiovisual works, collapsing

them into abstract unembodied and de-spatialised markers on a timeline. Our very tools of production therefore encourage a temporal approach to the management and development of media.

This, in turn, affects the way in which we conceive of and discuss the creation of works. As has been argued by Phillip Tagg, fixation upon poiesis and discussion of the technical realisation of works can often obscure or mask our understandings of the work's aesthetic result (Tagg 2011; Hill 2013). We are frequently returned to the two-dimensionality of the timeline – discussing technologies and tools: plugins, processes, procedures and clips – instead of the experience of the work itself. Temporally-led discussion of creative practices encourages fixation upon the physical signals of the work, building blocks which may underpin – but are very much distinct from – the resultant work: the perceived experience.

Many theories of audiovisuality primarily frame themselves in relation to the temporal. For example, Michel Chion's terminologies frequently take their definitions from moments of temporal synchronisation:

- audiovisual phrasing = temporalisation, synchronisation, vectorisation;
- concomitance = simultaneous perception of sounds and images;
- dissonance = pairing of sounds and images at a point in time;
- point of synchronisation = moment of synchresis;
- synchresis = fusion of simultaneous seen and heard.

(Chion 2009)[2]

Likewise, Nicholas Cook's metaphor model – and similarity and difference tests – are predicated upon isolating an individual moment in time, a point at which one can draw an analysis of the binary relationship between audiovisual materials (Cook 2001). Eisenstein's quote above – while signalling the dissolution of sound and image into an audiovisual whole – still describes this process in relation to a specific moment, or point, in time. Similarly, notions of audiovisual counterpoint – extended from the Western classical tradition – are often applied as metaphor for audiovisual relationship. While it might be possible for such a similie to discuss patterns within time that could represent multiple species layers, there is no escaping the fact that the contrapuntal system is based upon metric grid-based structures – that Trevor Wishart refers to as the "lattice of the pitch duration paradigm" (Wishart 1996: 23) – which cannot help but atomise continuous audiovisual flow into discrete and isolated points in time (see Battey 2015). Adam Basanta's three-dimensional model of audiovisual relations, which he refers to as a 'spatial model', is likewise restricted by its temporal contrapuntal focus; he strains to include spatial concepts, but the empowered temporal elements always overcome them (Basanta 2013: 34). In film sound studies, the diegetic is frequently defined and constructed through implied source bonding, a result of temporal congruence, but such a definition often masks

the expressive potential of these sounds within the construction of filmic narrative; they are frequently relegated to mere markers of action in time (see Knight-Hill 2019).

These examples are not exhaustive, but give an overview of the range of theoretical positions and contexts in which temporality forms the main framework for conceiving audiovisual relationships. Of course, almost all of these models and approaches try desperately to represent the richness of the audiovisual experience, but their temporal bias hampers their ability to describe the diverse potentiality in sound and image relationships, resulting in vague and non-specific terminologies (e.g. added value (Chion 1994), emergent meaning (Cook 2001), fantastic gap (Stillwell 2007)). Primacy of the temporal abstracts the audiovisual experience into a series of striated points, denying us the opportunity to discuss, engage with and understand the full potential of sound/image experiences.

Of course, temporal frameworks are not only implicit in analysis of the audiovisual. Doreen Massey thoroughly critiques wide-ranging perspectives on time and space, invoking Grossberg who asserts "the bifurcation of time and space, and the privileging of time over space was perhaps the crucial founding moment of western philosophy. It enabled the deferral of ontology and the reduction of the real to consciousness, experience, meaning and history" (Grossberg in Massey 2005: 58). Thus, temporal primacy facilitates a dematerialisation of the real and its fragmentation into isolated and frozen time-spaces. Temporality re-enforces dichotomies of the mind and the body, thought and experience. As Constantin Boundas states "the great dualism inherited from the classical rationalists and empiricists – matter and mind – is repositioned now on the distinction between duration and space" (Boundas in Massey 2005: 58). Thus, time and space become key battlegrounds in wide-ranging philosophical disputes between structuralist and post-structuralist schools of thought. Temporality lends itself towards the insular and the conceptual, the formalist and structural, while space lends itself towards the external, embodied and the experiential. As Massey asserts, "If experience is not an internalised succession of sensations (pure temporality) but a multiplicity of things and relations, then its spatiality is as significant as its temporal dimension" (Massey 2005: 58).

This re-assertion of spatiality provides an opportunity to reconnect with experience, to overcome the classic mind and body dualism through an integrated phenomenological and embodied understanding of our engagement with sounds and images.

## Space-time

The fundamental vectoral nature of sounds and moving images ensures that they can never be accurately defined through conceptions which seek to identify and discuss the audiovisual via individual snapshots of single moments in

time. Electroacoustic audiovisual works, and even the increasingly prevalent timbral orchestral scores in narrative film, use materials which often do not conform to a "clear temporal lattice around which to organise [their] qualities" (Battey 2015: 29). Thus, temporal frameworks for analysis are immediately impoverished when they attempt to analyse the activity and affect of these planes and masses of sound.

A direct example of this paradox is the representation of a moving, flowing audiovisual work with a single image. A compelling snapshot of one moment in time is one of the hardest things to isolate from an audiovisual work. This is because the essence of the work is dynamic, embodied within movement. A still image can only ever stand as an impoverished indicator of the full audiovisual experience.

Figure 4.1 can never represent the dynamic movement of audiovisual gestures at play within the film *GONG*, nor can it display multiplicity – the individual trajectories which are entwined, evolving and shifting independently within the one work. This abstracted point in time obscures the evolution of materials and the complexes of association built to operate through potention and retention in audiences' perceptions of the work. As Gilles Deleuze and Felix Guattari state, "[in painting] the line does not go from one point to another, but runs between points", [while music] rests on transversals that continually escape from the coordinates or punctual systems functioning as musical codes at a given moment" (Deleuze and Guattari 1987: 298–299). Thus, to seek to understand audiovisual works as a series of isolated moments in time is, by definition, grossly abstracting. As Brian Massumi asserts, to define fluid motion in such a way presents only an impoverished dimension of

**Figure 4.1** Still image from *GONG* (Dir. David Leister).

reality, "in so doing we are thinking away its dynamic unity, the continuity of its movements" (Massumi 2002: 6).

Empirical research in embodied cognition further supports these assertions, as evidenced by Arne Cox:

- What we perceive are states, changes of state and differences between states, along with the temporality in our experience of these perceptions.

  (Cox 2016: 133)

- Temporality is integral to experience, but the concept of temporal motion is derivative and illusory.

  (Cox 2016: 120)

- A habitual focus on linearity can inhibit appreciation of features such as texture, timbre and a sense of relative weight.

  (Cox 2016: 122)

The site of expression is found not within a breakdown of individual moments, but within trajectories constructed by spatial transitions. Temporal congruences are perceived as an emergent quality of movement. Therefore, temporality is a construct derived from our recognition of changes in space; a way of conceptualising and rationalising changes of form, perspective, relationship and position.

This reappreciation of space is not a total denial of temporality, but a counter to the dominance of time-space, which is insular and limited. Instead, space-time is open to textures, forms and materiality. Space embraces subjectivity and the multiplicity of trajectories (Massey 2005: 59).

If we want to fully understand the audiovisual we can no longer discuss binary states of A or B at particular moments in time. Instead we must find ways to embrace the continuous trajectories which emerge and flow into one another through an audiovisual work. To co-opt Edgard Varèse "the movement of sound-masses, of shifting planes, [. . . *can* and will take] the place of linear counterpoint" (Varèse in Cox and Warner 2004: 17, *my addition*).

## Experiential space and touch

Spatial notions of the audiovisual are not new. Space frequently appears as a key parameter in discussions of expanded cinema and experimental film practice (in which projectors or light-sources are combined to cast images and project into

and around a physical space, e.g. Oskar Fischinger's *Raumlichtkunst* (literally, Space Light Art). Film sound concepts, developed within the context of narrative film, discuss notions of on-screen and off-screen space, implying fields beyond the image articulated by sound – for example, Chion's 'superfield' (1994) and Mark Kerrins (2011) 'ultrafield'.[3] But while the consideration of space has long existed within the cinema, all of these concepts dispose themselves in relation to the frame of the image with its inherent visual and temporal primacy. As Kathryn Kalinak notes:

> While the film was projected from the rear of the hall to the screen at the front, so music played at the front was projected backwards over the audience and "through a kind of transference or slippage between sound and image, the depth created by the sound is transferred to the flat surface of the image".
>
> (Kalinak in Cooke 2008: 6)

In this reading, the projection of sound onto image provides a spatial pull – sound constructs offscreen space, complementing the image, and audiovisuality comes into existence – but it is visually driven, with this limited spatiality simply manifesting itself upon the 'flat surface of the image'. Through Kalinak's implication, the audiovisual is a mere extrusion upon the image, framed as formal physical articulation of panoramic space. This is an extension of the striated, the image remains distanced while the sound strains to draw it closer to the audience. It is not a truly engaged audiovisual experience, but one fixated upon the materials of construction; the physical signals as opposed to the perceived object.

In contrast, Alexander Sesonske considers the phenomenological experience, "a film [. . .] provides its own space to replace that of our normal visual field. [O]nly sight and hearing are fully active, and the totality of the audio-visual world present" (Sesonske 1973: 400). This is a space distinct from the formalistic 'real' of the external world; a spatial domain which is affective, tactile, kinaesthetic and continuous. A domain of audiovisual space constructed within the mind of the audience member, in which the senses of sight and hearing take on a hyperposition, embodying experience for all sensory modalities. This 'virtual' audiovisual space replaces our 'normal' visual field, surpassing the striated distance of the optical world, constructing a smooth and haptic experience[4] (Deleuze and Guattari 1987: 493). This is a phenomenological space. One which is not formalistic but relational. It allows us to transcend the auditorium or the gallery and to be completely immersed in the work. It is a space of experience.

Vivian Sobchack describes the process of engaging with film phenomenologically as an exchange between the body of the viewer and the body of the film, and in which the viewer participates in the production of the cinematic experience: "The viewer shares

and performs cinematic space dialogically" (Sobschack 1992: 10–15). This is a rendering of experience that is embodied and physical. As Massumi describes, the body both moves and feels, and it can do both simultaniously. Thus, when the body experiences movement it can experience feeling (Massumi 2002: 15).[5] Cognitive research has long demonstrated that "neurons fire both when action is observed and when it is executed" (Cox 2016: 24), thus stimulating vicarious impression of movements and textures physical bodily response to incoming stimulus.

Such haptic experience is fundamental to audiovisual expression. The film *GONG* (Dir: David Leister) features the looped gesture of the Rank Organisation gong man repeatedly striking his instrument (Video 4.1). Over the course of the film, four visual loops are layered and manipulated via coloured filters, and shifts in focus and zoom. In resonance, the soundtrack seeks to amplify the visual activity, embodying tactile experiences of this iconic gong through closely recorded resonance textures, material gestures, as well as shifts in proximity and scale.

The soundtrack begins with the crackly distorted recording of the original optical sound, its rough, clipped and filtered, nature highlighting the mechanics and mechanisms of reproduction (and the historic and cultural position of this iconic film clip). This has a distancing effect, engaging the viewer in a striated and detached examination of the film and the largely unprocessed (though yellow filtered) individual gong man. By drawing attention to the timbre of the low-fi optical sound, the mediated nature of the film is apparent, the audience is estranged from the image.

As the film evolves, shifts in visual focus and colour begin to abstract the gong man into amorphous shapes and forms. The soundtrack moves in sympathy, with the gradual introduction of high-fidelity close-up recordings of bowed tam tam and metallic surface scrapes. These new sonic materials are rich – spectrally full with clear transients – in stark contrast to the opening optical sound. Thus, as the focus in the image shifts, so too does the auditory focus.[6] The close microphone recordings of the tam tam draw the listener into apparent proximity with the sound object, the tactile timbres of scraping and bowing provide a highly material textured soundspace, while lower frequency resonances build up standing tones in the auditorium.

Formalistic spatialisation within the piece does not extend beyond stereo and yet the materials of the soundtrack evoke a strong sense of spatial engagement with the image. The expanded frequency range and the high materialising sound indicies[7] excite resonance with the audience, an affect that draws them from distanced observation to close and immersed experience. Our embodiment in the world is inherently tactile and tactility is a key driver of spatial understanding, "a musical world that we tacitly create by way of embodied metaphoric reasoning" (Cox 2016: 108).[8]

The scrape of metal upon the tam tam surface embodies not just the mimetic sound, but also the tactile experience of that sound. We feel as if we too are touching and scraping on the surface of that iconic gong. This is a smooth embodied experience, as opposed to striated and distanced observation, "Smooth space is haptic, [. . .] intimate, in contact, close if not strictly speaking tactile" (Kassabian 2013: xvi). These haptic sounds act as a proxy for proprioception and tactility. The listener/ viewer ebbs and flows with the resonances and rhythmic pulsing of the light and sound, not just on a surface level but as a deep embodiment. We move 'as the gong man' vicariously through the rhythm of the sonic textures; "proprioception effects a double translation of the subject and object into the body [. . .] a dimension of the flesh" (Massumi 2002: 59).

Just after the point of climax, elements of the original distorted optical gong sound re-emerge, gradually increasing in volume and slowly pushing back against the audience's immersive engagement. The soundscape collapses back towards the screen and the documentary-like form of the original sample is re-revealed. The experience of *GONG* is not defined by specific points of audiovisual synchronisation, nor the distanced materiality of the various component elements on the cutting room floor (or within the media bin). It is an inherently haptic and tactile experience.[9]

Within this exposition, we can begin to conceive different fields of space, distinguished by notions of proximity. Cutting and Vishton propose that the space around the subject can be segmented into three circular egocentric regions that grade into one another:

1   Personal space. The zone immediately surrounding the observer's head, generally within arms-reach and slightly beyond. Typically, others are allowed to enter it only in situations of some intimacy or in situations of public necessity. Generally, within two metres.
2   Action space. The circular region just beyond personal space, a sphere of public action, within which we can move quickly within, talk to others, throw a projectile or undertake another, similar, interaction. Generally, between two and thirty metres.
3   Vista space. The space beyond this thirty-metre zone, where there is little immediate control, and perceptual cues are fairly consistent and lack depth.

(Cutting and Vishton 1995: 19–20)

These fields are fundamentally embodied, defined by our experience of interacting within the world. Thus, space constructed by audiovisual works cannot help but variously evoke these distinct spatial regions within its construct.

If we apply these spatial fields to *GONG* we can observe that the opening of degraded optical soundtrack operates to construct and elaborate the vista space,

in which clearly defined gestures take place in a distanced space, clearly separated from the listener. The lack of high-frequency partials in this opening sonic material inherently signifies distance, and the amplitude of the sound was contained. This sound was also presented in its raw mono form, thus contained no phase differentials which might imply an impression of panoramic space.

As the materials of the work evolve, they transition into the audience's action space. Materials and resonances possessing higher dynamic range and rich spectral detail are complemented by increasing phase differentials, encoded via stereo capture, that give an impression of widening panoramic space, thus shifting the soundtrack towards the audience.

At the climax, metallic scrapes join the resonances to shift listening into the personal space. This transition is aided by the further increased spectral energy in the high-frequency registers (implying source proximity), as well as increases in amplitude which boosts the lower registers to create resonant standing tones within the physical space of the auditorium. Such soundscapes invite the listener into a world of proximal attentive listening. In so doing, Shaviro highlights how such textural spatiality subverts the temporal narrative, "by entirely filling space, sound subverts the linear, sequential order of visual narrative" (Shaviro 2016: 375).

Framing the audiovisual experience spatially, we can begin to access an understanding of the communicative potential of the work as deeply embodied and visceral, either deployed for narrative purpose or for experiential effect. While rejecting the quantification of the temporal, the action of the soundtrack can still be qualified in a robust fashion. There is no distancing between the work and the audience – as with temporal fixation on abstract points of sync – and nor is there an othering of the component sound and image materials.

By its very definition, a point of synchronisation enforces difference and the separation of materials – this vs. that. Yes, materials are brought together, but they will always remain divided. The closer they get, the harder their dissimilarity pulls. True fusion of sound and image is always denied by temporally informed concepts of synchronisation.

In contrast, spatial framings of the audiovisual prioritise the affective experience over the conceptual, the materials of the work are not divided but actively unified into an experiential whole. Continuity, flow and movement are foregrounded.

## Movement and potentiality

As Doreen Massey argues, space is not static, it is an ongoing production; it is manifold. The movement of tones is experienced as a potentiality of change, not resolved or concluded at a fixed point, but as a movement in flux, experienced by the

audience (Massey 2005: 55). Thus, "rather than space being viewed as a container within which the world proceeds, space is seen as a co-product of those proceedings" (Thrift 2009: 96).[10] As Denis Smalley invokes via Lefebvre, "Physical space has no 'reality' without the energy that is deployed in it: energy modifies space or generates a new space" (Henri Lefebvre in Smalley 2007: 38). Audiovisual space is constructed through the articulation of sound and image materials, a dynamic flux of energies unfolding through time. The 'reality' of perceived space is a result of these materials and their articulation.

In the lexicon of electroacoustic music, the terms 'gesture' and 'texture' are frequently applied to describe the articulation of materials (see for example within this volume, Chapters 1, 2, 7, 16).[11] While often conceived of temporally, these terms actually have far more to offer when conceptualised spatially. In Smalley's original formulation, he clearly attributes a clear sense of temporality to gesture, and that of a de-temporalised space to texture. The assertive power of gesture is embodied – an affirmative action moving from point A to point B – while texture is ascribed laissez-faire – a passive state which "marks time", consumed by its own internal behaviour (Smalley 1986: 82). This is, of course, an example of the classic devaluation of space in favour of time. Smalley himself states that the relationship between gesture and texture should be considered as collaboration rather than antithesis, but the temporal framing of these terms actively obfuscate and complicate readings of his concept (Smalley 1986: 83). For clarity and renewed understanding, we must unpack texture and gesture through that which unifies them both – movement.

Gesture and texture are fundamentally defined by movement, they simply differ in the form of that movement. Gesture is externalised trajectory, while texture is internalised flux. This variation of movement is the reason why both are able to function along a unified continuum – between gesture carried and texture carried (Smalley 1986: 82). Temporal conception risks enforcing a binary division upon these forms – texture is static vs. gesture is dynamic – which denies their contiguous nature. One cannot assert that textures have no time, nor that gestures have no spatiality. Indeed, to define gesture as movement from point A to point B is to deny its continuity and affective form. As in quantum mechanics, where the position of an electron is defined by a probability within a region of space, movement is a "nondecomposable: a dynamic unity" and the "continuity of movement is of an order of reality other than the measurable divisible space it can be confirmed as having crossed" (Massumi 2002: 6). Thus, gestures and textures are simply different dispositions of energy in space. Such a reading allows us to conceive, not of discontinuous textural and gestural objects laid out within a striated form, but of continuous and changing articulations exuding a continuous flux of potential.

As described by Massey, spaces are manifold sites within which multiple "distinct trajectories co-exist. [. . .] Without space, no multiplicity; without multiplicity, no

space" (Massey 2005: 9). Massumi argues that "sensation itself is the result of this multiplicity. Sensation is the registering of the multiplicity of potential connections in the singularity of a connection actually under way" (Massumi 2002: 93). Thus, communicative and interpretative potential is not a matter of objects at static points in time, but of potential energy unfolding in space through movement.

The audiovisual composition *VOID* (2019) sought to elaborate these conceptions of space (Figure 4.2). It is a film inspired by the notion of the 'non-place', thus it negates the object through its focus on nothingness and becomes, not a film about a thing (or things), but a film about the construction and articulation of space itself (Video 4.2).[12]

As Georges Perec states:

- The subject [. . .] is not the void exactly, but rather what is round about or inside it.
- To start with then, there isn't very much:
- nothingness, the impalpable, the virtually immaterial; extension, the external, what is external to us, what we move about in the midst of, our ambient milieu, the space around us.

(Perec 2008: i)

The visual materials of the work are deliberately static and unprocessed (Figure 4.2).[13] Space is articulated via forced perspective, unusual camera angles, articulation of scale

**Figure 4.2**    *VOID* screenshot.

(and, later, movements of light). Impressions of scale are deliberately perverted. The viewer is presented macroscopic projections of individual details (for example: individual bolts or screws), placing these visual objects firmly forward, into the action and personal spheres of the audience.[14] The concrete reality of the images, in high-resolution, invoke an anticipation of tactility. This anticipation is engendered through the fact that their physical textural tactility is at first denied.[15] There is no sighting of flesh on inanimate form, and the sonic materials, likewise, reflect an inanimate soundscape of continuous droning machinery. Thus, the image remains detached, even though thrust into the personal space. We see the textures and we long to touch them, but the sonic materials of mechanical ventilation do not reciprocate this possibility. Thus, their audiovisual potential is unresolved. Anticipation is gradually built through the discourse of the film, before being finally shattered within the physical crash sequence [at 6:36]. Highly tactile sonic materials are brutally combined with fast visual edits to explode the previous continuity of the image and our tactile disconnection from the space. We are overwhelmed with tangibility, resolving the anticipation built up through the preceding six minutes.[16]

Sonic materials in the work are primarily articulated through textural evolution. These materials focus inwards and yet, subtly articulated, they flow gently against the visual, their almost imperceptible flowing movements providing a sense of trajectory and development across the robustly static images. Alternately shifting between a realistic aesthetic (almost documentary) and transformed abstraction (in which the harmonics from the various air conditioning units are extracted and amplified), the work actively deterritorialises the physical space of its source, embodying the notion of the democratised non-space which acts as the film's inspiration.[17] Mechanical units become pure tones which suffuse and immerse the audience, while perspectives shift as sounds are articulated into the personal space and pushed back into the vista. Articulation of movement through audiovisual materials transforms the physical space of the source location into spaces of experience.

Even the strongest gestural moments within the work are an elaboration of the underlying spatial construct. The movement of tones articulate various fields of space, from distant and reverberant ambiences to sounds of action and activity (the crashing and falling of objects within the space), to the very close-up textural contact of scraping metal, or close mic recordings of fans and whirring ventilation. Thus, the work utilises material and transformation to articulate an affective space through its material form. Building intensity through resonation or interference, amplification or dampening, "filled with motion, vibratory motion, resonation" (Massumi 2002: 26).

Though this is a work that contains gestural movement, it cannot be described through a temporally-led interpretation of gesture. Even the strongest sonic gesture within the work is so chaotic and complex that it is firmly located within a wider

textural field. Neither is the work purely textural or static. The multiplicity of movements drive its forward progression, whilst simultaneously opening up and inviting the audience to project themselves forwards into the space it constructs.

*VOID* functions via the manipulation of potential, elaborating space as its primary construct, through movements which engender anticipation. Such dynamic terms are better able to represent the flux, multiplicity and constant motion activated through a spatial conception of the audiovisual, embracing movement and a unity of sound and image.

Temporally led conceptions of the audiovisual could never hope to capture the richness and the resonance of the experience constructed within an audiovisual work such as *VOID*. But by embracing spatiality, we can simultaneously engage subjectivity and embodied experience into our understanding of the action of materials within the work, while also redefining conceptions of those materials to enable a coherent unification of forms through movement. Such a framework allows us to recognise the continuous flux of potential unfolding through the work, directing anticipation and drawing the audience into a unified audiovisual construct. We are not distanced from the work or its materials through abstraction, but proximal to them through our understanding.

## Conclusion

Within this chapter, we have begun to recontextualise established analytical understandings of the audiovisual via spatial frameworks. Novel perspectives afforded by the spatial have been demonstrated to overcome problematic binary constructs, which frequently undermine phenomenological understandings and analysis of the audiovisual.

Thinking spatially inherently integrates the audience as a key participant within the work and frames communicative potential in terms of the experiential, embodied and visceral. This prioritisation of affective experience over the conceptual leads to richer understandings of the actions of materials and forms, connecting compositional practice directly to the resultant work, without mediation.

Within spatial frameworks, the materials of the work are not divided, but actively unified into an experiential whole. This negates challenges inherent within time-led conceptions of the audiovisual, such as the unavoidable distancing of sound and image material when conceptualised as sequential points of synchronisation. Temporally-led binary conceptions of sound and image actively deny the full fusion of audiovisual material, and artificially obscure their continuous flows within the work. This leads to a masking of the fundamental actions of potential and anticipation; actions which underpin the experience of the work and directly drive and

inform the compositional process. To obscure thus is to deny understanding of both poietic and aesthetic practices.

Through space, the continuity, flow, and movement of the work is foregrounded. This has allowed for a reframing of the key concepts of gesture and texture, originating from electroacoustic music studies. Gesture and texture can be conceived spatially as different dispositions of movement – gesture as externalised trajectory; texture as internalised flux. Through spatial conception they are unified in movement, able to function seamlessly along a continuum of articulation, shifting smoothly between contiguous forms, overcoming the challenges inherent within the binarism of their temporally informed conception.

The multiplicity of potential has been demonstrated as a key communicative function of sound and image relationships. Instead of abstracting the association of sound and image via striated points in time, we can use spatial frameworks to consider the unfolding of the audiovisual experience and the disposition of potentiality which underpins the affective power of sound and image associations. 'Potential' and 'anticipation' can be used as unifying terms to describe the development of audiovisual affect, replacing terms such as 'dissonance' and 'counterpoint' which risk implying conflict and difference.

Recalling Eisensten's assertion at the beginning of this chapter, I argue that we have been distracted. We should not really be seeking individual moments – points in time – at which sound and image combine and sing. Rather, we need to recognise that it is within spatiality that we are able to fully dissolve the binarism between sound and image. It is through space that we can best begin to access the full potentiality of audiovisuality; and that imagining works as audiovisual spaces offers us rich potential to understand, explain and access this long-held desire for an audiovisual music.

## Notes

1  Just as the parameters of traditional notation foreground the pitch and durational properties of sound at the expense of timbre.

2  This is of course not exclusive, Chion's horizontal relations do afford consideration to evolution and movement in/over time.

3  "The superfield [is] space created, in multitrack films, by ambient natural sounds, city noises, music and all sorts of rustlings that surround the visual space" (Chion 1994: 150). "The Ultrafield is the three-dimensional sonic environment of the diegetic world, continuously reoriented to match the camera's visual perspective" (Kerrins 2011: 92).

4  "Smooth is both the object of a close vision par excellence and the element of a haptic space (which may be as much visual or auditory as tactile). The Striated, on the contrary, relates to a more distant, vision and a more optical space" (Deleuze and Guattari 1987: 493).

5  Massumi's ideas build upon those of Spinoza who defined the body in terms of "relations of movement and rest". "He wasn't referring to actual, extensive movements or stases. He was referring to a body's capacity to enter into relations of movement and rest. This capacity he spoke of as a power or potential to affect or be affected" (Massumi 2002: 15).

6  As Laura Marks observes, a lack of 'visual' focus can afford a transition to smooth experience, "haptic images pull the viewer close, too close to see properly" (Marks 2002: 16).

7  Materialising Sound Indicies (MSI) defined by Chion as, "aspects of sound that make palpable the materiality of its source and of the concrete conditions of its emission" (Chion 2009: 480).

8  Laura Marks describes the visual corollary of this experience "haptic images [. . .] encourage a bodily relationship between the viewer and the image" (Marks 2002: 3).

9  The sonic and visual components maintain their coherence through rhythmic similarities and common flows of movement.

10  This is not to negate time, because as Steven Feld asserts, "space is audibly fused with time in the progression and motion of tones" [and there is an indissoluble] "interpenetration of auditory space and time" (Feld 1996: 95).

11  'Gesture' and 'texture' are key terminologies within the field of electroacoustic music. Denis Smalley defined them thus: "Gesture is concerned with action directed away from a previous goal or towards a new goal", while "Texture is concerned with internal behaviour patterns [. . .] rapt in contemplation" (Smalley 1986: 82).

12  "The non-place never exists in pure form; places reconstitute themselves in it; relations are restored and resumed in it" (Marc Augé 1995: 64). The subject of the non-place also ironically invokes the negativity that is usually ascribed to space by temporally-led perspectives.

13  Except for some minor colour correction and balancing, any visual 'effects' within the work are entirely analogue.

14  Perspectival space also is articulated sonically within the work, with some sounds proximal and others more distant. This shifting of the physical acoustic spaces of the environment adds to the spatially skewed impression experienced by the audience.

15  The construction of anticipation is inherently embodied, as Massumi sets out, "Anticipation, which in a real and palpable way extends the actual moment beyond itself, superposing one moment upon the next, in a way that is not just thought but also bodily felt as a yearning, tending or tropism. [. . . Anticipation] is a registering of potential" (Massumi 2002: 91–92). This is a reflection of Husserl's potention and retention.

16  Concepts of potential and anticipation can be considered as replacements for the more commonly adopted notions of tension and resolution. While they represent forms of resonance that might otherwise be described as tension, they avoid the inevitable associations of conflict and difference.

17  "The deterritorializing element [in this case the sound] has the relative role of expression, and the deterritorialized element [the visual elements] the relative role of content" (Deleuze and Guattari 1987: 307).

# References

Augé, M. (1995) *Non-Places: Introduction to an Anthropology of Supermodernity* (trans. J. Howe). London: Verso Books.

Basanta, A. (2013) *Compositional Strategies in Light and Sound Installations*. MA Thesis, Concordia University. Available online: www.academia.edu/3749696/Compositional_Strategies_in_Light_and_Sound_Installations [Accessed 11/19].

Battey, B. (2015) Towards a Fluid Audiovisual Counterpoint. *Ideas Sónicas*. 17(4). pp. 26–32.

Chion, M. (1994) *Audio-Vision* (trans. C. Gorbman). New York: Columbia University Press.

Chion, M. (2009) *Guide to Sound Objects: Pierre Schaeffer and Musical Research* (trans. J. Dack; C. North). Available online: www.ears.dmu.ac.uk/spip.php?page=articleEars&id_article=3597 [Accessed 13/07/14].

Cook, N. (2001) *Analysing Musical Multimedia*. Oxford: Oxford University Press.

Cooke, M. (2008) *A History of Film Music*. Cambridge: Cambridge University Press.

Cox, A. (2016) *Music & Embodied Cognition*. Bloomington: Indiana University Press.

Cox, C.; Warner, D. (2004) *Audio Culture: Readings in Moderns Music*. New York: Continuum.

Cutting, J.; Vishton, P. (1995) Perceiving Layout and Knowing Distances: The Integration, Relative Potency, and Contextual Use of Different Information about Depth. In: W. Epstein; S. Rogers (eds.) *Handbook of Perception and Cognition, Vol 5: Perception of Space and Motion*. San Diego, CA: Academic Press.

Deleuze, G.; Guattari, F. (1987) *Thousand Plateaus: Capitalism and Schizophrenia*. Minneapolis: University of Minnesota Press.

Feld, S. (1996) *Senses of Place*. Sante Fe: SAR Press.

GONG (2019) [FILM] dir. David Leister; comp. Andrew Knight-Hill.

Hill, A. (2013) Interpreting Electroacoustic Audio-Visual Music. Thesis (PhD), De Montfort University.

Kassabian, A. (2013) *Ubiquitous Listening: Affect, Attention and Distributed Subjectivity*. Berkeley: University of California Press.

Kerrins, M. (2011) *Beyond Dolby* (Stereo: Cinema in the Digital Sound Age). Bloomington: Indiana University Press.

Knight-Hill, A. (2019) Sonic diegesis: Reality and the expressive potential of sound in narrative film. *Quarterly Review of Film and Video*. 36(8).

Marks, L. (2002) *Touch: Sensuous Theory and Multisensory Media*. Minneapolis: University of Minissota Press.

Massey, D. (2005) *For Space*. Thousand Oaks, CA: Sage Publications.

Massumi, B. (2002) *Parables of the Virtual*. Durham, NC: Duke University Press.

Perec, G. (2008) *Species of Spaces* (trans. J. Sturrock). London: Penguin Classics.

*Raumlichtkunst*. Oskar Fischinger [INSTALLATION] (1926/2012). Reconstruction by Centre for Visual Music.

Robertson, R. (2009) *Eisenstein on the Audiovisual*. New York: IB Taurus.

Sesonske, A. (1973) Cinema Space. In: *Explorations in Phenomenology*. The Hague: Martinus Nijhoff.

Shaviro, S. (2016) *Discognition*. London: Repeater Books.

Smalley, D. (1986) Spectro-Morphology and Structuring Processes. In: S. Emmerson (ed.) *The Language of Electroacoustic Music*. Basingstoke: Macmillan Press. pp. 61–93.

Smalley, D. (2007) Space-Form and the Acousmatic Image. *Organised Sound*. 12(1). Cambridge University Press. pp. 35–58.

Sobschack, V. (1992) *The Address of the Eye: A Phenomenology of Film Experience*. Princeton: Princeton University Press.

Stillwell, R. (2007) The Fantastic Gap between Diegetic and Nondiegetic. In: Goldmark; Kramer; Leppert (eds.) *Beyond the Soundtrack: Representing Music in Cinema*. Berkley: University of California Press.

Tagg, P. (2011) Music, Moving Image and the 'Missing Majority': How Vernacular Media Competence Can Help Music Studies Move into the Digital Era. *Proceedings of Music & the Moving Image*, Steinhardt School, New York University, May.

Thrift, N. (2009) *Non-Representational Theory: Space, Politics, Affect*. Abingdon, UK: Routledge.

VOID (2019) [FILM] dir. & comp. Andrew Knight-Hill.

Wishart, T. (1996) *On Sonic Art*. Abingdon, UK: Routledge.

# Rhythm as the intermediary of audiovisual fusions

## Daniel von Rüdiger

### Audio + Video = Audiovisual + x

The wish to be able to combine music and the moving image arose long before the technical synchronicity of image and sound in audiovisual media became possible.[1] Today we find ourselves in an 'audio-visual media environment' and technologically facilitated connections between audio and video are omnipresent.[2]

The unification of audio and video can be described as a *fusion*. The term 'fusion' emphasises that the result of the medial combination is more than the sum of its parts. In this sense, the combination can't be described as a simple addition.[3] Rather, the result is much more a *surplus*.[4] This increase in value can essentially be linked to the interweaving of our visual and auditory perception. Seeing and hearing are two different sensory modalities which, by mutually influencing each other, become a multi-modal form of perception.[5]

I suggest analysing the fusion of audio and video on the basis of the model equation $A + V = AV + x$. Auditory objects (A) and visual objects (V) form audiovisual Gestalts (AV), leaving a remainder (x). This analysis targets the unknown x, which expresses a difference between audio and video ($x = A + V - AV$). In order to describe x, reference parameters have to be established. They aid in estimating whether the auditory and visual objects to be examined encounter one another congruently or incongruently. If they are congruent we can assume that they make up audiovisual Gestalts (AV) whereas if they are incongruent their distance (x) is increased. In order to establish reference parameters we will use rhythm as a primary audiovisual point of reference.

As an artistic research undertaking, the development and reflection of audiovisual live performances have been used to understand audio and video as rhythmic instruments whose relationship to one another is revealed in their being played together.

I begin this chapter by considering rhythm as a tool of inquiry; this then segues into a discussion of rhythm in my own audiovisual media practice. Following on from this, I define reference parameters and examine several case studies to illustrate and clarify my points. I conclude with some more generalised reflections on audiovisual aesthetics.

## Rhythm as an tool of inquiry

The work presented proposes rhythm as a primary criteria for the comparison of audio and video. As a common point of reference it should help in determining reference parameters between the different sensory stimuli.

Rhythm possesses intermodal relationships, addresses all sensory organs and can be seen as a *general quality*.[6] In addition, it can be applied equally to phenomena in time and space.[7]

Rhythm research is interdisciplinary and its basis is in the exchange between aesthetic disciplines and branches of science and the humanities. Michel Chion refers in his important work *Sound on Screen* to rhythm's intermedial competence by conceiving of rhythm as an 'element of film vocabulary' which refers to *transsensorial perception*. Since rhythm is 'neither specifically auditory nor visual', it's well suited as a point of reference by which to set multisensory impressions in relation to one another.[8] This makes it possible to use rhythm as an investigative tool for both auditory and visual structures and thus to tackle questions about their fusion. In the words of the ethnographer and philosopher Gregor Bateson, my work pursues 'a search for similar relationships between different things' – thereby viewing rhythm as the pattern which connects them.[9]

Before we can use rhythm as an analytical tool, we have to agree on how the term is to be used. The Greek word $\rho v \vartheta \mu o \varsigma$ (rhythmós) refers to the structures of movement as well as to proportion and ratio.[10] It suggests no limitation to musical arrangement. The application of the word 'rhythm' is inflationary and not limited to a scientific or aesthetic discourse. Cosmological, mathematical, aesthetic and body-related rhythm theories, to name a few, coexist and compete.

Rhythm presupposes a temporal repetition of objects. Once something is recognized as repetition, the temporal or spatial positions can be related to one another. These relations describe a structure and rules can be derived from it. These rules, in turn, determine the degree of the structure's *order*.

Structures can be hindered by countless interactions, due to which a given order is subject to continuous variation. This leads to changes in the repetition which can be grasped as *movement*.

The two states which describe the elementary condition of rhythm are *order* and *movement*. The interplay of these contradictory terms obtains a *rhythmic quality* due to the oscillation of regularity and variance.[11]

We can assume an *objective* or a *subjective* term of rhythm.[12] One focuses on the *objects of experience*, the other on the *experiencing subjects*.[13] It's important to emphasize that rhythm owes its complexity to the interaction of these aspects. Yet estimating rhythmic efficiency is not the concern of this inquiry; rather, we seek to elaborate concepts of rhythm for audiovisual analysis. This requires, not only a comparison of structures, but a consideration of their mutual influence which can be described as describe as *resonance*.

## Rhythm in audiovisual media

Artistic research unites practical and theoretical analyses. It benefits from a reciprocal interaction between the production and reception of audiovisual artefacts and its basis is the conviction that knowledge is not only expressed with language but also through sensual experience. Artistic work aids thereby in constructing practical experiences from which theoretical knowledge can be derived.

During the course of this enquiry, an extensive body of work was developed. It includes music videos, video art, documentary film, audiovisual live performance, music album and video installations. The aim was to unify and test rhythmic forms in an audiovisual medium. Each of the different medial expressions investigate various fields of audiovisual interplay and aid in elaborating the reference parameters of audio and video.

To this end, the wide field of audiovisual design has to be narrowed through limitations of medium and content. This chapter will concentrate on loop-based music and for video on live-action film footage of body movements.[14] The focus on work and dance as filmic *sujets* suggests itself in terms of rhythm. In addition, the inclusion of my documentary footage from Papua New Guinea refers to the emergence of cultural rhythms through the communal synchronization in work (see Figure 5.1, available online: https://vimeo.com/danielvonruediger/kanubelongkeram).

According to Karl Bücher's thoughts on *work and rhythm*, physical labour, with its rhythmic sequences of movement, can be seen as a starting point of human artistic expression. Music was cultivated as an auditory expression of rhythmic body movement. Because music and dance depend on the body, they exist in an audiovisual relationship at the beginning of human culture.[15] In their connection, dance becomes hearable and music visible. Like dance and music, the moving image enables rhythm to develop in time and space and unite auditory and visual structures.

As a musician, I was particularly concerned with being able to transmit the bodily experience that accompanies making music to the image, and use it for furtherment of knowledge. The performative praxis of the audiovisual live performance enabled me to *play* audiovisual rhythms.

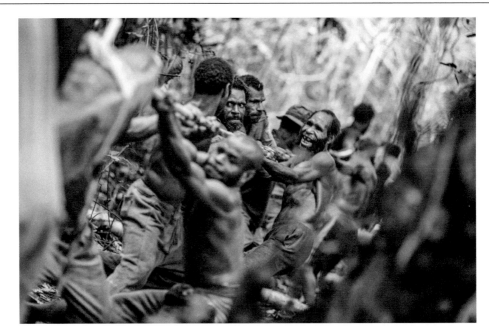

**Figure 5.1**   Screenshot from my documentary *Kanu belong Keram*. Men synchronize with each other by shouting in order to pull a large dugout canoe out of the jungle.

Source: https://vimeo.com/danielvonruediger/kanubelongkeram

Experimentation with the manipulation of film projections in real time was already a focus in the *Expanded Cinema* of the 1960s. The projector was implemented 'like an instrument' in order to expand film to encompass a performative level.[16] In the video art of the 1970s, trials were undertaken to apply the concept of the auditory synthesizer to the image. The loop established itself both in music and in image montage as the foundation of rhythmic design.[17] Technical advancements made it possible by the 1990s to mix moving images live onstage, facilitating the evolution of audiovisual concerts.[18] The digital transmission of video signals at the beginning of the 21st century massively reduced the technical effort involved in manipulating moved images live. Today it's possible, with the help of VJ software, to cut high-resolution video material and add effects in real time. Controlling software with MIDI pads makes editing a similar process to playing drums. Manipulating the moving image has become as *instrumental* as early light organ players could only dream of.[19]

## Reference parameters

If audio and video are grasped as synchronous, one is lead to make relational assumptions about content as well. The Congruence-Association Model (CAM)

describes how structural congruency leads one to assume the existence of a semantic relationship, even in the absence of contextual indications.[20]

In addition, the *Shared Semantic Structural Search Model* says that temporal and spatial discrepancies of auditory and visual stimuli are more likely to be tolerated if they possess similar connotative meanings.[21] Numerous trials demonstrate the perception of video tracks and soundtracks as unified despite their being asynchronous.[22]

For this reason, Shin-ichiro Iwamiya divides correspondences of audio and video into *formal congruency* and *semantic congruency*.[23] Formal congruency refers to the *structure* of audio and video and addresses synchronicities, whereas *semantic* congruency describes the correspondence of meaning. Both types are important when analyzing 'cross-modal interaction of disparate events in auditory and visual domains'.[24]

In order to discuss these congruencies separately, it makes sense to divide the reference parameters into structural (formal) and semantic parameters. However, before we can examine the structure or the semantics of audiovisual objects, they must be released from the stream of perception. To this end we will need *object parameters* with which the sensory content of auditory and visual stimuli can be grasped. We borrow the object term from musicology and apply it to visual stimuli.[25]

In order to estimate the congruencies of audio and video, I suggest therefore a three-way division of the reference parameters into *object*, *structure* and *semantics*.

A three-way division of concretizing perception can already be found in David Hume's reflections on human understanding. Hume links the possibility of unifying conceptions to the following three principles: similarity, spatiotemporal proximity and causality.[26] Hume's division finds a correlate in the three processes of sensual experience which the *Psychological Encyclopaedia* calls sensory function, organisation and interpretation.[27]

These concepts are helpful when concretizing the reference parameters – object, structure and semantics – before we differentiate them further into subcategories.

- Object parameters: Similarity or, respectively, sensory function enables the separation of perception into single, dividable building blocks. They are determined by the relationships of immanent qualities of a stream of perception.
- Structural parameters: The organization or spatiotemporal proximity of objects can be understood as their structure. They are determined by the relationship of objects to a space-time scheme.
- Semantic parameters: The reference to the interpretation which results through causality indicates semantic contents. They are determined by the relationship to personal associations and experiences.

## Object parameters

It should be noted that the congruency of the sensory content of auditory and visual objects can only be brought into relation metaphorically. There's no way, for example, to comparatively measure the brightness of a sound and an image, so such comparisons won't be considered in the investigation.[28] Object characteristics – for example volume, pitch, timbre, brightness and colour – serve purely to distinguish objects.

### Object characteristic

The term 'object' refers not only to the construction of new auditive or visual phenomena (e.g. the beginning of a chord or the start of a movement, but to any point of modification of object characteristics (e.g. a pitch alternation when changing from one chord to another or the transition of the direction of a movement). All changes of object characteristics contribute to the marking of an object and therefore to the arrangement of a structure. Changes of object characteristics indicate an apex which is central both for measurements and for our perception. If many object characteristics change, an object becomes particularly obvious. Therefore a cut in video, or a drum stroke breaking the silence, is an especially strong punctuation mark. The more incisive the changes of the object characteristic, the more clearly they define the object's border.

### Object border

Rhythm can be understood as a structuring of object borders. Because we're focusing on temporal objects, we can use the musical terms *on-* and *offset* to differentiate between a beginning and an end.[29]

Because so many object characteristics change all the time in music and moving images, determining object borders is in no way unambiguous. It is helpful therefore to reduce the complexity and to examine examples with minimal drum-based music and the act of dancing as the visual object.

I collaborated with the dancer Piotr Temps Marciszewski to have him translate structures of different rhythmical electronic instruments in body movements. I used the single choreographies in music to compose not just audio but also the visuals in the music video *Dance Instruments* (see Figure 5.2, available online: https://vimeo.com/danielvonruediger/danceinstruments). The aim of the experiment was to understand the complexity of auditive and visual objects and how they can be merged in time and space. It became increasingly apparent how different the visual and auditive capacities of detecting object borders were, especially when more structures are brought together.

Besides dance movement the juxtaposition of different work routines – like chopping wood with sawing – led me to separate visual transitions in movement based

**Figure 5.2**  Screenshot from my music video *Dance Instruments* with the dancer Piotr Temps Marciszewski. The musical instruments were transcribed as different body movements by the dancer and connected in space.

Source: https://vimeo.com/danielvonruediger/danceinstruments

on a change in the *direction of movement* and the *speed of movement*. Precise visual objects like a stroke of the axe are defined by the abrupt interruption or reversal of both the direction and the speed of movement. This pointalistic modification of movement accounts for the object's incisive character. As an accentuated movement, the blow can be contrasted with drawing back, an unaccentuated circular movement.[30]

Observations of changes to the speed of movement and the direction of movement can organize the visual stream of perception in objects and explain the precision of the object borders. This is helpful for determining relationships between body movements and music. The definition of object borders is a first step towards being able to assess the congruency of auditory and visual objects.

### Object dimension

If object borders are brought into relation with a grid, the object dimension, or rather its spatial and temporal *size*, can be determined. This relational grid can be temporal or spatial and its resolution is responsible for the precision of the spatiotemporal structure and its analysis.

The expansiveness of an object determines whether it refers to a *point* in timespace or whether it occupies a spatiotemporal *surface*. Despite the variety of possible object dimensions, I propose classifying them accross two groups: *pointalistic* and *expansive*.

Expansive objects fill observable durations of time. Their construction in onset, object body and offset is clearly recognizable. Expansive objects, like sonorous guitar chords or arm movements, can be *connected* with and transition into each other. In the process, certain object characteristics on their object borders change, (for example the pitch or the direction of movement), while others like timbre or form remain unchanged.

In contrast, on- and offset coincide in one sensory impression for pointalistic objects. For example, a video cut or a drum stroke occur so closely that their proximity is below the fusion threshold of both senses alike. Pointalistic objects can't transition into each other because they need a pause in order to separate themselves from a background. It should be noted here that pauses can also have the status of expansive objects.

The dimension of an object is therefore of vital importance for the relationship between form and background. Pointalistic objects require a background from which they can distinguish themselves and appear as figures. Expansive objects fill the background and can be perceived not only as figures but as the background itself.

We conclude that it is possible to relate auditory and visual objects to each other based on their object border and their object dimension. Audio and video can equally be categorized as pointalistic or expansive objects, whereby the congruency of this parameter can be altered and analyzed. Registering object borders and object dimension is a prerequisite for the analysis of their structure.

### Structural parameters

*When* is the central question of a temporal analysis and *where* that of a spatial analysis. The temporal and spatial organization of objects is mirrored in their structure. A structure describes the position of different objects inside a grid. For a fundamental categorization of the temporal relations between auditory and visual objects, we will refer to Chion's division of synchronicity into vertical and horizontal relations.[31] Thereafter, we can discuss convergences separately, based on points in time and extended periods of time.

### Vertical relations

In the case of a vertical object reference, different objects of the same spatiotemporal point are related to each other simultaneously. In order to create vertical relationships and to relate objects to each other at the same time, their object characteristics have to be assessed as dissimilar. For auditive and visual objects this is a matter of course.

We define that the vertical congruency of audio and video in time is derived from synchronicity and in space from convergence. In the case of the spatial congruency

of audio and video, the positions of their objects in space must be compared. In discussing space of sound and image, it proved helpful to divide them into x, y and z axes. However, to avoid going beyond the scope of the current investigation, I will concentrate here on temporal concurrence or what we might call synchronicities.

Synchronicity

Synchronicity is necessarily subject to the imprecision of a measurable or perceivable threshold. Because of differences between an objective and a subjective synchronicity, it makes sense to differentiate them in terms of our investigation of convergences.

To achieve technical synchronicity of audio and video, structural grids have to be coordinated with one another. To this end, we must assume a fixed framerate for moving images and a fixed metre with metronomic tempo for music. To interrogate audiovisual synchronicities audiovisual synchronicities, I developed the audiovisual live performance *1Hz* by *0101* with the guitarist Stefan Carl (available online: https://vimeo.com/danielvonruediger/1hz0101). By selecting a tempo of 60 BPM and a framerate of 24, all note values, upto 32nd notes, can be technically synchronized with a specific frame.[32] This was a prerequisite for creating objective asynchronicities and, in a next step, exposing subjectively perceived synchronicities.

Stimuli have to bridge distances in our bodies, which makes stimulus processing itself a complex synchronization problem.[33] For audiovisual synchronization, the different speeds of sound and light further complicate matters. In order to compensate these differences, our perception acts to recognizing objects as synchronous which objectively are not. The result is a subjective synchronicity, intensified by an aspiration for *Gestalts* or harmonious forms.[34] Because they appear *meaningful* to us, our perception is literally intent on prioritizing synchronicities.[35]

Our tolerance for objective asynchronicity is dependent on the image content and the direction of the sound-image shift. Subjectively, the greatest synchronicity takes effect when sound is played with a one-frame delay at 24 frames per second.[36]

It became evident that clearly recognizable accents in music and image are essential for an initiation of synchronicity.[37] To this end, goal-oriented, accentuated movements like the strike, video cuts and pointalistic sounds are particularly well suited.

I investigated the phenomenon of subjective synchronicity with the video installation *ein sehen raus hören* (see Figure 5.3, available online: https://vimeo.com/daniel vonruediger/esinstallation). Since the audio and video tracks were of different lengths, they continuously shifted in relation to each other while looping together. Because the video worked with many quick movements of objects with undetermined borders, many auditory and visual objects were nonetheless perceived as synchronous. Audio and video were perceived as an apparently unified current of stimuli and objects.

**Figure 5.3**   Installation view of the audiovisual installation *ein sehen raus hören*. The six-channel video work was asynchronously coupled with a passacaglia to examine and reveal subjective synchronicity.

Source: https://vimeo.com/danielvonruediger/esinstallation

## Horizontal relations

In contrast to vertical references, horizontal object references contain different objects of varying spatiotemporal points, related to each other in succession. Horizontal references can be identified for similar or dissimilar objects.

### Beat/metre

The musical pulse is well suited to analyzing horizontal references. It facilitates the identification of objects within a structure and sets intuitive temporal positions. The affiliation of single objects with a beat, results from their position and their emphasis. In addition to emphasis, the rhythmic structure is also responsible for the arrangement of objects.[38] To comprehend an extra-sensory arrangement, we can refer to further factors of Gestalt theory. In particular the principles of proximity, similarity and common movement, which are essential for the assignment to a group.[39]

The metre indicated by the musical beat is central for the transposition of a *musical movement* to a body movement. Let us explore these movements which result from structure in more detail, as independent structural parameters.

## Anticipatable movement

The effect of rhythm can be attributed to *movement transfer*. Its basis is the idea of comparing body movement and musical motricity.[40] The so-called *phi-phenomenon* says that even *two* spatially removed blinking points can be perceived as one moving point.[41] In this sense, the repetition of an object becomes a movement *through time*.

The prediction of structural movement expresses itself via the fact that future objects can be anticipated. When the direction of a movement is predictable, we assume its continuation. For example, an object which moves through an image anticipates the moment of its disappearance from the frame. Musical movements demonstrate this in the same fashion, for example with the continuation of an expected beat. By breaking the beat, and with it our anticipation, the unfulfilled expectations become obvious.

When it's oriented on music, dance can be understood as a visualization of musical movements. Performative investigations of visualization for a passacaglia, juxtaposes musical and visual movements and pursues their congruencies. The choreography works with different articulations of the repeating and varying musical structure. Manipulating the video image enables fixing a movement in two dimensions and thereby making *traces of movement* visible (see Figure 5.4). The aim was

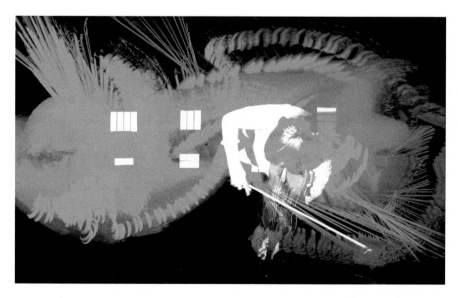

**Figure 5.4** Performance in cooperation with Malwina Sosnowski based on the visualization of a passacaglia for solo violin in G-minor (1674) by the composer Heinrich Ignaz Franz Biber. Live capture makes it possible to fix the motions of her playing and walking in space and to combine them with her musical movements.

Source: https://vimeo.com/danielvonruediger/esperform

to compare possibilities of expressing movement in sound and image, as well as in time and space.

We establish that auditory and visual objects are congruent when they are part of a common structural movement and evoke similar anticipations.[42] Put another way expectation, as a common reference point, unites dissimilar objects in a common movement.

A movement is the expression of a change which can only be experienced in time. The timespan necessary for this change determines its tempo.

## Tempo

To bring tempo into relation in audio and video, we have to compare how it can be captured in each medium. In turn, we can develop systematics to relate BPM (beats per minute) to FPS (frames per second). If two structures orient themselves on the same grid and if its objects are synchronous, the structures have the same tempo. However, it's entirely possible for isochrone structures to have the same tempo too. For the juxtaposition of auditory and visual tempi, both must be grasped separately and then compared to each other to define them as congruent or incongruent.

We summarize that beat structures and their metre, the appearance of common movement, as well as the tempo, can be used to examine the horizontal congruency of auditory and visual objects.

## Semantic parameters

Whereas structure refers to spatiotemporal organization, semantics refer to the interpretation of meanings. Focusing on structure lends itself to an analysis of rhythm. Yet, investigations of audiovisual perception demonstrate that semantics are also important for relating auditory and visual sensory modalities to one another. Structure and semantics go hand in hand in the development of audiovisual Gestalts. A structural incongruency can be compensated by semantic congruency, and a semantic incongruency by structural congruency.

The use of documentary materials for my musical visualization showed that structure and semantics relate antagonistically in regards to attention. One gains attention at the loss of the other. In order to counteract this antagonism, music visualizations usually resort to abstract depictions. They possess a lower semantic intensity and distract less from the structure. I established the performance duo *0101* (www.0101.wtf) to investigate possibilities for decreasing the semantic intensity of video footage, for example by altering the visual material to be its negative (see Figure 5.5).

It's not easy to classify the concreteness or abstractness and therefore the semantic level of a visual or auditory object. I propose using the technical reversal of the

**Figure 5.5**   The semantic intensity of the video footage from Papua New Guinea is decreased by various techniques, for example altering the visual material to be its negative and projecting on a plastic screen.

Source: https://vimeo.com/danielvonruediger/1hz0101

direction of playback to divide the semantic value into three levels, *undefined, defined* and *deliberate*.

- The first level indicates an undefined direction of action. A reversal of the playback direction can't be detected. Instead, the presence of both visual and auditory noise is striking.
- The second level indicates a defined direction of action. A reversal of the playback direction can be detected, although both directions seem intuitive for our experience. There's no clear direction of playback. It can be compared to a river trip on which both a movement upstream or downstream is potentially possible. The reversing of sounds is especially common in electronic music.
- The third level indicates a deliberate direction of action. A reversal of the direction of playback can be detected and only one direction seems intuitive for our experience. A comparison to language suggests itself, or to body movement. The reversal of the swing of an axe loses its meaning when it assembles a tree trunk. A reversal of the playback direction of a language recording robs it of its semantic content and also the character of an acoustic instrument is lost when reversing its sound.

In addition to the direction of action, there is the potential to develop other parameters to investigate the semantic congruency of audio and video.[43] However, the current deficiencies with regard to semantic parameters needn't prevent us from summarizing the reference parameters developed so far, reaching towards a definition of x.

## Conclusion: X =

We recall that x = A + V – AV (x = Audio + Video – Audiovisual).

Over the course of my inquiry it has been possible to develop reference parameters, which aid in formulating a statement on the congruency of audio and video. By delving into an analysis of x, I have offered an incentive to further develop, change, criticize, dismiss, extend, rename, confirm and above all to use the parameters developed. I would be greatly pleased if x was further reflected upon and the implied questions of intermediality confronted by my fellow practitioners.

The development of three main and numerous subreference parameters is a first step to determine x. They can be collected as shown in Table 5.1.

It becomes apparent that x is a subjective estimation which can't be determined absolutely. The value (x) exists in relation to evolving audiovisual Gestalts (AV). When the previously listed parameters prove to be incongruent in audio and in video, this curbs the development of audiovisual Gestalts and increases the value of x. The relation of x to AV can be simply described in two ways.

I    x < AV
II   x > AV

For I the Gestalt character of auditory and visual objects is predominant and the distance between audio and video is minimal. An audiovisual fusion with x < AV can be described as *consonant*.

**Table 5.1** Reference parameters to describe x

| Object Parameters | Object characteristic Object border Object dimension | | |
|---|---|---|---|
| Structural Parameters | Vertical Relations | Synchronicity | Objective Subjective |
| | | Convergence | x axis y axis z axis |
| | Horizontal Relations | Beat/Metre Anticipatable movement Tempo | |
| Semantic Parameters | Direction of action | undefined defined deliberate | |

For II the deviation of the auditory and visual objects is predominant and the distance between audio and video is large. An audiovisual fusion with x < AV can be described as *dissonant*.

From a particular value of x upwards, the moving image falls into two separate sound and image tracks. To borrow a phrase from Chion, one can speak of a 'hollowing-out' effect. With an obvious x, auditory and visual perception can be 'divided one by the other instead of mutually compounded'. This quotient can lead to 'another form of reality, of combination, emerged'.[44]

The acceptance of structural and semantic discrepancies is subjective and context-dependent. Thus an obvious asynchronicity can be praised as *avant-garde* and grasped as meaningful in an art film, while regarded as irritating in a feature film. Expectations of and tolerance towards structural and semantic discrepancy are both largely dependent on their *framing*.

This should serve as an incentive to use x as a formal element and to work consciously with the distances between audio and video. A variable x in one audiovisual media can provoke an undulation between auditory and visual attention and evoke audiovisual tension.

Furthermore, x should advance media-theoretical investigations. In Danto's terms, x can be used for the assessment of audiovisual fusion as *pure representation* or as an *artwork*. A *pure representation* aims at a state of pure transparency in relation to its medium.[45] An artwork on the other hand indicates the medium and is in this sense *opaque*. X as a factor of representation is responsible for the opacity of a work, whereby x becomes a variable of expression and can help a representation to become art.[46] This function depends on whether the implementation of x occurs consciously and whether x is used *to express* something. In that x expresses something about the content of a work, x itself can be become an *expression*.[47]

The audiovisual investigation closes there with the expressed aim of contributing to the philosophical debate examining the relationship between art and reality.

In the end it is the medium which separates reality from art.[48]

## Notes

1 The reader *See This Sound* provides an historical and perception-theoretical overview of combinations of image and sound, corroborated by numerous examples from artistic praxis. Vgl.: Dieter Daniels und Sandra Naumann, Hrsg., *See This Sound: Audiovisuology a Reader* (Köln: Buchhandlung Walther König, 2015).

2 Daniels und Naumann, "Introduction", 5.

3 Chion, *Audio-Vision. Sound on Screen*, 133.

4 Ruccius, "Musikvdeo als audiovisuelle Synergie. Michel Gondrys Star Guitar für the Chemical Brothers", 98.

5 In part, this intertwinement of senses can be neurologically substantiated.
Stein und Meredith, *The Merging of the Senses*.

6 "Klangkunst im intermedialen Wahrnehmungsprozess", 35.

7 Schmitt, *Der kunstübergreifende Vergleich. Theoretische Reflexionen ausgehen von Picasso und Strawinsky*, 34.

8 Chion, *Audio-Vision: Sound on Screen*, 136.

9 Bateson, *Geist und Natur: eine notwendige Einheit*, 15.
ebenso: Müller, "Das Muster, das verbindet. Gregory Batesons Geist und Natur".

10 *Rhythmus – Balance – Metrum. Formen raumzeitlicher Organisation in den Künsten*, 7.

11 In nature, such movements constitute evolution and are deemed by Hegel as responsible for the 'naturally beautiful' (*Naturschöne*).
Hegel, *Vorlesung über die Ästhetik I*, 190 f.

12 Spitznagel, "Geschichte der psychologischen Rhythmusforschung", 9.

13 In the introduction to his standard reference work Wilhelm Wundt describes these as two factors of one and the same experience. He prescribes the objects of the experience to science, whereby the experiencing subject is examined by psychology. The humanities, by contrast, attempt to explain the mutual connections of both factors.
Vgl.: Wundt, *Grundriss der Psychologie*.

14 The term 'music' isn't defined by the use of musical instruments. Arranged sounds are also incorporated into musical structures. Live-action film footage is used in contrast to animation film and to computer-generated filmic images. Live-action film is recorded with a camera.

15 Woitas, "Immanente Choreographie oder Warum man zu Strawinskys Musik tanzen muss", 226.

16 Alexander, "Audiovisual Live Performance", 109.

17 Stöhr, *endlos. Zur Geschichte des Film- und Videoloops im Zusammenspiel von Technik, Kunst und Ausstellung*.

18 Alexander, "Audiovisual Live Performance", 200ff.
Predecessors were, among others, *Coldcut,* who demonstrated the potential of real-time moved-image montage with their *Natural Rhythm Trilogy.*
Warren-Hill und Coldcut, *Natural Rhythm (Natural Rhythms Trilogy Part II) (Coldcut).*

19 A colour organ is a instrument that projects areas of light and it often is controlled by means of a keyboard.
Alexander, "Audiovisual Live Performance", 199.

20 Cohen, "Congruence-Association Model of Music and Multimedia: Origin and Evolution".

21 Boltz, Schulkind, und Kantra, "Effects of Background Music on the Remembering of Filmed Events".

22 For an overview and graphics of various trials in asynchronicity, see: Schlemmer-James, "Schnittmuster: Affektive Reaktionen auf variierte Bildschnitte bei Musikvideos", 30ff.

23 Iwamiya, "Perceived CeAuditory and Visual Elements in Multimedia".

24 Iwamiya, 141.

25 The object term is often supplemented by the terms 'entities', 'auditory event', 'auditory image', 'auditory scene'.
See: Chion, *Guide to Sound Objects.*

26 Hume, *Enquiry Concerning Human Understanding.*

27 (1) *Sensory function* stands for the reception and differentiation of stimuli based on simple stimulus characteristics; (2) *organization* for registering the structure of the stimuli; and (3) *interpretation* for grasping meaning.
Möckel, "Warhnehmung". 'Sensorik, Organisation, Interpretation'.

28 It is however possible to compare different sensory objects based on a *change* to their parameters. A *lowering* of the pitch and a *lowering* of image brightness can be described as congruent.

29  It has been shown that both while seeing and while hearing two different networks report the appearance and the disappearance, respectively, of an object to the brain.
Scholl, Gao, und Wehr, "Nonoverlapping Sets of Synapses Drive on Responses and Off Responses in Auditory Cortex".

30  Schlemmer-James, "Schnittmuster: Affektive Reaktionen auf variierte Bildschnitte bei Musikvideos", 38.

31  Chion, *Audio-Vision: Sound on Screen*.

32  Whole note (1 beat) = 96 frames (fr); 4s; half note = 48 fr; 2s; quarter note = 24 fr; 1s; eighth note = 12 fr; 0.5s; 16th note = 6 fr; 0.25s; 32nd note = 3 fr; 0.125s.

33  Kassung, "Der diskrete Takt des Menschen", 268.

34  The German term, *Gestalt*, roots from Gestalt theory. Its dogmatic views have been seen critically especially because of the attempt to define 'laws' (*Gestaltgesetze*) to describe patterns of perception. Buchwald, "Gestalt."

35  Cohen, "Congruence-Association Model of Music and Multimedia: Origin and Ee."

36  Heide und Maempel, "e"

37  Schlemmer-James, "Schnittmuster: Affektive Reaktionen auf variierte Bildschnitte bei Musikvideos", 38.

38  The foundations of group formation are addressed by Bergman's *auditory streaming* theory.
Bergman, *Auditory Scene Analysis: The Perceptual Organization of Sound*.
Also: Lange, "Musikpsychologische Forschung im Kontext Allgemeinpsychologischer Gedächtnismodelle"e.

39  Spitzer, *Musik im Kopf. Hören, Musizieren, Verstehen und Erleben im neuronalen Netzwerk*, 121.

40  Chion, *Audio-Vision. Ton und Bild im Kino*, 113.

41  See: Fitzek, *Gestaltpsychologie. Geschichte und Praxis*, 27ff.

42  Bakels, *Audiovisuelle Rhythmen. Filmmusik, Bewegungskomposition und die dynamische Affizierung des Zuschauers*, 161.

43  A cooperation with linguistics would therefore certainly be helpful.

44  Chion, *Audio-Vision: Sound on Screen*, 126.

45  Danto, *Die Verklärung des Gewöhnlichen. Eine Philosophie der Kunst*, 225.
English version see: Danto, *What Art Is*.

46  Danto, *Die Verklärung des Gewöhnlichen. Eine Philosophie der Kunst*, 227.

47  Danto, 226 ff.

48  Danto, 234.

# References

Alexander, A. (2015) Audiovisual Live Performance. In: *See This Sound: Audiovisuology a Reader*. Köln: Buchhandlung Walther König. pp. 198–211.

Bakels, J.-H. (2017) *Audiovisuelle Rhythmen: Filmmusik, Bewegungskomposition und die dynamische Affizierung des Zuschauers*. Berlin: Walter de Gruyter.

Bateson, G. (1995) *Geist und Natur: eine notwendige Einheit* (Vol. 4). Frankfurt am Main: Suhrkamp.

Bergman, A.S. (1990) *Auditory Scene Analysis: The Perceptual Organization of Sound*. Cambridge: MIT Press.

Boltz, M.; Schulkind, K. (1991) Effects of Background Music on the Remembering of Filmed Events. *Memory and Cognition*. 19 (o. J.). pp. 593–606.

Buchwald, D. (2010) Gestalt. In: *Ästhetische Grundbegriffe*. Stuttgart: J.B. Metzler. pp. 820–862.

Chion, M. (1994) *Audio-Vision: Sound on Screen*. New York: Columbia University Press.

Chion, M. (2009) *Guide to Sound Objects*. London. Available online: https://monoskop.org/images/0/01/Chion_Michel_Guide_To_Sound_Objects_Pierre_Schaeffer_and_Musical_Research.pdf.

Chion, M. (2012) *Audio-Vision. Ton und Bild im Kino.* Berlin: Schiele und Schön.

Cohen, A.J. (2013) Congruence-Association Model of Music and Multimedia: Origin and Evolution. In: *The Psychology of Music in Multimedia.* Oxford: Oxford University Press. pp. 17–47.

Daniels, D.; Naumann, S. (2015) Introduction. In: *See This Sound: Audiovisuology a Reader.* Köln: Buchhandlung Walther König. pp. 5–16.

Danto, A.C. (1984) *Die Verklärung des Gewöhnlichen. Eine Philosophie der Kunst.* Frankfurt am Main: Suhrkamp.

Danto, A.C. (2014) *What Art Is.* New Haven: Yale University Press.

Fitzek, H. (1996) *Gestaltpsychologie. Geschichte und Praxis.* Darmstadt: Wissenschaftliche Buchgesellschaft.

Grüny, C.; Nanni, M. (2014) *Rhythmus – Balance – Metrum. Formen raumzeitlicher Organisation in den Künsten.* Bielefeld: Transcript.

Hegel, G.W.F. (1992) *Vorlesung über die Ästhetik I.* Hegel in 20 Bänden: Auf der Grundlage der Werke von 1823–1845 13. Frankfurt am Main: Suhrkamp.

Heide, B.L.; Maempel, H.-J. (2010) Die Wahrnehmung audiovisueller Synchronität in elektronischen Medien. *Tonmeistertagung – VDT International Convention.* 26. pp. 525–537.

Hume, D. (2017) *Enquiry Concerning Human Understanding.* Jonathan Bennett. Available online: www.earlymoderntexts.com/assets/pdfs/hume1748.pdf.

Iwamiya, S.-I. (2013) Perceived Congruence between Auditory and Visual Elements in Multimedia. In: *The Psychology of Music in Multimedia.* Oxford: Oxford University Press. pp. 141–164.

Kassung, C. (2005) Der diskrete Takt des Menschen. In: *Anthropometrie. Zur Vorgeschichte des Menschen nach Maß.* München: Wilhelm Fink. pp. 257–275.

La Motte-Haber, H. de (2013) Klangkunst im intermedialen Wahrnehmungsprozess. In: *Wahrnehmung – Erkenntnis – Vermittlung. Musikwissenschaftliche Brückenschläge.* Hildesheim: Georg Olms. pp. 32–40.

Lange, E.B. (2005) Musikpsychologische Forschung im Kontext Allgemeinpsychologischer Gedächtnismodelle. In: *Musikpsychologie.* Laaber: Laaber. pp. 74–100.

Möckel, W. (1998) Warhnehmung. In: *Psychologische Grundbergriffe.* Hamburg: rowohlts enzyklopädie. pp. 681–683.

Müller, A. (2015) Das Muster, das verbindet. Gregory Batesons Geist und Natur. In: *Schlüsselwerke des Konstruktivismus.* Wiesbaden: Springer. pp. 113–127.

Ruccius, A. (2014) Musikvdeo als audiovisuelle Synergie. Michel Gondrys Star Guitar für the Chemical Brothers. In: *Bildwelten des Wissens Bild – Ton – Rhythmus.* Berlin and Boston: Walter de Gruyter GmbH. pp. 98–106.

Schlemmer-James, M. (2005) *Schnittmuster: Affektive Reaktionen auf variierte Bildschnitte bei Musikvideos.* Technische Universität.

Schmitt, A. (2001) *Der kunstübergreifende Vergleich. Theoretische Reflexionen ausgehen von Picasso und Strawinsky.* Würzburg: Verlag Königshausen & Neumann GmbH.

Scholl, B.; Gao, X.; Wehr, M. (2010) Nonoverlapping Sets of Synapses Drive on Responses and Off Responses in Auditory Cortex. *Neuron.* 65(3). pp. 412–421.

Spitzer, M. (2002) *Musik im Kopf. Hören, Musizieren, Verstehen und Erleben im neuronalen Netzwerk.* Stuttgart: Schattauer.

Spitznagel, A. (2000) Geschichte der psychologischen Rhythmusforschung. In: *Rhythmus. Ein interdisziplinäres Handbuch.* Psychologie Handbuch. Bern: Hans Huber. pp. 1–41.

Stein, B.E.; Meredith, M.A. (1993) *The Merging of the Senses.* Cambridge: MIT Press.

Stöhr, F. (2016) *endlos. Zur Geschichte des Film- und Videoloops im Zusammenspiel von Technik, Kunst und Ausstellung.* Bielefeld: Transcript.

Warren-Hill, S.; Coldcut. (1996) *Natural Rhythm (Natural Rhythms Trilogy Part II) (Coldcut).* Musikvideo.

Woitas, M. (2007) Immanente Choreographie oder Warum man zu Strawinskys Musik tanzen muss. In: *Die Beziehung von Musik und Choreographie im Ballett.* Berlin: Vorwerk 8. 219–232.

Wundt, W. (1911) *Grundriss der Psychologie.* Zehnte Auflage. Leipzig: Verlag von Wilhelm Engelmann.

# The curious case of the plastic hair-comb

## A rhythm-based approach to a parallel (sound-image-touch) theory of aesthetic practices

Matthew Galea

The relationship between sound and image within this text is discussed primarily through their relationship with touch engaged through structures understood in terms of rhythm. Touch has a secure footing within both realms of vision and audition whilst simultaneously existing as an independent category of sensory phenomena. Touch is an integral component in the discourse on sound and image. Touch is both sending and receiving. When we touch something we physically engage with it and we are acting upon it. Touching a screen on a smartphone does something to the phone, often resulting in a sound or an image. Seeing things and hearing them does nothing to the things themselves (although it does on a socio-cultural level). Our relationship with technology and media pulls touch towards the surface placing it firmly and solidly in the equation.

It is through touch that my practice as an artist relates to the image and to the sound. Early on as a sculptor, I recognised that as a vibration, sound can be touched; and, sculpturally, if it can be touched, it can be physically manipulated. In contrast, my predominant conception of music was as a visual process where the act of organising sound was always approached as a conversion between visual cues (notation) that were translated to touch (performer actions), only finally resulting in sound. As my practice has evolved, I have developed an aesthetic sensibility that considers sound, image and tactility as parallel aesthetic processes.

## The curious case of the plastic hair-comb

As a material thinker, the plastic hair-comb is somewhat of an anomaly to me. It is one of the few examples of an object where what is seen, heard and felt tacitly is equivalent, or at the very least the content is expressed in the same manner across the senses (Figure 6.1). The notion of a plastic hair-comb described in this text can be understood as tool or method for which to approach an audiovisual format of

**Figure 6.1**    The plastic hair-comb.
Source: Matthew Galea.

sculpture. The word 'plastic' in the title of this text is taken from the standpoint of the 'plastic arts', defined in this case as formats for the production and consumption of the arts or medium that is mutable, manipulatible through active processes involving the addition or the removal of matter or information.

The first consideration in how the plastic hair-comb as an object differs from the conventional art object is in the manner in which 'content' is delivered. The content of a hair-comb is essentially nothing, as the comb in itself is a tool in order to perform an action. The plastic hair-comb can be therefore understood as an object that contains the space for content, each rib behaving like a placeholder of sorts. What is particularly interesting in the comb is how the content is potentially delivered. As an object on a table, the comb works on a visual level. The ribs or the content holders are visible yet only hold a third of the experience. In order to get to hearing one has to go through touch. Stroking the comb, or touching it across time, reveals the comb's sonic potential. The content of these ribs is a pattern that may be visually, aurally and tacitly experienced. Varying the rate of action across time does not modify the content, the pattern, but it does modify the experience. The manner in which the content is delivered across time is a crucial factor in how the object is experienced, yet the content remains essentially the same.

Such a phenomenon is not exhibited when experiencing, for instance, a painting. Taking Vincent Van Gogh's *The Starry Night* (1889) as an example, the painting in itself contains no sound and whilst possessing visually discernable tactile qualities, most painting is not meant to be touched. Similarly, the moving image contains both the seen and the heard, however, touch is absent. I can never touch a movie; I can only touch the screen or the projected rectangle. Essentially I am only touching the technology, never the content. Examples such as Anthony McCall's *Line Describing a Cone* (1973) do, to a certain extent, allow for one to 'touch' the content, however, this comes then at the expense of movement. Again, whilst the projection *is* moving, it is the technology not the content that is in motion. On the same level in conventional formats of music, whilst the auditory and the tactile may align, vision does not objectively follow. Technology has made significant inroads into the 'transferability' of content across sensory modalities, however, it usually does so at

the expense of materiality. It is worth considering on which levels these aesthetic transfers are occurring. Once again it is worth nothing that technology in itself is of little artistic significance and in the context of this text should be understood as a tool or a platform that holds the content together.

The plastic hair-comb is in itself a piece of technology, a structure or a tool kit with which to approach aesthetics from a parallel standpoint. Technology aids us in discovering or more accurately in identifying new patterns and relationships between things. Fritjof Capra (1988) makes an interesting observation in this regard. When discussing a systems approach to society Capra refers to the idea of an 'object' which he views as created through a specific pattern of relationships as identified by the human observer. Technology is increasingly becoming the manner in which such patterns are generated and focused. Technology aids us in discovering or more accurately in identifying new patterns and relationships between things.

## Why use a comb?

I propose an 'alternative route' to the conventional discourses on sound-image relationships, one where sound and the image combine in materials, objects and spaces that possess tactually tangible qualities. This approach can be exemplified through the practice of Paul De Martinis, who Erkki Huhtamo (2016) describes as a 'thinkerer', a kind of artist-inventor whose practice depends on an approach to thinking through doing. This observation links to the notion presented by Andy Clark (2008) that of tool-making as a cognitive scaffold, a manner of understanding one's world by simplifying it, by breaking things down and looking at how the individual pieces are coming together, so that they can be modified and transformed, in order to make the leap from ordinary to extraordinary. The extraordinary object is central to the notion of the artwork in terms of audience expectations. Both artists and audiences can feel a strong connection between the seen and the heard and art becomes the perfect vehicle to express these similarities where conventional forms of language struggle.

The plastic hair-comb that acts as a central motif in this text is – in essence – a tool-making process, a process that decentralises the creation of meaning through language, proposing in its stead an approach through rhythm. Rhythm (and the experiencing of it) appears to act at a level that is prior to the cognitive processes and the socio-cultural implications that the spoken and the written word appear to operate upon. This is not to say that language in its word form is not integral to the art-making process, however, I believe that in order to properly understand the structures of the visual-aural relations, one has to search for the structures that link the two at the root. Adding touch to the sound/image relationship offers new routes and possibilities in understanding this field of creative practices.

## Delivery of content – the notion of rhythm

Brigid Costello (2018) cites Michael Thaut (2005) in stating that Rhythm organises the experience of time. As a sculptor I view time as a phenomenon that contains no real information in itself. Time in this context is understood as a measure of distance from one event to the next. Meaning, sensation and intensity are what is given to time (pure duration) through the spatio-temporal montages we form with media. Rhythm, on the other hand, is a way of establishing relations between content as well as between content and an audience. It is one of the so-called formal elements of the arts and its role in the arts is solely dedicated to structuring relationships across time but also across two-dimensional and three-dimensional planes. Rhythm, like time, has no real 'meaning' in and of itself, however, it tempers our relationship with the artwork, it puts us in a place where we can relate to an artwork and consume it. Rhythm is a tool for consumption, a vehicle that breaks down content into human-sized bites. On the other side of the coin, rhythm, from a maker's perspective is what bonds content and event together in structures and patterns of information that point to specific aesthetic or meaningful directions.

Every action be it walking, breathing, dancing or speaking is governed by a rhythmic structure. Rhythm is the glue that holds the experiencing of the content together. It is what connects one event to another – to the one before it, as well as to the one after it. It is not time that connects the event as time is nothing but a measure of distance. It is not space that connects as space is a container, in physical terms a volumetric container where events occur and that objects occupy.

As Thaut (2005) states, "Rhythm can be approached as a process of an organization of time, much as in the same manner as John Cage (1937) described music as an 'orgainisation of sound'" (p. 23). A musical tone in itself means nothing, or at least it means itself. It is its relationship to what precedes it and what succeeds it that turns 'a sound' into music. The start of the tone and the end of the tone can be measured across time, the distance between one tone and another may also be measured through time, but those distances in terms of duration on their own provide us with little meaningful information (in an artistic context). In music, a rhythm has specific functions, however, in a wider context, rhythm as a pattern contains not only the content across time but is also intrinsically tied to the before and the after. A unit of rhythm (in music the beat, in this case the pulse) is composed of a before and an after, much as described by Deleuze (1986) when discussing the image (the still frame) in the context of the moving image. Rhythm is dependent on the relationship between the before and the after, as rhythm is discernable through difference – through the contrast between sound and no sound, black and white, matter and no matter – therefore, rhythm is dependent on a change of state, or change of event. Furthermore, rhythm contains information about intensity, accents, timbre and other factors. Rhythm should not be merely understood as a function of time, but

rather as structures of information across time. The same rhythm may move slowly or quickly across time, its progression need not be linear across time – as in the ticking of a clock – but a rhythm may be fast, and slow, or change direction, making use of what can be described as a trickling form of time. Rhythm can be understood as the consumption of information, snippets of content that are woven together to create larger, more complex weaves of information that in themselves are independent to a fixed time both in terms of the moment, but also in terms of duration.

## Rhythm in the visual arts

The main distinction between the image and the sound is their relationship with time. The seen and the heard do not necessarily work on the same temporal structures, furthermore they do not necessarily work on the structure of the human, or to be more precise, the Western understanding of time. The seen and the heard can be understood as bound together through the spatial and planar and more importantly through the degree(s) of motion that spatial planes allow for. In this regard Erin Manning (2007) states, "The body does not move into space and time, it creates space and time: there is no space and time before movement" (p. xiii). As with all things that we engage with as humans, the image and the sound – and consequently all artefacts and art objects that man has created – are understood in terms of human time, however, neither the seen or the heard are governed in themselves specifically by a notion of time. Rhythm has the capacity to alter this. Rhythm acts as an interface between the object and the audience, drawing the audience into a new time, the time of the artwork. As a sculptor, touch becomes the interface to rhythm where the action by the artist and that of the audience become 'equal' where each time that an artwork is engaged with, it is created anew.

Approached from a sculptural point of view, audio-visuality finds its roots in the late 1960s and the early 1970s, a period that Cornelia Lund (2015) defines as the 'expanded arts period', the second wave of visual music that followed the fascination with syesthesia in the early part of the 20th century. Even though there are other earlier examples such as Bernard and Francois Baschet who were active since the early 1950s (Baschet 2000), these practices were few and far between, at least in terms of recorded evidence. It is predominantly in this era that the notion of looking beyond the limitations of one's medium or discipline started gaining some serious traction. Visual artists were making use of and exploring the possibilities of sound. As visual artists tended to understand sound physically, they attempted to manipulate it in the same manner that they were accustomed to. Reinhold Pieper Marxhausen produced sculptural work that looked at the relationship between objects and their sound, engaged with through the sense of touch and dependent on an active audience. His best-known works are a series of sculptural objects collectively known as

*Stardusts* (Grayson 1975). These consist of metal wires welded to a round object in a stereo configuration. By connecting two of these together with steel bands Marxhausen created headphone-like sculptures that a listener would place on his or her head – arranged, as conventional headphones, over each ear – and by caressing the metal wires, one could hear a whole range of hauntingly beautiful sounds. Harry Bertoia produced metal sculptures out of rods and wire, predominantly in bronze that vibrated and made sound when touched. Similarly, Charles Mattox created sculpture that was meant to be touched. Mattox combined sculptural forms with audio-kinetic mechanisms that he devised, making use of electromagnets, mechanical gears, springs and electronic circuitry. His sculptures were often interactive such as his *Theremin Piece* (1969) or involve the sense of touch directly, such as in *The Fuzz is Your Friend* (1967) built out of springs and monkey hair which Mattox states creates erotic overtones through the movement of the fur (Mattox 1969).

Examples of how sound-image-touch relationships have been explored through rhythm also come from other streams of the arts. This phenomenon can be observed in works such as Hans Richter's *Rhythmus 21* (1921) as well as Lis Rhodes's *Light Music* (1975) and *Dresden Dynamo* (1971–1972) that come from the moving image, however particularly in the case of Rhodes's *Light Music* spill significantly in areas beyond the conventional remit of cinema. Touch appears to be initially absent from these examples, however, touch need not necessarily be physical. Richter's and Rhodes's work engage with the sense of touch by other means. The rhythmic, graphical imagery, as well as the sonic element, touch the eyes in an inexplicable yet undeniable manner. The weight of the light on your face, as the images flash in succession is a strange but perceivable feeling. This opens up a whole new dynamic range of touch that is only accessible through the relationship it has with the sound and the image. Other examples touch employed through its 'absence' can be found in works by Jennie Jones such as *Blues in C Sharp* (2014) where acoustic paneling on the painting dampens the sound of the environment that the painting is placed within, the image touches the sound and consequently modifies it. In Chris Meigh-Andrews's *Streamline* (1991) the artist creates not an image of a stream or a representation but rather reconstructs a stream physically through video and the monitors themselves. The physical, spatial and temporal elements that make a stream a stream are all there, reconstructed physically through other media – moving image, sound and structured sculpturally within space and time, what is absent is the notion of wetness, the tactile element of the steam itself giving the feeling of observing from outside a bubble, shifting the viewer's perception and locational relationship with space thus creating a situation of artifice.

Within my own practice, I have employed the notion of touch on an illusory level such as in the case of *(Re)Diffusion* (2017) where the visual's tactility extends in 'empty space' and expresses itself audibly (Figure 6.2). *(Re)Diffusion* attempts to create a sculptural situation that has the ability to distort space around meaning

**Figure 6.2** *(Re)Diffusion* (2017), interactive sculptural situation: gun (replica), rediffusion cabinet, electronics, digital delay.
Source: Matthew Galea.

and modify it in real-time by reconsidering how sculpture is engaged with, across multiple levels and modalities. In this work, multiple layers of meaning are accessed through different modalities of interaction and temporary structures or relationships built between the artwork and its audience. The work comments on the sociocultural use of mass media as weapon of destruction, through distraction, reflecting upon the personal relationship we somehow build with mass-media, designed to target the masses, but always perceived by its audience in a personal manner.

The spatial qualities attached to sound and the tactile qualities of this artwork aim to re-establish sculpture as a three-dimensional object, in terms that it is not thought of visually, in terms of images, but rather as an object with 'real' tactile and physical connections between the seen and the heard. The artwork plays with the expectation of how the seen and the heard usually relate, which is obviously never fulfilled. The sound starts too early, before it is expected, which negates the idea of sound as physically depending on matter to be initiated and propagated. There is also a temporary detachment between action and consequence, until the brain recalibrates and reconsiders how this new relationship works. The sound is furthermore unexpected, having no real relationship with the gun.

In other instances within my practice, such as in the work *Point and Shoot* (2016) the relationship between the seen and the heard is mediated through motion and touch, where one may move in relation to the image, resulting in sound (Figure 6.3). The nature of the artwork allows for one to physically engage with sound and colour, that are digitally converted in real-time from RGB values to MIDI information, that the audience consumes through moving a large, gun-shaped contraption on wheels within the gallery space dictating the speed and the pattern of the sounds as well as the directionality and distance of how the colours in the painting are relating to each other.

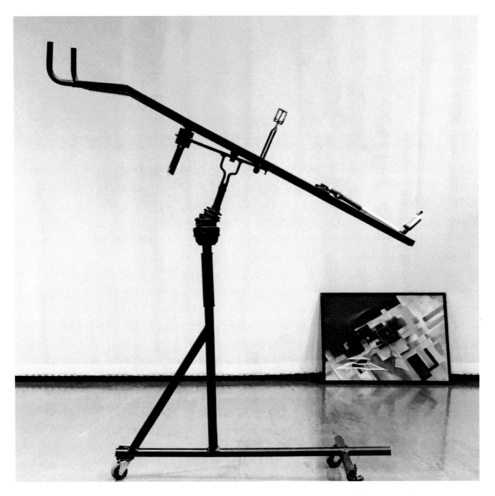

**Figure 6.3** *Point and Shoot* (2016), interactive sculptural situation: mild steel, object trouvé, accelerometers, smartphone, software.

Source: Image credits and copyright: Matthew Galea.

## Rhythm before meaning?

As discussed previously, rhythm is a production/consumption device that breaks down the amalgam of media/content across temporal or spatial planes. Beyond the specificities of art disciplines that all have to a lesser or greater degree an ingrained relationship with rhythm as well as the notion of technology that essentially annihilates rigid segregations of artistic practice, rhythm also has to negotiate its relationship to meaning in the processes of art-making and consumption.

Art itself is a process of meaning-making. The notion of the artefact here, or the artwork, is approached from the etymology of the word 'artifice' and in context reads as an externalised reaction to objects and environments that through human action are expressed in the form of objects and/or events that do not form part of the original object/environment scenario (and as such are external to it) but are essentially constructed of it, or to be more accurate, of the relationship between the human and the scenario. Artistic practice – irrespective of modality – functions through meaning, there is a certain universal expectation for an artwork to 'mean something'. Meaning is cultural, socially constructed through assimilation of prior knowledge as an individual, as a society and as a species. Meaning requires language to be developed, organised cognitive processes that compute at any one time whatever the individual is experiencing and correctly identify what is happening by calling its name, or as discussed earlier by identifying the pattern. Language develops meaning and meaning develops language. If one were to encounter an unfamiliar situation, one extrapolates the sensory information, processes it and articulates it through language in order to arrive at a conclusion.

As a sculptor, I tend to understand rhythm as a physical process whilst meaning as a cerebral one. Rhythm and meaning complement each other as one draws you in, whilst the other keeps you within. Rhythm draws the audience, synchronising them with the artwork. Rhythm dictates the pace with which we relate to the artwork and consequently to the meaning behind it. "Rhythm is, then, something that patterns the flow of experience and binds memory and attention to cycles of prediction and anticipation" (Costello 2018: 8).

Rhythm appears to operate at a level prior to the articulation of complex language. Rhythm is therefore perhaps less subject to specific social and cultural connotations that translate into the arbitrary maps between the seen and the heard that, for instance, most colour-tone relationships exhibit. Whilst one can certainly see the logic behind colour-tone association especially from the angle that both sound and light are essentially waves on the same continuum (the electromagnetic spectrum), the notion that light and colour are the same thing, popularised through scientific approaches, synesthesia and later video art can be problematic. Our relationship to colour is culturally constructed and this is not conventionally constructed in parallel with an understanding of tone. Within our understanding of colour lie multiple

socio-cultural artefacts that differ from culture to culture and from era to era. There appears to be evidence that the notion of colour develops through the development of language (Berlin and Kay 2000; Kay et al. 2009). Attached to colour there are social and cultural significances that have little to do with the nature of both sound and image but rather to the meaning constructed around them. This is, however, not to say that there are no cultural connotations that are interwoven with our understanding of rhythm.

Rhythm in Western musicology is frequently understood as a function of time, and – due to its relationship with time – is somewhat always seen as liner and consistent. Rhythm goes beyond subdividing time. It also goes beyond the 'flavour' of time that in music creates genres and sub-genres where rhythm plays a central determining factor between, for instance, jazz and rock music. There are rhythms that 'belong' to particular cultures where certain rhythmic structures can be developed and passed down the generations through cultural exposure. This phenomenon could, however, limit multiple (or other) understandings of rhythm. This cultural exposure does, however, seem to be localised to specific forms of art-making. As rhythm can be also understood in physical terms rather than solely as an abstract relationship between points, the grasp of cultural exposure, whilst present, is arguably easier to overcome. Our brain is hardwired to recognise patterns and no amount of cultural exposure can change that. Meaning, on the other hand, is more of a computational process where we evaluate content through past knowledge and understanding and is by nature more susceptible to cultural constructs and previous experience. In essence, our current understanding, capabilities and approaches to the process of art-making are built upon past knowledge and understanding of art. Oliver Grau whilst discussing how we read images notes how "No image can be 'read' if one has not read other images before" (2016: 28).

## Rhythm as meaning-making (language's other)

Employing the plastic hair-comb as a model allows for one to explore the meaning-making process within artistic practice from a standpoint that departs from the written or spoken word, which for the most part tends to dominate our relationship to the artwork. Language is one of the major road-blocks when attempting to uncover the mechanics of art before meaning is ascribed to the artefact through language. Is meaning attached as the artefact is processed through language, or does meaning also operate before the word? In music Kendall Walton observes how "Mere titles often suffice to make music patently representational; indeed I cannot imagine music which an appropriate title could not render representational" (1994: 47). Does this mean that the artefact (the musical piece) exists in a state before any meaning is attached to it? More importantly, is that (the word) part of the artwork? Does this apply across media and disciplines?

Representation and meaning are not, however, the same thing. Meaning contains both representation (to stand in for something) and presentation (to show something, known or unknown) and through rhythm, this can also extend to sensation. The central notion behind meaning is the capability to express an idea or a concept to someone else, someone who does not partake in the initial process of creation or ideation. The word is possibly our most effective tool in passing on ideas to others as we have developed a whole range of vocabulary that can adapt and be suited for most situations as it goes hand in hand with social and cultural norms and beliefs, however, the word is a hard limit that restrains the range of human expression. The visual arts need not be bound by the word and by language as the sole structures to create meaning. That is not to say that these (language and the word) should be excluded either as these are an intrinsic part of that which makes us human, however, one may argue that the meaning-making process is capable of residing in the artwork itself, before the articulation and rationalisation imparted by language. Approaching art-making from a standpoint where meaning is created prior to language extends the dynamic range of creative expression, the capability of tackling complex problems that are beyond language and engaging with the world from a shifted standpoint where one is capable of relating to 'the other'. Rhythm allows for sense to be utilised as the meaning-making mechanism with sense being understood from Frege's distinction between 'reference' and 'sense' as the manner in which we are tied or relate to the concept, in this case, the art object. Wittgenstein reasoned that language cannot refer directly to an internal state. Sensation, on the other hand, obtained through a rhythmically related amalgam of the image, sound and touch is a process through which the unnamable still remains unnamable but becomes transferable and sharable and as long as it remains outside of the word it 'means' the same for everyone, irrespective of the audience having dissimilar understandings of the concept, object or form in question. If engaging with the comb results in pain, pain is pain to everyone, irrespective of personal thresholds, associations and even emotional reaction to pain (pleasure or sorrow). The word can only point at one form of pain at any given time, the sensation is the here and now.

The problem with classical models of looking at artworks in terms of meaning-making which permeates across all the levels of current artistic practices is that we tend to process artworks solely in terms of language. We articulate the complex web of experiences, sensory data and thoughts that constitute or that result in the artwork through linguistic processes expressed verbally in terms of words. The identification and naming of these patterns occur through language, thus rendering redundant position and function of the artwork to express that which is not adept to be expressed linguistically. Structuralist (Semiotics) and Post Structuralist (Grammatology, Deconstruction) and other explorations of meaning-making look at the relationship between the word and the object. The issue with these, when

applied to art, is that art as experience can happily exist outside of language, and that the art object is not an object at all as whilst containing 'being' an art object does not necessarily depend on its existence but rather on its subsistence and absistence as put forward by Alexius Meinong in his *Theory of Objects* (1904). Even though one has to add, the reasons as to why we are capable of tracking mental concepts that do not necessarily exist objectively is mainly a function of language. How these are experienced, however, does not necessarily require language in the form of the word.

## Mapping the plastic hair-comb

The hair-comb as a model is to be considered on a level where the object has no meaning in terms of language, but a series of relationships between sensory modalities of engagement. Visually the comb has no time in and of itself. Time is added – or rather unpacked – as a consequence of motion, with motion itself a consequence of touch. Motion through touch can have multiple and simultaneous directions, left to right, right to left, both inwards, both outwards, or none. With motion comes sound, where – assuming that all the teeth in the comb are identical and spaced equally – this directionality does not act on the sound (in terms of pitch), it simply causes it to be.

The comb as a thing, an object, holds more affinity with the idea of sculpture over that of an image, and therefore the comb is here presented as a model to approach an audiovisual format of sculpture. A sculpture in itself can be understood as a series of images (of the same thing) in motion against time (conventionally one is not capable of seeing the front and the back of a sculpture the same time). As a visual object, the sculpture is consumed perceptually against time, making it culminative like the song, the film and the novel. This process is potentially narrative, however, narrative is not an element that can be considered as a defining characteristic of most sculpture. Instead the unfolding 'story' is about the sculpture itself, of how the viewer experiences the sculpture against time.

The comb is a crystallisation of the relationships across the sensory modalities of touch, vision and hearing bound together in a tool. A finite form where one modality makes up for the shortcomings of the others. Where all three sensory modalities can combine without there being any meaning, but are gelled together through rhythm, without which the structure of the comb would not be available across modalities. Rhythm is the spine that holds these in object form, and it is what allows the audience access to its polymodal nature. The comb is, therefore, an audiovisual form whilst simultaneously being an object. It is both the instrument, the notation and the music; the story and its material properties. It is all of this before any meaning

is ascribed to it. The comb is a non-object, it is a thing that has no relation to any other thing apart from itself.

Using the analogy of a book as a form of literature, the plastic hair-comb exhibits similar qualities. Like the pages of the book, the individual teeth of the comb – whilst independent – are bound together by a spine that structures the distances between the pages where the content lies. In the book – like in the popular song – the content is the word, the written word. Whilst conventionally in books each page is different from the other, the form of the book ties them together and makes them considered as a whole. A book without content is still a book. The book can contain its own structure where the content of the book is the form of the book itself. The model of the plastic hair-comb works on a similar level. The content of the comb as a form is the manner in which the visual plane(s) relates to the aural and the tactual dimensions. Space, time and tacit feeling are all devoid of meaning on their own. The comb is, therefore, a carcass, a container that is rhythmically structured allowing for the artist to fill the sensory planes with stimuli that relate to each other and produce larger stimuli that culminate in meaningful content. The form of the comb is significant, because it delivers content in a manner that does not require articulation of the word in order to 'be meaningful'. The intervention lies at a stimulus level, on a level that is prior to language.

Like the book, the plastic hair-comb allows the audience to consume it at its own rate. One may read a book at a steady pace, finishing it at one go, or may read a page a day, or start from the middle and skip every other chapter. Music and painting on the other hand operate as pre-digested art forms. A book is not as rigid in these terms. There is a suggested direction, however, the author has little control on how this is consumed. This is echoed in sculpture where there technically is no real front or back and the audience may approach from any angle and consume any part of the whole. Mieke Bal (2008) observes how the audience's movement through space and the temporal sequentiality involved in a gallery visit makes an exhibition always to some extent narrative. She continues by referring to the spectator as 'co-narrator' "fulfilling in her own way the script that predetermines the parameters within which the story can be told" (Bal 2008: 20).

Applied to sculpture, whilst there is a suggested direction depending on how this is installed in space, the audience may opt to circumvent this and approach in any manner or form they desire. One may engage with the comb on any level. The positioning of the audience and the degree of freedom that the model of the plastic hair-comb presents is one of its defining characteristics. The audience is involved, they are presented with creative choices that in other forms of art-making are predetermined by the initial author. Unlike the pages of the book, however, the spaces between the teeth in the comb are movable and removable. The artist has ample degrees of flexibility on imparting the rhythmic structure, whilst leaving enough room for the audience to consume this at their own rate.

## Taking a comb test

Whilst the model of the plastic hair-comb cannot be put forward as a fully fledged modality or as an independent art format in its own right, as an approach, it can be adopted in various art-making processes. Extending Jack Burnham's (1968) observation on sculpture onto tool-making and model-making, the plastic hair-comb becomes an object that makes our environment and actions within it sub-dividable and transportable. Using the comb as a model, one may ask: how is content being delivered, does this change across time? What flavor is the structuring of the content across time imparting on the artefact? Does the content equate in terms of sensory stimuli, in other words, is the content the same across sensory modalities? Does this matter? Is the artefact omnidirectional across time? Can it travel in any direction, at any speed, in different rates? Does the artefact feed back in real-time? Does the audience determine the modality of engagement? Does the content change if a different modality of engagement is initiated?

Applied to one's practice, these questions may help approach the process of art-making from angles other than what one is accustomed to. Drawing analogies between one's practice and a plastic hair-comb, whilst sounding silly as a premise initially, can offer new and rich insights in one's practice. The comb as a test sheds light on the structural relationships between content and how this is consumed. It allows for a simultaneous reading from both ends of the communication spectrum, both from the aspect of what is being sent, as well as what is being received. It also allows for one to (re)consider multiple sensory avenues, if these work in parallel, or if the 'inequality' between how the content transfers from sensory modality of engagement to another adds to the content, such as in the creation of tension through two opposing ideas/sensations that operate within the same artwork, but are brought about through discrepancies in how we see against how we hear or feel through touch.

## In conclusion

As a creative, my practice lies in multiple in-between areas, between disciplines and modalities of art-making: between the visual arts and the performing arts; between sculpture and drawing; the mechanical and the digital; music and interaction, and multiple blends and iterations of these. Whilst this understanding of sound and image being connected through touch comes somewhat naturally within my practice, it has been elusive to verbalise this in a formal manner, hence my need to create a physical model, in order to conceptually articulate tacit relations between the seen and the heard. As with any other phenomenon that deals with 'other' forms of knowing, the model of the hair-comb is not being put forward as a definitive or

comprehensive formula for practice. As remarked by Juha Varto, "Research always requires a degree of reduction, generalisation, categorisation, naming and prioritisation of phenomena, which means that it is unwillingly doing violence to the richness and diversity of the reality out of which it is picking its phenomena" (2014: vii).

The model of the plastic hair-comb is a proposition to consider the aesthetic experience in terms of how the content and the audience combine to create instances where the work of art is created anew every time the audience engages with it by allowing the audience to partake in the act of artistic creation. It is where an absolute meaning itself is not codified within the art object through notions of embodiment, translation and re/dematerialisation but rather sensations are placed in particular rhythms creating meaning in real-time offering the audience a 'guided tour' of artistic experiences where sound image and touch combine in ways and forms that transcend the promised but never delivered notion of a transcendental sign.

Rhythm is a manner in which meaning is created through the establishing and the restructuring of the relations between the elements that constitute the art object in themselves prior to any links and associations denoted by language. Through rhythm, the art object has agency over its own role as a meaning-making process, one that gains independence over the word in relating to the outside world.

## References

Bal, M. (2008) Exhibition as Film. In: R. Ostow (ed.) *(Re)Visualizing National History: Museums and National Identities in Europe in the New Millennium*. Toronto: University of Toronto Press. pp. 15–47.

Baschet, F. (2000) Les Sculptures Sonores-the Sound Sculptures of Bernard and François Baschet. *Leonardo*. 33(4). pp. 336–337.

Berlin, B.; Kay, P. (2000 [1969]) *Basic Color Terms: Their Universality and Evolution*. Stanford, CA: CLSI Publications.

Burnham, J. (1968) *Beyond Modern Sculpture: The Effects of Science and Technology on the Sculpture of This Century*. New York: George Braziller.

Cage, J. (2011 [1937]) The Future of Music: Credo. In: C. Kelly (ed.) *Sound: Documents of Contemporary Art*. Cambridge, MA: The MIT Press. pp. 23–25.

Capra, F. (2015 [1988]) Systems Theory and the New Paradigm. In: E. Shanken (ed.) *Systems: Documents of Contemporary Art*. Cambridge: MIT Press. pp. 22–27.

Clark, A. (2008) *Supersizing the Mind: Embodiment, Action, and Cognitive Extension*. Oxford: Oxford University Press.

Costello, B. (2018) *Rhythm, Play and Interaction Design*. New York: Springer.

Deleuze, G. (1986) *Cinema 1: The Movement-Image* (H. Tomlinson & B. Habberjam, Trans.). London: Continuum. (Original work published in 1983)

Grau, O. (2016) Digital Arts and Its Impact on Archives and Humanities. In: C. Paul (ed.) *A Companion to Digital Art*. Oxford: Wiley-Blackwell. pp. 23–45.

Grayson, J. (ed.). (1975) *Sound Sculpture: A Collection of Essays by Artists Surveying the Techniques, Applications and Future Directions of Sound Sculpture*. Vancouver: A.R.C. Publications.

Huhtamo, E. (2016) At in the Rear View Mirror: The Media-Archeological Tradition in Art. In: C. Paul (ed.) *A Companion to Digital Art*. Oxford: Wiley-Blackwell. pp. 69–110.

Kay, P.; Berlin, B.; Maffi, L.; Merrifield, W.R.; Cook, R. (2009) *The World Color Survey*. Stanford, CA: CSLI Publications.

Lund, C. (2015) Visual Music. In: C. Lund; A. Carvalho (eds.) *The Audio Visual Breakthrough*. Berlin: Fluctuating Images. pp. 23–29.

Manning, E. (2007) *Politics of Touch: Sense, Movement, Sovereignty*. Minneapolis: Minnesota University Press.

Mattox, C. (1969) The Evolution of My Audio-Kinetic Sculptures. *Leonardo*. 2(4). pp. 355–363. doi: 10.2307/1572118.

Meinong, A. (1960 [1904]) The Theory of Objects (trans. I. Levi; D.B. Terrell; R.M. Chisholm). In: R.M. Chisholm (ed.) *Realism and the Background of Phenomenology*. Detroit, MI: Free Press. pp. 77–117.

Thaut, M. (2005) *Rhythm, Music and the Brain*. New York: Routledge.

Varto, H. (2014) Foreward. In: J. Suoranta; T. Vaden; M. Hannula (eds.) *Artistic Research Methodology: Narrative Power and the Public*. Bern: Peter Lang. pp. vii–x.

Walton, K. (1994) The Philosophy of Music. *The Journal of Aesthetics and Art Criticism*. 52(1). pp. 47–61.

# The spaces between gesture, sound and image

## Mark Pedersen, Brigid Burke and Roger Alsop

## Introduction

Emerging from the audiovisual performance practice of the authors, SeenSound has established itself as a regular monthly visual music event in Melbourne, Australia, running formally since 2012. SeenSound has a focus on live, typically improvisational, audiovisual performance, and also showcases a wide range of fixed media visual music works from around the world. As a space for exploring improvisational performance, SeenSound shares common attributes with other long-running experimental music performance events, but is unique in its local context for focusing on audiovisual performance as an integrated practice. It is in the sense of the artists holding to the audiovisual contract of "the elements of sound and image to be participating in one and the same entity or world" (Chion 1994: 222), or of "the primacy of both ear and eye together" (Garro 2012:106), through an "equal and meaningful synthesis" (Lund and Lund 2009: 149) that SeenSound positions itself within the field of visual music, rather than ascribing to the visual centricity of cinema or the audio centrality of (typically electronic dance) music presentations which include projected visuals as an element of the set or decor.

When considered within the broader genre of acousmatic music, a traditionally fixed medium, visual music could be thought of as purely compositional process resulting in another fixed media form for direct playback in a performance space, and not incorporating live performance. While including fixed media visual music works, SeenSound is an event that emphasises live audiovisual performance, and that is the central theme of this discussion.

Live audiovisual performance can take the form of generation and manipulation of integrated audiovisual material, typically by one or more individual performers using a combination of software and electronic or acoustic instruments. Visual material (either fixed or generative) may also be presented with an invitation to performers to improvise in response to the visual material, where the visual material

functions as a loose and inspirational score. This approach to reading such a score is based on a high level of engagement with the materiality of the visual elements – the raw perceptual elements of colour, luminance, basic structural elements and temporal variance – not a purely symbolic moving notation of the type seen, for example, in the *Decibel Score Player* (2019). Naturally enough, there is a spectrum of performance practices that defy neat categorisation. Each individual performance may fall somewhere in between these (and other) modes, and we will explore these in the three performances discussed in this chapter.

As an environment for collective development of audiovisual performance, Seen-Sound focuses on the liminal space between sound and vision as concepts, with an emphasis on exploring the actualities, combinations, co-incidents and collisions of both concept and embodied practice. In this regard, there is a conscious embracing of the complexity of the creative (poietic) and perceptive (aesthesic) processes (Nattiez 1990). For live performances, this complexity arises from both the bespoke nature of individual works, which may be constructed of unique assemblages of software, control interfaces and instruments that embody the work itself, and the unique circumstance of performance with others, where the make-up of the performing ensemble may be unknown beforehand. This degree of idiosyncracy, whether arising from a necessarily idiosyncratic interpretation of a score, or from an idiosyncratic performance system, is likened by Magnusson (2019: 186) to Renaissance music, where composers did not write for specified instruments, and performers were often as much inventors of the piece as they were interpreters.

This looseness in what constitutes an individual piece is at the heart of Seen-Sound's emphasis on live performance, and we would argue, even at the heart of fixed media renditions of visual music, in that the work itself exists ephemerally in the moment of multi-sensory apprehension by all participants, including the audience. That is, it exists in relationships between subjects, not in the material of any given set of objects. While this may be said of any art form, visual music is in many ways particularly concerned with such relationships: at a literal level, between sound and vision in terms of gestural associations, whether through direct parametric mapping, synchresis (Chion 1994: 63) or looser intuitive associations (Garro 2012: 107). Watkins (2018) and Dannenberg (2005) also address visual music in terms of the creative tension between tight synchronicity of sound and vision on the one hand and complete disconnection on the other, and more broadly, the tension between intention and form, given visual music's existence as an unstable art form mediated by the constant flux in available technology and cultural influence, interest and practice.

## Gesture as an analytical framework for visual music

To gain an insight into the interior spaces of audiovisual performance, we contrast personal reflections on audiovisual composition and performance practice with

analysis of three examples of audiovisual performance. There is an inherent tension between the 'objective' distance afforded by visual media and the immanence of sonic experience which makes analysis of visual music paradoxical. Voegelin (2010: 15) suggests that sonic experience requires a degree of inter-subjective engagement which is not so obviously required when considering visual media in isolation. Given writing is nothing if not both visual and symbolic, within the context of writing about visual music it is difficult to avoid making the sonic subservient to the visual, and doubly so when attempting to reduce the ephemerality of audiovisual experience to static objects which can be examined.

In this regard, we cautiously seek to complement practitioners' subjective reflections with an approach to analysis via visualising the 'trace' of several audiovisual performances. Visualisations of this kind are not unprecedented in the realm of analysing complex performances: Borgo (2005) uses fractal correlation as a means of examining the features of improvised musical performances by the like of Evan Parker and others, while Jensenius et al. (2010) and Francoise et al. (2012) have developed systems for analysing physical gestures and sound together. It is from this latter work that the motiongram analysis used here arises, although in this case, we apply it to the analysis of the visual component of the works under discussion (i.e. the motion "on screen"), as opposed to the analysis of the movement of dancers or performers conducted by Jensenius et al.

More conceptually, our analysis owes much to Cox's proposal for a materialist approach to thinking about sound. In approaching not only sound but also visual motion from the perspective of the flux of "forces, intensities and becomings of which it is composed" (Cox 2011: 157), we are interested not in seeking to determine "what it means or represents, but what it does and how it operates". In addition, the work of O'Callaghan (2017) on multi-sensory perception provides a framework for engaging with audiovisual work that invigorates the intersecting nature of our various modes of perception. In doing so, he specifically addresses the assumption that vision is our dominant mode of perception, drawing upon evidence for non-visual stimuli informing perception equally (or at times even primarily) compared to visual stimuli. In this regard, the juxtaposition of analytical images derived from the auditory and visual domains is intended to reveal some of the underlying gestural similarities and differences which may be at work within a visual music piece as a whole.

To develop this idea further, a multi-sensory approach to understanding visual music need not treat the visual trace as reductive. Rather, it can point to an underlying unification of perception within the body. Key to this perspective is evidence for a close coupling between the cognitive processes for movement and perception. Leman (2008: 77–102) provides extensive discussion of the evidence, including the behavioural observation of infants' innate ability to perceive gestures and replicate them, and the neurobiological observation that some of the same neurons which

are fired to create a gesture (e.g. grasping-with-the-hand) also fire when the subject observes another performing the same action.

> The tight coupling of movement and perception at a cognitive level gives rise to the idea that just as our movements arise from intentions (simulation of the movement), so perceptions of the external world map back to intentions because of the trace left by the shared cognitive processes. This action-oriented ontology suggests that even at the social level, the actions of others are understood in terms of our own intentions, i.e. our own simulated actions. The "moving sonic forms" of music are likewise attributed with intentionality because of the coupling of perception and movement. Thus, because individuals develop their own action-oriented ontology in a similar way by virtue of a common physiology, if not common culture, semantic communication is possible through music.
>
> (Leman 2008: 92)

By utilising analytical tools which draw directly on the qualities of both sound and motion, our goal is to support a discussion of the inter-subjectivity of abstraction and embodiment that manifests in visual music, particularly looking at the idea of gestural surrogacy. Such an analysis is not intended to present any kind of definitive truth of the way in which visual music functions, but rather is offered as a limited view into the complex flux of forces at work within visual music. While there are many other frameworks for analysing movement and visual aesthetics, for visual music we find Dennis Smalley's work on spectro-morphology (Smalley 1986, 1997) highly adaptable. Smalley's typology is laden with physical metaphors and fundamentally uses the concept of gesture as a starting point for looking at sound qualities. It is easy to extend the same analysis to qualities of visual gestures, as much as it is to spectrally moving forms in the auditory domain, giving us a common framework (see also Garro's phenomenological correspondences in Chapter 1).

At the root level, Smalley considers sound in terms of motions, space, structural functions and behaviours. Motions include both the motion of sounding objects, including such categories as ascent, descent, oscillation, rotation, dilation, contraction, convergence, divergence. He also suggests several characteristic motions including floating, drifting, rising, flowing, pushing or dragging. One can easily imagine these categories being applied to human movement, at either the individual or group level, and by extension the visual morphologies of audiovisual artworks.

When we consider the gestural relationship between sound and vision in visual music, it is useful to look at the way in which Smalley links spectromophological forms of sound art to the morphology of human movement (Smalley 1997), an insight which is backed by the work of Leman. The key idea here is that we make sense of what we see and hear by drawing upon our experience as embodied beings,

even though in visual music the experience to which we attend is generally abstracted away from anything immediately recognisable. From a compositional perspective, Smalley identifies several levels of gestural surrogacy, that is, degrees of abstraction away from both the source material and the gestural archetype:

- primal gesture: basic proprioceptive gestural awareness, not linked to music making.
- first order: recognisable audiovisual material subject to recognisable gestural play without instrumentalisation.
- second order: traditional instrumental musical performance.
- third order: where a gesture is inferred or imagined in the music, but both the source material and the specific gesture are uncertain.
- remote: where "source and cause become unknown and unknowable as any human action behind the sound disappears", but "some vestiges of gesture might still remain", revealed by "those characteristics of effort and resistance perceived in the trajectory of gesture".

Building on an awareness of the primal gestural level, first order surrogacy provides simple, immediate accessibility for the interactor, while sustained engagement is generated by providing elements which operate at the higher levels of gestural surrogacy. The aesthesic process is further complicated by the fact that the relationship between gestures which are audibly perceptible versus those which are visually perceptible is not necessarily direct, but exists on a spectrum, as previously discussed. In addition, such gestures may not follow the normal rules of physics in the material world (and in the context of an artwork, it would probably be quite boring if they did).

Outside of visual music, a simple example of such gestural mapping is that of ventriloquism: the puppet's mouth movements are linked with audible speech events and although we know that puppets don't speak, perceptually we are still convinced that the sound is coming from its mouth. Despite the novelty of the effect, the congruence of audiovisual stimuli result in what O'Callaghan (2017: 162) argues for as perceptual feature binding: a multi-sensory perception of the same event which may have distinct features such red and rough or bright and loud, but are nonetheless a unified percept. In Smalley's terms, the ventriloquist's performance would contain elements of first order gestural surrogacy.

Lower order gestural surrogacy may manifest in visual music through direct parametric mapping between sound and visual elements. For example, the amplitude of a percussive sound being directly linked to the size of a visual element such that repeated patterns of an underlying gesture may result in an experience of auditory and visual pulsing. In this way, the size of the visual object and the amplitude of the sonic object may be perceived to be the result of the same gesture of 'striking', even though in our experience of the material world, while percussive instruments may

in fact make a louder noise the harder we hit them, visual objects do not routinely become bigger when we hit them.

The same approach could be taken to linking sound elements which may have a floating or gliding quality, for example, with visual elements that also have the same quality of movement. Such a relationship may be parametric, as might be observed via visualisation of audio as a waveform, where a gently undulating tone may have a similar quality to its shape. Or the relationship may be formed through synchresis, that is, simply if two elements appear within the relevant perceptual stream at the same time, without having any explicit parametric mapping at a compositional level.

It can be difficult to distinguish between parametric mapping and synchresis, as the mapping is typically hidden and only inferred (we imagine the ventriloquist is controlling the puppet, but we typically don't see it explicitly, we only see the puppet's movements synchronising with audio events). This is the paradoxical challenge of a well-realised mapping process: when the mapping is seamless, the audience assumption can be that events in one sense-modality have just been composed to synchronise with events in the other, rather than having one arise from the other. Live performance can help reduce this effect by demonstrating that multi-sensory events are arising from a common gestural source in the moment, rather than being pre-composed.

In using gestural surrogacy as a tool for analysing visual music, it is important to distinguish between the degree of unification within an audiovisual event (tight versus loose feature-binding) and the degree of gestural surrogacy. If we consider gesture to be a recognisable pattern of experience, in whatever sense-modality, then gestures can be thought of as arising from the features of an event as it unfolds. Tightly bound features, which consistently co-occur or share the same qualities, may be perceived as being the result of first or second order gestures. The more tightly bound a gesture is, the more obvious the relationship between apparent 'cause' and 'effect', and perhaps thereby, the more obvious the intention behind the gesture. Such an inference arises because of embodied cognition: our experience of physical movement informs our experience of surrogate forms of movement in other 'bodies'.

Loosely bound features bring uncertainty into the experience of an event: is there a common gesture, a common cause? Are these phenomena even linked? Within such uncertainty, it is harder to recognise the gesture behind them, however that does not mean it is not there. At higher degrees of gestural surrogacy, we may experience less overt, conscious recognition, receiving only hints or vestiges of an underlying pattern. The original gesture may be disrupted or distorted in some way through interruption, amalgamation or elongation, and yet still evoke a response.

At a performance of Jakob Ullmann's *Munzter's stern* by Dafne Vicente-Sandoval, a sparse work which is performed at extremely low volume and requires intent listening from the audience during extended periods of silence, there was a noticeable stirring among the audience just prior to the end of the work, despite no

apparent indication that the work was ending. In speaking with Vicente-Sandoval after the performance, she commented that this is almost always the case – the audience knows that the piece is ending, even though it is virtually impossible to recognise it consciously. In writing about her experience of performing the piece, she notes that:

> The long duration of the piece, another characteristic of Ullmann's works, contributes to hinder the audibility of the tonal progression which is nonetheless present. The structure, having become unintelligible, can only be absorbed in the listeners' unconscious.
>
> (Vicente-Sandoval 2019)

A similar experience of gestural surrogacy arose during the performance of an audiovisual work by Megan Kenny at one edition of SeenSound, in which audio elements from improvised flute and electronics are paired with an almost static visual projection, displaying only the most subtle shifts in hue and saturation across the whole field. Nonetheless, the viewer's attention is drawn into the visual centre of the work, and being so held, the audio elements exist as figures against a captivating ground. In discussion with Kenny after the performance concluded, it was revealed that there was in fact footage of a face buried behind multiple layers within the visual projection – with only enough of a residual trace remaining to draw the eye as it seeks a feature to latch onto. Thus, the experience of being looked at, even as one looked, became more consciously understood.

To draw together the various threads of this background discussion, we suggest that within visual music, the spectrum of multi-sensory gestural associations arise from, and abstracts our own embodied cognitive processes, and that through examining both the creative intent of the composer/performer and the various gestural traces, however we might obtain them, a deeper understanding emerges. Within this framework of understanding, we present these reflections on three selected performances as an engagement with the intersection of multiple perceptual modes as a space for collaborative art-making beyond the confines of textuality and symbolic representation, with the hope that the reader is inspired to engage more deeply in their own experience of the form.

## Wind Sound Breath

*Wind Sound Breath* is a visual music work by Brigid Burke, performed in this instance by Nunique Quartet (Brigid Burke, Steve Falk, Megan Kenny and Charles MacInnes). This piece utilises densely layered and heavily processed visual material incorporating elements of video footage and graphic elements. In this piece, the

visual material is fixed and performances are largely improvised, with certain recognisable elements used to mark sections of the performance.

The piece incorporates live and pre-recorded interactive audio electronics, live visual footage and synchronised video for live performance. Thematically, the piece draws inspiration from Yarra Bend Park, the natural bush land near Melbourne Polytechnic. *Wind Sound Breath* explores connections with the present histories within the campus, Burke's own musical influences and the importance of the Yarra Bend as an ecological site. In the performance analysed here, live instruments included clarinet, percussion, flute, trombone and live electronics. An overview is given in Figure 7.1.

Figure 7.2 shows detail of an excerpt between 1:46 and 2:17. Sparse clarinet and flute notes enter in the first 10 seconds, distributed against a background of field recordings of ocean waves and a wood fire. Visually, dense root-like patterns fade in and out with slow pulses of colour, modulated by a rippling visual overlay. The motiongram shows the periodic pulsing of this segment and the spectrogram shows a number of loose correlations between the visual pulse and bands of broadband noise. In this instance, listening to the audiovisual recording reveals this pattern

**Figure 7.1** *Wind Sound Breath*: overview.

**Figure 7.2** *Wind Sound Breath* excerpt 1: detail.

arises from modulations of the volume of the ocean and wood fire recordings and the corresponding modulations of visual material.

Figure 7.3 shows detail of an excerpt between 3:50 and 4:10. This much more active section features lively figures of trombone, clarinet and flute over timpani, with elements of reversed tape material. Visually the underlying root-like pattern persists, layered with footage of monochromatic lapping water and highly colourised, horizontally scrolling footage of a cityscape. Approximately halfway through the excerpt, the colourised city footage begins to shrink behind the monochromatic water footage. A corresponding drop in activity in the motiongram can be seen from this point. Likewise, activity in the audio performance drops away, with less volume and density compared to the first half.

From Burke's perspective as the composer, the aesthetic focus of the work is on exploring relationships between composition, improvisation, visual impact and

**Figure 7.3** *Wind Sound Breath* excerpt 2: detail.

listening. While pre-composed visual elements are utilised, these are used in impro-
vised video projection performance alongside the improvised audio performance.
Audio performers are free to interpret the visual score as it unfolds, and the visual
material itself is modified as part of the performance.

In speaking about her process, Brigid Burke explains that concepts for a piece
often start with a visual structure in mind, which then drives her to seek out sounds
which match that internal visualisation. In terms of actual material, sound always
comes first, after which visual elements are created or collected to fit with the audio
material. This kind of round trip between an internally visualised concept, soni-
cally realised and followed by a visual realisation, keeps the various elements tightly
bound. Burke notes that she's found if she starts with creating visual material first,

the piece tends to lack coherence compared to pieces which have audio as the material foundation.

Visual elements are typically built up from a combination of real-world video footage and heavy processing. Frequently Burke creates paintings and sculptures first and films these works as part of the process. Individual elements are combined in layers to create a dense structure. In processing the material, colour and the underlying pulse of change is an essential expressive element.

For live performance, Burke is frequently manipulating one or more elements of either the audio or visual material in addition to live instrumental performance. Live clarinet performance is combined with either live video mixing or live manipulation of synthetic audio elements. In ensemble performances, the visual element acts in terms of setting the dynamics of instrumental improvisation.

This can be seen in the preceding analysis, with various dynamic changes synchronising across both audio and visual elements. However, the relationship is not just one way, from visual score to audio performance. For Burke, the relationship with other players in the ensemble is of equal weight in terms of shaping the dynamics of her playing and manipulation of either video or audio elements. Thus, while not directly parametric, there is a degree of feedback between audio performance and visual performance which binds the work into a multi-sensory whole.

Perhaps more profoundly, in looking at both the minutiae of audiovisual material within the context of Burke's creative process, there is a glimpse of the way in which *Wind Sound Breath* is not representative of any underlying idea, but is thoroughly a manifestation of itself as a complex set of intensities within the material of the visual score, not as an abstract object but as a dynamic field of interpretation, and the players, not as followers of instructions, but as similarly dynamic (i.e. embodied) sites of interpretation of these same intensities.

## Shiver and Spine

Roger Alsop's piece *Shiver and Spine*, for solo guitar and responsive visuals, demonstrates another approach to audiovisual improvisation: one in which visual material arises from the sonic performance, as opposed to improvisations which respond to fixed visual media. A dynamic visual element, depicting the apparent victor of current-to-the-time internal political struggles within the Australian Federal Government, leaps on the screen in response to distorted gestures from an electric guitar. Figure 7.4 shows a still from the performance, while Figure 7.5 provides an analytical overview of the work. This was an overtly political work intended to demonstrate Alsop's position, which is unusual in the SeenSound context.

In the overview, three episodes are marked. Episode A (from 0 to 1:12) introduces the elements of the piece, with video elements distorting in terms of shape,

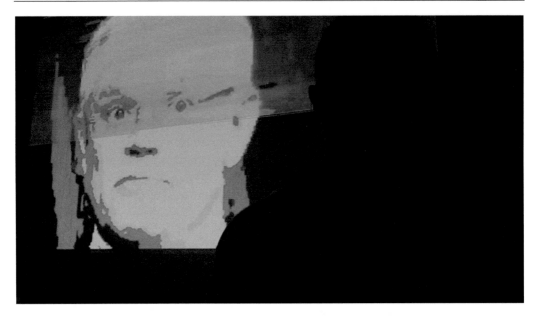

**Figure 7.4**  *Shiver and Spine*: still.

**Figure 7.5**  *Shiver and Spine*: overview.

luminance and colour in response to distorted chords and textural scratching from the guitar. During this section, audio and video appear to be tightly synchronised. Episode B (from 1:12 to 2:25) is comparatively sparse, with occasional struck chords left to decay before more gentle tapping of strings is used to re-introduce movement.

Video elements continue to be active during the decay of each chord, calling into question exactly what drives the motion – is it frequency modulation rather than attack, or is there a less direct relationship than had previously been suggested by the performance during episode A? A short section of stronger struck chords introduces episode C (from 2:35 to 3:05), which shows a distinct drop in visual activity in the motiongram with a corresponding sustained block of broadband audio activity in the spectrogram, generated by fierce strumming by Alsop. The responsive visual material is literally saturated by this block of audio input, filling the screen with a red field of colour – an extreme close-up of the piece's subject.

It is conceivable that without the image of the performer and the guitar in the room, there would be no way to determine if the audio or the visual elements were dominant. In fact, only through a tacit understanding of the technical processes, coupled with the tightly synchronous performance, would the audience determine that the visuals are responding to the audio and not that the performer is responding to the visuals. Like Burke's *Wind Sound Breath*, *Shiver and Spine* does set up a feedback loop between the responsive visuals and the audio performer: at a gestural level, visual response invites audio exploration, and perhaps at the broader discursive level, the sheer repetition of the subject's image, pushes the audio performer into a moment of sonic rage such as we see in episode C.

Alsop frequently creates works which utilise audio-responsive visual elements, and does so in a way which enfolds the performer and the audience within a recursive loop of stimulus and response. He observes that many interactive audiovisual artworks function to augment human performance, and in this way function as an instrument rather than an interlocutor. In many of his works, rather than create work that unifies or coheres disparate elements, Alsop seeks to interpret human gesture as a different artwork, to be viewed without and separate from the human element involved in its creation. In this regard, he considers it important that when interacting with systems for audiovisual improvisation, performers experience their own actions represented in an unfamiliar way, so that they do not revert to familiar styles or clichés similar to those they may use when interacting with another performers (dancers, musicians).

In *Shiver and Spine* we see the way in which initial tight correspondences between audio and visual gesture can, through the presence of this kind of feedback loop, generate occasions of rupture where prior relationships begin to break down under the weight of the feedback loop itself, perhaps not unlike the way in which the (too) tight couplings of politics, media commentary and public perception distort the processes of stable government.

## *Apophenic Transmission (i)*

*Apophenic Transmission (i)* is part of a series of live performance works which interrogate the human tendency toward spontaneous perception of connections and meaning in unrelated phenomena. In part (i), the performer is challenged to seek occasions of apophenia through the use of a somewhat opaque and chaotic control interface, in much the same way as one might attempt to tune a radio or a television set to a dead channel for the purpose of encountering electronic voice phenomena. Both the audio and the visual elements are purely generative, with the audio arising from a software simulation of the Synthi AKS, and the visuals arising from software simulation of analog video synthesiser (Lumen). Part of the purpose of this piece is to call into question the parametric mapping approach to visual music, which Pedersen frequently uses. While the physical performance controls used for both the generative audio and video elements overlap, the performance framework for *Apophenic Transmission (i)* deliberately confuses this control interface, so that both performer and audience have cause to question whether there is any direct relationship between what is heard and what is seen. As Garro (2012: 106) suggests, "visual music is more than a mapping exercise; the absence of a relationship is itself a relationship".

Figure 7.6 gives the spectrogram and motiongram analysis for the whole piece. Compared to the audiovisual analysis of the preceding works, it is no surprise that observable correspondences between sound and vision are hard to extract. Looking more closely at an excerpt from between 1:51 and 2:42, shown in Figure 7.7, we can start to identify features which may trace a common underlying gesture. The

**Figure 7.6** *Apophenic Transmission (i)*: overview.

**Figure 7.7** *Apophenic Transmission (i)* excerpt 1: detail.

motiongram shows several distinct episodes, labelled A–G. In the spectrogram we can see corresponding changes in each of these episodes, although some are more subtle than others. Comparing screenshots from episodes B and D, as shown in Figures 7.8 and 7.9, there is a shift from visual static to a more structured pattern. Dynamically, in episode D the width of the visual bands pulses. There is broadband noise in episode B, which drops away in episode D to reveal beating sine tones, which can be seen as horizontal bands across the spectrogram. These same bands are also faintly apparent in the spectrogram of episode B, but the broadband noise masks them. Episode E exhibits the same qualities as B, and episode F exhibits the same qualities as episode D. Thus the piece starts to establish a gestural link between the presence of audio and visual noise, which masks other underlying patterns.

**Figure 7.8**   *Apophenic Transmission (i)* excerpt 1: screenshot from episode B.

**Figure 7.9**   *Apophenic Transmission (i)* excerpt 1: screenshot from episode D.

Figure 7.10 shows a segment close to the end of piece. There are fewer distinct episodes compared to the earlier excerpt, as the piece moves toward its conclusion. The audio at this stage is dominated by low sine tones, visible in the spectrogram by relatively higher energy horizontal bands at the bottom. Higher frequently noise still sits across this section, but it decreases in energy across the episode, and is weaker in lower frequency bands between X and Y. Visually we can see a distinct oscillating

**Figure 7.10** *Apophenic Transmission (i)* excerpt 2: detail.

pattern across the top of the motiongram between 10–40 secs, which corresponds to a pattern of horizontal bands expanding and contracting in a general downward rolling bounce, typical of the classic bouncing ball motion of a modulated low frequency oscillator. The audio spectrogram shows periodic punctuations in the high frequency noise band, which correspond to the lowest point of the visual oscillation (when the horizontal bands are at their widest). The strength of this pattern gradually declines from 35 seconds onward, with lower contrast visually, and a corresponding reduction in high frequency noise content.

Pedersen notes that for him, performances start "in the body". His internal feeling is the generative core of each performance, and physical expression of that emotion is typically an essential component. His aim is seeking sounds, or rather transformations of sounds, which match the expressive quality of that internal feeling. In this sense, sound becomes the vehicle for expressing the internal (emotional) state. The range of expression could be very dynamic or very subtle, and the interfaces which support the appropriate range of gestures are a key consideration.

In this regard, a performative aspect to each piece is important, and correlates between gesture and sonic effect are highly desirable. For dynamic pieces, interfaces which allow a range of performative gestures, such as Kinect motion sensors are preferred. Subtle performances are more easily accommodated via traditional knob and slider interfaces. Each system may still need to be learned in terms of gesture mapping. Difficulty in performance is welcomed, as the challenge of various gestures can be part of the desired emotional expression. Likewise, it is sometimes important to not know or understand the mapping. In this case the feeling being sought is one of loss of control/confusion.

This is the case for *Apophenic Transmission (i)*, where the control surface used for performance is mapped into both the audio and visual generation systems, which otherwise are independent from each other. The mapping is deliberately unstable and unrehearsed – leading to accidental, or unintentional correspondences as the performer seeks to understand the affordances of the control surface, both visual and auditory, just as the audience is also seeking to make sense of the system as revealed through the briefly emergent occasions of correlation between sound and image.

## Visual music, gesture and affect

To recap on the introduction, in considering visual music, particularly where there is an element of improvisation, the body is a natural starting point for sense making, since as embodied beings, sound cognition is intimately linked with the way our brains also process movement. Yet as habitual meaning makers, bare experience is not sufficient: there is a human tendency to ascribe intent to what we perceive as gestures, however abstract, and connect those gestures with our own personal history and framework for understanding the world. When visual music, as a genre, actively resists narrative, which may be considered the realm of cinema, then what remains is affect – the mood or the feeling, that which is present before narrative emerges, or perhaps that which remains after narrative has been taken away. Furthermore, we are specifically interested in the nexus of audiovisual as a field of affect, as distinct from that which may arise from just a single channel auditory or visual experience.

Let us consider that affect is autonomous of subjective experience, allowing for individual, subjective experience while not denying the existence of a non-subjective reality. Starting with sonic experience, we can consider that sound is likewise autonomous of audition, as a generalisation of the concept of noise being the generative virtual beyond/below perceptual thresholds.

There are several arguments from within sound studies which equate sound and affect. Henriques's concept of a sonic logos builds upon Lefebvre's (2004) *rhythmanalysis*, embracing a broader framework of vibration as not just the means of propagating knowledge and affect, but taking the position that affect is vibration.

Affect is carried across varying media, be they electromagnetic, corporeal or socio-cultural, and each of these layers of media manifests the rhythms, amplitudes and timbres of vibrational affect in different ways, be that certain patterns of audible frequencies, pulse rates, muscle contractions, patterns of movement, emotional responses, or cycles of social events, styles or fashions (Henriques 2010). The same vibrational analysis is also found in Alfred North Whitehead's process philosophy, which underpins much recent significant theorising of sonic experience, from the work of Steve Goodman (Goodman 2009) to the work of Susanne Langer, as discussed by Priest (2013).

In particular, Scrimshaw (2013) takes up the concept of equating sound, or vibration more generally, and affect, suggesting that sound, like affect, is independent of the subjective experience of audition: just as affection is the subjective experience of affect, and that affect in-itself is that which remains in excess of subjective experience, so too sound in-itself is that which remains in excess of audition. Sound-in-itself in this sense is virtual: real, but not actualised in terms of audition.

This equating of sound and affect generalises Cox's analysis of noise as the generative field for signal (Cox 2009). The vibrational-materialist approach restores the transcendent to the immanent field of sound by placing the locus of meaning within the relational web of vibrating and listening bodies. Affect finds its meaning in the relational, multi-sensory matrix of repeated patterns, arising from the repetition of a musical phrase, the enactment of ritual, the cycle of seasonal events. This repetition is not the mechanical reproduction that Benjamin (1969) speaks of, let alone the digital replication inherent in current modes of information distribution. Rather it is the repetition of the dawn, which is always new. Henriques quotes Lefebvre:

> No rhythm without repetition in time and space, without reprises, without returns . . . but there is no identical absolute repetition, indefinitely. Whence the relation between repetition and difference. . . . Not only does repetition not exclude differences, it also gives birth to them; it produces them.
>
> (Lefebvre 2004: 6)

Turning to the aesthetics of visual experience and affect, the same approach to embodied cognition has been applied to cinema; Rutherford (2003) gives a concise summary, suggesting that "shape, colour, texture, protrusions and flourishes all reach out and draw us to them in an affective resonance", particularly highlighting the work of Michael Taussig on mimesis, quoting:

> It is not the mind's eye that reaches out to grasp or grope the image or space before me, it is my embodied self locating, placing myself in the world which I am viewing.
>
> (Taussig 2018)

With this in mind, and drawing upon O'Callaghan's argument that perception is truly multi-sensory, it is perhaps useful to consider visual music as being an integrated space of "affective resonance". Within this mimetic space, it is the quality of the gestures embodied within audiovisual artworks, however abstracted they may be, which evoke engagement with the audience.

Considering the examples analysed here, what affective resonances arise? In *Wind Sound Breath* there is perhaps a sense of playfulness in the performance as a whole as it shifts between delicate, interlocking filigrees and occasions of robust wrestling. *Shiver and Spine* is comparatively much more raw, possibly evoking anger or at least frustration in the urgent, distorted guitar, as both performer and audience alike are taunted by a kind of jack-in-the-box visual element. In contrast, *Apophenic Transmission (i)* evokes a degree of confusion, a tentative, exploratory questioning or doubt about what is being seen and heard. With little that is overt in terms of gesture, the experience is more akin to a half-remembered dream, for both performer and audience.

In reflecting on our experience with hosting SeenSound over more than six years, the experience of liveness that arises from the sharing of gestures in the moment is the compelling reason to continue participating, for creators, performers and audience members alike. If, as Taussig suggests, the act of perception is itself also a gesture, then we are all seeking those moments of contact that arise beyond (or beneath) narrative, in the space between gesture, sound and image.

## References

Benjamin, W. (1969 [1936]) The Work of Art in the Age of Mechanical Reproduction. In: H. Arendt (ed.) *Illuminations*. New York: Schocken. pp. 217–251.

Borgo, D. (2005) *Sync Or Swarm: Improvising Music in a Complex Age*. Bloomsbury Academic.

Chion, M. (1994) *Audi-Vision*. New York: Columbia University Press.

Cox, C. (2009) Sound Art and the Sonic Unconscious. *Organised Sound*. 14(1). pp. 19–26.

Cox, C. (2011) Beyond Representation and Signification: Toward a Sonic Materialism. *Journal of Visual Culture*. 10(2). pp. 145–161.

Dannenberg, R. (2005) Interactive Visual Music: A Personal Perspective. *Computer Music Journal*. 29(4). The MIT Press. pp. 25–35.

Decibel Score Player. (2019) Available online: www.decibelnewmusic.com/decibel-scoreplayer.html. [Last Accessed 11/11/19].

Francoise, J.; Caramiaux, B.; Bevilacqua, F. (2012) A Hierarchical Approach for the Design of Gesture-to-Sound Mappings. *9th Sound and Music Computing Conference*, Copenhagen, Denmark. pp. 233–240. Available online: https://hal.archives-ouvertes.fr/hal-00847203 [Last Accessed 11/11/19].

Garro, D. (2012) From Sonic Art to Visual Music: Divergences, Convergences, Intersections. *Organised Sound*. 17(2). pp. 103–113.

Goodman, S. (2009) *Sonic Warfare*. Cambridge, MA: The MIT Press.

Henriques, J. (2010) The Vibrations of Affect and Their Propagation on a Night Out on Kingston's Dancehall Scene. *Body and Society*. 16(1). pp. 57–89.

Jensenius, A.R.; Wanderley, M.; Godøy, R.; Leman, M. (2010) Musical Gestures: Concepts and Methods in Research. In: R. Godøy; M. Leman (eds.) *Musical Gestures: Sound, Movement, and Meaning*. New York: Routledge.

Lefebvre, H. (2004) *Rhythmanalysis: Space, Time and Everyday Life*. Continuum.

Leman, M. (2008) *Embodied Music Cognition and Mediation Technology*. Cambridge, MA: The MIT Press.

Lund, C.; Lund, H. (2017 [2009]) Audio: Visual: On Visual Music and Related Media: Editorial. In: C. Lund; H. Lund (eds.) *Lund Audiovisual Writings*. Available online: www.lundaudiovisualwritings.org/audio-visual-editorial [Last Accessed 11/11/19].

Magnusson, T. (2019) *Sonic Writing: Technologies of Material, Symbolic, and Signal Inscriptions*. New York: Bloomsbury.

Nattiez, J. (1990) *Music and Discourse: Towards a Semiology of Music* (trans. C. Abbate). Princeton, NJ: Princeton University Press.

O'Callaghan, C. (2017) *Beyond Vision: Philosophical Essays*. Oxford: Oxford University Press.

Priest, E. (2013) Felt as thought (or Musical Abstraction and the Semblance of Affect). In: M. Thompson; I. Biddle (eds.) *Sound, Music, Affect: Theorizing Sonic Experience*. Bloomsbury Academic.

Rutherford, A. (2003) *Cinema and Embodied Affect*. Available online: http://sensesofcinema.com/2003/feature-articles/embodied affect/ [Last Accessed 06/07/19].

Scrimshaw, W. (2013) Non-Cochlear Sound: On Affect and Exteriority. In: M. Thompson; I. Biddle (eds.) *Sound, Music, Affect: Theorizing Sonic Experience*. Bloomsbury Academic.

Smalley, D. (1986) Spectro-Morphology and Structuring Processes. In: S. Emmerson (ed.) *The Language of Electroacoustic Music*. pp. 61–93. Basingstoke: Macmillan Press Ltd.

Smalley, D. (1997) Spectro-Morphology: Explaining Sound-Shapes. *Organised Sound*. 2(2). pp. 107–126.

Taussig, M. (2018) *Mimesis and Alterity*. Abingdon, UK: Routledge.

Vicente-Sandoval, D. (2019) *On Performing Jakob Ullman*. Available online: https://blankforms.org/dafne-vicente-sandoval-on-performing-jakob-ullmann [Last Accessed 06/07/19].

Voegelin, S. (2010) *Listening to Noise and Silence: Towards a Philosophy of Sound Art*. Bloomsbury Publishing.

Watkins, J. (2018) Composing Visual Music: Visual Music Practice at the Intersection of Technology, Audio-Visual Rhythms and Human Traces. In: *Body, Space & Technology*. School of Arts, Brunel University. pp. 51–75.

# The gift of sound and vision
## Visual music as a form of glossolalic speech

Philip Sanderson

## Introduction

Glossolalic speech (also known as speaking in tongues) uses intonation, accent and rhythm to generate something that approximates recognisable language and yet isn't (Samarin 1972). Similarly many visual music practitioners have sought to develop a vocabulary that in part echoes the language of music, but again isn't. This chapter argues that the history of visual music across its various trajectories can be viewed as a quest for a singular audiovisual language. This quest ranging from early experiments in the form of colour organs, up through abstract film and video to contemporary computer-generated work has been doomed to failure owing to the search for absolutes in the audiovisual itself.

Rather than a singular vocabulary based on the inherent properties of sound and image, visual music can be better understood as being created in the mind(s) of the audience at the moment of reception. A glossolalic discourse between practitioner, the work and the audience is generated. This discourse suggests the coherence of a language but is to a degree always indecipherable. It is this locus beyond comprehension that creates the oft-attributed synaesthetic dimension, the potential for visual music to be experienced as immersive or even induce hypnogogic trance. The extent to which this occurs depends on the agency granted the audience as a glossolalic discourse might encourage active participation and reflexive self-awareness, or immersive surrender.

To understand the glossolalic it is useful to first undertake an examination of the various quests to define a singular language, as these reveal not the absolutes, certainties and correlations that creators often seek, but rather a far more arbitrary dynamic between sound and image. This may include counterpointing, synthesis and dissonance made sense of by an audience through a process of audiovisual adhesion. Whilst technological developments have historically facilitated new modes of expression in visual music, it isn't until the underlying paradigm shifts from a focus

on the audiovisual itself to a model that embodies and foregrounds the role of the audience that the quest for a single language is replaced by a fluid and glossolalic syntax.

## Which colour is middle C?

When defining visual music a two-way translation or equation between the senses is commonly offered as in 'seeing with sound' or 'hearing in colour'. This model can be traced back to Aristotle, but it was Newton in the 17th century who drew up a diagram equating the colour spectrum to the musical tones in an octave (van Campen 2008: 46). These ideas found physical expression in Castel's 1761 prototype for an ocular 'harpsichord for the eyes', and the subsequent variations on the colour organ developed in the 19th and 20th centuries by Rimington, Scriabin, and Wilfred (Rogers 2013: 64).

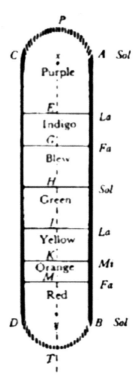

**Figure 8.1** Newton's colour scale (1675).

Source: Newton Isaac (1675), Hypothesis explaining the properties of light. In: Thomas Birch, *The History of the Royal Society, vol. 3* (London: 1757), pp. 247–305, 263.

Colour organs are predicated on a defined relationship between specific colours and particular notes. However, the various practitioners and inventors were unable to agree on which pitch equals which colour. For Castel middle C was blue as to him "it sounded blue", whilst Scriabin believed C to be red and Rimsky-Korsakov argued it should be white, though both Scriabin and Rimsky-Korsakov did agree that D major was yellow (Wilfred 1947: 248; Cook 1998: 35).

Malcolm Le Grice (2001: 270) observed that if examined from a simple physics perspective colour and musical harmony clearly do not operate on the same principles. Le Grice (2001: 271) does argue that "colour and music are able to transform existing meanings and create new ones", especially when the visual element is removed from representation to abstraction, and these new meanings "*belong* to the viewer" becoming part of "a dynamic process". Le Grice shifts the debate from a search for colour notational equivalence to the individual's interaction with the work. By doing so this grants a degree of agency albeit in a context that is socially and culturally defined.

## Sound and the moving image

The practical development of Castel's colour organ was hampered by the technological limitations of the day. The invention of film at the end of the 19th century, and then in the 1920s of a reliable method for synchronising moving images with sound brought new temporal dimensions and possibilities to the audiovisual.

Sergei Eisenstein, Vsevolod Pudovkin and Grigori Alexandrov's 'Statement on Sound' (1928/1985: 83) see synchronised sound as a double-edged sword. Synchronised sound has the potential to expand the language of cinema, but could also detract from it if filmmakers adopt the "path of least resistance" – that is using sound to create the "illusion" of "talking people" or "of audible objects". The 'Statement' identifies a fundamental characteristic of the audiovisual – that sound and moving image are inherently adhesive. Given any hint of simultaneity sound and image will appear in the mind of the viewer to adhere, creating a causal link between the seen and heard. To counter this tendency towards adhesion and illusion the Russian filmmakers argue for an act of resistance on the part of filmmakers through the use of non-synchronsiation, to be followed by a more sophisticated counterpointing of audiovisual elements.

Michel Chion's (1994) concepts of 'synchresis' and 'added value' could be viewed as logical developments of the principles laid out in the 'Statement'. Despite Chion's background as assistant to Pierre Schaeffer, and as noted composer of musique concrete the examples used in *Audio-Vision: Sound on Screen* (1994) are largely drawn from narrative films, films that suffer from the problem predicted in the 'Statement' of using sound and synchronised dialogue as part of a broadly illusory strategy.

Chion's analysis reveals how sound works within the sealed environment of mainstream cinema, but the applicability of his theories to visual music is limited by the constraints of narrative, presuming illusory cinema as given. In contrast, having identified adhesion as the key audiovisual mechanism the 'Statement' seeks to argue for ways to problematise its use so as to engage the audience in an active process of generating meaning.

For visual music adhesion offers opportunities and dangers. That sound/music and image should combine so easily is a compositional asset. Almost any moving image sequence if married with a soundtrack will produce some form of adhesion, the visual music equivalent of the "path of least resistance". The examples given in the 'Statement' of "talking people" or "of audible objects" relate to representational imagery, and in this context adhesion will create a causal link between the on-screen action and the sound heard. For example, an image of a glass hitting the ground is perceived as being the source of the smashing sound heard from the speaker.

Within visual music, adhesion and causality take place in a more complex and conflicted fashion, particularly if the imagery is animated or abstract. Moving and plastic shapes will tend to adhere to changes in tempo, pitch and velocity. This may be read causally as either the imagery being choreographed by the music, or as the sound responding to the dynamics of the form. From this flows many of the quests at establishing universal principles. 'Seeing with sound', or 'hearing in colour' spring not from the inherent qualities of the material, but from attempts made by the viewer and composer at adhesion.

If non-synchronisation was an initial blunt response to the dangers of adhesion both Pudovkin (1929) and Eisenstein (1949) were each to develop the concepts outlined in the 'Statement' advocating forms of asynchronism and counterpointing. This located sound and vision as juxtaposed on parallel tracks with punctuated rather than continuous adhesion.

Two examples of the asynchronous approach in visual music are Len Lye's *A Colour Box* (1935), and Le Grice's *Berlin Horse* (1970). In both works the music (Cuban jazz in the case of Lye, and piano loops by Brian Eno for Le Grice) provides a sense of propulsive syncopated rhythm. The audiovisual elements are not synchronised to any specific sound, beat or on-screen action. Rather, fleeting moments of adhesion occur between the treated footage of horses and Eno's piano loops (Le Grice), and the dance rhythms and abstract colour shapes (Lye). Asynchronism is not reliant on any particular technology, its inherently glossolalic aspect lies in individual audience members perceiving different moments of adhesion, each generating their own readings. Such confluences are to an extent arbitrary but distinguished from the random for if asynchronism is to 'work' an appeal to shared tempos, rhythm, and what might be described as sympathetic visual and musical gestures is required.

The development of sound film created the potential for a direct physical relationship between the audio and the visual in the form of the optical track. Though designed to reproduce spoken dialogue and music Arseny Avraamov in Russia, and Oskar Fischinger in Germany (amongst others) discovered that by drawing or photographing lines and shapes directly onto the optical track one could synthetically create sound (James 1986: 81). What Guy Sherwin (Sherwin and Hegarty 2007: 5) describes as "an accident of technological synaesthesia" is produced when the image on the optical track coincides with the projected frame.

One devotee of optical sound was Norman McLaren who in *Pen Point Percussion* (1951) outlines the process of making a work, but does not (nor seemingly ever did) address the aesthetic ramifications of the simultaneous projection of optical sound and the source image. Lis Rhodes, working at the London Filmmakers Co-operative in London in the 1970s was more forthright. In an interview at the time of the installation of her piece *Light Music* (1975–77) in Tate Modern's Tanks, Rhodes (2012) commented that in *Light Music* "what you see is what you hear". This moves beyond causality to the suggestion of a strict equivalence.

Just as with the arguments over which colour middle C might be, unequivocal equation is called into question by the existence of multiple optical sound mechanisms (see Figure 8.2). That the unilateral, bilateral and variable density methods

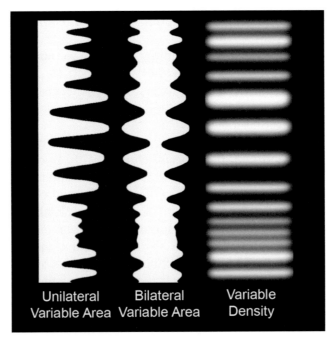

Figure 8.2  Optical sound formats (2019) by Philip Sanderson.

each reproduce the same sound, but with three different shapes denies an absolute correlation between optical sound and image.

Commenting on the version of *Light Music* shown in the Tate's Tanks, Hamlyn (2011: 168) describes "a cacophonous interplay of direct and reflected sound", with the hard concrete walls of the tanks creating a "partial de-synchronisation of sound and image" experienced dynamically by the audience as they move in and around the two projectors. It is this asynchronous element that when combined with the element of performativity makes the work come to life. The material of *Light Music* might suggest equivalence but the experience of it is all about audience participation and individual interpretation.

## Arbitrary logic – from analogue to digital

Rather than attempting to correlate pitch with colour a broader musically analogous approach was adopted in the 1920s by a milieu of European artists and filmmakers including Hans Richter and Viking Eggeling, Paul Klee and Eisenstein. The musical form that found favour was the Bach fugue whose polyphonically recurring motifs acted as a model for the spatial location of abstract visual elements in Richter's *Rhythmus '21* (1921–1924), and Eggeling's *Diagonal-Symphonie* (1924) (Robertson 2009: 16–22). It was an idealised model as the analogy sought was not with any specific Bach fugue. For though seeking a structure through music, the music then becomes to a degree redundant. Rees (1999: 37) comments "The (musical) metaphor, or analogy, is made the stronger by Eggeling's insistence that his film *(Diagonal-Symphonie)* be shown silent".

By incorporating temporal and multi-dimensional aspects the model was a development from the colour organ, however once again the project was bedevilled by the 'quest' for absolutes with Richter and Eggeling believing that they were engaging in the discovery of a universal language of artistic production (Cook 2011).

The desire for an overarching paradigm governing audiovisual correlations continued throughout the 20th century, and if anything the development of new technologies led various practitioners to renew the quest with more vigour. Significant in this were the brothers James and John Whitney who built a range of bespoke analogue equipment that enabled them to create visual music pieces such as *Five Film Exercises* (1941–1944). It was natural that once digital computers became available John Whitney would use them, and *Arabesque* (1975) is an early example of the combination of digital computer-generated graphics with instrumental music. Whitney's work was underpinned by a return to musica universalis, "I tried to define and manipulate arrays of graphic elements, intending to discover their laws of harmonic relationships" (Whitney 1980: 40–44). Like Richter and Eggeling who sought a universal language of the arts, Whitney (1980) believed that there was a set of unifying

principles based upon complimentary ratios that governed both music and graphic form. Whitney saw the computer as a means of actualising these mathematical relationships as it could "manipulate visual patterns in a way that closely corresponds in a manner in which musical instrumentation has dealt with the audio spectrum" (Whitney 1971: 1382–1386).

Whitney's insights prefigure observations by Le Grice (2001: 268), and Lev Manovich (2001: 52) about digital sound and image. Once transformed into digital data, Le Grice notes that all media "whether visual, auditory or textual" is represented numerically and thus becomes interchangeable, and Manovich observes that as data it also becomes programmable.

One must be wary of technological determinism, but whilst Diego Garro (2005: 4) argues the increasing sophistication of software and the power of computers does not in and of itself "provide any significant aesthetic breakthrough", treating sound and images as data sets to be manipulated has opened up innumerable possibilities. Crucially, the arbitrary and glossolalic tendencies of visual music are revealed and enhanced by the plurality of syntax facilitated by the many opportunities for digital audiovisual correlations, combinations and permutations.

In my own practice in the early 2000s I investigated the possibilities offered by digital mapping to test the visual music tropes of 'seeing what you hear' (or vice versa), and seeing how far one might 'play' with adhesion and causality. *Quadrangle* (2005) takes as its starting point Richter's *Rhythmus '21* (1921–1924), and similarly uses a white square whose spatial movements are mapped to a numerical sequence produced by a Max 5 (Cycling 74) patch. This digital information is also mapped via MIDI, to a synthesiser. The patch is designed to create random staccato bursts of data, and as the electronic music starts and stops, so simultaneously the square performs a synchronised spatial choreography.

Over the course of the piece the musical mapping remains constant whilst the visual mapping changes. So an increase in value of say 120 always produces a rise in frequency of an octave, but in one section this will correspond with the white square's movement across the screen from left to right, whilst in another it causes the rotation of the square by 360 degrees. The intention is that just as the audience begins to adhere one set of sound and image correlations the parameters switch, thereby necessitating a recalibration to a new syntax.

In *A Rocco Din* (2004) (see Figure 8.3) an image of an accordion is dissected and re-arranged using the digital data derived from a piece of accordion music. The bass and treble parts are mapped to different visual parameters creating synchronised but contrary visual motion. Causality is questioned as the viewer is invited to ask – is the accordion playing the music, or the music playing (the image of) the accordion?

By using the simple tool of digital mapping to question the oft-cited visual music principles of equation, the role of the audience is foregrounded. I explored different variations on switching mapping parameters across a number of short

**Figure 8.3**   *A Rocco Din* (2004) by Philip Sanderson.

pieces, employing both abstract and representational imagery. This was followed by works such as *Kisser* (2007), and *Tracking* (2017) which combine reciprocally evolving granular synthesis audio and atomised imagery creating a wider glossolalic framework.

## Sonic sensibilities – electroacoustic visual music

One consequence of the technological convergence of sound and image has been the number of electroacoustic composers seeking to apply the techniques and aesthetics of electroacoustic music to visual music. Like 'visual music' the term 'electroacoustic music' covers a range of practices, but two elements are key to a definition, the first regards process. Andrew Knight-Hill (2019: 303) argues that the electroacoustic is defined less by a specific aesthetic style and more by "the methods and practices, which make it possible".

Complimenting process is an equal focus on reception, for at some level all electroacoustic music is underpinned by Schaeffer's (1966) concept of the 'acousmatic', a form of 'reduced listening'. These two complimentary elements in part explain why the involvement of electroacoustic music composers in visual music has increased awareness and interest in the role of the audience and their perception in the 'making' of visual music. A further factor may be that electroacoustic visual music contains an inherent contradiction for 'reduced listening' suggests an absence of the visual rather than its addition. One way to avoid accusations of redundancy is by incorporating the audience experience as central to the project. To understand how this works in practice it is worth examining a series of visual music pieces entitled *Estuaries 1-3* (2016-2018) by the electroacoustic visual music composer Bret Battey.

In *Estuaries* Battey employs two twin processes with the imagery produced from a visualisation of the Nelder-Mead method, and the audio created by the generative Nodewebba software. The Nelder-Mead method is a simplex search algorithm that can be employed to find an optimal value be it a minimum or maximum (Singer and Nelder 2009). In *Estuaries* the Nelder-Mead method is used to locate the brightest points in a source image. In so doing this creates an evolving sequences of fluttering

light patterns that dance across the screen. The unpredictability and self-determina-tion makes the patterns akin to some natural phenomena. The Nodewebba software designed by Battey in Max 8 echoes the Nelder-Mead method. This mathematically based generative music tool uses a number of mutually influencing and interlocking patterns to create self-improvisatory musical sequences (see Chapter 18 for a full exposition).

There appears to be no direct parametric mapping of data in *Estuaries*, instead loosely reciprocal processes determine both parts of the audiovisual. The slowly evolv-ing sound and image movements mirror each other, shifting in and out with fleeting moments of adhesion. In certain sections imagery and music are brought into tighter synchronisation with adhesion heightened by specific moments of punctuation. For example towards the end of *Estuaries* 3 a series of piano-like tones find an echo on the screen in the form of green bars that move in time with the notation from left to right.

Interestingly whilst Battey is approaching visual music using a methodology derived from the electroacoustic there are many echoes of the asynchronous model employed by Lye in *Colour Box*, and Le Grice in *Berlin Horse*. Whitney is also a reference point in terms of a shared interest in mathematical principles. The key dif-ference is whereas Whitney believed there to be universal harmonic ratios between sound and image Battey (writing in a paper with Fisschman) (2016: 73) draws on the paradigm of Rudolf Arnheim's isomorphism in articulating "a mix of clear cor-respondences of localized phenomena and higher order intuitive alignment". Battey is not alone in adopting elements of a Gestalt approach as Knight-Hill (2013) has studied in some detail the factors affecting audience interpretations and responses to electroacoustic visual music in a range of different contexts. In this way electro-acoustic visual music composers have shifted the paradigm away from the quest for an absolute language to a model in which the reception by each member of the audience is central.

## Conclusion – the entrancement of the audience

Marcel Duchamp's (1957: 140) view of the importance of the audience's role in making an artwork was that "All in all, the creative act is not performed by the artist alone; the spectator brings the work in contact with the external world by deciphering and interpreting its inner qualification and thus adds his contribution to the creative act". Incorporating the viewer as an integral part of the realisation of a work is key to understanding glossolalic communication in visual music.

If the relationship between audiovisual data is not fixed by universals the only laws governing such relationships are those "determined by the composer" (Garro 2005: 4). Thus of all the artforms, visual music arguably makes the audience work the hardest in the collaborative process.

Samarin's (1972: 120) analysis of the structure of glossolalia identifies the use of elements of language such as vowels, consonants and syllables. "Variations in pitch, volume, speed and intensity" create realistic word and sentence-like structures with a "language-like rhythm and melody" (Samarin 1972: 239). This internal flexible structure elevates glossolalia from being just nonsense, providing a conduit for language-like communication. In response to the failed project of establishing a universal absolute language for visual music glossolalia offers a model for understanding the multi-layered pluralities of visual music and its reception.

Foregrounding the role of the audience does not necessarily grant agency and the glossolalic discourse generated around a work may seek to immerse in much the same way that 'speaking in tongues' is used in a religious setting. The total effect of the complex syntax used by visual music composers can be disorientating. In such circumstance audiences may choose to simply 'surrender' rather than engage reflexively. This can lead to the oft-attributed synaesthetic dimension in which the illusion of sensory fusion takes place. It is not surprising that terms such as 'trippy' or 'dreamlike' are often found in the comments section of online postings of visual music videos.

Whilst the condition of visual music is inherently glossolalic, immersive synaesthesia is not a given. The artist can use a number of strategies to encourage self-reflexive participation, for example disrupting adhesion. This was seen in the analysis of Rhodes's *Light Music* where despite the tight audiovisual adhesion of the material the performativity of the installation allows a reflexive role for the audience. Battey's *Estuaries* series is immersive, but the range of visual music syntax employed encourages the viewer into an awareness of their perceptual processes. Within my own practice a space for active engagement has been sought by deploying an anti-illusionist methodology in the digital domain.

Nonetheless even when an artist seeks to encourage agency this can pose challenges as one is not always in control of the dynamics of reception. The commentary on the works discussed was made after several viewings, and it is only then one begins to unpick the structures and dynamics. It is an anomaly that unlike recorded music where repeated plays are the norm one may see a visual music piece only once or twice at a festival or conference. Works are screened in these contexts as part of longer programmes leading to a cumulative sensory effect. Online and DVD copies of works are increasingly available. Though these rarely offer the same experience in terms of scale and resolution, this can be an advantage allowing one to comprehend the compositional dynamics. Having seen many 'classics' of visual music firstly in a cinema and then online, one's appreciation of them when seen again in an auditorium is all the greater.

One can perhaps talk of three viewing experiences. Firstly, an initial glossolalic viewing in an auditorium when a work communicates, but in a way that may overwhelm the senses. Secondly an online screening less satisfying aesthetically,

but informative in terms of decoding the mechanisms of a piece. Then thirdly, an informed viewing in an auditorium, which is still glossolalic but reflexive rather than involuntary.

Glossolalic discourse is a complex process in which numerous factors come into play. This includes aspects of audiovisual adhesion, asynchronism, counterpointing, synthesis and dissonance. Rather than a surrender to subjectivity the glossolalic articulates a unique combination, the gift of sound and vision. The artist's role is pivotal not only in terms of composition, but also in determining the degree to which a work either confounds the audience, or reflexively engages its participation.

## Bibliography

Andean, J. (2014) Sound and Narrative: Acousmatic Composition as Artistic Research. *Journal of Sonic Studies*. 7. Available online: www.researchcatalogue.net/view/558896/558922 [Last Accessed 20/04/19].

Battey, B.; Fischman, R. (2016) Convergence of Time and Space. In: Y. Kaduri (ed.) *The Oxford Handbook of Sound and Image in Western Art*. Oxford: Oxford University Press.

Campen, C. van. (2008) *The Hidden Sense: Synesthesia in Art and Science*. Cambridge, MA: The MIT Press.

Chion, M. (1994) *Audio-Vision*. New York: Columbia University Press.

Cook, M. (2011) Visual Music in Film, 1921–1924: Richter, Eggeling, Ruttman. In: C. de Mille (ed.) *Music and Modernism*. Cambridge: Cambridge Scholars Publishing.

Cook, N. (1998) *Analysing Musical Multimedia*. New York: Oxford University Press.

Cycling 74 (2019) *Max/MSP/Jitter*. Available online: https://cycling74.com. [Last Accessed 18/04/19].

Duchamp, M. (1989 [1957]) The Creative Act. In: M. Sanouillet; E. Peterson (eds.) *The Writings of Marcel Duchamp*. Boston, MA: Da Capo Press.

Eisenstein, S.M. (1949) *Film Form: Essays in Film Theory*. New York: Harcourt, Brace & World.

Eisenstein, S.M.; Pudovkin, V.I.; Aleksandrov, G.V. (1985 [1928]) A Statement on Sound. In: E. Weis; J. Belton (eds.) *Film Sound: Theory and Practice*. New York: Columbia University Press.

Elder, R.B. (2007) Hans Richter and Viking Eggeling: The Dream of Universal Language and the Birth of the Absolute Film. In: A. Graf and D. Scheunemann (eds.) *Avant-Garde Film*. Amsterdam: Rodopi.

Garro, D. (2005) *A Glow on Pythagoras' Curtain: A Composer's Perspective on Electroacoustic Music with Video*. Available online: www.ems-network.org/spip.php?rubrique34.

Goodman, F.D. (1972) *Speaking in Tongues: A Cross-Cultural Study of Glossolalia*. Chicago: University of Chicago Press.

Hamlyn, N. (2003) *Film Art Phenomena*. London: British Film Institute.

Hamlyn, N. (2011) Mutable Screens: The Expanded Films of Guy Sherwin, Lis Rhodes, Steve Farrer and Nicky Hamlyn. In: A.L. Rees; D. White; S. Ball; D. Curtis (eds.) *Expanded Cinema: Art, Performance, Film*. London: Tate Publishing.

James, R.S. (1986) Avant-Garde Sound-on-Film Techniques and Their Relationship to Electro-Acoustic Music. *The Musical Quarterly*. 72(1). Oxford Academic. pp. 74–89.

Knight-Hill, A. (2013) *Interpreting Electroacoustic Audio-Visual Music*. PhD Thesis. Leicester: De Montfort University.

Knight-Hill, A. (2019) Electroacoustic Music: An Art of Sound. In: M. Filimowicz (ed.) *Foundations of Sound Design for Linear Media*. New York: Routledge.

Le Grice, M. (2001) *Experimental Cinema in the Digital Age*. London: British Film Institute.

Manovich, L. (2001) *The Language of New Media*. Cambridge, MA: The MIT Press.

Pudovkin, V.I. (1985 [1929]) Asynchronism as a Principle of Sound Film. In: E. Weis; J. Belton (eds.) *Film Sound: Theory and Practice*. New York: Columbia University Press.

Rees, A.L. (1999) *A History of Experimental Film and Video: From the Canonical Avant-Garde to Contemporary British Practice*. London: British Film Institute.

Rhodes, L. (2012) *Lis Rhodes: Light Music (Page Contains Video of Interview with Rhodes)*. Available online: www.tate.org.uk/whats-on/tate-modern-tanks/display/lis-rhodes-light-music [Last Accessed 20/04/19].

Robertson, R. (2009) *Eisenstein on the Audiovisual: The Montage of Music: Image and Sound in Cinema*. London: I.B. Tauris.

Rogers, H. (2010) *Visualising Music: Audio-Visual Relationships in Avant-Garde Film and Video Art*. Saabrucken: Lambert Academic Publishing.

Rogers, H. (2013) *Sounding the Gallery: Video and the Rise of Art-Music*. Oxford: Oxford University Press.

Samarin, W.J. (1972) *Tongues of Men and Angels: The Religious Language of Pentecostalism*. New York: Macmillan.

Schaeffer, P. (1966) *Solfège de l'objet Sonore*. Paris: Institut National de l'Audiovisuel and Groupe de Recherches Musicales.

Sherwin, G.K.; Hegarty, S. (2007) *Optical Sound Films 1971–2007*. London: Lux.

Singer, S.; Nelder, J. (2009) Nelder-Mead Algorithm. *Scholarpedia*. 4(7). p. 2928.

Whitney, J.H. (1971) A Computer Art for the Video Picture Wall. In: *IFIP Congress (2)*. Ljubljana IFIP. pp. 1382–1386.

Whitney, J.H. (1980) *Digital Harmony: On the Complementarity of Music and Visual Art*. Peterborough, NH: Byte Books and McGraw-Hill.

Wilfred, T. (1947) Light and the Artist. *Journal of Aesthetics and Art Criticism*. 5(4). Hoboken: Wiley-Blackwell. pp. 247–255.

## Filmography

Arabesque (1975) [FILM] dir. John Whitney Sr. USA: John Whitney Sr.

Batchelor, Norman McLaren. Canada: National Film Board of Canada.

Berlin Horse (1970) [FILM] dir. Malcolm Le Grice. UK: Malcolm Le Grice.

A Colour Box (1935) [FILM] dir. Len Lye. UK: GPO Film Unit.

Estuaries 1–3 (2016–2018) [VIDEO] dir. Bret Battey. UK: Bret Battey.

Five Film Exercises (1941–1944) [FILM] dir. John & James Whitney. USA: John & James Whitney.

Kisser (2007) [VIDEO] Philip Sanderson. UK: Philip Sanderson.

Light Music (1975–1977) [FILM] dir. Lis Rhodes. UK: Lis Rhodes.

Pen Point Percussion (1950) [FILM] dir. Don Peters, Lorne.

Quadrangle (2005) [VIDEO] dir. Philip Sanderson. UK: Philip Sanderson.

Rhythmus 21 (1921–1924) [FILM] dir. Hans Richter. Germany: Hans Richter.

A Rocco Din (2004) [VIDEO] dir. Philip Sanderson. UK: Philip Sanderson.

Symphonie Diagonale (1921–1924) [FILM] dir. Viking Eggeling. Germany: Viking Eggeling.

Tracking (2017) [VIDEO] dir. Philip Sanderson. UK: Philip Sanderson.

# 9

# Visual music and embodied visceral affect

Julie Watkins

## Foundations of a visual music

This chapter seeks to reflect an expanded concept of visual music which includes embodied visceral affect as a key principle.[1] It rejects traditional narratives around the birth of visual music, engaging wider artistic practices and forms of expression, with particular emphasis on the painterly works of J.M.W. Turner. This chapter posits that Turner became a progenitor of visual music when he 'broke' the canvas, and that visual musicians can use this key moment to build a new conceptual foundation of visual music upon the premise of affective expression.

The modernistic formalist principles espoused by Oskar Fischinger, Walter Ruttmann and Hans Richter – which are often seen as the starting point of visual music – emerge from the techniques and processes available in the 1920s–1930s. Fixated on the techne and means of production, this origin story gives visual music a deeply technical foundation, which pervades much creative thinking around it; visual music becomes about how sound is synced with the picture, and of direct conceptual links between image and sound. This is a view of visual music that is limiting, which denies both the human artist and the human participant of the audience. In order to create a truly expressive form of visual music, we must strive to create works that operate beyond the duality of eye and ear. Transcending the technical to create an indivisible synthesis of the visual and the audible.

The frequent resurgence of practitioners who seek to discover direct analogies between music and the visual, or to invoke concrete psychological effects such as synaesthesia are examples of continued obsession with direct and formalistic mapping strategies in visual music. Director of Centre for Visual Music, Cindy Keefer and visual music artist and historian Jack Ox, identify that direct translation of image to sound has been called pure visual music (Ox and Keefer 2008). However, despite all of the looking across all of the generations, no credible ubiquitous direct mapping

132

of sound to image, or image to sound has ever been found. This is summed up by the artist Frantisek Kupa, analysing the effect of listening to music on mental imagery:

> listening to a musical work evokes different images in everyone, an accompaniment that each draws from his/her own visual memory. That is, chromatism in music and musicality of colours has validity only in metaphor.
>
> (Kupa, cited in Brougher and Mattis 2005: 41)

Synesthetic visual music remains metaphorical, rendered impossible by the subjectivity of our individual experiences. Nevertheless, this seemingly irrepressible desire to synthesise light and music has not deterred those who still seek this holy grail of absolute association. What can be disheartening is how all of the diverse strategies for direct audiovisual associations almost always foreground abstract conceptual linkages between sound and image, while disregarding the human potential for gestural, emotion, feeling and embodied visceral affect.

## Turner, the sublime and affect

While reflecting upon my own practice I felt my creative potential stifled by this fixation upon technology. My own intention was to engage more physically with sound and image, to create an embodied and visceral affect in my work. And thus I began to look outside of the traditional visual music cannon for additional and alternative sources of inspiration. I did not have to look far before I began to recognise the resonance and connection that the renowned painter J.M.W. Turner (1775–1851) had with visual music expression. Named by some as 'the father of modern art' (Ruskin 1897: 381) his influence upon 20th-century art practices has been formidable, and includes many prominent practitioners that are considered to be seminal visual artists. Moholy-Nagy wrote:

> Abstract painting can be understood as an arrested, frozen phase of kinetic light display leading back to the original emotional, sensuous meaning of color of which William Turner (1775–1851), the great English painter, was an admirable predecessor.
>
> (Moholy-Nagy 1947: 150)

Turner's late work foreshadows both Abstract Expressionism and Rothko's veils of colour, placing pure, intense sensuality in the foreground and obviating intellectual activity. Turner foreshadows James Turrell's light works by placing the viewer in the painting, in colour and light. In giving dominance to process over product, he

foreshadows Paul Klee, and in giving dominance to the rhythm of his painterly process, the hand as important as eye, all in motion, he evokes the entire field of animation. What particularly compelled me in the work of Turner was his engagement with the sensation of light and movement. One of the main aspects that set Turner's practice apart was his articulation and invocation of embodied visceral affect via the sublime.

### From the sublime to visual music

In the mid-18th century Edmund Burke's *Philosophical Enquiry* contrasted 'beauty' – aesthetically pleasing, calming, and an expression of God's kindness – against the sublime – caused by fear of death, brought about by the tension felt when experiencing vastness, magnificent nature and a sense of infinity (Burke and Phillips 2008). The sublime was understood to be beyond culture and beyond reasoning (Finberg 1910).

Building upon this early work, Immanuel Kant, in his *Critique of Judgement* of 1790, analysed what he called the feeling of the beautiful and how it arises from rationally controlled order and harmony. Analysing the sublime more formally than Burke, he identified scale and modes as key. Defining the 'mathematical sublime', he conceived of a vast scale that was overwhelming, impossible to take in in a single look or hearing. Kant recognised the human body as our standard unit of scale, with the universe both infinitely large or infinitely small and therefore un-measurable. He defined our response to the 'dynamic sublime' as of having two reactions to the same thing that we can't reconcile; for example faced with a fierce storm he argued that we alternate between contrasting emptions of fear and pleasure and that these two states vibrate in us. Kant was concerned that such experiences of nature, or even art, might lead to us being overwhelmed; to us experiencing 'might over the mind' (Kant and Pluhar 1987: 269). Both the mathematical and the dynamical sublime have that potential, and for Kant it is only by reason that we can reconcile them, after the event. Thus, Kant's definition is similar to recognising the existence of a pre-reflective, embodied state of affect.

Gilles Deleuze adopted and developed Kant's concept of the sublime in his writing on film:

> [T]he whole could become organic whole, dialectical totalisation, measureless totality of the mathematical sublime, intensive totality of the dynamic sublime.
>
> (Deleuze 2005: 57)

The 'organic whole' is the pool of possibilities for different embodied affects and his 'dialectical totalisation' is a linking together of the whole. The sublime, then,

is intrinsically bound up with the body, and in the body's possible relations to the world.

The notion of the sublime has had a long-lasting influence in art. Turner himself has long been associated with the romantic sublime: an approach which sought to capture the mixture of awe and terror inspired by nature that paradoxically delights. In his late works, Turner concentrated on his experience of the visible world, however much it was dissolved by dazzle, mist and light. He discarded what he knew of the structure of objects and matched what he saw and felt using his painterly process (Watkins 2017).

John Ruskin wrote:

> "[T]he aim to the great inventive landscape painter must be to give the far higher and deeper truth of mental vision, rather than that of the physical facts.
> (Ruskin, cited in Wilton 1987: 222)

And this is what Turner sought to achieve. Not satisfied with slavish reproduction Turner sought to bring the viewer into his paintings, into his sensation of the light. In *Rough Sea* (1840) (Figure 9.1), he creates a viewpoint with no shoreline – the viewer does not have the safety of being on land. Turner compounds the effect by

**Figure 9.1** An impression of Turner's *Rough Sea*, charcoal and pastel, Julie Watkins.

not defining the line of the horizon – leaving the viewer off-balance, moving with the sea and the light. On viewing this painting, we experience light in motion; there is no need to search for a horizon line, or question which of the elements are sea, or mist or air. The viewer's gaze is swept over and into this moment of light in tumultuous movement. *Rough Sea*, in the nature of all paintings, privileges a moment caught in time and yet its effect is absolutely dynamic: it encapsulates turbulent movement; it does not still the moment.

Deleuze hugely admired Turner's late work, drawn to its explosive power. Deleuze saw Turner as the creator of catastrophe that is part of an on-going cycle of destruction and creation. He mused that Turner was not just painting catastrophe, but that he created an artistic catastrophe breaking with the dominant painting styles of his time to create new, life-affirming, visions of light and colour that was primordial in its evocation of light:

> Turner's last watercolours conquer not only all the forces of impressionism, but also the power of an explosive line without outline or contour, which makes painting itself an unparalleled catastrophe (rather than illustrating the catastrophe romantically).
>
> (Deleuze et al. 2005: 85–86)

Deleuze posits that Turner's late works, beyond foreshadowing later art, have an ageless quality. He positions them as Turner's creative response to the tensions between reaching beyond aesthetic and technical limitations and a terminal, chaotic breakdown – a response that results in a breakthrough.

> The canvas turns in on itself, it is pierced by a hole, a lake, a flame, a tornado, an explosion. The themes of the preceding paintings are to be found again here, their meaning changed. The canvas is truly broken, sundered by what penetrates it. All that remains is a background of gold and fog, intense, intensive, traversed in depth by what has just sundered its breadth: the schiz. Everything becomes mixed and confused, and it is here that the breakthrough – not the breakdown – occurs.
>
> (Deleuze and Guattari 2013: 157–158)

Turner's shattering of his contemporary norms was much derided at the time. The first curator of the Turner collection at the Tate, Andrew Wilton, quoted a contemporaneous review which demonstrates the contempt in which Turner was held by his contemporaries for his explorations and development in colour; *Ulysses Deriding Polyphemus* (1829) was described as:

> This is a picture in which truth, nature and feeling are sacrificed to melodramatic effect . . . he has reached the perfection of unnatural tawdriness. In fact it

may be taken as a specimen of colouring run mad – positive vermilion – positive indigo; and all the most glaring tints of green, yellow and purple contend for mastery on the canvas, with all the vehement contrast of a kaleidoscope or a Persian carpet.

(Wilton 1987: 160)

But, to the contrary Deleuze notes that Turner's breakthrough shows his art as process:

We have seen this in the case of the painter Turner and his most accomplished paintings that are sometime termed "incomplete": from the moment there is genius, there is something that belongs to no school, no period, something that achieves a breakthrough – art as a *process* without goal, but that attains completion as such.

(Deleuze and Guattari 2013: 420)

It is the process of painting, the tactile and haptic aspects of painting, that banish the optical sense of order to render a pure sensation of light and movement. Deleuze emphasises the manual aspects of painterly processes in freeing the artist from the absolute, and automatically assumed, norm of Turner's time, the figurative rendering of the world:

And above all, they are manual traits. It is here that the painter works with a rag, stick, brush, or sponge; it is here that he throws the paint with his hands. . . . These almost blind manual marks attest to the intrusion of another world into the visual world of figuration. To a certain extent, they remove the painting from the optical organization that was already reigning over it and rendering it figurative in advance. The painter's hand intervenes in order to shake its own dependence and break up the sovereign optical organization: one can no longer see anything, as if in a catastrophe, a chaos.

(Deleuze et al. 2005: 82)

Deleuze uses the term 'diagram' to delve into and to contextualise painterly processes, "the diagram is the operative set of signifying and nonrepresentative lines and zones, linestrokes and color-patches. The diagram ends the preparatory work and begins the act of painting" (ibid., 83).

The diagram organises space sensually through line, tone and hue, rather than in an optical grid-perspective, or through mimicking the direction of light in order to give the illusion of three-dimensional form. Deleuze delineates different paths through nonfigurative 'chaos', paths that are not mutually exclusive. One path is abstraction which has a minimal diagram. In contrast, "A second path, often named

abstract expressionism or art *informel*, offers an entirely different response, at the opposite extreme of abstraction. This time the abyss or chaos is deployed to the maximum" (ibid., 85). This path is where the diagram and the final work are one and the same. Process is all. Deleuze includes Turner's late works here – 'an explosive line without outline or contour' (ibid., 85).[2]

It is perhaps less known but Turner often worked frenetically at his canvases:

> [H]e began by pouring wet paint till it was saturated, he tore, he scratched, he scrubbed at it in a kind of frenzy and the whole thing was chaos – but gradually and as if by magic the lovely ship, with all its exquisite minutiae, came into being.
>
> (Wilton 1987: 114)

Turner's hugely energetic methods, his physical embodiment of the creative process of painting foreshadowed Deleuzian ideals of embodiment and physical engagement and brought a tactile affect to his creative work which still resonates today. His obsession with the subtleties of water, cloud, the sun and light were the foundations that led to his eventual breakthrough, linking the sublime through an artist's vision to inspire an embodied visceral affect.

## Embodiment, phenomenology and affect

Embodied experience and the phenomenal body are concepts that frame affect as seen from a philosophical standpoint. Affect is used in its philosophical meaning, to emphasise embodied experience. Affect indicates a change in the experience of a body and a change in being-able-to. It is pre-reflective. As Brian Massumi asserts,

> L'affect (Spinoza's *affectus*) is an ability to affect and be affected. It is a prepersonal intensity corresponding to the passage from one experiential state of the body to another and implying an augmentation or diminution in that body's capacity to act.
>
> (Massumi, cited in Deleuze and Guattari 2004: xvii)

Embodiment, as proposed by Maurice Merleau-Ponty, posits that there is no difference between perception and experience: we experience the things that we perceive; it is direct. We don't receive information and then process it, we simply experience (Merleau-Ponty 2014). This is in opposition to the dualist, rationalist view of the mind as separate from the body (such as that proposed by Réne Descartes). Merleau-Ponty's theory of embodied existence undermines the distinction between the subject and the object, with the body existing as both subject and object. Thus his

phenomenological conception always begins with the body; we perceive from within our bodies and the body is the agent of perception, the body is embedded within the world.

The 'body schema' is a pre-conscious framework that allows the phenomenal body to experience sensations such as touch, physically position itself in the world and gives it a kinaesthetic sense of its own movement. The ability of the phenomenal body to respond to the current situation is defined as the 'intentional arc'. Merleau-Ponty writes:

> [P]erceptual life is underpinned by an "intentional arc" that projects round about us our past, our future, our human milieu, our physical situation, our ideological situation, and our moral situation, or rather, that ensures that we are situated within all of these relationships. This intentional arc creates the unity of the senses, the unity of the senses with intelligence, and the unity of sensitivity and motricity.
>
> (ibid., 137)

The phenomenal body uses its skills and intentional arc with the aim of creating an optimal relationship to the current situation. The phenomenal body does not need to form an explicit goal to make a purposeful response to a situation, as its tendency is to continuously refine its responses to the world. Acquired skills allow more fine-honed responses and orientation in the world, towards future skills acquisition, all of which enhance the intentional arc. The phenomenal body imagines different possibilities and perspectives through its aspect of the 'virtual body', which is "an imaginative ability to consider alternative uses of the body and to assume different perspectives from which to observe a situation" (Steeves 2004: 22). The negotiation between the imaginings of virtual body and habitual skills endow embodied existence with the possibility to articulate creative and aesthetic experiences.

> The phenomenal body involves a dialectic between habitual behavior and what Merleau-Ponty calls the virtual body, the ability to imagine alternative perspectives and modes of embodiment and to use that ability to develop habits into symbolic activity. The to and fro movement between acquired and creative modes of embodiment underlies both ordinary perception and aesthetic activity, instilling in the heart of embodied existence an element of creativity and imagination.
>
> (Steeves and DePaul University 2001: 370)

Therefore, when looking at images the virtual body can imaginatively enter into the image. When viewing *Rough Sea*, one can imaginatively embody the physicality of

being at sea, being thrown around in the tumult of the waves, being in the damp mist, the salt air and the bright sunlight; all the senses can be called on by the virtual body. The intentional arc, when applied to this virtual body experience, can summon every relationship that would situate us in our embodied imaginings. When viewing *Rough Sea* these might include past memories of the sea, future hopes and fears of being at sea or our ideological relation to the sublime. It is possible to 'fall' into a painting, i.e. the virtual body does not need to be explicitly told to imagine being in the painting, once this ability to project has been acquired it will be used if it tends towards an optimal relationship to the current situation. The phenomenal body directly experiences art.

Deleuze's takes this further through his notions of parallel unfolding. Deleuze wants to go beyond where the edges of the body are and talk of a dissolving of subject/object. In so doing they become reversable parts of the one thing. In other words: I and the thing I am experiencing intermingle.

> The being of sensation, the bloc of percept and affect, will appear as the unity or reversibility of feeling and felt, their intimate intermingling like hands clasped together.
>
> (Deleuze and Guattari 1994: 178)

The embodied visceral affect of art is distinct from emotions and feelings aroused by art. Affect is considered to be pre-reflective rather than pre-personal as unconscious and neurological responses are personal to individuals. The body responds with an analogue of the intensity of the affect, in "the facial muscles, the viscera, the respiratory system, the skeleton, autonomic blood flow changes, and vocalisations" (Tomkins and Demos 1995: 19).

Whereas affects are pre-verbal, emotions are "complex, constructed experiences" (Eerola et al. 2017: 3); emotions are socially displayed feelings Shouse (2005). Each individual has a unique set of memories of sensations to delve into that informs how they name and interpret their feelings. Affect is powerful because it is pre-reflective. It allows direct immersion in the moment without naming, and therefore, without circumscribing the effect of the work. Thomas Wilfred likened the experience of his lumia to an incredible experience, a voyage in space amongst radiant lumia, and simultaneously to a very familiar experience, sunlight on skin (Kim 2018). Affective visual music can be both an incredible new experience and as immediate and touching as sunlight on skin. Shouse writes:

> The power of affect lies in the fact that it is unformed and unstructured (abstract). It is affect's "abstractivity" that makes it transmittable in ways that feelings and emotions are not.
>
> (Shouse 2005: 3)

## *Towards an embodied visceral visual music*

There are many examples of experimental film and visual music practice which seek to represent life and experience through art. Visual musician Stan Brakhage sought to create new ways to see so that the world might appear anew and always full of wonder; he wrote:

> Imagine an eye unruled by man-made laws of perspective, an eye unprejudiced by compositional logic, an eye which does not respond to the name of everything but which must know each object encountered in life through an adventure in perception. Imagine a world alive with incomprehensible objects and shimmering with an endless variety of movement and innumerable gradations of color. Imagine a world before the "beginning was the word."
>
> (Brakhage and McPherson 2001: 12)

Brakhage sought to create immediate and unmediated impressions through his work. He asserted that to name objects is to define those objects through perspective, thus relegating the subject to a fixed view-point from which the "man-made laws of perspective" make sense of objects in the scene. This experience he contrasted with the life, light, colour and motion seen "through an adventure of perception". Brackage sought to construct an affective experience through his films just as Turner did through his canvas.

Paul Klee asserted, if artists follow their passion and let their work grow, then their curiosity can lead to new realities, a new vision. This vision – and each artist has a fundamental right to their own unique vision – needs to be realised, developed into works of art (Klee in Klee and Findlay 1966: 11–19). Similarly, Merleau-Ponty posited: "The Painter, whatever he is, while he is painting practices a magical theory of vision" (Merleau-Ponty and Edie: 1971: 178). Thus, artistic sensitivity to the world is inherently combined and fused with imagination, freeing the artist from replicating reality and allows them to see creation as an on-going process that engages all possibilities from the past to the future, from the microcosm to the universe (Klee and Findlay: 1966).

Like Turner's 'breakthrough', Klee's artist's vision foreshadowed Deleuze's dialectical totalisation, a linking together of the whole, and elicits embodied visceral affect via the mathematical and dynamical sublime. Klee's writings demonstrate his ability to mix scientific methodology and an almost mystical, transcendental approach. As Sibyl Moholy-Nagy stated in 1925 in her introduction to Klee's *Pedagogical Sketchbook*:

> [A] reverberation of the finite in the infinite, of outer perception and inner vista. The experience of this dual reality of the SEEN and the FELT essence

of nature, impels the student toward a free creation of abstracted forms which supersede didactic principles with a naturalness, the naturalness of the work.

(Klee and Moholy-Nagy 2000: 12)

Deleuze echoes this mystical aspect of artistic creation that links back to metaphorical synaesthesia when he writes of Klee's process: "the visual material must capture nonvisible forces. *Render visible*, Klee said; not render or reproduce the visible" (Deleuze and Guattari 2004: 377). Klee did not give solutions to artists in the form of rules but proposed processes in his writings and by his own example, processes that would lead artists to find their own solutions.

Such approaches of Turner, Brakhage and Klee are required to reinvigorate the sometimes turgid space of visual music. Technological tools, now largely digital, draw the artist in with the tempting potential of creating direct one-to-one mappings. But the disappointing effects of the ubiquitous visualisation software on audio playback programmes reflects the continuing danger of these one-to-one correlations in visual music.

In its traditional conception visual music is a thoroughly modernist construct. According to Bruce Elder, the filmmaker and critic: "meditation, contemplation, trance and dream are not incorporated into modernity's model of normative cognition" (Elder 2010: xxvi). As a result, we must make Visual Music wake up. It must awaken from the world it inhabits of abstraction and Cartesian dualism. And stretch its arms out into the physical and embodied world of our experience.

By looking beyond the standard histories and formalisations of visual music, artists and composers can draw upon and construct truly affective works, compositions which appreciate the power of communication through embodied immediate experience recognising the key inspirational potential in artistic invocations of the sublime which, as in Turner's paintings so frequently rely upon the articulation and delicate disposition of light.

Visual music can be reframed in terms of how it is perceived, how it is created and how it is displayed; visual music can be created anew, an affective artform fit for the 21st century.

## Notes

1   This chapter provides a summary of findings from *Composing Visual Music: Human Traces, from an Animator's Perspective* (Watkins 2019).
2   Deleuze also included Jackson within this same category:

> [T]his line-trait and this color-patch will be pushed to their functional limit: no longer the transformation of the form but a decomposition of matter, which abandons us to its lineaments and granulations. The painting thus becomes a catastrophe-painting and a diagram-painting at one

and the same time. . . . Action Painting, the "frenetic dance" of the painter around the painting, or rather in the painting. . . . The diagram expresses the entire painting at once; that is, the optical catastrophe and the manual rhythm.

(ibid., 86)

# References

Brakhage, S.; McPherson, B.R. (2001) *Essential Brakhage: Selected Writings on Filmmaking* (1st ed.). Kingston, NY: Documentext.

Brougher, K.; Mattis, O.; Museum of Contemporary Art (Los Angeles, Calif.); Hirshhorn Museum and Sculpture Garden (eds.). (2005) *Visual Music: Synaesthesia in Art and Music since 1900*. London, and Washington, DC and Los Angeles: Thames & Hudson, Hirshhorn Museum and Museum of Contemporary Art.

Burke, E.; Phillips, A. (2008) *A Philosophical Enquiry into the Origin of Our Ideas of the Sublime and Beautiful*. Oxford: Oxford University Press. ISBN-13: 978-0199537884.

Deleuze, G. (2005) *Cinema 1*. London: Continuum.

Deleuze, G.; Guattari, F. (1994) *What Is Philosophy?* New York: Columbia University Press.

Deleuze, G.; Guattari, F. (2004) *A Thousand Plateaus: Capitalism and Schizophrenia*. London: Continuum.

Deleuze, G.; Guattari, F. (2013) *Anti-Oedipus: Capitalism and Schizophrenia*. London: Bloomsbury Academic.

Deleuze, G.; Smith, D.W.; Conely, T. (2005) *Francis Bacon: The Logic of Sensation*. Minneapolis: University of Minnesota Press.

Eerola, T.; Vuoskoski, J.K.; Peltola, H.-R.; Putkinen, V.; Schäfer, K. (2017) An Integrative Review of the Enjoyment of Sadness Associated with Music. *Physics of Life Reviews*. https://doi.org/10.1016/j.plrev.2017.11.006.

Elder, R.B. (2010) *Harmony and Dissent: Film and Avant-Garde Art Movements in the Early Twentieth Century*. Waterloo: Wilfrid Laurier University Press.

Finberg, A.J. (1910). *Turner's Sketches and Drawings*. London: Methuen.

Kant, I.; Pluhar, W.S. (1987) *Critique of Judgment*. Indianapolis, IN: Hackett Pub. Co.

Klee, P.; Moholy-Nagy, S. (2000). *Pedagogical Sketchbook*. London: Faber and Faber.

Klee, P.; Findlay, P. (1966) *On Modern Art*. London: Faber.

Kim, T. (2018) Reflection of Light as a Methodology for New Lumia. *Presented at Seeing Sound 2018*, Bath Spa University.

Merleau-Ponty, M. (2014) *Phenomenology of Perception* (trans. D. Landes). Oxon: Routledge.

Merleau-Ponty, M.; Edie, J.M. (1971) *The Primacy of Perception: And Other Essays on Phenomenological Psychology, the Philosophy of Art, History and Politics* (2. paperback print). Evanston, IL: Northwestern University Press.

Moholy-Nagy, L. (1947) *Vision in Motion*. Chicago: Paul Theobald & Co.

Ox, J.; Keefer, C. (2008) On Curating Recent Digital Abstract Visual Music. *Abstract Visual Music*. (2006–2008).

Ruskin, J. (1897) *Modern Painters* (Vol. 6). G. Allen.

Shouse, E. (2005) Feeling, Emotion, Affect. *M/C Journal*. 8(6). Available online: http://journal.media-culture.org.au/0512/03-shouse.php.

Steeves, J.B.; DePaul University. (2001) The Virtual Body: Merleau-Ponty's Early Philosophy of Imagination. *Philosophy Today*. 45(4). pp. 370–380. https://doi.org/10.5840/philtoday200145424.

Steeves, J.B. (2004) *Imagining Bodies: Merleau-Ponty's Philosophy of Imagination*. Pittsburgh, PA: Duquesne University Press.

Tomkins, S.S.; Demos, E.V. (1995) *Exploring Affect: The Selected Writings of Silvan S. Tomkins*. Cambridge, England, New York and Paris: Cambridge University Press and Editions de la Maison des sciences de l'homme.

Watkins, J. (2018) An Impression of Turner's Rough Sea. *Charcoal and Pastel on Paper*.

Watkins, J. (2019) *Composing Visual Music: Human Traces, from an Animator's Perspective*. PhD, University of Greenwich, London.

Watkins, J. (2017) An Investigation into Composing Visual Music Today. *Body, Space & Technology*. 16.ISSN 1470-9120 (Online). doi: http://doi.org/10.16995/bst.9.

Wilton, A. (1987) *Turner in His Time*. London: Thames & Hudson.

# The function of Mickey-Mousing

## A re-assessment

Emilio Audissino

Jerry Mouse tip-toes around the sleeping Tom Cat, each step punctuated by piz-zicato strings; Errol Flynn swings from one ship-mast to another, his bravados mirrored by swirls of the woodwinds and harp glissandi; a dejected and famished Scarlett O'Hara collapses to the ground, her descent replicated by a falling figure of the basses. These are all examples of what has come to be called "Mickey-Mousing", the "split-second synchronizing of musical and visual action" (Brown 1994: 16). While a synch-point is an isolated moment in which the action in the music and the action in the visuals coincide – a gun is fired and a dramatic blast of dissonant brass explodes on that precise moment – Mickey-Mousing is an interconnected series of synch-points that replicate very tightly in music what happens in the visuals.

Sergio Miceli distinguishes between "explicit synch-point" and "implicit synch-point" (Miceli 2009: 636–638). The latter is a serendipitous encounter between the musical flow and the visual flow, a "fortuitous coinciding of music and visuals [. . .] in which the musical gestures are not excessive, flamboyant, or onomatopoeic. Their coinciding is mostly of metaphorical or symbolic nature" (Miceli 2009: 636, my translation). Composers like Ennio Morricone do not think about synch-points *explicitly* when they compose: "Music must follow its own phrasing and have its own unity; encouraging synchronism means giving up all this" (Morricone in Comuzio 1980: 161, my translation). The structural unfolding of music, when coupled with the film, does highlight enriching correspondences – say, the reprise of the theme starting exactly on a significant cut – but these are *implicit*, not designed punctually and minutely during the composition process. On the other hand, Hollywood com-posers – particularly those with a classical or "neoclassical" style (Audissino 2014: 121–122) – are used to writing around *explicit* synch-points, which are notated very precisely in preparatory "spotting sessions" – say, "At 2.25 into the scene a door is slammed: a music stinger has to catch that." Fred Karlin and Rayburn Wright call the former Morriconian approach "playing through the drama": "You can play

through a scene (or a series of scenes), establishing a mood that will ignore specific moments of greater or lesser intensity" (Karlin and Wright 2004: 154). The latter is called "hitting the action" (Karlin and Wright 2004: 157). This tailor-like fashion of composing finds its most intensive expression in Mickey-Mousing.

The moniker of this close-synch technique originated in the industry after its original usage in animated cinema, notably by Carl Stalling, the composer of the early Disney sound-shorts (Karlin 1994: 167). It was then adopted in the 1930s Hollywood feature-length dramas as well, most prominently by Max Steiner. For Steiner, music had to fit the film "like a glove" (Steiner in Buhler 2001: 45). To this end he employed Mickey-Mousing in conjunction with a recording technique that had also been imported from cartoons, the "click track", a sort of aural metronome fed into the musicians' headsets to guide them during the recording and keep the orchestra perfectly in synch with the film – the technique was reportedly invented by Carl Stalling, who called it "tick system" (Barrier in Cooke 2010: 110). Says Steiner: "Like the cartoon people, I simply decide on a tempo and then compute the frames into which the desired effects must enter, and write my music accordingly" (Steiner in Cooke 2010: 67).

Outside of the industry's circles, the term "Mickey-Mousing" is applied with pejorative connotations, to indicate a type of composition that is structurally formless, totally subservient to the film, devoid of internal musical coherence, even cartoonish, as its very term suggests, in its "tendency to provide hyperexplicit moment-by-moment musical illustration" (Gorbman 1987: 87). Art-composers working in films generally eschewed – and mostly despised – the tightly sartorial modus operandi of their Hollywood counterparts. In Aaron Copland's words: "An actor can't lift an eyebrow without the music helping him do it. What is amusing when applied to a Disney fantasy becomes disastrous in its effect upon a straight or serious drama" (Copland in Cooke 2010: 88). The second generation of Hollywood composers – in particular Miklós Rózsa and Bernard Herrmann – sought an approach that was less illustrative and more allusive, employing timbres and colours more than close mimicking. But already in 1937 a Hollywood "top brass" like David O. Selznick had voiced his reservations about the excesses of Mickey-Mousing, which led to frictions with Steiner: "My objection [is] to what I term 'Mickey Mouse'. [. . .] It has long been my contention that this is ridiculous and that the purpose of a score is to unobtrusively help the mood of each scene without the audience being even aware that they are listening to music" (Selznick in Wierzbicki et al. 2012: 104). The next pop generation working in the 1960s – represented by Henry Mancini – would write music that could be effective in the film but also effective as a stand-alone track in a tie-in album, and hence preferred stronger and self-contained musical forms, and refrained from the looseness of Mickey-Mousing. Case in point is Mancini's boogie-woogie "Baby Elephant Walk" from *Hatari!* (1962, dir. Howard Hawks). On the one hand, Mickey-Mousing has thus come to be identified as unmusical or debasing for a

serious composer; on the other hand, modern practitioners and viewers have grown to sense Mickey-Mousing as "excessively obvious and even distracting" (Kalinak 1992: 86).

Despite some exaggerated usage by Steiner – and particularly by lesser epigones in B-movies – I argue that Mickey-Mousing is worthy of a re-evaluation as a film-scoring technique as legitimate as the others, and not easier to handle than the others. It requires additional timing skills that are not necessarily possessed by every composer, and a keen sense for audiovisual integration to coordinate the requirements of the musical flow with those of the prefixed chart of synch-points to be hit. The criticism that I have mentioned about the lack of musical form originates from a misunderstanding of what music is supposed to do, first of all, in a film: support the *film's* form, not seeking or imposing its own form. Some composers, like Erich Wolfgang Korngold or John Williams, can write film scores that both serve the film and, for the most part, stand up on their own, but this cannot be the first preoccupation when writing for films. Composers from the concert arena that try their hand at film scoring often indulge too much in musical form, not paying attention to the film's form. A much-reported example is that of Leonard Bernstein in his only foray into film music. Discussing the score to *On the Waterfront* (1954, dir. Elia Kazan) – whose music was so refined that it provided materials for a concert suite – Roy Prendergast, an industry person, points out:

> Bernstein's lack of experience in the area of film composition tends to destroy the effect, in terms of the picture, of what is some very beautiful music. [T]he same material as *film music*, becomes, in many places, intrusive and inept-sounding from a dramatic standpoint. [. . .] A composition that has a "beginning, middle and end" implies a composition of a highly linear quality. As pointed out [. . .] however, most linear music is unsuited to films for it competes with the dramatic action by drawing too much attention to itself. [. . .] Bernstein is going to state the *entire* melody during a scene regardless of what is going on up on the screen. This gives the material unwanted linear quality that it might not have had had it been handled by a more experienced film composer.
>
> (Prendergast 1977: 130–132)

Besides this music-form/film-form misunderstanding, I think that much criticism is also due to broader prejudices about film music and cinema in general.

## The visual bias and the a-priori assessment of film music

The Hollywood composer that is widely held in the highest esteem is Bernard Herrmann, to the point that he was the first to be the subject of a PhD dissertation in

the 1970s, when there was not yet such a thing as an academic consideration of film music (Rosar 2003: 145). Herrmann did not even live in the Hollywood premises, nor worked within a studio's music department, but remained a New York–based free-lancer. This independence, and his notoriously outspoken free-spirited character, are already liable to place him above the average, the "Beethoven of film music" (Rosar 2003). Moreover, his approach to film scoring looked at the essence of a filmic situation, not at its surface: "Whatever music can do in a film is something mystical. The camera can only do so much; the actors can only do so much; the director can only do so much. But the music can tell you what people are thinking and feeling, and that is the real function of music" (Herrmann in Thomas 1991: 177). Herrmann aimed at providing music that *comments*; the typical Hollywood composer provides music that *accompanies*. This distinction between music as "comment" and music as "accompaniment" has come to be improperly charged with a value judgement. Film music can and should accomplish both, depending on the situation: "commenting" and thus help clarify the film's thematic level (the film's meaning); "accompanying" and thus help reinforce the film's narrative and stylistic level (storytelling and editing, camerawork, lighting, etc.).[1] Yet, "commenting" film music is mostly regarded as inventive, interesting, and praiseworthy, while "accompanying" film music is mostly dismissed as formulaic, unimpressive, and not really worthy of consideration. This a-priori assessment is a consequence of prejudice.

As Kathryn Kalinak has explained, Western culture is characterised by a dominance of vision as the most important of senses (Kalinak 1992: 20–39), which led to a visual bias that has influenced film criticism and theory since its inception (Audissino 2017a: 26–28). The visual bias, first of all, has provided an apt justification to underestimate the agency of music in films, or neglect it altogether. If/when music was taken into consideration, it was handled with theoretical concepts like the aforementioned comment/accompaniment, or parallelism/counterpoint: if music mirrors emotionally and formally what happens in the images that would be an instance of "parallelism" or "synchronism"; if music plays against the images, that would be "counterpoint" or "asynchronism". These dyads betray a visual bias: "Such nomenclature assumes that meaning is contained in the visual image and that sound can only reinforce or alter what is already there" (Kalinak 1992: 24). The same applies to the comment/accompaniment category: the central dimension is the visual one and music would add its own comment or simply obliging with a complying background. It is no surprise that these terminological dyads and their subtended value judgement were disseminated by theoreticians or practitioners like Rudolf Arheim, René Clair, and Sergei Eisenstein who professedly opposed the new sound technology and saw "audiovisual counterpoint" or "asynchronism" as the only way to save film art from its debasing transformation into "talkies".[2]

Closer to our times, the post-structuralist framework adopted by Film Studies in the 1970s caused a further boost and propagation of the visual bias and this binary

a-priori distinction. With the raise of the audiovisual paradigm in the 1980s, where the aural aspects of film were brought more centrally to the attention of film scholars (Audissino 2017a: 28–29), music became an element to be taken into consideration. Post-structuralist tools were adopted that had been already in use in Film Studies, imported from literary semiotics and narratology, on the one hand, and Lacanian psychoanalysis corrected with Althusserian subject-positioning, on the other. The semiotic approach sees films as means of communication, with communication strategies to be analysed and messages to be interpreted. If one's priority is that of interpreting signs and messages, the primary interest is the message that is being communicated – the "content". If so, the material way in which said message is carried – the "form" – often tends to be of lesser or even of no interest at all. Psychoanalysis, similarly, is about the interpretation of the psyche's content and is interested in unearthing and untangling its meanings. Its combination with semiotics within the post-structuralist paradigm has determined that further relevance has been given to "content interpretation" instead of "formal analysis". When music is tackled, primary attention is given to those instances of musical comments or "audiovisual counterpoints" with a "communication function" that brings a message to be interpreted, while such formal functions of music as Mickey-Mousing and its action-supporting role are given secondary attention, if any at all. Music that comments is music that communicates some meaning. Music that accompanies is not really communicating anything, or it is a devious accomplice to the film's communication strategies. In the latter case, music is seeing as cooperating in a manipulative way to pass on the "messages" of the dominant ideology: "if the film makes its meanings very explicit indeed, the critic has to deal with them as if they were implicit or symptomatic – otherwise, what would he or she have to talk about?" (Thompson 1988: 15).

The basic techniques employed by the film-music style of the classical Hollywood all created a strong accompaniment-driven approach to composition, one that was more aimed at formal consolidation rather than at "communicating" anything. Such techniques have long been targets for criticism. Mood music that set the atmosphere of a scene – thus working on the stylistic level and reinforcing, for example, the art director's visual work – was famously dismissed by Igor Stravinsky as "wall-paper music": "The film could not get along without [music], just as I myself could not get along without having the empty spaces of my living-room walls covered with wall paper. But you would ask me, would you, to regard my wall paper as I would regard painting, or apply aesthetic standards to it?" (Stravinsky in Cooke 2010: 277). Like wallpaper, music is seen as decorative and superficial rather than substantial – that is, accompaniment, not comment. Ben Winters has taken aim at this de-evaluation of mood music:

> It would surely be far more sensible to imagine that the majority of music we hear is not doing the narrating, but is instead part of the narrative *as*

*it is narrated*: in other words, it is *the product of narration not the producer of narrative*. As such, just as the wallpaper in a film scene can be seen as a product of narration, and might lend itself to characterising the nature and feeling of the space in which the action takes place, but itself does not narrate, so might we hear music (scoring as well as source music). [. . .] [In *The Best Years of Our Lives* (1946, dir. William Wyler, music by Hugo Friedhofer)] [the] narrative space through which the cab drives has a particular Coplandesque musical flavour [. . .] that is as at least as important an articulation of American identity as any visual information Fred, Al, and Homer see.

(Winters 2012: 42–43, 47)

Winters, basically, is pointing out that music in films cannot be expected only to comment – "doing the narrating" – but also to accompany and be part of the overall stylistic and narrative level – "being narrated".

Another staple of Hollywood scoring was the leitmotiv technique – adapted in a "condensed" version (Brown 1994: 97) from Wagner's own *wortondrama*. It consists of attaching to each principal character or idea in the film a correlated musical motif, which the composer summons every time said character or idea appear on-screen or are mentioned. A famous critique is in Hanns Eisler and T. W. Adorno's *Composing for the Films*: Hollywood leitmotiv is compared to a "musical lackey, who announces his master with an important air even though the eminent personage is clearly recognizable to everyone" (Adorno and Eisler 2007: 3). As the role of mood "wall-paper" music has recently been vindicated, so Hollywood's leitmotiv technique has increasingly enjoyed a serious interest in the academic circles, for example in Bribitzer-Stull (2015), or Frank Lehman's work on the leitmotiv network in the *Star Wars* films (Lehman 2018).

The other major Hollywood technique, Mickey-Mousing, is equally worthy of some re-consideration. Lea Jacobs has contributed to such work by studying its importance in the transition to sound and analysing the nuances of its usage in cartoons, in a book chapter titled "Mickey Mousing Reconsidered" (Jacobs 2014: 58–108). Jacobs has pointed her attention to the contribution of Mickey-Mousing on the filmic *temporal* dimension – what I call, later, "temporal-perceptive function" – in terms of rhythm of the music vis-à-vis the rhythm of the images (Jacobs 2014: 92). Henceforth, I claim that Mickey-Mousing is also a key device to operate on the film's *spatial* dimension. If the formal rationale of "wallpaper" music is that of setting the atmospheres of the film and the one of the leitmotiv is that of following the characters and situations in their dramaturgical development, Mickey-Mousing's is that of tracking the movement within the film space, a "spatial-perceptive function".

## Mickey-Mousing and the spatial-perceptive function

A film's system is made up of three sub-systems, or three principles of narration: *narrative logic* (causality), *time*, and *space* (Bordwell 1985: 51). Music's agency has been more recurrently investigated within the time or causality levels. Music unfolds across time, and hence it is rather obvious that it can contribute importantly in the delineation or strengthening of the filmic time. Music is built out of reprises, thematic repetitions, variation-techniques that vest it with an internal logic, with antecedents that lead to consequents, a musical cause-effect chain that can be injected into the film to reinforce its cause-effect chain. The way music cooperates with the space sub-system, on the contrary, might prove something more elusive to observe, probably because the spatial dimension – in terms of actual *physical* space – is not one which one tends to associate with music *prima facie*.[3]

When referring to music and space, I do not mean here how music depicts the profilmic space, that is the sets, locales, ambiances, exotic landscapes, and the like, as in "mood music" – for example, when music would illustrate a scene set in China by using stereotypical pentatonic scales and Ehru violins. I am referring to how music helps viewers connect with the film's space. Elsewhere, I have identified three functions that music can perform in films, mapped onto the three areas of activity of film-viewing: perception, emotion, and cognition (Thompson 1988: 10). I have called these: "emotive function" (micro-emotive and macro-emotive); "cognitive function" (denotative-cognitive and connotative-cognitive); and "perceptive function" (temporal-perceptive and spatial-perceptive) (Audissino 2017a: 130–151). The emotive function is responsible or co-responsible for the configuration of moods, affective responses, and emotion moments locally and globally in the film, while the cognitive function consists in music contributing to the understanding of denotations (explicit meanings and bits of narrative information) and the interpretation of connotations (implicit meanings and "messages"). Music has a perceptive function when it helps viewers configure the spatio-temporal perception of the scene/sequence – as my use of the word "configuration" might reveal, the theoretical framework which my approach is based on is Gestalt theory.[4] Amongst the film-music techniques, Mickey-Mousing is one of the most powerful to operate on the spatial dimension, and its space-related origins can be traced back to the silent era.

Numerous attempts were made in the 1910s to regulate the type of music being played during film screenings, in the form of cue sheets (list of musical pieces that the film company provided the cinema exhibitors with) or anthologies of musical pieces, either original or from the concert repertoire, classified under moods and situations (danger, courtship, countryside, chase, thunderstorm) (Cooke 2008: 15–18). Interestingly, the two excesses that cue sheets and anthologies tried to

battle were extreme cases of musical comment, on the one hand, and musical accompaniment, on the other. The former case was referred to as "jackass music" (Harrison in Wierzbicki et al. 2012), and had musician/s playing musical puns to provide arbitrary and incongruous commentaries to the films: "The titles and lyrics of popular tunes were so well known [. . .] that audiences would instantly grasp the connection between the title of the song and a particular film event. [. . .] Each song is chosen not because of its musical characteristics, but because its title provides an ironic or comic match to the events it accompanies" (Altman 2004: 220–221). In an exaggerated fashion, music here played against the images, refusing to serve them subserviently but instead creating a sort of asynchronous "counterpoint".

To the opposite side of the spectrum, other live musicians and sound-effects people accompanied *too much*, that is they tried to attach some sound to each and all of the elements in the visual space, even the irrelevant ones:

> One evening we had the interior scene of a peasant's cottage, and a painful parting between two lovers was taking place. All at once a bird began to sing with great violence. I looked at the piano player in wonderment and found him looking the same at me. "What's that for," he asked. "You've got me," I replied, "I'll go and see." I found my friend [the sound-effects man] with his cheeks and his eyes bulging out, blowing for his very life. "What's the trouble?" says I. "The bird! The bird!" says he, without removing the whistle. "Where?" says I. "There!" says he, pointing triumphantly with a stick to a diminutive canary in a tiny wooden cage on a top shelf at the far corner of the room.
>
> (Hoffman in Altman 2004: 238–239)

The "Canary Effect" can be seen as an early and extreme manifestation of Mickey-Mousing, where the sound-accompanist tried to attach a correlated sound to every action that happened within the filmic *space*, indiscriminately.

Moving to sound cinema, the traditional account has it that no non-diegetic music was utilised in the early "talkies". Steiner recounts his experience with RKO: "They didn't want any music in their dramatic pictures. This was motivated not only by the economic factor, but because they had decided you could not have background music unless you showed the source. In other words, you had to have an orchestra on view, or a phonograph or performers, so that people would not wonder where the music was coming from" (Steiner in Thomas 1991: 66–67). Even if recent studies (Slowik 2014) have shown that early sound-films did not entirely fit this inveterate narrative, the inception of the Mickey-Mousing technique might have had something to do with the "realist" sound aesthetic of the early sound cinema. In silent

cinema, music was performed live, and the audience could see the musicians actually playing in the theatre. The worry of the RKO executives, as reported by Steiner, seemingly was to make the transition less distracting. In terms of "invisibility" – Hollywood's foregrounding of the storytelling, with style and technical apparatus being concealed by making them transparent – diegetic music was motivated by the presence of a musical source within the film's space. Non-diegetic music needed an equal motivation to be acceptable under this premise, and Mickey-Mousing might have been the answer:

> The vocal track in classical cinema anchors diegetic sound to the image by synchronizing it, masking the actual source of sonic production, the speakers, and fostering the illusion that the diegesis itself produces the sound. Mickey Mousing duplicates these conventions in terms of nondiegetic sound. Precisely synchronizing diegetic action to its musical accompaniment masks the actual source of sonic production, the offscreen orchestra, and renders the emanation of music natural and consequently inaudible.
>
> (Kalinak 1992: 86)

Roy Prendergast provides further reflections along these lines: "An interesting aspect of the music to *The Informer* [1935, dir, John Ford] is the way in which the music makes its entrances and exits. It almost always enters or exits on some sort of physical action, such as a door opening or slamming shut. [. . .] [I]t gives the music, especially in case of the music's entrance, an unconscious 'reason' for being there" (Prendergast 1977: 43).

For today's standards, Steiner might seem too heavy-handed in handling Mickey-Mousing. In *The Informer*, he was apparently obsessed with replicating in music some dripping water on screen:

> There was a sequence toward the end of the picture in which McLaglen is in a cell and water is dripping on him. This is just before he escapes and is killed. I had a certain music effect I wanted to use for this. I wanted to catch each of these drops musically. The property man and I worked for days trying to regulate the water tank so it dripped in tempo and so I could accompany it. This took a good deal of time and thought because a dripping faucet doesn't always drip in the same rhythm. We finally mastered it.
>
> (Steiner in Thomas 1991: 68)

Yet, this sartorial adherence was not always and necessarily the superficial frill chastised by Copland: "In *Of Human Bondage* [1934, dir, John Cromwell] [Steiner] had the unfortunate idea of making his music limp whenever the clubfooted hero

walked across the scene, with a very obvious and, it seemed to me, vulgarizing effect" (Copland in Cooke 2010: 88). It might have a deeper dramaturgical motivation, as explained by Kate Daubney in what is a fitting rebuttal to Copland's criticism:

> [Steiner's] apparent penchant for catching every movement seen on screen has been interpreted in more recent, sophisticated contexts as trivialising the narrative function of music. [. . .] It is important however, to draw a distinction between occasions when music imitates or mimics physical action as a means of providing insight into the experiences of the characters, and situations where the mickey-mousing is placed for uncomplicated emphatic effect. The former case occurs in some of Steiner's early scores: for *Of Human Bondage* (1934), he uses a combination of uneven rhythm and dissonant chords to capture the physical and social discomfort of Philip Carey's limp. It appears to be a simple imitation of the rhythm in which the character walks, yet the harmonic effects create a strong sense of how Carey views his own disfigurement. Similarly, in the score for *The Informer* (1935) the well-chronicled catching of the dripping water in Gypo Nolan's cell uses the imitation of action to emphasise the anxiety that the character is feeling.
>
> (Daubney 2000: 27–28)

Steiner's Mickey-Mousing was functional in pointing the viewer's attention to a specific element or action within the filmic space, a symbolic element for the film's storytelling: the limp in the case of *Of Human Bondage*, a handicap that is central to and overwhelming in the character's life; the water drops – the last drop – that tick away as a clock, a count-down to Gypo's final moments.

This ability of music to guide the viewers' attention to some important visual detail or action by highlighting their presence or trajectory through an isomorphic musical structure or action is what I call spatial-perceptive function. Music mimics some extramusical configuration happening within the filmic space: an obvious example is a character falling down a flight of stairs accompanied by a fast downward scale of the violins. The configuration of the visual action (falling down) is matched with an isomorphic configuration of the music (falling down) which produces a super-configuration (falling down) that acquires a stronger salience in the formal system of that scene and thus attracts our attention. Empirical evidence gathered with eye-tracking experiments (for example, Mera and Stumpf 2014; Wallengren and Strukelj 2015) has confirmed that music has a great influence in determining what part of the screen our eyes are going to point to and stop on. At the 2014 Music and the Moving Image conference, Miguel Mera presented the results of his study with a live demonstration, employing a scene from *The Artist* (2011, dir. Michel Hazanavicius) and convincingly showing that with the original sentimental music the eye-tracking

traces coalesced around the two flirting characters in the foreground, while with a different upbeat faster music the eyes tended to drift away and focus on the people moving in the background.

Even if today this kind of extensive reliance is not in use any more – mostly replaced by sound effects to punctuate visually salient details – the Mickey-Mousing technique can still be a resourceful scoring tool. In the ghost story *Crimson Peak* (2015, dir. Guillermo Del Toro, music by Fernando Velázquez) the mother's phantom appears now and then to the young protagonist. The main apparition, as usual, is preceded by very quick manifestations, mainly in the background. In one shot, the ghost rapidly materialises behind the protagonist, in the distance. If it weren't for the sudden chord that punctuates its appearance, we might fail to notice that something happened in the background. In this case, we have a static shot with static, ominous music; when something suddenly, quickly and briefly happens in the music, we automatically scan the shot for the isomorphic element within, and thus we notice the sudden, quick, and brief appearance of the ghost. This "Look There!" function of the music can be very effective. The sudden and noticeable change in configuration of the music lets us know that there must be a similarly important change in the configuration of the narrative.

Mickey-Mousing can also perform another type of spatial-perceptive function. If the aforementioned can be called "spatial-visual" because of its agency in guiding the viewer's eyes, there is another one that can be termed "spatial-tactile function". In this case, through music, the viewer is led to perceive almost physically what the characters are perceiving. Think of the use of the trembling theremin-motif in Miklós Rózsa's score to *The Lost Weekend* (1945, dir. Billy Wilder), where the music replicates the dizziness, nausea, and confusion of the alcoholic protagonist. This function might overlap with the emotive function: doesn't sentimental music make viewers perceive that a character is in love? The differentiating criterion is filmic space. While emotions and sentiments are internal phenomena, here music is isomorphic with some external phenomenon, taking place within the filmic space, and music helps viewers connect *physically* to said phenomenon. Consider the so-called stingers in horror films, those abrupt dissonant chords that punctuate some shocking revelation or appearance. Spatially, a stinger replicates in music some visual action – the abrupt apparition of the monster. And it also fulfils an emotive function, of course: the grating dissonance makes us experience the configuration as unpleasant, unsettling, scary. But the very nature of the stinger – a loud and sudden sound – triggers a physical reaction that goes beyond the emotive sphere. Music touches us physically, exploiting the "Startle Effect", a physiological response that is inescapable. When we hear a loud and sudden sound we tend to recoil and enter into a defensive and alerted mode – "fight or flight" – because we register said sudden and violent noise as a potential danger.[5] There is more apart from the musical replication of the abrupt apparition and the

elicitation of horror and fear using the long-tested musical devices used in horror and scary music. There is also an almost tactile aspect in the stinger, as when we touch something hot and we automatically withdraw our hand. Also think of the shower murder in *Psycho* (1960, dir. Alfred Hitchcock, music by Bernard Herrmann). The music is so effective because, in a way, it is a Mickey-Mousing of the furious stabbing: the harsh grating dissonance of the murder motif (painful to the ears) makes us feel the pain of the knife repeatedly violating the flesh in an almost tactile way. Marion's slashed body is part of the filmic space, and music helps viewers connect with it.

Mickey-Mousing, in its relation with the film's space and movements, has also a balletic aspect to it. Music is coordinated with the physical actions and brings the viewer's attention to the gestures and movements, much as ballet music is written to interact with the dancers' movements. Mervyn Cooke, highlighting the influence of ballet music on such composers as Dimitri Tiomkin, Alex North, and John Williams, points the attention to its general influence on Hollywood music:

> The influence of ballet, as the supreme example of music-as-movement, on the art of film scoring has long been neglected by scholars on account of the emphasis traditionally placed on sometimes unconvincing parallels with the classical genres of opera and symphony. Yet, elements of ballet in general, and the attractively coloured instrumentation of Russian ballet music from Tchaikovsky to Prokofiev in particular, are ubiquitous in mainstream Hollywood scoring.
>
> (Cooke 2008: 120)

Erich Wolfgang Korngold's film scores, for example, have many episodes of Mickey-Mousing which are developed and integrated in a balletic way, and in which the demands of musical form are balanced with those of precisely timed filmic accompaniment. Case in point is the climactic sword fight in the final act of *The Sea Hawk* (1940, dir. Michael Curtiz). Particularly noteworthy is the ambush sequence in Sherwood Forest in *The Adventures of Robin Hood* (1938, dir. Michael Curtiz and William Keighley): "While Korngold may not synchronize his music as closely with the visuals as Max Steiner did, there are still numerous instances where Korngold's scores engage in so-called Mickey Mousing" (Winters 2007: 37). Music here alternates between the two cross-cut lines of action – Robin setting the trap, and the oblivious soon-to-be ambushed people marching onwards, punctuates most jumps and flights of Robin's "Merry Men", but also manages to do all of this while keeping a substantial musical form, to the point that the concert suite incorporates much of the sequence's score as it is. Says Winters:

> [It] is also a highlight of the score in its synchronisation of music and picture, its integration of thematicism, and its subsequent delineation of a narrative

space. [. . .] The cross-cutting between the scenes of Robin and his men engaging the advance guard and Sir Guy's party riding toward the trap are thus perfectly matched by the musical structure of the sequence. The moment when the Sheriff of Nottingham spies on the attack and brings these two separate locations together is achieved effortlessly by the score.

(Winters 2007: 130)

The sequence looks and sounds, in a way, like a perfectly musically coordinated choreography, with Robin's and his rebels leaping dance-like from tree to tree, and the battle sublimated into a colourful Technicolor ballet piece. High-level balletic Mickey-Mousing can also be found in John Williams's music, for example the Prokofievian Battle of Endor sequence in *Return of the Jedi* (1983, dir. Richard Marquand) or the Stravinskyian *Sacre*-like music for the Velociraptor attack in *Jurassic Park* (1993, dir. Steven Spielberg).[6]

## Conclusions

Mickey-Mousing is a resourceful technique of film scoring that has the important function of connecting viewers with the filmic space. If we wish to exemplify the difference using the old form/content split, the music might seem to have no "content" to pass simply because this type of music has *not* the function of operating on the thematic level but that of operating on the stylistic and narrative levels; *not* that of passing any "message" but that of reinforcing the film's *form*. Much of the criticism directed at Mickey-Mousing seems to be a consequence of the preference of most film-studies circles for content interpretation over formal analysis. Also, Mickey-Mousing has often been identified with its exaggerations and mannerist declinations, but such generalisation is myopic if applied to the technique itself and not to the single cases. The same happened to Hans Zimmer's so-called Braaahm sound, an electronically sweetened low-timbre momentous horn sound. Employed effectively in *Inception* (2010, dir. Christopher Nolan), it has since become a cliché because of its subsequent numerous imitations and less savvy utilisations (Abramovitch 2015). Used appropriately and sensibly, the "Braaahm" can be haunting, evocative, and ominous; used exaggeratedly – as in most action-film trailers – it is predictable and ludicrously caricatural.

Though not extensively and intensively as in the old days, Mickey-Mousing can still have fruitful applications. John Williams has made ample and sagacious use of Mickey-Mousing, not only in the Steineresque score to *Raiders of the Lost Ark* (1981, dir. Steven Spielberg),[7] or more recently in both adventure films (*The Adventures of Tintin*, 2011, dir. Steven Spielberg) and dramas (*War Horse* 2011, dir.

Steven Spielberg). A case study in modern and refined Mickey-Mousing is his score to *Jaws* (1975, dir. Steven Spielberg, music by John Williams), where the technique performs a spatial-perceptive function that is both visual (we cannot see the shark and music materialises its presence for us) and tactile (in the opening sequence music makes us also feel the pain of the mangled victim).[8] As other devices and conventions of classical Hollywood cinema, Mickey-Mousing deserves an unprejudiced re-evaluation.

## Notes

1  For a definition of the thematic, stylistic, and narrative levels and their interaction within the film's form, after Kristin Thompson's neoformalism, see Audissino (2017a: 78–83).
2  On the resistance against the coming of sound, see Wierzbicki (2009: 96–101).
3  Music, like poetry, is a *temporal* not a spatial art, if we abide with Lessing (1887).
4  For reasons of space I cannot delve into it, but a presentation can be found in Audissino (2017b).
5  On the startle effect in horror films, see Sbravatti (2019).
6  For more on Williams's ballet-like film music, see Cooke (2018: 14–19).
7  On Mickey-Mousing in *Raiders of the Lost Ar*k, see Audissino (2014: 161–182).
8  On the functions of the music in *Jaws*, including Mickey-Mousing, see Audissino (2020).

## References

Abramovitch, S. (2015) 'Braams' for Beginners: How a Horn Sound Ate Hollywood. *Hollywood Reporter*, 5 May. Available online: www.hollywoodreporter.com/news/braaams-beginners-how-a-horn-793220 [Accessed 15/07/15].
Adorno, T.W.; Eisler, H. (2007 [1947]) *Composing for the Films*. London and New York: Continuum.
Altman, R. (2004) *Silent Film Sound*. New York: Columbia University Press.
Audissino, E. (2014) *John Williams's Film Music: 'Jaws', 'Star Wars', 'Raiders of the Lost Ark' and the Return of the Classical Hollywood Music Style*. Madison, WI: University of Wisconsin Press.
Audissino, E. (2017a) *Film/Music Analysis: A Film Studies Approach*. Basingstoke: Palgrave MacMillan.
Audissino, E. (2017b) A Gestalt Approach to the Analysis of Music in Films. *Musicology Research*. 2(Spring). pp. 69–88. Available online: www.musicologyresearch.co.uk/publications/emilioaudissino-agestaltapproachtotheanalysisofmusicinfilm.
Audissino, E. (2020) 'The Shark Is Not Working': But the Music Is: Scoring a Hit with *Jaws*. In: I. Hunter; M. Melia (eds.) *The Jaws Book: New Perspectives on the Classic Summer Blockbuster*. New York: Bloomsbury.
Bordwell, D. (1985) *Narration in the Fiction Film*. Madison, WI: University of Wisconsin Press.
Bribitzer-Stull, M. (2015) *Understanding the Leitmotif: From Wagner to Hollywood Film Music*. Cambridge, UK: Cambridge University Press.
Brown, R.S. (1994) *Overtones and Undertones: Reading Film Music*. Berkeley, Los Angeles and London: University of California Press.
Buhler, J. (2001) Analytical and Interpretive Approaches to Film Music (II): Analysing Interactions of Music and Film. In: K.J. Donnelly (ed.) *Film Music: Critical Approaches*. New York: Continuum.
Comuzio, E. (1980) *Colonna sonora. Dialoghi, musiche rumori dietro lo schermo*. Milan: Il Formichiere.
Cooke, M. (2008) *A History of Film Music*. Cambridge, UK: Cambridge University Press.
Cooke, M. (ed.). (2010) *The Hollywood Music Reader*. New York: Oxford University Press.

Cooke, M. (2018) A New Symphonism for a New Hollywood: The Musical Language of John Williams's Film Scores. In: E. Audissino (ed.) *John Williams: Music for Films, Television and the Concert Stage*. Turnhout: Brepols.

Daubney, K. (2000) *Max Steiner's Now, Voyager: A Film Score Guide*. Westport, CT and London: Greenwood Press.

Gorbman, C. (1987) *Unheard Melodies: Narrative Film Music*. London and Bloomington, IN: BFI and Indiana University Press.

Jacobs, L. (2014) *Film Rhythm after Sound: Technology, Music, and Performance*. Berkeley and Los Angeles: University of California Press.

Kalinak, K. (1992) *Settling the Score: Music and the Classical Hollywood Film*. Madison, WI: University of Wisconsin Press.

Karlin, F. (1994) *Listening to Movies: The Film Lover's Guide to Film Music*. Belmont: Schirmer.

Karlin, F.; Wright, R. (2004) *On the Track: A Guide to Contemporary Film Scoring* (2nd ed.). New York and London: Routledge.

Lehman, F. (2018) The Themes of Star Wars: Catalogue and Commentary. In: E. Audissino (ed.) *John Williams: Music for Films, Television and the Concert Stage*. Turnhout: Brepols.

Lessing, G.E. (1887 [1767]) *Laocoon: An Essay Upon the Limits of Painting and Poetry* (trans. E. Frothingham). Boston, MA: Roberts Brothers.

Mera, M.; Stumpf, S. (2014) Eye-Tracking Film Music. *Music and the Moving Image*. 7(3). pp. 3–23.

Miceli, S. (2009) *Musica Per Film: Storia, Estetica, Analisi, Tipologie*. Lucca and Milan: LIM and Ricordi.

Prendergast, R.M. (1977) *Film Music: A Neglected Art: A Critical Study of Music in Films*. New York: W.W. Norton & Company.

Rosar, W. (2003) Bernard Herrmann: The Beethoven of Film Music? *The Journal of Film Music*. 1(2/3). pp. 121–150.

Sbravatti, V. (2019) Acoustic Startles in Horror Films: A Neurofilmological Approach. *Projections*. 13(1). pp. 45–66.

Slowik, M. (2014) *After the Silents: Hollywood Film Music in the Early Sound Era, 1926–1934*. New York: Columbia University Press.

Thomas, T. (1991) *Film Score: The Art and Craft of Movie Music*. Burbank, CA: Riverwood.

Thompson, K. (1988) *Breaking the Glass Armor: Neoformalist Film Analysis*. Princeton, NJ: Princeton University Press.

Wallengren, A.; Strukelj, A. (2015) Film Music and Visual Attention: A Pilot Experiment Using Eye-Tracking. *Music and the Moving Image*. 8(2). pp. 69–80.

Wierzbicki, J. (2009) *Film Music: A History*. Oxon and New York: Routledge.

Wierzbicki, J.; Platte, N.; Roust, C. (eds.). (2012) *The Routledge Film Music Sourcebook*. New York: Routledge.

Winters, B. (2007) *Erich Wolfgang Korngold's 'The Adventures of Robin Hood': A Film Score Guide*. Lanham, MD: Scarecrow Press.

Winters, B. (2012) Musical Wallpaper? Towards an Appreciation of Non-Narrating Music in Film. *Music Sound and the Moving Image*. 6(1). pp. 39–54.

## Works cited

*The Adventures of Robin Hood* (1938) [FILM] dir. Michael Curtiz and William Keighley. Warner Bros.

*The Adventures of Tintin* (2011) [FILM] dir. Steven Spielberg. Paramount.

*The Artist* (2011) [FILM] dir. Michel Hazanavicius. Wild Bunch.

*'Baby Elephant Walk'* (1962) [MUSIC] Henry Mancini. RCA Victor.

*Best Years of Our Lives* (1946) [FILM] dir. William Wyler. RKO.

*Crimson Peak* (2015) [FILM] dir. Guillermo Del Toro. Universal.

*Hatari!* (1962) [FILM] dir. Howard Hawks. Paramount.

*Inception* (2010) [FILM] dir. Christopher Nolan. Warner Bros.

*The Informer* (1935) [FILM] dir. John Ford. RKO.
*Jaws* (1975) [FILM] dir. Steven Spielberg. Universal.
*Jurassic Park* (1993) [FILM] dir. Steven Spielberg. Universal.
*The Lost Weekend* (1945) [FILM] dir. Billy Wilder. Paramount.
*Of Human Bondage* (1934) [FILM] dir. John Cromwell. RKO.
*On the Waterfront* (1954) [FILM] dir. Elia Kazan. Columbia.
*Psycho* (1960) [FILM] dir. Alfred Hitchcock. Universal.
*Raiders of the Lost Ark* (1981) [FILM] dir. Steven Spielberg. Paramount.
*Return of the Jedi* (1983) [FILM] dir. Richard Marquand. Twentieth Century Fox.
*The Sea Hawk* (1940) [FILM] dir. Michael Curtiz. Warner Bros.
*War Horse* (2011) [FILM] dir. Steven Spielberg. Touchstone.

# Performing the real
## Audiovisual documentary performances and the senses

### Cornelia Lund

Audiovisual documentary performances can be described as a performative practice that combines elements of documentary cinema with live audiovisual performance. With sound and images performed live and in real time, these performances create a new sensory approach to documentary and challenge the viewing and listening habits shaped by traditional, more linear or narrative documentary structures.

In terms of theoretical discourse, the realms of audiovisual performance and documentary cinema have never substantially overlapped. Nevertheless, it is true for them, what Scott MacDonald claims for the neighbouring but not identical complex of what he calls Avant-Doc – a combination of Avant-garde and documentary film: although they have different histories and "are different kind of terms" (MacDonald 2015: 1) that address different institutional frameworks and modes of production and presentation, in practice they are "malleable and interactive categories" (ibid.). This consideration leads to a number of questions that I will try to answer throughout the chapter: With audiovisual documentary performances, we have already identified one practice generated through a combination of audiovisual performance and documentary cinema. If they are malleable and interacting categories, what other, neighbouring forms have been developed recently from the combination of elements of both realms? How can they be described in terms of media dispositif and aesthetics? What is the theoretical and practical framework they evolve in? Can they be addressed adequately by the existing theoretical and methodological approaches?

The answer to the first questions will be deferred until later in this chapter, and I will start by sketching a panorama of the relevant developments in theory and practice. On the basis of which I will then proceed to the analysis of contemporary artistic productions combining audiovisual and documentary performative practices.

## Documentary between cinema and the art context

One major impact on our field has certainly been made by the so-called documentary turn in the art context, which encouraged the emergence of new documentary practices not only in the context of fine arts but ultimately also across neighbouring disciplines such as dance, theatre and cinema. There is a general consent to place this documentary turn at the beginning of the 1990s, in close relation to the year 1989 and the connected changes in the political landscape (for example Lind and Steyerl 2008: 14). The concrete reasons for the documentary turn invoked by scholars and practitioners vary. It is often described as linked to the repoliticisation of art, which in turn cannot be separated from an increasing interest of artists in documentary practices as a form of gaining access to the real world (e.g. Lucchesi 2012: 10).[1]

Performances play an important role in this newly developed field of documentary practices; they can draw on autobiographic and biographic experiences, such as Rabih Mroué's screen-assisted theatre performance *Riding on a Cloud* (2014), which is based on the life story of his younger brother Yasser, namely his experiences during the Lebanese Civil War. They can also take the form of lecture performances and performances dealing with historical topics in general or personal ways, as in the body of works mostly signed by Filipa César, which takes up films from the time of the war of independence and some years after from the archive of the National Institute of Cinema and Audiovisual (INCA) in Guinea-Bissau.

As the examples already show, these very diverse productions of documentary practices often work with photographic or filmic images and their related sound, but can nevertheless not easily be addressed with theoretical discourses originating in the traditional cinema context. They have, of course, from the beginning on been included in the discourses that accompanied the documentary turn in the art context, with its first obvious point of culmination at the documenta 11 in 2002, curated by Okwui Enwezor, where more than 40 per cent of the presented works could be described as using documentary practices (Bartl 2012: 10).

It can be said that cinema studies in general were rather slow in embracing this new field of documentary practices, but several conferences and festivals and their resulting publications have supported the exchange between practitioners and scholars from the art and the cinema context. In the "Introduction" to *Truth or Dare: Art and Documentary*, the editors and initiators of the eponymous conference, Gail Pearce and Cahal McLaughlin, describe the situation that lead them to organise their first conference as follows: "We noticed how increasingly the boundaries between artists using 'documentary' themes, and documentary makers experimenting with structure, form and content, as well as exhibition possibilities, had brought some film-makers from both disciplines closer together. We also suspected both groups knew little about each other as the two worlds could be hermetic" (Pearce and McLaughlin 2007: 9). *Truth or Dare* was followed some years later by another conference and book to

deepen the investigation into the topic and to raise some questions anew, as the title, *Truth, Dare or Promise: Art and Documentary Revisited* suggests. The Visible Evidence Conference, an international conference on documentary film, also attempts to bring the "two worlds" together and has been investigating the relationship of documentary and the arts for some time now; and the three editions of the Berlin Documentary Forum held at the HKW (Haus der Kulturen der Welt) in Berlin in 2010, 2012 and 2014 were key in opening a space for documentary experimentation and dialogue between the "two worlds" in their programmes and publications. These are just a few major examples, which are complemented by a large number of international events and publications, such as the books *Ortsbestimmungen: das Dokumentarische zwischen Kino und Kunst* (Hohenberg and Mundt 2016; Localizations: documentary between cinema and the arts) and *Un art documentaire* (Caillet and Pouillaude 2017; A Documentary Art).

At the same time, cinema in general has undergone major changes that affect all its components as an institutional framework in which artistic or pop-cultural products are produced, distributed, presented and watched. Since the implementation of digital technologies in all steps of the cinematic value chain, the traditional cinema hall is no longer the privileged venue where films are presented and watched, nor is the living room with its stationary TV. Films can be watched on mobile screens of various sizes (laptops, tablets, mobile phones) at any time and place now. These new forms of presentation and screening situations also encouraged new modes of conceiving films: they can work with transmedia narratives, images and sound can be changed and treated in real time, for example. Subsequently, cinema studies also partly left the cinema hall and became interested in the changing landscape of cinema. The focus was no longer on the film itself, the cinematic experience became also worth investigating, and with it the question of the involvement of the body and the senses in this experience (Elsässer and Hagener 2009).

This is basically the wider field, in which live audiovisual performances with a documentary approach evolve when we place the focus on the documentary and cinematic parameters. Before we proceed to a more detailed discussion and analysis of these audiovisual performances, they should be defined more specifically.

## Live audiovisual performance as a documentary practice

There is a wide range of possibilities how sound and image can come together in a performance to develop a documentary perspective. The real has always been a part of performances with moving images and sound, and performers have always been and are still using found footage or their own sound recordings and moving images documenting certain occurrences, motives and moments explicitly for the purpose of being used in a performance. According to the concept behind the performance,

this sound and image material is subjected to different approaches. In many cases, a more or less experimental exploration of the formal and aesthetic qualities of the images and the sound becomes the focus. Performances exploring the sounds and movements of the city can be named as one example here; the arrangement of movements of people working or dancing to create a sort of filmic choreography would be another. The moving images and the sound are, however, very rarely arranged in a way that conforms to documentary cinema in its more traditional form, as produced for the cinema or TV context. Accordingly, in academic analyses, these performances have mostly been addressed from other perspectives than documentary cinema studies, namely as belonging to the fields of experimental film, expanded cinema or audiovisual performance.

The performances addressed in this chapter, however, form a comparatively small and rather young body of works and are characterised by certain specific parameters. According to Ana Carvalho's definition, live audiovisual performances are "contemporary artistic expressions of live manipulated sound and image, defined as time-based, media-based, and performative" (Carvalho 2015: 131). An important element of these expressions is improvisation, which becomes possible "when the technology used allows for production in real time" (ibid.). So, one could say that for Carvalho, the use of real time technology and the resulting aesthetics are even part of the definition of a live audiovisual performance.

Software used for the manipulation of images in real time usually allows to work with rather short film clips, which can be arranged and re-arranged in real time, instead of screening a pre-arranged, usually linear sequence of scenes as in a cinema screening. A lot of the software has originally been used and developed for the VJ or club context, such as Modul8, Vjamm, VDMX or Resolume.[2] It therefore offers the features needed to accompany club music dominated by a rhythmical set: looping, repeating, layering, playing backwards, inverting, remixing, to name just a few. These features allow for an aesthetic that is very far from the traditional, linear documentary. Metaphorically speaking, the loop as a movement that comes back to where it has started is at the opposite of the linear, progressive movement of a traditional narrative film, just as the turn in a dance resembles poetry, whereas walking resembles prose, according to Paul Valéry (Valéry 1957: 1329ff).

Regarding the sound, the most prominent characteristics probably is that, at least in important parts of each performance, music prevails over speech, or, if speech is used, it blends with the music, becomes part of it and undergoes a musical treatment. Depending on how strong the reference to the club context is, the music is more or less dominated by the bass and drum kit.

Even so, the audiovisual performances we are interested in here do not use documentary film clips simply as a basis for aesthetic experimentation in real time, they convey a documentary argument, the synopsis of which might read very similar to the synopsis of a traditional documentary. Only the way this argument

is performed is completely different, which ultimately also influences the documentary experience.

In terms of spatial, social and organisational arrangements, audiovisual documentary performances share parameters mostly with the art, the performance and the club contexts: While a more traditional cinematic setting is not excluded, there is no fixed form for the performances and the elements of the "cinematic space" (Elsässer and Hagener 2009: 4), or respectively the performance space and their organisation can vary considerably. The performances can take place in theatre or art spaces, in clubs, churches, tiny bars or big open-air venues. Depending on the choice of venue and the framework – festival, cinematic, concert-like or party-like event – the performances are organised in the form of a theatrical event with a fixed beginning and end and/or predefined positions of the spectators or they take a looser form where people come and go as they please, walk around, eat and drink.

Many audiovisual documentary performances have an organised structure that defines how they evolve while giving enough room to the improvisational elements of a performative act. They also show a preference for more or less directional spatial settings, but normally they don't imply the strict discipline of a traditional theatre event where one is supposed to sit still, remain silent and abstain from the consumption of food and drink.

## Audiovisual documentary performances – examples

Documentary practices allow for a wide range of topics; basically every element of "reality" can be addressed, and, of course, the real can also be faked.[3] For the time being, audiovisual documentary performances, however, seem to show a certain predilection for documentary topics that are typical for a so-called ethnographic approach. The performance *SuperEverything\** (2011) by the Light Surgeons, for example, was commissioned by the British Council to explore "identity, ritual and place in Malaysia,"[4] whereas *Are We Doing Right?* (2013) by the Brazilian collective Embolex is the performative live version of the eponymous documentary film mainly addressing political struggles of minorities in Brazil and elsewhere in the world. Both performances are rooted in the loop-based and drum-oriented aesthetics originally developed for and by the DJ/VJ combinations in the club context, but it is transformed to convey their documentary topic(s) and includes more performative elements, especially regarding the music. In both cases, music is played live on electronic and acoustic instruments. Speech is also present, single sentences may be audible, but, rhythmically looped, the speech oscillates between transporting verbal meaning and a primarily musical value; as it never appears as isolated sound, but is always linked to an image, it becomes an element of the choreography of interrelated images and sounds. This choreography with its multi-layered, looped and remixed

elements doesn't offer one single view on its topic, it rather develops a polyphonic tableau, or, as Chris Allen, the founder of the Light Surgeons puts it, it offers a "multi-threaded documentary story telling" (Keen 2013).

The screen arrangements also contribute to the complexity of the storytelling. While the arrangement is still relatively simple for *SuperEverything** – the performers are placed between two semi-transparent screens and thus appear as shadows, which may be read as a reference to pre-cinematic forms or to the Wayang Kulit, the Malaysian shadow theatre (Figure 11.1) – the dispositif for *Are We Doing Right?* is much more complex. As usual, Embolex work with a multi-screen dispositif where the performers are placed in the middle, in front of the main screen. Their laptops as well as the front of the table they are placed upon also serve as screens, and additional screens are placed in an altar-like arrangement on the left and right. Although the performance is organised in several short movements of some minutes addressing different aspects of the main topic, the abundance of information offered on the multiple screens is not easy to absorb when seeing the performance for the first time – especially if one wishes to read the information conveyed by the subtitles. What happens is, that there is not one defined series of images every spectator follows, but depending on the screens one chooses to focus, the composition shows variations, which emphasise slightly different aspects of the argument. The unifying

**Figure 11.1**    Image taken from *SuperEverything**, a live cinema performance by The Light Surgeons. Captured at a performance at Hackney Empire in collaboration with The Barbican in 2013 © The Light Surgeons / photo by Glasshopper.

element here is the sound. It varies a little, of course, depending on the position of the spectator in the space and in relation to the loudspeakers, but the same sound accompanies all images arranged over the multiple screens. The sound does not only, in a sense, envelop all images, they are also structured according to its rhythm in a much more consequent way than we would ever find in traditional documentary cinema. Furthermore, the sound directs the gaze: the latter is, for example, normally attracted by someone, who is speaking. And in the first movement or piece about the Sahrawi Arab Democratic Republic (SADR), the sound of the electronic drum is in sync with and therefore emphasises the images that show hands playing drums and clapping. In this scene of musical performance, occasional voice sounds made by the female performers complement the rhythmical clapping and drumming. These rather high-pitched diegetic sounds in turn attract the spectator's gaze each time they set in.

What becomes evident here is, that sound can be used in audiovisual documentary performances not only as a sort of spatial framework for an intricate, multi-layered visual part; when it is as closely intertwined with the images as here, via synchronisation and the use of diegetic sounds, for example, the sound plays a prominent role for and channels the way the performance is perceived.

One could make the argument that film music and sound have the same function. Elsässer and Hagener observe, that in cinema studies "the analysis of sound is often framed in terms of a power struggle with the image over dominance and dependency" (2009: 154). Very often, film scores, as important as they are for the success of a film, are treated as a secondary element, which, at least in classical cinema, is seen as subordinated to the narration (cf. ibid.). If we take up this logic for a moment, one could say that, in live audiovisual documentary performances, it almost seems to be the other way round, music and sound guide through the documentary argument and serve as structuring and binding elements. Especially, if we take into account, that, depending on the volume and intensity of the sound, the rhythmical bass drum can and shall cause a very bodily experience.

The performance *1Hz* (2015) by Daniel von Rüdiger and his performance duo 0101 is structured by such an intense and, in this case, very strict underlying beat whose frequency is already indicated by the title of the performance: one beat per second or 60 BPM.[5] The performance is organised in two parts, the first part shows male inhabitants of the village Kambot in Papua New Guinea constructing a traditional dugout canoe, the second part is dedicated to the production of sago in the same village. The sound of the life music, played by Daniel von Rüdiger (electronics) and Carl Creepy (guitar), and its regular beat is only interrupted in the middle of the first part, when the men start to pull the finished boat towards the water; we see and hear them talking, and they develop their own working rhythm, quite similar to an observational documentary film.

The performance starts with an evolving arrangement of abstract colours and forms; they soon become more and more concrete and materialise as the village to

which the actions of the two parts are linked. After this introduction, we see mainly one man who is working a tree, which later on will become the canoe, with an axe. The beat and the rhythm of the axe join in and become part of the beat and the rhythm of the music played by the two performers.

When the music sets in again after the scene where the men pull the boat towards the river, the screen is subsequently split into parts that become smaller and smaller until the images appear almost like an abstract pattern. Clips showing different stages of the construction work are combined on the split screen, while the movements of the men are reworked in relation to the music, by playing the clips forwards and backwards, for example. The non-diegetic music is complemented by the diegetic sounds of speech and sawing, and the whole interplay of music, sound and various clips confers the impression of a fervent working activity (Figure 11.2).

While this part of the performance still tells the story of how the dugout canoe is made and the second part shows the process of sago making, the emphasis is neither on an observational ethnographic attitude nor is there a strong educational commentary. The short clips and the repetitions stress the dance-like rhythm inherent to this kind of bodily working process, thus referring to a long-standing tradition of showing bodily work in film and video as a form of rhythmic choreography. This reference is even reinforced by the part without music where the inherent rhythmical structure of this type of work becomes evident. And through the way the process of constructing a dugout canoe is presented in the performance, for example, how this

**Figure 11.2** Image taken from the performance *1Hz* by Daniel von Rüdiger/0101 © Daniel von Rüdiger/0101.

process is divided into short clips and how they are reworked in sync with the audio part, the attention of the spectators may shift from the mere sequence of actions to details, and they might start to see differently and different things.

In these performances, the chosen ethnographic and/or activist topics undergo an aesthetic treatment, which is far away from the usual ethnographic approaches. The observational documentary material and the recorded interviews are heavily reworked and submitted to a process of rhythmic structuring that ultimately makes it all, to put it simply, danceable. With respect to the people shown in these images and their sometimes precarious conditions, one could ask if this treatment still follows the rules of respect that usually are at the basis of documentary films. One could also ask if it is appropriate to submit the material – regardless of its provenance – to some sort of clubby reworking that ultimately goes back to Western pop music.

While it is absolutely ineluctable to keep this problematic in mind, it is hard to make a general statement. Performances are choreographed very differently and therefore must be judged individually and also according to changing parameters in this field. One argument, which is repeatedly made in the discussion of documentary cinema and documentary practices in the art context is, that "although the aesthetics may be the same, the ethics are very different." So, depending on the field or context a documentary practice is placed in, it also refers to "different ethical frameworks" (Ellis 2007: 59). Therefore, an aesthetic choice, which might be considered impossible in the context of a TV documentary, might still seem offensive but not impossible in the art context, when it strengthens the artistic argument.[6]

The role of pop music has to be considered very carefully and according to every context, too. Pop music is very often explicitly used to transport political and activist messages, and in many African countries, the youth is so tired of politics that the best way to inform the younger generations about politics or to mobilise them is via pop music. The political protests in Senegal before the elections in 2012, for example, were spurred by rap musicians and their music.[7] Another, genuinely audiovisual example for the use of pop-cultural forms to transmit political information is the *Journal rappé* (rapped news) founded by the two Senegalese rappers Xuman et Keyti. This is, of course, not the same as working with material documenting people from different cultures, but it might show that pop-cultural approaches can be used in various ways not only to entertain, but also to inform and present the audience with new perspectives on a subject.

The ethical question seems to cause less uneasiness once we leave the per se not unproblematic complex of a gaze turned towards "other" cultures. But sometimes, exploring one's own culture can also turn into a difficult task from an ethical point of view:

For her performance project *Intruders*, the video artist A-li-ce received an invitation to work with the archives of Ciclic–Pôle Patrimoine de la Région Centre-Val de Loire in France.[8] These archives contain thousands of private films and videos,

thus exclusively material, which was never meant to be seen and heard by strangers. A-li-ce teamed up with Swub for the music. They made a very careful selection from the archival material, which is the basis for the video and the audio part, except the drum that is added in the last part of the performance. The argument of the performance is almost completely composed out of the given material, no commentary is added to explain the material or to give information about the purpose of the film.

The selection of the material shows a distinct awareness for the vulnerability of the private moving images by treating them with the utmost respect. *Intruders* does not expose individuals in their private moments, the chosen scenes are already in most cases clearly enacted for the camera or part of public presentations.

The performance works with short clips showing typical moments that are part of the collective private film memory: birthdays, New Year's Eve, walks in the garden – and titles (Figure 11.3).

As the Ciclic archives collect films and videos from different periods, the chosen scenes show these typical moments over a long period of time, as we can tell from the clothes, haircuts and also occasional direct indications of a date.

**Figure 11.3**   Still from *Intruders* by A-li-ce & Swub © A-li-ce & Swub.

Presented as standing alone, these moments probably wouldn't catch the attention of the audience, precisely because they fulfil an expectation in that they are typical for this genre. The short clips and repetitions, however, emphasise these moments, and collectively, they gain a relevance that goes beyond the private context they were initially made for. Sound-wise, these typical moments are represented by parts of well-known tunes, for example, that are equally emphasised through repetition.

In this sense, the performance develops a history of private film. The more so, as the typical moments are complemented by images of the technical apparatus – cameras, film, viewing dispositifs, which becomes also audible at the beginning of the performance through the rattling of a film projector. By highlighting these references to the apparatus, the performers even go beyond developing a typological history of private film; they develop a reflection on cinema itself that is mirrored by the voice material.

And, in an ultimate twist, the performers solve the ethical problem posed by the material, so to speak, by turning it into a central topic of the performance: *Intruders* not only reflects on the history of private film and on cinema as such, at the same time, it also becomes a reflection on memory and the archive: "a conversation with our own ghosts," it is called, in an allusion to Roland Barthes. The eerie, hauntological sound, that bears the same traces of a former life as the images, adds to that ghost-like atmosphere. By playing the moving images and sounds live, the performers in a sense re-animate the people in the images, give them back their lives. They dance to the same tunes they used to, but their presence and liveliness remains ephemeral, linked to the performance. They move in a world apart, which, at the same time, we share with them or they with us. One could ask who the intruders of the title are: the ghosts of the past who are intruding into our world? Or is it us, intruding into theirs by disturbing their archival peace?

## The sensory experience

The specific ways of combining sound and images used in the performances analysed previously are certainly not customary for documentary productions, although in the history of documentary cinema, there are examples that experiment with sound or where music becomes a prominent, structuring element, as in *Jazz Dance* (1954) by Roger Tilton and Richard Leacock, for example. In more recent years, the question of sound has become central to the research done at the Sensory Ethnography Lab (SEL) formed at Harvard by Lucien Castaing-Taylor in 2006. Sensory ethnography tries to understand cultural contexts not so much through speech and explanations, but through sensory experiences and their representations in different media, one of them being film. The concentration on the visual side that we still find in "Visual Anthropology" is questioned here, other notions such as "smellscapes"

or "soundscapes" become important (Pink 2009: 15f). The SEL has developed its own very specific approach and "uses cinema to provide sensory experiences of cultural practices in the process of transformation" (MacDonald 2015: 374); to do so, it experiments with innovative aesthetic approaches based on a combination of ethnographic, documentary and artistic practices. The experimental camera work is certainly a key characteristic here, but so is the emphasis on sound. For *Sweetgrass* (2009), a documentary about remaining modern-day shepherds in Montana, Lucien Castaing-Taylor and Ilisha Barbash used direct recording with separate lavalier microphones (MacDonald 2015: 387ff). In consequence, in the film, we can hear very close recordings in sync with the images filmed from a certain distance, which creates an interesting tension between the external gaze of the camera and the sensation of being part of the scene conveyed by the intimacy of the sound. In regard to *Leviathan* (2013), their film about deep-sea commercial fishing, Lucien Castaing-Taylor and Véréna Paravel state that "the sensorial intensity of life on a boat is as acoustic as it is visual," and that it therefore was clear for them "to afford equal billing to sound and picture" (MacDonald 2015: 409). The very intense sound work and the images taken by the GoPro cameras seeming to sway their way through the trawler according to its movements and those of the humans and fish on and below deck – and even occasionally under water – translate the atmosphere into a cinematic experience that implicates the senses in a way that even provokes a slight seasickness in some spectators.

At a first glance, the films made in the context of the SEL and their approach to an audiovisual aesthetic may seem very different from the approaches we have so far analysed in audiovisual documentary performances. Both documentary practices share, however, the aim to explore innovative combinations of sound and image, which on the one hand rely on addressing and involving the senses in the documentary experience much stronger than traditional documentary cinema does, and on the other hand refrain from clarifying everything, in order to leave room for polyphonic perspectives, as well as uncertainties, mysteries and doubts, as Lucien Castaing-Taylor explains (MacDonald 2015: 404).

The different documentary practices are, in any case, not clearly separated and separable, as there exist various mixed forms. An interesting example is *The Gamblers. The Zama Zama Miners of Southern Africa* (2019) by Rosalind Morris. The work combines two parts, the first one can be described as an installation-performance – we will come back to this later – and the second one is a 16mm film performance. Like many other works in the field of documentary practices, it is part of a larger project called *The Zama Zama Project* that explores its topic, in this case the life and work of informal miners, the zama zama (gamblers), in South Africa, in different media, from documentary film to writing and experimental video forms. In a similar way, some cinematic works of the SEL, for example, take the form of installations, Embolex initially set out to make a documentary film, and Daniel von Rüdiger has

used his material for installations and documentary films, and it has become part of an artistic research PhD as well. Addressing the same subject in different media and formats allows to concentrate on and to highlight different aspects of it. For an in-depth analysis of the single product, it is therefore extremely important to also consider the larger project context, because the project parts complement each other.

*The Gamblers. The Zama Zama Miners of Southern Africa* as shown at the ICI Berlin Institute for Cultural Inquiry in January 2019 was an experiment – for the artists as well as for the institution that is not exactly an art or performance space but has a focus on more academic presentations and research. So, the first part was a presentation described as a three-screen video installation in the accompanying booklet (Magill 2018: n.p.); but except from the very gallery-like set-up of the screens, the presentation contained elements of an expanded cinema event, combining characteristics of a film screening – fixed beginning and end, public assembled as a group – and of a performance – uniqueness and ephemerality of the presentation, audience sitting on the floor in an unconstraint manner. The performative aspects of the presentation as a whole were reinforced by the second part, an actual performance with 16mm film stripes and loops on several projectors by Philippe Léonard.

The first part was dedicated to three informal miners, their work and life down in the mines as well as a stroll to the city, and the work of the women above ground. Down in the mines, it was the miners themselves filming and recording sound, which creates a very intimate situation and a closeness to the action similar to the aesthetics of the SEL (Figure 11.4).[9]

**Figure 11.4**   Still from *The Gamblers. The Zama Zama Miners of Southern Africa* © Rosalind Morris.

The material shown on the three screens is related, but not necessarily in sync, and those small delays together with sometimes rapid cuts remind in turn of some audiovisual documentary performances.

The second part shows an interesting analogital or post-digital approach: its topic is the boarder and the ruinous state of the mining landscape. Filmed digitally with a drone, the material is then transferred to analogue film and performed and treated by hand during the performance. The shift to the analogue material was chosen in relation to the hard bodily and very analogue work of the miners.[10] The images of the post-industrial mining landscape are complemented by droney sounds that add to the impression of emptiness and decay.

*The Gamblers* as a mix of media and approaches to documentary and performance is very specific and rather unique. There is, however, another approach to combining documentary and performance that shares some parameters with audiovisual documentary performances: live documentary as performed by Sam Green or by Kim Nelson and her collaborators. Live documentary takes up the live narrator from the early years of cinema, the moving images are arranged in clips that can be played live but are usually not rhythmically reworked as in audiovisual documentary performances. Music is also played more or less live on stage and can become very prominent in some cases. Sam Green has even teamed up with the Kronos Quartett for *A Thousand Thoughts* (2019), a live documentary about and accompanied live by the Kronos Quartett. Kim Nelson and her collaborators prefer the expression "interactive documentary" because their performances are always followed by a Q&A during which the performers spontaneously answer either verbally or with clips that are prepared but must be chosen live according to the questions from the audience.

## Conclusion

While these neighbouring forms don't exactly work in the same way as audiovisual documentary performances, they open up fields for a fruitful experimental exchange. Audiovisual documentary performances with their aesthetic characteristics based on an audiovisual aesthetic initially developed in and for the club context are placed at the intersection of various fields and developments, as described previously. Theoretical approaches to audiovisual documentary performances therefore have to take into account these different fields, from cinema with its newly developed interest in the cinematic experience and the role of the senses to documentary practices in the art field and developments in audiovisual performance proper. As the analysis of performances show, the performances draw upon all these different fields to explore experimental audiovisual strategies to produce documentary arguments that offer other perspectives and construct their reference to reality in a different way than traditional documentary cinema. As the field is still a rather young one and therefore

in constant flux, the thoughts and analysis presented in this chapter are like a snap-shot in time and will have to evolve; if one could express wishes for future directions where the flux could lead, one could maybe wish for even more experiments with sound and for the courage to tackle more unconventional topics.

## Notes

1 For an in-depth analysis of the discussions around and various approaches to the so-called documentary turn in the arts and their relation to the cinema context see the author's article on "Elastic Realities – Documentary Practices between Cinema and Art" (Lund 2019).
2 Modul8: www.garagecube.com/modul8/; Vjamm: www.vjamm.com/; VDMX: https://vidvox.net/; Resolume: https://resolume.com/ [Last accessed: 10/11/19].
3 In his article on "Documentary Film in Media Transformation," Thomas Weber gives an in-depth analysis of how the reference to reality is produced in different media milieus. He stresses that, "while references to reality in the field of the fictional remain optional, we see reliable methods in the documental field to ensure those references" (Weber 2013: 119). Knowledge about these methods also allows to identify if reality is faked, if we are, for example, dealing with a mockumentary. For a discussion of the more "elastic" reference to reality in documentary practices in the art context see Lund (2019).
4 See http://supereverything.net/what-is-superevrything/ [Last accessed: 10/11/19].
5 See also www.0101.wtf/ [Last accessed: 10/11/19].
6 As example can be mentioned Renzo Marten's film *Episode 3 (Enjoy Poverty)* (2008), where some very direct and painful images of sick and starving children in Congo are shown. See Lund (2019: 175–177).
7 The events are well documented in Rama Thiaws's documentary *The Revolution Won't Be Televised* (Senegal/France 2016).
8 More precisely, the invitation came as a residency offered by Ciclic and the Art Center Bandits-Mages in Bourges.
9 The underground miners/cameramen are Prosper Ncube, Rogers 'Bhekani' Mumpande and Darren Munenge; director of cinematography is Ebrahim Hajee.
10 See the discussion held after the presentation at ICI in Berlin on January 7, 2019: www.ici-berlin.org/events/the-gamblers/ [Last accessed: 10/11/19].

## Bibliography

1 HZ (2015) [AV performance] Daniel von Rüdiger/0101 (electronics Daniel von Rüdiger; guitar Carl Creepy).
Are We Doing Right? (2013) [AV performance] Embolex.
Bartl, A. (2012) *Andere Subjekte. Dokumentarische Medienkunst und die Politik der Rezeption*. Bielefeld: Transcript.
Caillet, A.; Pouillaude, F. (eds.). (2017) *Un art documentaire*. Rennes: Presses universitaires de Rennes.
Carvalho, A. (2015) Live Audiovisual Performance. In: A. Carvalho; C. Lund (eds.) *The Audiovisual Breakthrough*. Berlin: Fluctuating Images. pp. 129–141. Available online: http://www.ephemeral-expanded.net/audiovisualbreakthrough/ [Last Accessed 10/03/2020].
Ellis, J. (2007) Dancing to Different Tunes: Ethical Differences in Approaches to Factual Filmmaking. In: G. Pearce; C. McLaughlin (eds.) *Truth or Dare: Art and Documentary*. Bristol and Chicago: Intellect Books. pp. 57–64.

Elsässer, T.; Hagener, M. (2009) *Film Theory: An Introduction through the Senses*. New York: Routledge.

The Gamblers. The Zama Zama Miners of Southern Africa. (2019) [film installation/performance at ICI Berlin] Rosalind Morris, Philippe Léonard.

Hohenberger, E.; Mundt, K. (eds.). (2016) *Ortsbestimmungen. Das Dokumentarische zwischen Kino und Kunst*. Berlin: Vorwerk 8.

Intruders. (2014) [AV performance] video A-li-ce; sound Swub.

Keen, S. (2013) A Kaleidoscopic Portrait of Malaysia. *InDaily: Adelaide's Independent News*, 13 September. Available online: https://indaily.com.au/arts-and-culture/festivals/2013/09/13/a-kaleidoscopic-portrait-of-malaysia/ [Last Accessed 10/11/19].

Leviathan. (2013) [film] dir. Lucien Castaing-Taylor, Véréna Paravel.

Lind, M.; Steyerl, H. (2008) Introduction: Reconsidering the Documentary and Contemporary Art. In: M. Lind; H. Steyerl (eds.) *The Greenroom: Reconsidering the Documentary and Contemporary Art #1*. Berlin and New York: Sternberg Press. pp. 11–26.

Lucchesi, S. (2012) It's Hard to Touch the Real. In: F. Bertolotti (ed.) *Lo Schermo dell'Arte. Bulletin #1: The Documentary in Contemporary Art Practice*. Florence: Archive Books. pp. 9–18.

Lund, C. (2019) Elastic Realities: Documentary Practices Between Cinema and Art. *Ars*. 17(35), Dossiê Membranas: intersecções entre arte, ciência e tecnologia. pp. 167–182. doi: 10.11606/issn.2178-0447. ars.2019.152831. www.revistas.usp.br/ars/article/view/152831/153218.

MacDonald, S. (2015) *Avant-Doc: Intersections of Documentary and Avant-Garde Cinema*. New York: Oxford University Press.

Magill, J.R. (ed.). (2018) *The Zama Zama Project: Rosalind Morris*. Berlin: The American Academy in Berlin.

Pearce, G.; McLaughlin, C. (eds.). (2007) *Truth or Dare: Art and Documentary*. Bristol and Chicago: Intellect Books.

Pearce, G., et al. (eds.). (2013) *Truth, Dare or Promise: Art and Documentary Revisited*. Newcastle upon Tyne: Cambridge Scholars Publishing.

Pink, S. (2009) *Doing Sensory Ethnography*. London: Sage.

Supereverything*. (2011) [live cinema performance] The Light Surgeons.

Sweetgrass. (2009) [film] dir. Ilisha Barbash, Lucien Castaing-Taylor.

Valéry, P. (1957) Poésie et pensée abstraite. In: J. Hytier (ed.) *Œuvres complètes* (Vol. 1). Paris: Bibliothèque de la Pléiade, Gallimard. pp. 1314–1339.

Weber, T. (2013) Documentary Film in Media Transformation. *InterDisciplines*. 1. pp. 103–126. doi: 10.2390/indi-v4-i1-79.

# Blending image and music in Jim Jarmusch's cinema

## Celine Murillo

Watching Jim Jarmusch's films is always listening to them. The importance of music is rooted in Jim Jarmusch's creative process and in his formative years in the 1970s in Downtown New York since he was part of the Punk movement (Suarez 2007: 16; Rombes 2005: 5–6), which was egalitarian, anti-establishment, and even opposed to learning. We want here to, first of all, retrace the ideological and artistic implications of Jim Jarmusch's formative years. Then in the second part we will show how in his films he considers music and the other matters of expression (Hjemslev quoted by Aumont et al. 2004: 137) as being equally important and interdependent. Eventually we contend that this enables Jim Jarmusch to express ideas which would prove the efficiency of the punk ethos. Our third and fourth part will dwell on the example of *Mystery Train* (1989) and show how the uses of music debunk the myth of Elvis.

### Formation: egalitarian aesthetics in the 1970s

When Jim Jarmusch was a student in the late seventies, there were artistic and more specifically musical movements that contributed to the blurring of borders between various epistemological fields such as music and philosophy or music and mathematics, between high and low art, and between different types of art media (Girard 2010: 31). Jim Jarmusch was part of a group of artists called "The Downtown Scene" (Taylor 2006) that included musicians, painters, photographers, filmmakers and writers that lived and worked in Downtown New York. For example, Basquiat, Patti Smith, Amos Poe, The Ramones, The Talking Heads were part of the Downtown scene, and repetitive minimalists such as La Monte Young were part of it as well. Ideologically speaking, the Downtown spirit can be defined as "an insurgency against the silence of institutions, the muteness of the ideology of form, the unspoken violence of normalization" (Siegle 1989: 4).

Among these artists, the American punk movement "stripped music to basics, emphasized the words, questioned musical virtuosity, and played small local venues" (Taylor: 18). The punk movement was a response to unemployment, poverty and recession. After the 1960s protests, universities opened to more people and to more disciplines – namely film studies (Reekie 2007: 162; Myles and Pyle 1979: 54–55). Some of these new undergraduates (such as Jim Jarmusch) came to live and study in New York City where, because rents were very low (Suarez 2007: 9), they could live very cheaply, did not have to work much to pay for their lifestyle and could simply concentrate on their art. Moreover, because everybody flocked to Downtown New York, they had access to a lot of performances.

But this boost in creative energy had its downsides. Indeed, in the aftermath of the oil crisis of 1973 and the Stock Exchange crisis, New York City was on the verge of bankruptcy (Rusher 1978: 12). The recession had hit the city particularly hard (Zevin 1977: 11–29). In addition to the low rents, the metro system was not properly functioning, and assaults in the metro were customary, Central Park was also dangerous: in general, the crime rate was very high (Reynolds 2005: 144). Young students or artists in New York had to face poverty in this violent environment. This led them to a second and total rejection of the school system (after the first countercultural movement in the 1960s and the subsequent changes brought to education). The subversive art movement that is No Wave or Punk did not want to have anything to do with the school system: they did not want to change the university system, they plainly rejected it. They did not value know-how. They believed that regardless of technical skills everybody could be creative and practice art:

> No video rentals of Walkman's. No MTV. In other words, less interference. Blocks of abandoned buildings. Apartments with low rents, the toilet in the hallway and bathtub in the kitchen. Few distractions, few ambitions and even fewer bills to pay. Being in a band even if you couldn't play, making art even if you never learned to paint.
>
> (Ann Magnuson in Taylor: 46)

The quote by Ann Magnuson here draws a link between rejection of know-how and the economic conditions. It also corresponds to an egalitarian principle: nobody is superior to anybody else regarding art creation. In other words, even if you did not have access to art training, you were as entitled to create as a trained artist. Altogether, it meant a rejection of know-how and an emphasis on creation. As a result, the Downtown scene was dominated by an ethos that led to the blurring of borders between arts and, as far as we are concerned, between music and cinema:

> Beginning with Amos Poe's path breaking *Blank Generation* in the mid 1970s, young filmmakers would thematize the music scene, feature Punk, New Wave

musicians as actors, or collaborate musically with them. This massive identification of the visual art world with the rock scene must surely have affected the practices of experimental and avant-garde jazz musicians who were always looking for new ways to expand their small audiences.

(Taylor: 56)

In Amos Poe's *The Blank Generation* (1976), even if certain tunes are relatively coherent and well played such as "Psycho Killer", the lack of synchronization between images and sound attests to limited know-how and small budget. Further in the film, the song "Are you a boy or are you a girl" (sung by transsexual leader Jayne County) plays a complicated game with genre, intertwining images and song. And when Blondie's lead singer Debbie Harry gets on screen, she further enmeshes images and music by claiming as a singer that she is all image: "I want to be a platinum blonde". Debby Harry's looks made her iconic, and this made for her celebrity as much as her vocal skills. Iconic looks were very important in a time "of reduced expectations" (Suarez 2007: 57). Amos Poe's film is not music illustrated by images nor the other way round: music and images cannot be separated here. The clip relies on their close links.

Another example of interdependence between image and music occurs in Glenn O'Brien's TV party. This TV show claimed to be "a cocktail party that could be a political party". It made use of the public access TV network that developed in the 1970s (Jane 1987: 14). When Cable Access TV first reached New York, it had the obligation to broadcast any other shows, as a counterpart for charging subscriptions:

The idea behind public-access television is, in essence, a simple one: that you or I, the man or woman down the street, even the kid next door – in short, *anyone* who wishes – should have the opportunity to produce, direct, hold forth on our own television programs. An experiment in such "people's television" has been going on for some time in New York City, over specially set aside cable television channels.

(Doty 1975: 33)

Glen O'Brien took advantage of this progressive rule to broadcast all the exponents of the Downtown Scene. His shows heavily relied on DIY music, devoid of learning, going against the bourgeois expectation of a well-played, well-rehearsed tune (Galvin 2013: 332). In the same way the camera work was also DIY, as none in the crew had experience making TV shows. Music and image went hand in hand in the subversion of the mainstream expectations regarding TV shows.

As far as Jim Jarmusch is concerned, he was initially trained in literature, then started studying cinema first with Laszlo Benedek, and then as Nicholas Ray's teaching assistant (Belsito 1985: 24). At the time, he was friends with John Lurie and Eric Mitchell (Belsito: 28), who were musicians and the founders of a small theater and

moviemaking venue called New Cinema. Jim Jarmusch was utterly untrained as a musician yet, "in the early 1980s, he alternated between film and music and was a member of the band Del Byzanteens, a minor new wave act whose only album came out in 1982" (Suarez 2007: 20). Moreover, he dropped out of university and financed *Permanent Vacation*, a feature-length films that document the Lower East Side with the Mayer grant he had received to pay for his tuition fee (Stark 1985: 51). Jarmusch had obtained significant technical training but still turned his back on academia, and never made a career in the big studios in Hollywood. Unlike those directors who did so, he managed to keep some financial and creative independence, even if he did at times distribute some of his features through mini majors such as Focus Features (Murillo 2012b). This posture bears the traces of the egalitarian DIY esthetics of the Downtown Scene. Jim Jarmusch comments: "The music scene was interesting because you didn't have to be a virtuoso to make music. [. . .] This period was important, because there were a lot of different artists – musicians, filmmakers – that had this 'make it-in-the-garage spirit'" (Andrew 1999: 24).

## Jarmuschian music

In Jarmusch's movies, music is intertwined with images both regarding their theme and their form. Thematically speaking some films are centered on existing musicians, such as his feature-length documentary *The Year of the Horse* (1997) that follows Neil Young and his band on tour. As far as his creative process is concerned, Jim Jarmusch does not respect the primacy of storyline and causality that is customary in mainstream cinema. Jim Jarmusch starts with collecting music, meeting actors and musicians before a story emerges from these elements:

> Rather than finding a story that I want to tell and then adding the details, I collect the details and then try to construct a puzzle of story. I have a theme and a kind of mood and the characters but not a plotline that runs straight through.
> (Jarmusch interviewed by Jacobson 1985: 60)

Working with a musician sometimes leads him to adapt his working style, and this is especially true of his collaboration with East Coast hip-hop musician RZA on *Ghost Dog* (1999). Let us note that hip-hop is "a genre that, like his own work, has a double allegiance to the avant-garde and the popular" (Suarez 2007: 100). When they met, Jarmusch recalls how RZA suggested the way to work with the music he was providing for the sound track:

> I'd say, "Does it go anywhere? Any ideas for a particular place in the film?" "Nah-nah you guys figure that shit out, you gotta use hip-hop style, can edit it, you can change it, you can put two together, here's some stuff".
> (Andrew 1999: 190)

This creative process had a strong influence on the film and more precisely on its pace. For example, when the hero, Ghost Dog, practices martial arts on his rooftop with different types of swords [32:10–33:32], the music is meant to be non-diegetic and thus supposedly perceived by the spectators only. But it is very difficult to bear that in mind since Ghost Dog's movements are partially synchronized to the images: the sword movements, the downbeat and the cut do not perfectly coincide, but yet seem to react to each other.

Ghost Dog's moves are choreographed like a dance; they create gestural synchresis which is not quite a perfect point of synchronization (Chion 1994: 59). The flow of the images is accelerated or slowed down to loosely fit the rhythm of the music, giving a sensation close to "mickey-mousing"(Jones 1946: 365). Our appreciation of the musical and gestural effects is intensified since there is no proper narrative or causal justification to this sequence: it is atmospheric, sets a mood which contributes to building the character.

This musical track is reduced to a very pure ostinato, which "can be defined, *stricto sensu*, as all *the uninterrupted repetitions of one and the same rhythmic structure* inscribed in a periodical form, this rhythmical structure may be linked to another parameter such as pitch or harmony"[1] (Schnapper 1998: 30, my emphasis). Here, as it is standard in hip-hop, the track is composed of three of four looped bars. If you could hear them individually you would hear their melody, but when looped, the melody loses its prominence and they become essentially rhythmical:

> When one listens attentively to a looped sample in the uniqueness of its two or three bars, isolated from their context, one may be stricken by the inherently melodic character of the fragment, a line from a guitar, a trumpet, a vibraphone or a piano, arranged horizontally where notes follow each other (melody), more than they overlap (harmony). Yet thanks to a technically mastered iteration, the little chosen musical phrase loses its melodic character and suddenly assumes a rhythmical dimension it did not have in the first place.
>
> (Béthune 2003: 70)[2]

If we expect music to contain, as it usually does, such features as rhythm and melody, then the looped tune only provides rhythm in the form of a steady beat. It is the backdrop against which Ghost Dog's fluid movements are evocative of a visual melody which completes the audio track that is devoid of a melodic line.

The sequence sports many jump cuts: the clip is made of several takes edited together. We are aware of this since the weapons change many times. Moreover, the same take is often shown twice and superimposed with a time lag creating a form of visual echo or visual canon. Altogether the analysis of this sequence shows that the parameters that are generally associated with the notion of music are here associated with both sonic and visual elements.

In other films by Jim Jarmusch, the link between image and music is strengthened because of the use of visual rhythms, which are not so frequent in fiction films. Indeed visual rhythms, likes stripes, for example, tend to attract the viewers' attention away from the narrative and its progression, which is contrary to the rules of classical Hollywood style (Borwell et al. 1988: 1–87) still dominant in mainstream cinema and which Jarmusch had learned when working with Nicholas Ray. To quote but a few examples, in *Coffee and Cigarettes* (2003), the credits are made of black-and-white screens that alternate according to the beat of the "Louie, Louie" song. The equivalence between musical rhythm and visual rhythm is included in the spectatorial contract drawn by the opening frames. Indeed, the film is fraught with black-and-white checkered patterns, which compensate for the virtual absence of rhythmic music in the rest of the film. They also provide some visual structure where the rest of an episode is very loose narratively and largely unscripted. The film seems to follow Chopin's advice to pianists that "their left hand should be a strict conductor, while their right hand could do as it liked" (Belic 200: 219).

In the incipit of *Down by Law* (1986), the music is essentially about voice, including timber and melody but nearly devoid of a beat, while the image creates a steady and very obstinate visual rhythm due to a long tracking shot along wooden houses and gardens. As it is the very beginning of the film, one is carried away and into the fiction along the lines of houses. The alternation between houses and gardens becomes rhythmical since we stay at the same distance and we have no cues that would help us see the houses as the abodes of any character: they are just shapes on the screen. This time melody is in the music while rhythm is predominantly in the image. The extended duration of the sequence – more than two minutes – makes the alternation more tangible. When, after a cut, the camera continues to track along graves, and spaces between the graves, then the pessimistic transformation of houses into graves feels like an easy metaphor, enhanced by the continued song and visual rhythm.

## *Mystery Train*: music and ideology

In *Mystery Train* (1989), Jim Jarmusch affirms the centrality of music for him, as well as its link with ideology, thanks to a rather simplistic statement: "for me the beautiful things about America [. . .] almost all have grown out of a multiethnic synthesis. I mean, rock & roll" (Da Silveira 1996). In *Mystery Train*, he proceeds to foreground and debunk the figure of Elvis and to defend the black musicians whose style Elvis had emulated. Indeed, there was a plethora of famous black Rockabilly musicians in Memphis in the 1950s; when Elvis sang cover versions of their songs or copied their style, this very style became popular and it increased black singers'

fame. It was both theft and publicity (Assayas 2000: 192–197). In her discussion about Presley's supposed theft, Martha Bayles summarizes:

> Racists attacked rock and roll because of the mingling of black and white people it implied and achieved, and because of what they saw as black music's power to corrupt through vulgar and animalistic rhythms. [. . .] White cover versions of hits by black musicians [. . .] often outsold the originals; it seems that many Americans wanted black music without the black people in it.
>
> (Bayles 1996: 22)

The film circles around these issues thanks to its repeating form (Stam et al. 1992: 121): three episodes that show the same period of diegetic time successively, through the eyes of three different set of characters, as if giving three different points of view of the same moment.

In the first episode, the Rockabilly fans visiting Memphis are Japanese and not American. To them, Rockabilly is a way to have their own style to free themselves of the rules of traditional, mainstream Japanese society, by donning Rockabilly outfits complete with a pompadour and black leather jackets. But at the same time, Rockabilly was the music imported by Americans during the war: what it means to be a rock fan becomes difficult to assess, as it may signify both independence from traditional Japanese society or kowtowing to America – Japan's victor. The value of music for the two characters is both central to their identity yet covered in a thin layer of irony.

The ideological attack on Elvis's music is first thematized in narrative elements. Elvis is everywhere in the film, but every time he appears, he is held up to ridicule – for example, when the bellboy and the hotel manager discuss how much Elvis would have weighed if he had been on Jupiter at the time of his death [18']. This discussion mixes several levels. It refers to his obesity thanks to scientific data which help them to fathom this abnormal weight. Instead of being "a star" whose body is admired by fans, Elvis mockingly becomes a dead weight subjected to gravitational forces. Moreover, there are at least sixteen manifestations of Elvis throughout the film. In addition to the discussion about Elvis's weight and to an urban legend about his hitch-hiking ghost [47:45–51:50], he is verbally mentioned three times, his songs are heard five times, twice for *Mystery Train*, once sung by himself [2:09–4:37], the other by Junior Parker [1:47:09–1:49:04] and three times for *Blue Moon* [34:36–36:06], [1:04:54–1:07:28], [1:26:50–1:28:22]. He is seen in the form of a statue [15:58], three portraits, a ghost [1:05:31–1:06:18] and a lookalike. All these occurrences are repetitive and heavy-handed, yet they do not erase the African American singers' presence.

Conversely, the film defends the presence of African American musicians by showing how numerous they are. For example, the Japanese boy utters a long list

of African American musicians' names – "Roy Orbison, Howlin Wolf, Jerry Lee Lewis, Carl Perkins" [15:50]. His girlfriend opposes this multiplicity by saying a unique name: Elvis. In the same way, there are only two songs by Elvis in the film, but they are repeated several times, while African American singers are heard through various unrepeated songs. The film represents Elvis's domination as a star that creates a lot of repetition, while the African American singers remain multiple, varied and scattered: it is left to the spectator to account for that ideologically speaking.

## Music and film form

In Jarmusch's early films, it was difficult for spectators to identify with characters – especially in *Permanent Vacation* (1980). But "from *Mystery Train* onwards, this distancing diminishes to the benefit of a more humane and sentimental understanding of his characters" (Viejo 2001: 57).[3] We contend that this spectatorial identification is facilitated by music.

At the beginning, the characters listen to Elvis's "Mystery Train" song in their headphones, making it clearly intra-diegetic. As the music becomes louder and clearer when the image changes to the title card reading "Mystery Train", it loses its links with a diegetic source and becomes acousmatic (or non-diegetic). By collapsing diegetic with non-diegetic, it performs a form of suture through music. According to Slavoj Zizek, in the phenomenon of suture "the trickery thus resides in the fact that the gap that separates two totally different levels – that of the enunciated content (the narrative fiction) and that of the decentered process of enunciation – is flattened" (Zizek 2001: 30).

Here the enunciated content is the onscreen music, whereas the enunciative agency is felt in the non-diegetic music: the collapsing of both immerses us in the film and brings us close to the characters who are, like us, listening to the music. We lower our barriers, we tend to be less critical. We expect that the music "carries with it traces of plenitude, wrapping film content in a kind of nostalgia" (Kalinak 2010: 27): thus we become more sensitive to the tracking shot letting us see defaced landscapes with car scrapyards and more generally a derelict Memphis.

At some point, music seemingly contributes to a "fullness of experience" (Kalinak 2010: 27): after the Japanese couple's lovemaking, we can hear Elvis's mellow song "Blue Moon". However, this comfort is immediately taken away when Mitusko calls "June" exactly when the song says "moon" and makes the romantic moment slightly over the top. So the music builds identification and filmic continuity, but does so in a very ambiguous way that subtly cracks the wholeness of the filmic world and our adhesion to it.

The most striking musical pattern in *Mystery Train* is linked to three themes that are very repetitive and accompany the characters as they walk or drive along the

streets and are laterally tracked by the camera. In these sequences, which individually last from 50" to 170", the repetition in the music is equivalent to the visual repetitions in the images. In other words, there is *a* musical rhythm and visual *rhythms*. In the first episode [9:51–10:41] [13:04–15:06], the visual rhythms depend on the duration of the tracking shot. They are due to the alternation house/garden and the perpendicular street in between. The second episode contains two walking sequences ([43:23–44–33] and [46:30–47:20]). In the first of those, when Louisa walks along a fence the bars also create an additional visual rhythm. Moreover, the binary rhythm of the characters' walk is an extra layer added to the rhythm of the music. All of this creates a polyrhythm without any arresting notable points of synchronization where the characters' walk, the music, the houses would coincide in a striking way; on the contrary the rhythms create a general ambulatory tempo and everything flows fluidly, giving an effect of duration, and aimless wandering (Murillo 2012a: 235).

In the third episode there are no walking sequences but several driving ones. They portray successively three friends driving to a liquor store, these men being shocked after one of them (Johnny) has shot the store owner, and then getting progressively drunk as they drive around in search of a hideout. One of these driving sequences [1.24:00–1:25:40] is accompanied by a tune that is even more repetitive than the standard blues patterns in the previous episodes. Here the image contributes to repetition thanks to the routine of passing a bottle of whisky around, and to the blackouts that separate each round. Here again the superimposed rhythms enhance the passing of time.

In all these sequences, lack of aims or direction and lost time tend to emphasize the lack of meaning, both for the characters and the spectators, who could even experience boredom. On the other hand, these sequences give the film a clear organization. Each episode has walking (or driving sequences) with repeated blues patterns that finish neatly at the moment when the sequence ends. Moreover, each episode finishes with the same brief and conclusive track made of two chords.

The blues score is well adapted to the place and goes hand in hand with the meaning of the film and the way the characters move. But the way the music tunes are placed in the different episodes contribute to the esthetic of the repeating form mentioned earlier. A quite unusual way of showing events, the repeating form leads us to see thrice the same stretch of time in the same town. But it takes a while for viewers to understand how the film is structured. When the spectators finally realize they are watching the same moment in the same town, it is a reward for them, increased by the perception of the very formal musical organization.

Instead of enjoying the blues, of pining for dead Elvis or being angry at forgotten bluesmen, we experience the pleasure of understanding, for example, who shot a gun in the first episode, but mostly we can see the film as a form that is complete and satisfying, yet whose in-depth meaning remains elusive.

While it is generally admitted that film music is a carrier for emotion, here it works exactly in the opposite way. We are led to experience a mental, non-emotional, sense of wholeness, a dry satisfaction.

Pushing this one step further, we see that the film becomes an empty form, which furthers the film's criticism of Elvis and Memphis. Indeed, we learn little about Elvis even if his presence pervades the film.

<p style="text-align:center">***</p>

Born and bred on the DIY egalitarian ethos of the Downtown scene and the Punk movement, Jarmusch uses music as cinema. In many of his films, the essential musical elements, such as rhythm, melody and harmony, are also to be found in the image. This fluid use of music changes the meanings that can be derived for film music. For example, its contribution to suturing the filmic world is very ambiguous, leaving slight gaps. Jarmuschian music definitely does not provide fullness of emotion, thus it goes against the mainstream style on the formal level. It serves progressive values (such as anti-racism) in subtle ways. For example, *Mystery Train* foregrounds the black musicians Elvis had overshadowed. And most importantly the musical organization in this film contributes to the perception of the film as an empty shape that shows the hollowness of Elvis's myth.

## Notes

1 My translation of "L'ostinato peut être défini, au sens strict, comme l'ensemble des répétitions ininterrompues d'une seule et même structure rythmique inscrite au sein d'une périodicité, cette structure rythmique pouvant être associée à un autre paramètre, tel que les hauteurs et ou l'harmonie".
2 My translation of "Lorsqu'on prête l'oreille à un échantillon monté en boucle dans l'unicité de ses deux ou trois mesures, isolées de leur contexte, il arrive qu'on soit frappé par le caractère foncièrement mélodique du fragment prélevé, ligne de guitare, de trompette, de vibraphone ou de piano à l'organisation horizontale où les notes se succèdent (mélodie) plus qu'elles ne se chevauchent (harmonie). Or, par le jeu de l'itération technologiquement maîtrisée, le caractère mélodique de la petite phrase élue se résorbe et prend soudain une dimension rythmique qu'à l'origine elle ne possédait pas".
3 A partir de Mystery Train (1989) dicho distanciamiento ira dismuyendo en favor de una compression mas humana y tambien mas sentimental de sus personajes.

## Bibliography

Allen, D. (2011) Rockabilly Culture in Japan. *Outsider Japan*. Available online: outsiderjapan.pbworks.com/w/page/36069962/Rockabilly Culture in Japan [Last Accessed 22/11/19].
Andrew, G. (2001 [1999]) Jim Jarmusch Interview. In: L. Hertzberg (ed.) *Jim Jarmusch Interviews*. Jackson: University Press of Mississippi.
Are You a Boy or Are You a Girl? *Let your Backbone Slip!* (1995) [MUSIC] Wayne County & the Electric Chairs. USA: RPM.
Assayas, M. (2000) *Dictionnaire du Rock* (Vol. 2). Paris: Robert Lafont.

Aumont, J.; Begala, A.; Marie, M.; Vernet, M. (2004) *L'Esthétique du Film*. Paris: Armand Colin.

Bayles, M. (1996) *Hole in Our Soul: The Loss of Beauty and Meaning in American Popular Music*. Chicago, USA: University of Chicago Press.

Belsito, P. (2001 [1985]) Jim Jarmusch. In: L. Hertzberg (ed.) *Jim Jarmusch Interviews*. Jackson: University Press of Mississippi.

Bertrand, M. (2000) *Race Rock and Elvis*. Urbana and Chicago: University of Illinois Press.

Béthune, C. (2003) *Le Rap: une esthétique hors la loi*. Paris: Autrement.

Blue Moon. (1956) [MUSIC] Elvis Presley. USA: RCA Records.

Borwell, D., et al. (1988) *The Classical Hollywood Cinema: Film Style & Mode of Production to 1960*. London: Routledge.

Chion, M. (1994) *Audio-Vision*. New York: Columbia University Press.

Da Silveira, L. (1996) Jim Jarmusch on *Dead Man*, God, Sam Peckinpah and Harvey Weinstein. *LA Weekly*, 17–23 May. Available online: www.jim-jarmusch.net/films/1995__dead_man/read_about_it/jim_jarmusch_on_dead_man_go.html [Last Accessed 10/09/08].

Doty, P. (1975) Public-Access Cable TV: Who Cares? *Journal of Communication*. 25(3). p. 33.

Galvin, K. (2013) TV Party: Downtown New York Scenes Live on Your TV Screen. *Journal of Popular Music Studies*. 25(3).

Girard, J. (2010) *Répétitions, l'esthétique musicale de Terry Riley, Steve Reich et Philip Glass*. Paris: Presses de la Sorbonne Nouvelle.

Harlan Jacobson. (1985) Three Guys in Three Directions. *Film Comment*, February.

Janes, B. (1987) History and Structure of Public Access Television. *Journal of Film and Video*. 39(3).

Jones, C. (1946) Music and the Animated Cartoon. *Hollywood Quarterly*. 1(4, July).

Kalinak, K. (2010) *Film Music: A Very Short Introduction*. New York: Oxford University Press.

Murillo, C. (2012a) L'Ostinato chez Jim Jarmusch: rythme/ mouvement/ machine. *Champs du signe*. 32.

Murillo, C. (2012b) *The Limits of Control* (Jim Jarmusch, 2009): An American Independent Movie or a European Film? *Immedia*. 1. Available online: https://journals.openedition.org/inmedia/129 [Last Accessed 21/01/19].

Myles, L.; Pyle, M. (1979) *The Movie Brats: How the Film Generation Took over Hollywood*. New York: Holt, Rinehart & Winston.

Mystery Train. (1953) [MUSIC] Elvis Presley & Junior Parker. USA: Sun Records.

Platinum Blonde. *Blondie*. (1976) [MUSIC] Blondie. USA: Private Stock.

Psycho Killer. *Talking Heads 77*. (1977) [MUSIC] Talking Heads. UK: Sire.

Reekie, D. (2007) *Subversion, the Definitive History of Underground Cinema*. London: Wallpaper.

Reynolds, S. (2005) *Rip It Up and Start again 1978–1984*. New York: Penguin.

Rombes, N. (2005) *New Punk Cinema*. Edinburgh: Edinburgh University Press.

Rusher, W. (1978) Bankruptcy for New York City? *Human Events*. 38(12).

Schnapper, L. (1998) *L'Ostinato Procédé Musical Universel*. Paris: Honoré Champion.

Siegle, R. (1989) *Suburban Ambush: Downtown Writing and the Fiction of Insurgency*. Baltimore: Hopkins University Press.

Smalley, D. (1986) Spectro-Morphology and Structuring Processes. In: S. Emmerson (ed.) *The Language of Electroacoustic Music*. Basingstoke: Macmillian Press.

Stam, R.; Burgoyne, R.; Flitterman, S. (1992) *New Vocabulary in Film Semiotics*. New York: Routledge.

Stark, C. (2001 [1985]) The Jim Jarmusch. In: L. Hertzberg (ed.) *Jim Jarmusch Interviews*. Jackson: University Press of Mississippi.

Suarez, J. (2007) *Jim Jarmusch*. Urbana and Chicago: University of Illinois Press.

Taylor, M. (ed.). (2006) *The Downtown Book*. Princeton and Oxford: Princeton University Press.

*TV Party*. (2005–2008) [TV SHOW] Poe, A.; O'Brien, G. (dirs.).

Viejo, B. (2001) *Jim Jarmusch y el sueño de los justos*. Madrid: Ediciones J.C.

Zevin, R. (1977) New York City Crisis: First Act in a New Age of Reaction. In: R. Alcalay; D. Mermelstein (eds.) *The Fiscal Crisis of American Cities: Essays on the Political Economy of Urban America with Special Reference to New York*. New York: Vintage. pp. 11–29.

Zizek, S. (2001) *The Fright of Real Tears*. London: BFI.

# The new analogue
## Media archaeology as creative practice in 21st-century audiovisual art

Joseph Hyde

## Introduction: retro culture and media

The work discussed in this chapter is part of a trend towards retrospection, where cultural artifacts and aesthetics from previous eras are resurrected and repurposed. This phenomenon can be seen throughout history and is arguably part of human nature. However, this chapter argues that it has been accelerated by (broadcast, recorded, live) media, here discussed particularly with respect to contemporary audiovisual practice.

It positions this as the second part of a cultural revolution brought about by the rise of mass media. The first, associated with the normalization of television as a cultural force during the 1960s and 1970s, fostered an idea of collapsing (geographical) boundaries. This can be seen in the commentary of Marshall McLuhan – in particular his ideas around the 'global village' (McLuhan 1964) – and in artworks such as Stan Vanderbeek's *Movie Drome* (Vanderbeek 1966) and Nam June Paik and John Godfrey's *Global Groove* (Paik and Godfrey 1973).

In the 1980s, the widespread adoption of video recording technology caused a similar collapsing with respect to time, making vast tranches of cinematic history asynchronously available from the nearest video store, and positioning home videos as the first widely available form of user-generated content and personal archives.

The cultural effects of media have been accelerated by the adoption of digital technology, which has made them accessible to the point of ubiquity and collapsed media history to an unprecedented degree. The World Wide Web has made it available, almost in its entirety, at the click of a mouse. One effect of this has been to further encourage the recycling of media in ever more complex and nuanced forms of retro culture.

Although this chapter focuses on the use of analogue technologies implied in its title, it starts its discussion in the proliferation of digital media which this 'analogue

turn' reacted against. It argues that the combination of analogue and digital techniques is particularly fertile territory for this area of practice, and theorises that a new kind of materiality of sound and light (transcending the duality of analogue or digital) is emerging.

## Aesthetics of (digital) failure

Early domestic digital media, such as the CD (brought to market in 1982), were marketed largely on their capabilities for high-fidelity reproduction. In comparison to the analogue media of the time, which were associated with undesirable artifacts, they offered a dream of infinite copy generation, with a copy (or a copy of a copy) being identical to the original.

While digital media were sold as the ultimate destination of 'hi fi' development, this was immediately challenged by artists, musicians and other enquiring minds. Their duplicability and 'perfection' was seen as a challenge by artists who found methods to subvert media and positively encourage error. Artists such as Yasanao Tone and Oval found ways to 'wound' CDs (Tone 1997), a process which would proliferate across other media and define a phenomenon and cultural movement known as Glitch. This can be seen as part of a long tradition of technological subversion in music (technology), including tools and techniques such as vinyl scratching, the prepared piano and the electric guitar. Whilst there was nothing explicitly retrospective in Glitch, it signaled a fallibility, and perhaps humanization, of technology which was to become important to much of the work discussed here. In particular, it established an aesthetic framework where errors highlight qualities unique to a particular medium, and therefore represent the authentic 'voice' of that medium in a new kind of materiality. These ideas and others were captured in Kim Cascone's seminal paper 'The Aesthetics of Failure: "Post-Digital" Tendencies in Contemporary Computer Music' (Cascone 2000), which can be seen as an early theoretical touchstone for the field of practice covered here.

Glitch was primarily an audio phenomenon, but Glitch aesthetics filtered through into the visual domain. It can be seen in the visual aesthetics of many music videos made for electronic music producers of the era, for example those directed by Chris Cunningham and Alex Rutterford. *Zoetrope*, an audiovisual work produced by the author of this chapter in 1998, explicitly attempted to explore an audiovisual aesthetic of failure, 'use and misuse; abuse, breakdown' across audio and video (Hyde 1998). More recently, a kind of visual Glitch language has been employed in the datamoshing phenomenon, where low-level software hacks are used to break and subvert the CODECs used by internet video platforms such as YouTube.

## Glitch to Hauntology: the analogue turn

The problematisation of digital technology's perfectionist dream was kindled by the experimentalists of Glitch, but can also be seen in mainstream music production. Here, it centred around a dialogue characterising digital media as alienating and 'cold' in comparison to the 'warm' qualities perceived in analogue media (and the older recorded material with which it was associated). The origins of this idea can perhaps be found in the crate-digging ethos of early East Coast Hip Hop, and its widespread adoption in the 1980s coincides not only with the rise of digital media, but also the widespread adoption and influence of Hip Hop. This can be seen for example in the career of producer Rick Rubin, who worked with New York–based Hip Hop artists in the early 1980s, had a crossover Rock/Hip Hop hit in Run DMC and Aerosmith's *Walk This Way* in 1986, and then went on to work with mainstream Rock, Country and Pop artists such as Johnny Cash and the Red Hot Chili Peppers, taking a pared-back, analogue production approach with him.

In the 1990s, this analogue nostalgia in popular music became more overt. It can be seen in the Trip Hop movement, which exaggerated the retro aesthetics of Hip Hop, highlighting the detritus and noise of (particularly older) technology and the erosion and decay of material, with a kind of melancholic nostalgia in mind. This can be seen in the production style of the British band Portishead, who went to considerable lengths to build these elements into their music, for example cutting material to dubplates and then distressing these records considerably before sampling them (and scratching and cutting them further).

Hip Hop aesthetics can also be seen in the early VJ scene emerging at around the same time. We see a direct equivalent of sampling in the use of 'plundered' video loops, and a similar set of aesthetic choices, where old and rare footage is sought after. VJ pioneers such as Hexstatic and Emergency Broadcast Network used audiovisual samples and breakbeats, relying on the cultural resonance of the repurposed material to add a narrative dimension to their work. This idea is taken further in the work of Vicki Bennett (*People Like Us*), who pioneered a unique kind of audiovisual collage in works such as *Story Without End* (Bennett 2005), based on old public information films collected in the Prelinger Archive (Figure 13.1).

Electronica duo Boards of Canada explored melancholic aesthetics similar to Trip Hop at around the same time. The elements of their musical language are very different, however, consisting of abstract soundscapes, woozy vintage synths and samples from 1960s information documentaries – the resultant sound is a kind of re-imagination of the work of the BBC Radiophonic Workshop in the 1960s and 1970s. This 'lost future' has become a vital force, particularly in the UK. British record label Ghost Box represents this niche prominently – many of their artists (examples being Belbury Poly, Pye Corner Audio and The Advisory Circle) could be characterised as occupying this kind of neo (perhaps alt-) radiophonic territory. The label

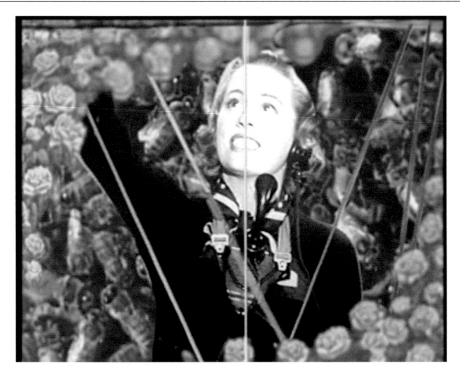

**Figure 13.1**    Still from *Story Without End, People Like Us.*

is represented by a strong visual aesthetic, referencing the artwork of 1960s Penguin paperbacks and children's Ladybird books and other memorabilia. This aesthetic territory has been explored writ large in the *Delaware Road* festival, which has had three iterations since 2006, featuring several of these artists. The festival, founded by Alan Gubby and mounted in unusual locations (including a nuclear bunker and a military base), combines retrospective audiovisual aesthetics with pagan imagery, and an occult mythology built around pioneers of the Radiophonic Workshop.

A younger generation of artists are exploring similar ideas but with a more recent set of reference points. Where Boards of Canada (mis)remember the VHS documentaries (with radiophonic soundtracks) they watched in the classroom, artists such as Burial and Zomby take a similar deconstructive and nostalgia-laden approach to the sounds of 1990s pop and dance music. In a parallel development, Vaporwave grew up alongside other niche internet-based genres chillwave and synthwave in the early 2010s. It is somewhat difficult to define, and is perhaps closer to an internet meme, or 'in joke' than it is to some of the other areas explored in this chapter. Nonetheless, it is a convenient shorthand for a field of contemporary aesthetics which centres around an ironic appropriation of 1980s and 1990s music styles such as lounge music, smooth jazz and R&B, influenced in particular by mainstream consumer capitalism and

advertising, and with a knowing and ironic take on its sources. These musical tropes are often accompanied by visual material that explores similar stylistic territory, emulating 1980s and 1990s video technology and early computer graphics and web design.

A number of artists take a more conceptual approach to the erosion of media with these creative ends in mind. Philip Jeck explicitly (but perhaps prematurely) mourned the death of vinyl records in his seminal *Vinyl Requiem* (1993), which employed a bank of 180 Dansette Record Players to produce a 'wall' of sound in which the signature crackle and hiss of vinyl became more dominant than the music encoded on the records themselves. In works such as *Disintegration Loops* (2002 onwards), William Basinsky works with tape loops, and runs these loops through reel-to-reel tape recorders until they disintegrate, producing an increasingly 'broken' and distorted sound and – eventually – long periods of silence.

These retrospective trends were distilled and defined as *Hauntology* by Jacques Derrida (Derrida 1993), with this term achieving wider coverage in the 2000s, where writers such as Mark Fisher and Simon Reynolds used it to describe work which explored a 'nostalgia for lost futures' (Gallix 2011). Several writers have argued that this type of Hauntology can be seen as a descendent of Glitch (Holmes 2010), exploring the ideas of the latter but in a broader context. Certainly it can be seen that there is a similar concern with the material nature of technologies used in art-making, and how those tools might be deconstructed (sometimes literally).

## Maker culture

There is considerable overlap between these aesthetic trends and the 'maker culture' which has become widespread in the last decade. One area of activity involves lo-tech modifications to existing hardware, known as Circuit Bending (Ghazala 2005) or Hardware Hacking (Collins 2006). Anyone foregrounding, questioning and subverting technology as a means is likely to be interested in interventions and hacks to this technology, and this approach can clearly be seen as another extension of the ideas behind Glitch.

For the purposes of this chapter we will limit ourselves to a handful of examples, specifically connected with audiovisual practice. One of the simplest and most fundamental subverts the basic electronic signals that comprise analogue audio and video, using a technique sometimes known as Composite Cramming (ibid.). It involves the use of standard definition composite video connections (now essentially obsolete) being cross-wired into the audio domain. Experienced as audio, these signals betray their origins, dominated by the 50Hz (PAL, 60Hz if NTSC) rate of the raster scan on which the TV signal is based, with the finer content of the image manifesting as pseudo-harmonics. Carefully chosen material, often involving repetitive patterns within or between frames, can sometimes yield quite legible audiovisual relationships. The reverse configuration is possible, where audio signals are read as video. However, it is

more difficult to produce 'legible' results. Any arbitrarily chosen audio signal is likely to yield chaotic, glitchy and noisy material, or indeed nothing at all as the video circuitry might designate it an invalid signal. The author of this chapter's work *End Transmission* (Hyde 2009) attempts this, and is built entirely around various composite cramming techniques, working in both directions between audio and video. Additional distortions are produced by transmitting and receiving these signals using short-range UHF transmitters/receivers, in a system where audio and video signals interfere which each other, and even with the movements of the artist while making the work (Figure 13.2).

Working at the low level of composite cramming, it is even possible to 'mix' video signals, albeit in a highly unpredictable and unstable way. This can be seen in the 'dirty video mixer' circuit designed by Karl Klomp, a very simple circuit capable of interesting if very glitchy results, ideal for building in DIY workshops. Deriving a coherent video image from an audio signal is complex, however, because it relies on synchronisation with the raster of the video display. Such synchronisation is at the heart of analogue video synthesis, which has enjoyed a rebirth in the last decade, based around new tools ranging from the lo-tech to complex and expensive solutions.

Jonas Bers's CHA/V (Cheap Hacky A/V) project, also the basis for many DIY workshops, allows for simple synchronisation (though it can also function without). This an

**Figure 13.2** Still from *End Transmission*, Joseph Hyde.

open source circuit for a simple video synthesiser which can be built with little expert knowledge and minimal expense. One of the key advantages of this circuit is that it is built around an existing device – a VGA signal generator. These are widely available and at minimal expense, so that a CHA/V video synthesiser can be built for under $10 at current prices. Another, slightly more expensive, device is the Synchronator, designed by Bas van Koolwijk and Gert-Jan Prins. The Synchronator simply adds video synchronisation and colour signals to an audio signal (with no other controls) to allow audio signals to be passed into the video domain with reasonable image stability. A companion device, the ColorControl, allows further control over colour (hue and saturation), and an HD version of the Synchronator is offered alongside the standard SD model. Another approach is offered by Netherlands-based artist Gijs Gieskes. Gieskes has designed a number of circuits for video production and manipulation (alongside many for audio and other purposes). Of particular note is the 3TrinsRGB+1 device, which represents a fairly fully featured video synthesiser at a price point below anything comparable. This device is available in various forms – Gieskes himself supplies PCBs and full kits for home builds, where various third parties offer fully built solutions.

## Modular systems

Much of the work discussed in the previous section relies on a 'hacker' approach, and the willingness of artists to build – or rebuild – their tools. This has offered an alternative to the 'black boxes' represented by commercial software and hardware, but there is room between these two poles. In the late 1990s, new areas of technology development offered a more modular approach, where building blocks could be assembled into bespoke systems without the need to wield a soldering iron or write code. This can be seen in computing in the emergence of 'physical computing' platforms such as the Arduino and modular coding environments such as Max/MSP and puredata, all of which have a place in contemporary AV practice.

Perhaps the most striking example can be seen in the re-emergence of modular synthesisers, and the establishment of the Eurorack standard, defined by Doepfer Musikelektronik in 1996. The latter is important because it allowed a huge explosion in this area, and a new approach: where in the modular synthesisers of the 1960s and 1970s, the modules making up such a synthesiser would generally be produced by one manufacturer (by necessity, in the absence of any standard), Eurorack allowed users to build bespoke instruments out of modules from a variety of companies. More importantly, it fostered the emergence of 'boutique' manufacturers, who might produce only one or two very specialised or idiosyncratic modules. It involved the musician directly in the design of their own instrument, and offered opportunities for a DIY approach (with many modules available as build-your-own kits, or open-source schematics).

The new modular synthesiser rapidly made an impact on the visual domain too. Alongside the emergence of companies making small-run audio modules, a number

of manufactures have started to make modules for video synthesis. The most prominent of these is LZX Industries, founded by Lars Larsen (US) and Ed Leckie (Australia) in 2008 and now based in Portland, Oregon. The company produces stand-alone video synthesis units such as the Vidiot, but is perhaps best known for its video synthesis modules. It makes a wide variety of such modules, covering most aspects of video synthesis, venturing into other areas such as laser control (through its Cyclops module), and including a large range of DIY modules in its Cadet range.

Perhaps most importantly, it has established a standard for video synthesis modules. This format is similar in many ways to the Eurorack standard – the physical specification is identical, and while the electronic specification is not, it is fairly easy to mix Eurorack and LZX-standard modules, and to convert control signals (where necessary) from one standard to the other.

A number of other manufacturers (or individuals) are worth mentioning here. Nick Ceontea, operating as *brownshoesonly*, offers a small number of modules designed to the LZX specification. Video synthesis pioneer Dave Jones is working towards a full video synthesiser system, but in the meantime produces the MVIP module. Unlike the LZX series, this module is designed with Eurorack-format control voltages in mind, and is essentially offered as a stand-alone solution to add video functionality to a Eurorack system.

A number of communities have grown up around these instruments and systems. These were first established in the US, where the Experimental Television Centre grew out of the media access programme founded by Ralph Hocking at Binghamton University in 1969, and moved to Owego, New York in 1971. The ETC was responsible for the development of many early video tools such as the Paik/Abe Video Synthesizer, the Rutt/Etra Scan Processor, and a suite of tools built by Dave Jones, and hosted video artists such as Steiner and Woody Vasulka, Gary Hill and Shigeto Kubota (High et al. 2014). The ETC wound up its residency programme in 2011, but Signal Culture, also housed in Owego, continues to offer facilities to artists, including some of the same tools.

The UK also has a long history of such communities, such as London Video Arts, which was founded in 1976 and (after a number of changes of name and focus) merged with the London Film-Makers Co-op in the late 1990s to eventually become LUX in 2002. A more recently founded community, Video Circuits, run by Chris King first as a blog and now as a Facebook group brings together some of the pioneers of analogue video with many younger practitioners. It is currently the most active such group online, with over 7,000 members at the time of writing.

## Cracked ray tubes

Some of the interest in analogue video is wrapped up in the unique aesthetics of the cathode ray tube, and methods to hack or 'crack' (Kelly 2009) this technology. This can be seen in parallel to video synthesis in historical terms, with video art pioneer

Nam June Paik (for example) as interested in the aesthetics of television sets themselves as the images they display.

The hacking affordances of TVs are somewhat limited, however, due to the complexity of the imaging process. Images are formed by means of a raster scan, where an electron beam is electrostatically deflected to form a synchronised pattern of scan lines. The Raster Manipulation Unit, colloquially known as the Wobbulator, developed by Paik with Shuya Abe in 1968, built on Paik's earlier experiments with magnets, and employs copper wire coils wound around the cathode ray tube of a black-and-white TV to further deflect and distort the scanned image. This is a fairly involved, and indeed dangerous process (due to the high voltages involved), but several contemporary versions of the device have been built. One is at Signal Culture, where Jason Bernagozzi and Dave Jones also developed a version based on a colour TV (Figure 13.3).

Working as *Cracked Ray Tube*, James Connolly and Kyle Evans 'explore the latent materiality of analog cathode ray tube televisions and computer monitors' shared using an open 'maker culture' approach based on video tutorials and hands-on workshops. One of their tutorials allows the raster scan of a TV to be bypassed. It effectively turns a raster-based TV into a vector monitor, where the horizontal and vertical positions of the electron beam are arbitrary and can be directly controlled using variable voltages, or indeed audio, making it much more open in terms of creative misuse. Vector monitors are most commonly found in oscilloscopes and have been used for 'oscilloscope music',

**Figure 13.3**   The Colour Wobbulator at Signal Culture.

Source: Photo: Joseph Hyde.

or 'oscillographics' since the 1950s, when Mary Ellen Bute developed a kind of lexicon for aesthetic visual representations of sound in works such as *Abstronic* (Bute 1952). During the 1960s and 1970s, oscillographics was a regular mainstay of popular electronics magazines. Its current resurgence includes the work of Australian artist Robin Fox, whose oscilloscope-based DVD 'Backscatter' was released in 2004. It arguably hit the mainstream through the work of Jerobeam Fenderson, whose YouTube videos went close to 'going viral' in 2014. A set of techniques for this practice has been defined by Derek Holzer (Holzer 2019), who has also been instrumental, with Ivan Marušić Klif and Chris King, in producing the Vector Hack festival centred on this practice.

A particularly vibrant hacker 'scene' has grown up around the GCE/MB Games Vectrex videogame console. The Vectrex, commercially available only from 1982 to 1984 and not commercially successful, is the only domestic video console to be based around a vector display. Its design is a clear digital/analogue hybrid, with one circuit board built around a microprocessor to run the game software, and one based on analogue circuits to drive the CRT display. The two boards are connected by three control voltages, controlling the X (horizontal deflection), Y (vertical deflection) and Z (brightness) of the electron beam. A simple hack is therefore possible, by means of disconnecting these signals and substituting others. Within certain constraints, audio works well, allowing the Vectrex to be used as a kind of oscilloscope, but with an image quality all of its own. This practice, established by Lars Larsen (based on earlier experiments with the console within the gaming community) in 2012, has become a mainstay of the Vector Synthesis community and has been well documented by Andrew Duff (an example of Duff's work with the Vectrex can be seen in Figure 13.4).

**Figure 13.4**   Vectrex Performance System v.1 – Andrew Duff
Source: Duff 2019.

## Light and sound materiality

The dialogue between analogue and digital, and the focus on technology implied therein, has perhaps run its course. In the 21st century, we see a new interest in working with sound and light as physical materials as opposed to electronic signals or media. We can observe a resurgence in sound art which explores physical space and acoustic phenomena. We can also see an equivalent burgeoning interest in the materiality of light.

Light has been explored through tantalising experiments in Colour Music and Lumia for centuries, and of course has always played a role supporting music and theatrical performances. Its use achieved a breakthrough in the context of the 1960s psychedelic movement, and the evolution of the light shows that accompanied performances by the biggest bands of the era, such as The Grateful Dead, Jefferson Airplane and Frank Zappa and the Mothers of Invention. These performances usually involved an overhead projector, and a set of interventions on the beam of this projector (typically involving glass containers and coloured liquids of various kinds) operated in real time to produce the lightshow. Artists producing such light shows included Glenn McKay, Elias Romero and Joshua White and the Single Wing Turquoise Bird collective.

This area of practice has maintained a continuous existence, and although it was perhaps overshadowed by other means of audiovisual production for several decades, it has had a renaissance in recent years. This continuity, and resurgence, has been fostered by the Psychedelic Light Show Preservation Society, an online community now based on a Facebook group (founded by Donovan Drummond and previously centred around various other communities off- and on-line). This community facilitates a connection between younger artists engaging with the area for the first time and those who pioneered this practice in the first place. Several key figures from the early days of the psychedelic light show are active contributors to the group, such as Joshua White. As well as contributing to the community through groups such as this, White (as an example) continues to actively perform, building on his work with the giants of 1960s psychedelic music with performances with contemporary bands such as MGMT (Figure 13.5).

There are many younger artists turning to this way of working. Others are using similar ideas about light as a fluid, architectural entity in other contexts. Kathrin Bethge extends classic liquid light show techniques for use in large-scale outdoor installations and as part of theatre and dance productions (she also performs as part of several audiovisual ensembles with leading contemporary musicians). Mark Weber, aka MFO, works across a similarly broad range of contexts. He combines some of the techniques of the liquid light show with digital tools, and his work generally explores light as a volumetric and immersive element as opposed to a projection (onto a surface). An example of this is his light show for Australian producer

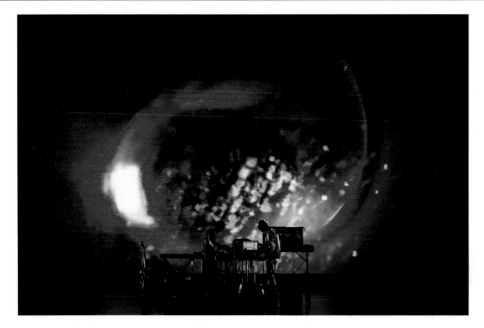

**Figure 13.5**   Joshua light show with MGMT 2002.
Source: Photo: Stan Schnier.

Ben Frost's A U R O R A tour, and his work as Director for Lights and Visuals of Berlin's Atonal festival has helped establish this kind of practice as a vital force in contemporary audiovisual performance.

A natural extension of the practice employed in Vector Synthesis is the use of lasers, usually in the form of ILDA (International Laser Display Association) specification RGB laser projectors. Such laser projectors cannot be described as obsolete technology – indeed they are in a somewhat febrile period of development where improved diode-based technologies are driving up the power and brightness of the beams while driving down the size and cost of projectors. The use of lasers, usually using specialist laser control software, is somewhat ubiquitous in large-scale live music productions. This type of practice achieves a high level in the work of high-profile groups such as the Laserium (operating in one form or another for 45 years) and Marshmallow Laser Feast. However, for the purposes of this chapter, only those taking a more hauntological, or 'cracked media' approach are discussed here.

With associations with 1980s clubs and 1990s raves, lasers are seen by some as having a somewhat retro quality, and some artists exploit this. Italian producer Lorenzo Senni's recent work is characterised by Senni as 'pointillistic trance' or 'rave voyeurism'. It deconstructs the euphoric highs of trance, house and rave music, and the use of lasers in his live shows references their (over)use in this context.

Others are finding ways of using laser projectors that are determinedly 'lo fi' and analogue. The ILDA spec includes a standardised 25-pin D-Sub connector which allows the external control of beam deflection and (colour) intensity. Although this is designed for connection to a PC, and to allow control of the laser by sophisticated software solutions (such as those offered by laser manufacture Pangolin), the actual interface technology is entirely analogue. It is therefore possible to bypass the use of existing laser control software and control the projector (x and y deflection of the beam, intensity of RGB beams) using analogue voltages. Within certain constraints (largely frequency bandwidth), audio signals can directly be used for this purpose, in a process similar to that employed in oscillographics.

Robin Fox, mentioned earlier, evolved his practice from oscillographics to the use of lasers in 2007. He has continued to explore a direct connection between sound and lasers in works such as *Single Origin Laser* (2018). Alberto Novello, aka JesterN, is an Italian scientist, composer and media artist. He is well known for his work with analogue audio synthesis, where he works as a solo artist and with senior figures in the field such as Alvin Lucier, Evan Parker and Trevor Wishart. His current work *Laser Drawing* (Figure 13.6) is again a development of earlier work using vector monitors, in this case the Vectrex.

Robert Henke's work using these techniques is particularly technically advanced. Although the lasers he uses in installation works such as *Fragile Territories* and

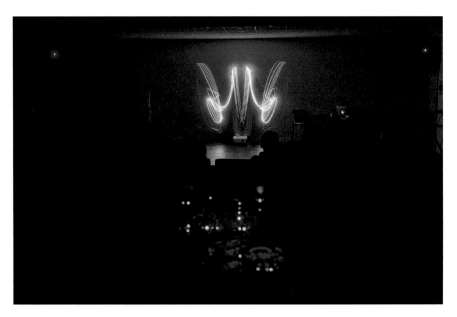

**Figure 13.6**  Alberto Novello's *Laser Drawing*.
Source: Photo: Erin McKinney.

performances such as the *Lumière* series are computer controlled, the software he uses is entirely self-built around Max/MSP and Ableton Live. The signals produced by the software are entirely in the audio domain and communications with the laser projector use analogue ILDA connectors, a potent combination of analogue and digital. Recently, Henke has also explored the structural properties of laser radiation. *Phosphor* uses an ultraviolet laser (invisible to the naked eye) and phosphor dust, with the laser leaving a 'trace of light' in the phosphor, which slowly erodes over time. *Deep Web*, with Christopher Bauder, combines lasers with a large kinetic sculpture in an environment which is exhibited both as an installation and performance space.

## Cinematic practice

It is beyond the scope of this chapter to discuss the world of cinema in general, but where it intersects with this renewed interest in the materiality of light (and sound) we can also find an undercurrent of Hauntology. The Structural Film movement of the 1960s and 1970s represented filmmakers becoming acutely concerned with the precise and unique qualities of their medium, as epitomised by perhaps the first structuralist film, Tony Conrad's *The Flicker* (Conrad 1965). Four years later in 1969, Ken Jacobs produced his best-known film, *Tom, Tom the Piper's Son* (Jacobs 1969), in which a short 1905 Biograph film is endlessly re-photographed. Of particular interest for our discussion is what Jacobs writes about it: 'Ghosts! Cine-recordings of the vivacious doings of persons long dead. Preservation of their memory ceases at the edges of the frame'.

More recently, New York–based filmmaker Bill Morrison has built an explicitly hauntological cinematic language through the use of archival film footage, which he often edits to contemporary music by well-known composers (including fellow New Yorkers Steve Reich, Philip Glass and Michael Gordon). Often he makes a particular feature of film stock which has decayed, a well-known example (with music by Michael Gordon) being his 2002 feature-length film *Decasia* (Morrison 2002).

As well as the medium itself, we see artists exploring older cinematic techniques such as stop-frame animation. An example of this can be seen in the work of Hong Kong–based artist Max Hattler. His early works such as *AANAATT* (Hattler 2008) re-imagine stop-motion animation for a 21st-century context and make a knowing and deconstructed approach to the medium. Johan Rijpma brings stop-frame animation to the texture and chaos of the real world, capturing in a phenomenological way patterns of evaporating water (Rijpma 2014b) or breaking ceramics (Rijpma 2014a). More explicitly linked to an audiovisual dialogue is *Noise*, by Kasia Kijek and Przemek Adamski (Kijek and Adamski 2011), a 'game of imagination provoked by sound' and 'the basics of synaesthetic perception', where sounds are represented in the visual domain by animated objects.

Other artists explore cinematic illusions that predate celluloid film. There are a number of re-inventions of the zoetrope, perhaps the most spectacular being Matt Collishaw's *All Things Fall* (Collishaw 2015), which uses a large-scale 3D printed sculpture to generate its effect. Jim LeFevre uses similar techniques (and coins the term 'phonotrope'), and makes use of carefully constructed 2D and 3D disks which can be played on a record turntable, extending this practice in interesting ways – for instance working with a potter to produce functional ceramics which also work as phonotropes. British audiovisual duo Sculpture work within a strongly hauntological aesthetic which makes heavy use of tape loops and delays. Their visuals are primarily based on zoetrope (or phonotrope) disks, which are controlled live by Reuben Sutherland to psychedelic effect (Figure 13.7). They have also released picture disks that function both as phonotrope and audio record, such as *Form Foam* (Hayhurst and Sutherland 2016).

One technique of particular relevance to our audiovisual discussion is Direct Sound, sometimes known as Synthetic Sound. This is a technique specific to celluloid film, with direct parallels with 'Composite Cramming' (discussed earlier). It offers a similarly literal approach to audiovisual relationships, where a signal

**Figure 13.7**  Sculpture performance with phototrope disk.

intended for one sense (sight or hearing) is experienced or interacted with using the other. In this case, the 'signal' is the optical soundtrack of celluloid film.

Optical sound was introduced in the 1920s, gradually displaced from mainstream usage by the magnetic soundtrack from the 1950s to the 1970s, but still in use today. Perhaps because an optical soundtrack is visible to the naked eye, 'hacking' this technology has proved irresistible to audiovisual artists since its inception. Many of the early pioneers of Visual Music, including Oskar Fischinger, Norman McLaren and the Whitney brothers, found inventive ways of manipulating or 'synthesising' an optical soundtrack. This technique might be considered a core part of the repertoire of structural cinema through the 1960s and 1970s, as exemplified in the work of Guy Sherwin and Lis Rhodes. It has enjoyed a continued existence and can be seen in more recent films such as Steve Woloshen's *Visual Music for Ten Voices* (Woloshen 2011) and Richard Reeves's *Linear Dreams* (Reeves 1997). It has formed a key part of the work of Bristol Experimental Expanded Film (BEEF), founded in 2015, who foregrounded it in their event *The Brunswick Light Ray Process* in 2017.

Similar techniques have been used removed from cinematic projection. There is a particularly strong tradition in this area in Russia, covered in depth in Andrey Smirnov's book *Sound in Z: Experiments in Sound and Electronic Music* (Smirnov 2013). Another example is the remarkable Oramics machine originally developed by Daphne Oram (founder of the Radiophonic Workshop) in 1957. This device was a synthesiser where the user input was via drawings made on multiple strips of film. In 2011, this work received a revival of interest around the exhibition *Oramics to Electronica* in London's Science Museum. This interest extended to an attempt to restore the machine. Although this was ultimately unsuccessful, it led Tom Richards to develop his *Mini Oramics* machine, completed in 2016 and built in accordance with Oram's never-realised plans for a portable version of her device.

## Conclusion: media (as) archaeology

This kind of practice can perhaps be seen as part of a broader discourse around media archaeology, which 'excavate[s] the past in order to understand the present and the future' (Parikka 2012: 2), and in particular views 'the new and the old in parallel lines' (ibid.), in the kind of temporal collapse discussed in the introduction to this chapter.

This taps into some of the most important sociological and environmental issues of the present day. Increasingly, the idea of technology as representing 'progress' has been cast into doubt, and deepening awareness around the climate emergency has been causing many to question the expansionist capitalist ethos it is built on. Recently, many artists working with technology have started to question the sustainability and impact of their technology usage. Where the central narrative of technological development was seen in somewhat utopian terms, people are increasingly

aware of its negative societal and environmental impacts. All these concerns make the recycling of technology attractive beyond purely aesthetic value, and are likely to see more and more artists incorporating this approach into their practice.

## Bibliography

Barbrook, R. (2007) *Imaginary Futures: From Thinking Machines to the Global Village*. London: Pluto.

Benjamin, W. (1992 [1934]) The Author as Producer. In: W. Jennings (ed.), R. Livingstone (trans.) *Walter Benjamin: Selected Writings, Volume 2 (1927–1934)*. Belknap Press of Harvard University. pp. 768–782.

Bennett, V. (2005) *Story without End*. Available online: www.ubu.com/film/plu_story.html [Accessed 15/11/19].

Bute, M.E. (1952) Abstronic. On *Visual Music from the CVM Archive, 1947–1986* (DVD). Center for Visual Music, 2017.

Cascone, K. (2000) The Aesthetics of Failure. *Computer Music Journal*. 24(4). pp. 12–18.

Collins, C. (2006) *Handmade Electronic Music*. Abingdon and Oxon: Routledge.

Collishaw, M. (2015) *All Things Fall*. Available online: https://vimeo.com/125791075 [Accessed 15/11/19].

Connolly, J.; Evans, K. (2014) Cracking Ray Tubes: Reanimating Analog Video in a Digital Context. *Leonardo Music Journal*. 24. pp. 53–56.

Conrad, T. (1965) *The Flicker*. Distributed by LUX. Available online: https://lux.org.uk/work/the-flicker [Accessed 15/11/19].

Derrida, D. (1993) *Spectres of Marx: The State of the Debt, the Work of Mourning, and the New International*. New York: Routledge.

Duff, A. (2019) Vectrex 3 X Inputs For X/Y/Z Oscillographics Modification v2. In J. Bernagozzi (ed.) *The Signal Culture Yearbook*. New York: Signal Culture.

Fisher, M. (2012) What Is Hauntology?. *Film Quarterly* (Vol. 66/1). Oakland: University of California Press.

Gallix, A. (2011) Hauntology: A Not-So-New Critical Manifestation. *London: The Guardian*, 17 June.

Ghazala, R. (2005) *Circuit-Bending: Build Your Own Alien Instruments*. Hoboken, NJ: Wiley.

Hattler, M. (2008) *AANAATT*. Available online: https://vimeo.com/27808714 [Accessed 15/11/19].

Hayhurst, D.; Sutherland, R. (2016) *Form Foam*. Available online: https://vimeo.com/192017698 [Accessed 15/11/19].

High, K.; Hocking, S.M.; Jimanez, M. (2014) *The Emergence of Video Processing Tools: Television Becoming Unglued*. Bristol: Intellect.

Holmes, E. (2010) Strange Reality: Glitches and Uncanny Play. *Eludamos Journal for Computer Game Culture*. 4(2). pp. 255–276.

Holzer, D. (2019) *Vector Synthesis: A Media Archeological Investigation into Sound-Modulated Light*. Helsinki: Self-Published.

Hyde, J. (1998) *Zoetrope*. Distributed by LUX. Available online: https://lux.org.uk/work/zoetrope [Accessed 15/11/19].

Hyde, J. (2009) *End Transmission*. Available online: https://vimeo.com/3241660 [Accessed 15/11/19].

Jacobs, K. (1969) *Tom, Tom the Piper's Son* (video). Distributed by Electronic Arts Intermix. Available online: www.eai.org/titles/tom-tom-the-piper-s-son [Accessed 15/11/19].

Kelly, C. (2009) *Cracked Media: The Sound of Malfunction*. Cambridge, MA: The MIT Press.

Kijek, K.; Adamski, P. (2011) *Noise*. Available online: https://vimeo.com/21154287 [Accessed 15/11/19].

McLuhan, M. (1964) *Understanding Media: The Extensions of Man*. New York: McGraw-Hill.

Morrison, B. (2002) *Decasia*. HD Stream Rented. Available online: www.amazon.com [Accessed 01/11/19].

Paik, N.J.; Godfrey, J. (1973) *Global Groove*. Distributed by Electronic Arts Intermix. Available online: www.eai.org/titles/global-groove [Accessed 15/11/19].

Parikka, J. (2012) *What Is Media Archaeology?* Cambridge: Polity Press.

Reeves, R. (1997) *Linear Dreams*. Available online: www.youtube.com/watch?v=vEvW-tHVhvg [Accessed 15/11/19].

Rijpma, J. (2014a) *Descent*. Available online: https://vimeo.com/92009557 [Accessed 15/11/19].

Rijpma, J. (2014b) *Refreshment*. Available online: https://vimeo.com/87478840 [Accessed 15/11/19].

Smirnov, A. (2013) *Sound in Z: Experiments in Sound and Electronic Music*. Cologne: Walther Konig.

Tone, Y. (1997) *Solo for Wounded CD*. (CD). Tzadik Records, Cat. #7212.

Vanderbeek, S. (1966) Culture Intercom, a Proposal and Manifesto. *Film Culture*. 40. pp. 15–18, reprinted in Battcock, G. (1967) *The New American Cinema: A Critical Anthology*. New York: Dutton. pp. 173–179.

Woloshen, S. (2011) *Visual Music for Ten Voices*. Available online: https://vimeo.com/20343694 [Accessed 15/11/19].

# Screen grammar for mobile frame media
## The audiovisual language of cinematic virtual reality, case studies and analysis

Sam Gillies

Cinematic Virtual Reality (henceforth CVR) is a technology that has emerged from developments in Virtual Reality (henceforth VR). VR is defined by *Merriam-Webster Dictionary* as "an artificial environment which is experienced through sensory stimuli (such as sights and sounds) provided by a computer an in which one's actions partially determine what happens in the environment" (Merriam-Webster Dictionary 2019). As a VR technology, however, CVR is differentiated from a fully interactive environment in both the kinds of media produced and the screen grammar these medias utilise.

In traditional visual media, the representation of the work is bound to a frame of some kind: the edges of the canvas, the borders of the screen, the lens of the camera, and so forth. The composition of the work is focused within the boundaries of this frame, and so regardless of what happens within these boundaries, the frame remains fixed. We can use the term 'fixed frame' to refer to work that is shaped by the construction of media within these boundaries. While fixed frame media dominates visual art, VR technologies have opened up the possibilities of activating the frame as a variable. VR technologies engage with the frame as one part of a wider space, building a situation where, if an image exists in a frame, then that frame must belong to some sort of wider context. I propose the term 'mobile frame' to differentiate such media from that created with a grammar shaped and articulated by a fixed frame. Necessarily, a mobile frame dramatically changes the perspective offered to the viewer from that of fixed frame media, eschewing any editorialising of viewpoint and instead anchoring perspective within that of a physical reality, with clearly drawn relationships to the surrounding environment. As such, the mobile frame is a defining characteristic of CVR and results in a screen grammar different to that of fixed frame media.

CVR can be differentiated from more conventional notions of VR through its foundation in a fundamental cinematic experience. VR refers to a completely

computer-constructed world, allowing the subject to navigate a 3D space and inter-act with that world according to physical properties encoded by the designer. As Ivan Sutherland outlined in 1965:

> The ultimate display would, of course, be a room within which the computer can control the existence of matter. A chair displayed in such a room would be good enough to sit in. Handcuffs displayed in such a room would be confin-ing, and a bullet displayed in such a room would be fatal. With appropriate programming such a display could literally be the Wonderland into which Alice walked.
>
> (Sterling 2009)

CVR allows for the same mobility of frame that VR does, however, it is limited to the position of the camera rig. CVR is filmed with a panoramic camera system so as to generate an equirectangular video file of the surrounding environment. (Ander-son 2016: 6). The equirectangular video can then be mapped to a sphere to recreate the proportions of the original scene. By placing a digital 'camera' (henceforth the viewer) in the middle of this sphere, a particular perspective of the video is visible. As such, CVR does not allow for the same mobility that VR does, yet it maintains a clear dialogue between technology, media, and subject (a point of focus) through viewer navigation. While proponents of VR are often quick to highlight this lack of mobility as a shortcoming of CVR, in reality it is a deeply cinematic feature, one that fixed frame media has refined over its history, and one which CVR, as a new media, is in the process of exploring and addressing. This chapter is about that exploration, and seeks to try to define some key aspects of this evolving screen grammar for mobile frame media through the observation and analysis of work created thus far.

## Perception and immersivity

VR relies upon a seamless interaction between the subject and the technology. When VR technologies project stimuli that surrounds and matches the users' expectations, an immersive experience can take place and the subject experiences 'presence' – the internal psychological and physiological state whereby the subject has a sense of existing in a physical space even when physically located elsewhere. Generally, the more effective the VR system is at stimulating the subject's senses in a realistic and expected way the more immersive the experience can be and the greater the potential for the subject to feel present in the virtualised world. However, when the mechanics of this stimuli are visible the illusion of a virtual reality is disrupted, immersion is limited or lost, and any feeling of presence is lost (Jerald 2016).

This relationship broadly holds true but is substantially different in the case of CVR. While CVR similarly relies on a hidden technology to convince us of the reality of the space we are seeing, the lack of mobility means that there is generally less reliance on the direct involvement of the viewer in the scene and more of a focus on allowing a scene to play out in the surrounding space. One of the main component illusions for creating a sense of reality in VR is that of a stable spatial place. That is, the stimuli presented to the viewer needs to feel and behave as though originating from real world objects in a three-dimensional space (Jerald 2016). Cutting and Vishton propose that the space around the subject can be segmented into three circular egocentric regions that gradually transition into one another:

1   Personal space: The zone immediately surrounding the observer's head, generally within arms' reach and slightly beyond. Typically, others are allowed to enter it only in situations of some intimacy or in situations of public necessity. Generally, within two metres.
2   Action space: The circular region just beyond personal space, a sphere of public action, within which we can move quickly within, talk to others, throw a projectile or undertake another, similar, interaction. Generally, between two and thirty metres.
3   Vista space: The space beyond this thirty metre zone, where there is little immediate control, and perceptual cues are fairly consistent and lack depth.

                                                                         (Cutting and Vishton 1995: 19–20)

It is interesting then to note that the experience of personal space ends at roughly the two-metre mark, which just so happens to be a key point for CVR. In most 360° camera rigs, moving closer than two metres results in a distortion of the image. Moving an object or person closer to the rig requires more cameras spaced closer together to ensure an accurate representation of the image (Anderson 2016: 24). While there are compositing tricks that can be done to work around this, most 360° camera rigs available to the amateur and semi-professional film maker do not allow for variations in their rig, often utilising simple rigs of two cameras. While this makes the technology cheaper and more available, it has resulted in a large amount of output that eschews action taking place within the personal space of the viewer, resulting in a feeling of distance from the subject or environment. While there are cases where interaction within the viewer's personal space benefits the material, generally speaking some distance between the action and the viewer benefits a CVR experience. Unlike a VR environment where the viewer has a degree of agency and interaction, and can respond to actions within their personal space (they can interact or move away from the intrusion, for example), CVR plants the viewer in a fixed space. Intrusion into personal space directly affects the viewer, however unlike VR they are unable to undertake any response to this other than turning

their backs on the intrusion. The result is somewhat akin to locked-in syndrome, where the viewer is aware but paralysed, a potentially distressing experience, creating a highly unnatural situation and ultimately reinforcing the awareness of the technology used to mediate the experience and compromising the viewer's ability to feel present within the space.

This role of the viewer as an observer of the scene is, in many ways, the cinematic component of CVR, and is in keeping with the cinematic experience of watching a moving image projected onto a flat screen. It is this combination of observation, immersivity, and presence that defines CVR as a unique media, foregoing VR's focus on embodying the subject in a space but immersing the viewer in a space or place just the same. *Führerstandsmitfahrt U44 in 360° // DSW21* (einundzwanzig 2017) demonstrates this.[1] The video is a 25-minute real time recording of the Westfalenhütte to Marten tram route, in Dortmund, Germany, from the perspective of the driver's cab. Across this journey we see the sights and sounds of the city from the familiar perspective of public transport, looking out the window as the city passes by. While the experience is passive, it is ultimately the same kind of passivity as the lived experience of being driven by public transport, arguably helping create immersivity by placing the subject in a situation that we know through lived experience is naturally lacking in agency. Meanwhile the technological illusion is unbroken, allowing the viewer to experience the sights and sounds of a foreign city without a clear disjoint between perspective and technology.

While intrusion into personal space can often be undesirable, it can nonetheless be effective if the mechanisms of the technology are readily addressed as a part of the immersive experience. That is, if the medium of CVR is not trying to convince the viewer they are in a space but rather convince them of the truthful documentation of a space. *Scott Base 360 VR Walkthrough* by Anthony Powell (2017) is a 45-minute real time walkthrough of the Scott Antarctic base, designed to help prepare future visitors for their time there. The video consists of Powell walking around the site with the 360° camera attached to a selfie-stick in a single unedited take. The technology of the video is clearly visible throughout, with the central figure of Powell moving in and out of what could be considered personal and action spaces of perception. The open Antarctic landscape is quickly replaced with familiar clean but utilitarian, cramped work spaces and corridors, largely non-descript but immediately familiar. What we have here is not an immersive site per se, but rather immersive documentation brought about through CVR. Viewer agency and intrusion into personal space is less problematic here because it is not an intrusion into a virtualised reality, rather we are clearly watching the documentation of Powell's intrusion into the camera's personal space as a product of his navigation of the surrounding environment. This reinforces the truthful expression of physical space, added greater weight through the inside-look nature of the documentation itself, creating an equally immersive experience.

## Space and reality

Unlike fixed frame media which necessarily presents a perspective of any given location, CVR concerns itself with placing the viewer within a representation of a physical space. This space may seek to document the unique characteristics of the space itself, or to stage some sort of event or happening within and in relation to it. The use of a recognisably real space points to a kind of truth in the medium – regardless of what happens in the space itself, the space in which it is set retains a connection to a reality. *Send Me Home* (LONLEYLEAP 2018) documents the story of Rickey Jackson who was wrongfully imprisoned for murder at the age of 18 and spent almost four decades in prison before being exonerated and released in 2014. Throughout the documentary the viewer is situated in contrasting spaces, from the close confines of Jackson's death row cell and prison hallways to the wide open spaces of the home and property where Jackson now raises a family. The emotionally affective visual language of this documentary is a product of CVR's ability to represent these physical spaces.

While a representation of the reality of space in CVR perhaps best lends the medium to documentary and field recording projects, creatives have attempted to utilise the media within narrative fiction as well. However, the construction of narrative stories within CVR does not negate the role that space and the representation of reality have to the medium itself. To explore this relationship, we can look at two examples of narrative film that uses CVR – *Hard World for Small Things* and *Home Invasion*.

*Hard World for Small Things* (Transport by Wevr 2017) goes to great effort to create a realistic experience. Set in South Central Los Angeles, the majority of the action takes place on the street outside a corner store, allowing the viewer to watch the different interactions unfold between characters in a naturalistic way. While utilising actors, the exchanges feel rooted in the communities in which they are set, and the absence of visible film making accoutrement or production techniques reduces any barrier to immersion. Although staged, the film presents its characters within a real and common enough location. The action that takes place is almost banal, as befits the setting. When the film does finally finish on an act of violence, it is handled naturalistically, underplayed, maintaining the illusion of reality established by the space itself.

We can compare this to Alex T. Hwang's *Home Invasion* (Tiberiusfilm LLC 2017), a short narrative film about a family subjected to a violent assault by gangster types. The 'home' appears to be a real home – in the grand tradition of low-budget film making it would not be surprising to find out that it was owned by a relation of someone in the film crew. As such, the setting is effective in creating a real home in which to set the 'invasion'. However, the action in the film is never able to create a sense of reality – the unnatural dialogue, overdubbed film soundtrack, awkward

blocking, and poorly established character motivations all work to undo any sense of immersion. Instead the viewer is constantly reminded that they are watching people making a film and acting within a real space. The film has a large number of issues quite aside from its inability to communicate effectively within CVR, but through this failure we can see some core facets of the media. CVR accurately captures action within the context of the space in which it is set, and if the creative plans to introduce artificial elements to this space, they will need to do so in a way that effectively works within the reality of the space itself.

However, it is possible to create a CVR experience that operates outside of a conventional experience of reality, instead creating an experience that constructs its own reality. The 360° music video accompanying Gorillaz's *Saturnz Barz (Spirit House)* (Gorillaz 2017) utilises the potential for animation to blend real and fantastical elements, bending time and space so that, whilst unrealistic, feels totally in keeping with the world that has been constructed. Similarly, Mike Celona's 360° video experiences utilise a mobile frame to experience audiovisual works that resist any sort of reality (Celona 2017). Mapping his fixed frame AV productions to a sphere so as to surround the viewer, Celona fuses textures and shapes with stock film footage, creating reworkings of recognisable images and forms, remapped to a new virtual space. This new virtual space creates its own sense of depth, of shapes and imagery that is always at the fringe of being perceptible. The mobile frame in turn restricts the viewer's perspective, ensuring that the entire scope of the visual environment is never able to be completely understood. The result is the creation of a virtual space that operates outside of any sort of realistic spatial understanding, and instead creates its own unreal but navigable space.

## Audible spaces

In *Audio-Vision: Sound on Screen* Michel Chion poses this question with response to sound in film:

> What do sounds do when put together with a film image? They dispose themselves in relation to the frame and its content.
>
> (Chion 1994: 68)

The relationship between sound and the mobile frame is somewhat different due to the latter not acting as an image in and of itself, rather it is a perspective of a larger, freely navigable panorama. As such, we could propose a rewording of this excerpt to fit this new context: "what do sounds do when put together with a mobile frame? They dispose themselves in relation to the space in which they are set." CVR has an inherent spatial quality as a visual medium, built on a literal positioning of

perspective within a space that can only ever be suggested in fixed frame media. As such, the creation of an effectively immersive VR experience can be thought to rely on the creation of a field of sound that:

1   Is reflective of the space in which the perspective is set, and
2   Dynamically responds to changes in the viewer's perspective of the space.

This first point reflects the creative decision making and selection of audio materials for a scene. These may be obtained through field recordings or created abstractly, separate to the space in which the video is recorded, and later paired with the video. The second point is more technical, and more of a question of implementation than creative decision making. Ambisonic audio has established itself to be the dominant audio format for CVR, allowing for 3D sound relationships to be recorded or encoded to a single multichannel audio file, and decoded dynamically in response to changes in viewer perspective. Outside of bespoke experiences in concert or exhibition settings, YouTube has supported positional audio for first order ambisonics since April 2016 (Wiggins 2016) while the feature is promised, but as of publication yet to be implemented, by alternative video sharing platform Vimeo. As such, while dynamically changing audio feedback is an essential element of CVR, its generation and implementation is not insignificantly complicated. For this reason, a large number of CVR experiences distributed online have opted to work only with stereo audio. As such, this chapter is primarily concerned with audiovisual relationships established through sound materials, and not wider spatial relationships.

*Sights & Sounds of a Coffee Plantation* by Shivakumar Lakshminarayana (2017) is a one-minute field recording of a space in a coffee plantation accompanied entirely by audio captured from the site itself. It is a clear example of a site-specific audiovisual field recording, situating the viewer within a VR representation of the space as accurately as possible. What is interesting to note here is the disjoint between the sonically rich field and its accompanying, relatively static scene, highlighting that the implementation of field recording in a CVR context does not necessarily have a correspondingly dynamic interplay of sound and visual activity. Similarly, Powell's tour of the Scott Antarctic base paints a similar audiovisual picture. The environmental sound changes dynamically as Powell moves throughout the site, with sounds from the harsh industrial sounds of the generator room to the quieter monitoring stations and administration spaces not necessarily reflecting a dramatic shift in the visual appearance of the corresponding spaces. In this way, the auditory experience is directly related to the experience of the space itself and helps to build a convincing virtual reality.

Some examples of CVR have opted to use sound that is not reflective of the space in which the experience is set, rather opting for a music overdub. Legal Nomads's *Uganda w 360* (2017) is a good example of this. While there are sounds from the field

present, there is a non-diagetic music track that dominates the video throughout. The result of this is a constant reminder of the artificial construction of the media experience, resulting in a less immersive experience of the various locations in which the viewer is placed. The importance of sound design in video work has long been acknowledged, however in the advent of a mobile frame the experience of the sound field is now tied directly to the experience of space and place.

My original work *Inland* (Gillies 2018) explores the dynamic between real and unnatural sound by blending field recordings and processed sound samples to create an evolving soundscape that weaves between the audiovisual interactions discussed earlier. The piece establishes early on that it operates within an unreal experience of space akin to the work of Mike Celona, pivoting between recognisable physical spaces and visual texture. A unique audiovisual interaction is constructed, so that abstract 'musical' soundscapes are paired with visual spaces that retain their identifiable physical properties, whilst field recordings are paired with spaces constructed of distorted, unnatural, or unidentifiable environments. By establishing from the outset that the piece intends not to operate within a construction of the real but instead contrasting audiovisual elements that reflect various aspects of real spaces, *Inland* utilises elements of site-specific field recordings to build a satisfying CVR experience without necessarily devoting the work to a literal depiction of a space.

## Viewer attention

While the function of space and sound to create an effectively immersive experience can be addressed separately, they often act as mutually affective forces to guide the viewer's interaction with CVR. One important part of CVR where both elements combine is in the effective direction of viewer attention. Kath Dooley has discussed the implications of CVR's viewer attention mechanic, explaining that:

> Whereas a filmmaker working with traditional screen media contained within a rectangular frame can use closeups and edit points to draw attention to certain actions or objects, the active VR viewer has a much larger field of vision to explore. The 360-degree video environment allows the viewer a great amount of freedom.
>
> (Dooley 2017: 168–169)

This freedom opens up potential problematic elements however, as the audience can choose to ignore or simply miss the action you are attempting to direct their attention towards (Dooley 2017). As a way of counteracting this effect, Anderson suggests that the action of a shot takes place within a 150° space in front of the viewer. This is based on a field of view of 90°, with an extra 30° of space made visible

through head turns (Anderson 2016: 39). Action that takes place outside of this 150° field of view requires some degree of contortion by the viewer which at best makes for an uncomfortable experience and at worst can result in the viewer either losing attention or becoming unsure as to which direction they are supposed to be looking.

Through observation it appears that in watching a work of CVR, there are four possible outcomes with respect to directing the viewer's attention during a CVR experience:

1   The viewer's attention is effectively directed to the desired focus point.
2   The viewer's attention is lost or misplaced, leading to them missing the subject or points of action.
3   The viewer's attention is split between two equal points of focus in exclusionary positions in the field, leading to them being unsure in which direction to look.
4   The direction of the viewer's attention is not an essential element to the audio-visual work.

To explore these states we can examine three different 360° music videos – Gorillaz's *Saturnz Barz (Spirit House)* (2017), Muse's *Revolt* (2016), and Björk's *stonemilker* (2015). Gorrilaz's *Saturnz Barz (Spirit House)* (henceforth *Spirit House*) is filled with well-executed and intuitive viewer direction. The pacing of action within, and cuts between, scenes is established early on and remains consistent throughout, such that the viewer quickly develops an understanding of the expected rate of change they should be experiencing throughout the video. When a perspective lacks action for a period the viewer is given a subtle hint to move their head in another direction through lighting or some sort of minor action or activity. The decision to do so is immediately rewarded by the presence of a new subject interaction. As such, at points of ambiguity, the viewer is clearly empowered, and subtly directed, to find the desired perspective in a manner that feels free and intuitive. Most importantly, all of the action guiding viewer attention takes place within the action space of the viewer, maximising viewer engagement.

We can compare this experience of viewer direction to the behaviour exhibited in Muse's 360° music video *Revolt*. The viewer witnesses the action ostensibly from the perspective of a drone flying around a clearly staged and stylised clash between a civilian rebellion and authoritarian stormtroopers. Issues arises where there are potentially a large number of elements on screen to look at, and no clear visual line to follow. For example, the video begins with a military convoy converging on an empty lot, with government vehicles approaching and passing by the viewer-drone as it flies through the convoy in the opposite direction. As the viewer flies over the scene, the impulse is the turn around and watch the convoy pass by as this is clearly a point of interest and there is little of note on the horizon in the direction in which the drone is heading. However, doing so positions the viewer to be facing away from

the subject of the next shot as, when the scene changes, the viewer now has their back to the band performing live, requiring a further 180° turn once they realise the point of interest is behind them. In this way, there's a lack of continuity between shots.

At some points this is a mere annoyance, but at others it results in the viewer potentially missing important plot points. In one case about halfway through, the viewer's perspective cuts from being surrounded by figures to a distant shot of the conflict, seemingly giving the viewer a respite from the intensity of being within a riotous conflict. However, immediately after this cut an important plot point of revolutionaries being arrested takes place almost directly below the viewer at a distance (in the vista space or at least beyond the viewer's action space). Some attempt is made to orient the viewer through the use of sound design, adding audible glitch sounds to accompany changes in the viewer/drones HUD, drawing the viewer's attention to the action. However, these cues are reliant on the viewer facing in the general direction of these events for them to be effective. If the viewer was facing away from the action, as they would be were they to focus on the aggressors in the previous scene, they might start hunting for the source of the sound and visual markers rather than engaging with the scene unfolding in front of them.

The end result of this poor scene construction is that the viewer is disoriented and does not feel meaningfully engaged with the action in the space around them. Instead of intuitively navigating the virtual world to follow the action in a meaningful way they are instead constantly forced to engage with the technology to reorient their perspective to try to find the more desirable perspective. Much of the action appears to have been created with an eye towards interesting spaces in which to inhabit – the 360° views of riots and drones both near and far are all engaging spaces in their own right. The problem is that these scenes don't communicate between one another as a coherent entity. The video appears to want to let the viewer freely look around in some scenes, but then constructs other scenes such that they can only convey meaningful information when the viewer happens to be looking in a particular direction and at a particular angle. This dissonance ultimately reminds the viewer of the virtual world they are inhabiting.

One possible solution to this concern with viewer attention is to create an experience that does not rely on guiding the viewer's perspective. Björk's video for *stonemilker* (Björk 2015) effectively creates such a space. Set on the Icelandic beach where Björk wrote the lyrics for the song, the video takes place across two key scenes on this beach, the first on an empty stretch of desolate beach, the second amongst the rocks in a lightly more detailed environment. Both scenes focus on Björk slowly working her way around the camera, singing to the viewer, and always occupying the viewer's action space. As scenes progress, multiple instances of Björk appear and occupy different points of the field. In many cases there may not be an easy way to take in all of Björk's action, forcing the viewer to focus on one particular instance of the singer at any given point in time. However, the actions themselves are fairly non-descript,

consisting of Björk singing, dancing, or moving in ways that feel unconnected to her multiple instances.

In *stonemilker*, Björk becomes a part of the field, and the significance of the space becomes less about the action taking place within it than of the viewer being situated in a space significant to the song's creation. Indeed, the original VR mix of the track takes the string arrangement and situates each of the 30 instruments in a tight circle around the viewer, steadfastly placing the viewer in the middle of a spatial experience (Björk.fr 2015) – but a spatial experience that has no directional queue, rather orienting the musical components as objects in the field, crafting a sonic character for the space. As such, while there are elements for the viewer to focus on, viewer attention is not a key element of narrative comprehension. This approach is in many ways contrary to the conventions of fixed media, but highlights the unique characteristic of CVR – its ability to accurately convey and communicate space.

## Conclusion

CVR has several unique characteristics which creates a multimedia experience unique to that of conventional fixed frame media. All CVR experiences are based on convincing the viewer they are present in a given space and seeks to minimise the presence of conscious technological mediation of that space. This is the experiential foundation from which CVR's screen grammar emerges. As such, the audiovisual relationship between elements of a CVR experience differs from that of fixed frame media, focusing not on forming a relationship between image and sound, but rather the relationship between sound, action, and space. What has been found through observation and experimentation is that works that base their materials – sound, action, object, setting – in the space in which they're set, or in which they're suited, more effectively generate a feeling of being present within the experience.

But inasmuch as the materials must match the experience of space, so too must the presentation of that space not draw attention to its artificiality, resulting in a number of conventions that minimise conscious technological mediation. The viewer's inactivity within the space must be normalised as natural for the experience while also minimising activity within the viewer's personal space, ensuring the viewer is appropriately positioned so as to view all important action within their field of view. Traditional fixed media techniques such as hard edits and montage draw attention to the artificiality of the visual space and disorient the viewer. This reinforces the idea that the viewer derives meaning not through the relationship of different perspectives of space, as is commonly articulated in fixed frame media, but rather through the relationship of the viewer to the space itself. CVR's more effective implementations trend towards long periods spent in a single location, with perspective changes corresponding to scene changes that allow for plenty of time for the

viewer to orient themselves to changes in their surroundings. Finally, the use of these spatial and technical elements must act harmoniously together to effectively guide the viewer's mobile perspective, either directing their perspective to desired points of focus or encouraging them to freely experience the virtual world.

CVR represents a significant development in visual media, eschewing a composed presentation of perspective through a fixed frame in favour of situating the viewer within a space with a freely navigable perspective. The uniqueness of this media renders many of the conventions of fixed frame media ineffective, and by understanding CVR's relationship with presence and immersion, this chapter provides a framework for the development of meaningful screen grammar and the effective use of CVR not as a novelty but as a way to create audiovisual experiences not possible any other way.

## Note

1 All media discussed in this chapter has been collected and is available for viewing via https://samgillies. dropmark.com/736919

## References

Anderson, G. (2016) *The Cinematic VR Field Guide: A Guide to Best Practices for Shooting 360°* (1st ed.). [online]. Available online: www.jauntvr.com/cdn/uploads/jaunt-vr-field-guide.pdf [Accessed 28/03/17].

Björk. (2015) *björk: stonemilker (360 degree virtual reality)*. Available online: www.youtube.com/watch?v=gQEyezu7G20 [Accessed 15/05/19].

Björk.fr. (2015) *Stonemilker VR | Björk Vulnicura VR*. Available online: www.bjork.fr/Stonemilker-VR [Accessed 15/05/09].

Celona, M. (2017) *Remorse Code (360)*. Available online: https://vimeo.com/217303220 [Accessed 28/05/19].

Chion, M. (1994) *Audio-Vision: Sound on Screen*. New York: Columbia University Press.

Cutting, J.; Vishton, P. (1995) Perceiving Layout and Knowing Distances: The Integration, Relative Potency, and Contextual Use of Different Information about Depth. In: *Handbook of Perception and Cognition* (Vol. 5). San Diego, CA: Academic Press. pp. 19–20.

Dooley, K. (2017) Storytelling with Virtual Reality in 360-Degrees: A New Screen Grammar. *Studies in Australasian Cinema*. 11(3). Routledge. pp. 161–171.

einundzwanzig. (2017) *Führerstandsmitfahrt U44 in 360° // DSW21*. Available online: https://vimeo.com/208103595 [Accessed 15/05/19].

Gillies, S. (2018) *Inland (2018) [IOA, 360]*. Available online: www.youtube.com/watch?v=wuBTy2-fUDc&t=585s [Accessed 02/06/19].

Gorillaz. (2017) *Gorillaz-Saturnz Barz (Spirit House) 360*. Available online: www.youtube.com/watch?v=lVaBvyzuypw [Accessed 15/05/19].

Jerald, J. (2016) *The VR Book*. IL: Association for Computing Machinery and Morgan & Claypool Publishers. pp. 46–49.

Lakshminarayana, S. (2017) *Sights & Sounds of a Coffee Plantation*. Available online: https://vimeo.com/241473904 [Accessed 31/05/19].

Legal Nomads. (2017) *Uganda w 360*. Available online: https://vimeo.com/218451644 [Accessed 01/06/19].

LONLEYLEAP. (2018) *Send Me Home | 360° Experience*. Available online: https://vimeo.com/295684342 [Accessed 27/05/19].

Merriam-Webster Dictionary. (n.d.) *Definition of Virtual Reality*. Available online: www.merriam-webster.com/dictionary/virtual%20reality [Accessed 15/05/19].

Muse. (2016) *Muse-Revolt [360° Music Video]*. Available online: www.youtube.com/watch?v=91fQTXrSRZE [Accessed 15/05/19].

Powell, A. (2017) *Scott Base 360 VR Walkthrough*. Available online: https://vimeo.com/207563097 [Accessed 15/05/19].

Sterling, B. (2009) *Augmented Reality: 'The Ultimate Display' by Ivan Sutherland, 1965*. Available online: www.wired.com/2009/09/augmented-reality-the-ultimate-display-by-ivan-sutherland-1965/ [Accessed 15/05/19].

Tiberiusfilm LLC. (2017) *Home Invasion VR 360*. Available online: https://vimeo.com/207889899 [Accessed 28/05/19].

Transport by Wevr. (2017) *Hard World for Small Things | 360 VR*. Available online: www.youtube.com/watch?v=VPTPQ_CYRsQ [Accessed 27/05/19].

Wiggins, B. (2016) *YouTube, Ambisonics and VR*. Available online: www.brucewiggins.co.uk/?p=666 [Accessed 01/04/19].

# Nature Morte
## Examining the sonic and visual potential of a 16mm film

**Jim Hobbs**

*Nature Morte* is a suite of 16mm films composed of different floral arrangements, whereby the visual subject matter also transforms into a source of sound. Looking back towards Robert Mapplethorpe's early floral photographs, the film takes on board the ideas that the flowers represented here are simultaneously life and death – humming with an intensified frequency. The focused and durational gaze for each "still life" explores the visual beauty of a staged composition, while at the same time searches for moments within the visual frame that are able to disrupt the optical soundtrack on the celluloid's surface. The resulting sounds are more akin to abstract noise that vary in intensity from scene to scene. The image becomes sound and the sound becomes image. *Nature Morte* has been exhibited in multiple formats including single channel screenings, live performances and sculptural installations. The following pages are yet another manifestation of the work, utilizing the format of a photo-essay to dissect the piece through visual scans and time notations. One has the ability to experience the film in its totality as a singular image, while simultaneously freezing time in order to scrutinize each frame's granular elements which produce sound.

Gypsophila paniculata ...........................................................................................

Ornithogalum thyrsoides .....................................................................

Phalaenopsis ...................................................................................................

Lilium orientalis  - - - - - - - - - - - - - - - - - - - - - - - - - - - - - - - - - - -

Zantedeschia aethiopica .................................................................

Tulipa gesneriana ............................................................................

Brassica .........................................................................

0' 12" - 1' 27"

1' 34" - 2' 50"

2' 57" - 4' 15'

4' 22" - 5' 46"

5' 54" - 7' 15"

7' 27" - 8' 55"

9' 03" - 10' 23"

# Capturing movement

## A videomusical approach sourced in the natural environment

Myriam Boucher

### Composing with visual and aural matter

Sky, birds, clouds, forest, sea, mountains. The natural environment presents an invaluable material world with and within which we maintain a complex relationship. In *Nature*, the writer Jeffrey Kastner explains:

> whether constituted as muse or foil, as contestant or collaborator, nature continues to loom as the elusive, originary Other – a system we are fundamentally native to, but unavoidably separate from; one that produces us, even as we (physically, conceptually, discursively) produce it; a complex of spaces, structures and organisms inexhaustibly good to think (and work) with.
>
> (Kastner 2012: 14)

In my videomusical work, I capture movement from matter as it evolves in its natural setting. Both sounds and images are recorded at the same time. Typically, I will choose a fixed camera/microphone position in order to capture the movement of a particular sound or image. If I decide to move the camera/microphone then it will be with the intention to present a precise point of view and perspective. This perspective will be chosen in order to construct a narrative.

Rather than approaching nature as a landscape, I am inspired by the physical experience of being present and immersed in the natural world, which consequently impacts on how I see and hear. I endeavour to perceive the world surrounding me in an active, participatory way and for this embodied knowledge to inform my work. This act of actively seeing and hearing within the natural world is followed by analysing and re-organising the movements I have captured and recorded in order to create videomusic.

In the studio, I edit these recordings to select aural and visual materials that speak to me with, for example, their gestural energy or textural qualities. In the

compositional process, the number of recordings I choose to use vary greatly. This material leads me to integrate and create more material. The result is a mixture of field recordings, live footage, found footage, instrumental recordings with musicians, and/or synthesised sound and image.

The materials are arranged and transformed by digital manipulations. The purpose of these manipulations is not to conceal the original source, but to accentuate aural and visual movement nestled in colours, shapes and forms. Most of the recordings I select have a subtle tone, a specific grain, detailed lines, dynamic behaviour or interesting arrangements that I isolate and amplify. I edit sound and image to create a dialectic relationship between the two media. This dialogue is related to our experience of the physical world.

The main objective at this stage of my composing process is to transform movements into musical gestures and textures which will be used to define the videomusical discourse of the work.

I will define *musical gesture* more precisely further on, however in videomusic, a musical gesture is both aural and visual, and understood as a meaningful shaping of materials through time. The context in which this *shaping* is manifest will, I hope, lead to a meaningful experience of time and motion.

My purpose is not to document or to represent something, but to create meaning within the videomusical form where sound and image contribute equally. Meaning is constructed as a poetic form, built from mental images, metaphors and symbolism, generated by the very matter it is built with and how it unfolds in time.

In the following sections, I will present movement, musical gesture, texture and meaning as interrelated concepts that form the backbone of my practice. I will use my works *Reflets* (2015), *Kabir Kouba* (2016) and *Vagues* (2017)[1] as relevant expressions of these ideas. They all use the movement of water.

## Movement

A movement is a change of position, a form developing or changing in a given direction. This direction need not be linear and its perception is based on the recognition of change. Crucially, movement and rate of change are independent concepts.

In the natural environment, movement resides in the behaviour of the material itself. For example, waves of water, wind in the trees, flocks of birds or a raging tornado are both aural and visual elements in motion.

By its very nature, sound is a consequence of movement. The continuous sound of a waterfall, the unpredictable soundings of thunder or the crack of a driving golf ball are all examples of how the energy of movement is transduced into acoustic energy. Indeed, all sound implies movement of one kind or another.

## *Capturing water movement*

My works *Reflets*, *Kabir Kouba* and *Vagues* are composed with the inherent musicality found in the movements of water:

> Day after day one walks along the strand, listening to the indolent splashing of the wavelets, gauging the gradual crescendo to the heavier treading and on the organized warfare of the breakers. The mind must be slowed to catch the million transformations of the water, on sand, on shale, against driftwood, against the seawall. Each drop tinkles at a different pitch; each wave sets a different filtering on an inexhaustible supply of white noise.
>
> (Schafer 1977: 29)

*Reflets* is constructed from footage of water reflections recorded at the Canal Lachine (Montréal, Canada) by a rainy, windy and cloudy day (see Figure 16.1) (Video 16.1).

The water is constantly moving and flowing, creating a homogeneous movement that becomes hypnotising. Our attention is drawn to textures: colour changes,

**Figure 16.1**   Footage from Canal Lachine (Montréal, Canada).

caustic lines and little waves caused by wind. The surrounding sound is loud, mainly composed of heavy wind and the noise of the city.

The aural and visual recordings of *Kabir Kouba* present a great variety of water flux coming from the Kabir Kouba Cliff and Waterfall crossed by the Saint-Charles River (Wendake, Canada) (Video 16.2). With its intersections, diversions and downstream flow, this stream presents various aural and visual movements, from the calmest to the most powerful (see Figure 16.2).

The materials used in *Vagues* contain movements recorded at Kabir Kouba (see Figure 16.2) and Lake Champlain (VT, USA – see Figure 16.3) (Video 16.3). This piece also includes visual directional movements, with clear beginnings and endings, like water splashes. Field recordings of water and environments relating to the sea, such as boats, birds, dinghies and the ambient noise of the harbour, are used. This larger variety of aural and visual movements used allowed me flexibility for the creation of musical gestures.

**Figure 16.2**   Footage from Kabir Kouba (Wendake Reserve, Canada).

**Figure 16.3**   Footage from Lake Champlain (VT, USA).

## Musical gesture

The definition of musical gesture is a complex and largely intuitive undertaking. Most writings on musical gesture make the assumption that a gesture is a movement, a mutating energy or change in state that becomes marked as significant by an agent (Gritten and King 2006). This definition considers human gesture as "[a]ny energetic shaping through time, whether actual or implied, and whether intentional or unwitting" (Hatten 2006: 1). The energetic shaping must also be interpreted as meaningful in some way. A musical gesture expresses meaningful combinations of sound and movement (Godoy and Leman 2010: 3).

In *Spectromorphology: Explaining Sound-Shapes*, Denis Smalley develops this idea of energetic gesture by arguing that a gesture is an *"energy-motion trajectory"* which excites the sounding body, creating spectromorphological life. From the viewpoint of both agent and watching listener, the musical gesture-process is tactile and visual as well as aural" (Smalley 1997: 111).

However, Hatten argues that gestures "translate into music as more than energetic through time, and more than the energy it takes a performer to produce sound" (Hatten 2006: 3). In music, energetic musical gestures are arranged into a musical discourse. This arrangement can be seen as a *virtual environment* "in which we can trace the presence of an animating force (implying an independent agent) by the constraints that weigh in on (deflect, deform, or resolve) otherwise freely motivated energetic movement" (Hatten 2006: 3).

According to Hatten, musical gestures can be motivated by several factors: *indexical* (dynamic, association by contiguity or connection), *iconic* (imagistic, association by the similarity of properties or structures), *syntactic* and *symbolic* (Hatten 2006: 3). It is the interaction of these motivations that makes the musical gesture so meaningful. Musical gesture, Hatten argues, conveys affective motion, emotion and intentionality by blending otherwise separate elements on a continuum of shape, drive and force.

Hatten and Smalley's definitions are easily transposable to a context where the gesture is not only dependent or directly associated with sound, but also with image.

In traditional cinema, a visual gesture usually has a direct transcription in sound (Oliveira 2018). By exaggerating visual movement, musical cues and sound effects joined with objects create more life than their simple presence as figures in motion (Whalen 2004). The sound design in action movies is an example of this transcription of visual gesture into sound: punching, fight scene, flying Superhero, etc. Another example is mickey-mousing, a film technique that syncs the music to the actions seen (see *The Band Concert* 1935).

However, in videomusic, we observe that many other kinds of relations between sound and image are used. It is possible to find connections between gestures in sound and image that have multiple meanings and go beyond the simple mimicry of one by the other. As reported by Oliveira (2018), if an image has a meaning, sound may or

may not support or increase that meaning by an aural musical gesture. On the other hand, sound can give meaning to an image that does not possess it intrinsically (such as a synthesised abstract object). The sound/image relation plays an important role in the organisation of the energy enacted by musical gestures (whether visual or aural). This relation, therefore, has a direct impact on how an audiovisual work is perceived and felt.

### Gesture and sound/image relation

I work with the movement of natural elements to compose relational progressions of sounds and images as they intersect, clash, distend or collide through time. By editing and combining aural and visual movements, it is possible, for example, to create musical gestures consisting of a river flow followed by a splash, a stream intersecting a sea wave, or two water trajectories clashing together. The sound of those gestures may come from water or not. The intention behind the sound/image relation is to give a viewpoint and to complexify the stimulus presented. In a major way, sound/image relations will lead the intention behind the musical progression. As they do so, they create expectations, directionality, suspension, emphasis or restraint. Musical gestures carry intentionality. Their meaning intuitively emerges in the mind of a viewer-listener via her/his imagination. This meaning is constructed by the way the viewer-listener's body responds to the energy deployed by the organisation of musical gestures.

In *Kabir Kouba*, moving images are edited to establish a dialogue between each other. Movements of the water cross each other, then they separate to meet again. Extracted from the footage, but constructed by image editing and understated synthesised images (see Figure 16.4), the visual composition is entirely joined with the sound. The idea was to compose the music from the image, using the visual composition as a musical score. Along with field recordings of water, synthesised sounds are used to support, increase and imitate visual movements in the flowing water.

The sound acts as an accentuator for visual elements, bringing directionality to the continuous movement of the images. Conversely, the sound is often an echo to the visual movements. Sound can evolve by itself for a while and then come back in symbiosis with the image. It is a composition of meeting points and counterpoints between visual and aural elements that move together or independently and evolve through a floating and ephemeral time. Visual gestures affect the musical path with

**Figure 16.4**  Stills from *Kabir Kouba*.

a transference of meaning going from image to sound. At the same time, aural gestures affect how visual material is perceived.

## Gesture and causality

The organisation of musical gestures refers to actions, evolution and transformations. It concerns the application of energy and its consequences (Oliveira 2018). It is a combination of intervention, direction and progression over time; "a chain of activity links a cause to a source" (Smalley 1997: 111).

Gesture, in Smalley's theory, represents a fundamental approach to structuring electroacoustic music. A musical gesture is related to the notion of causality, "where one event seems to cause the onset of a successor, or alter a concurrent event in some way" (Smalley 1997: 118). It relates to the communicative and expressive potential as an "articulation of continuum" (Wishart 1996: 17).

A simple example is to throw a stone into a lake. This action changes the state of the water, which was calm, by suddenly causing a series of waves around the entry point of the stone. This causal link (launching a stone that causes waves) is important for understanding how movement becomes gesture, and how the organisation of musical gestures relates to changes in energy.

As mentioned by Oliveira (2018), some examples of movement sharply contradict this idea of gesture. This happens when there is a limited or non-existent change in energy. In such a case, both sound and image lose their gestures to become textural.

## Texture and the absence of gesture

Texture intrinsically comes from movement. But unlike gesture, it presents static energy, a rest, with a non-defined causality (Oliveira 2018).

My work *Reflets* is composed of two superposed visual movements: waves and reflections of a bridge in the water. The images are transformed to present the fine lines created by the reflections and the waves. Their evolution is caused by wind variations and clouds passing above (see Figure 16.5). The visuals are always changing

**Figure 16.5** Stills from the three scenes of *Reflets*.

but do not give a clear directionality. The wind behaviour is used as a dynamic model for the music, which is composed of synthesisers and piano strings manipulations.

The movement found in this work induces an experience of stasis, because it is always changing in a similar manner. The music generally follows the same path. The absence of gesture in the image is reflected in the absence of gesture in the sound, except for the three visual cuts that are accentuated by a sonic musical gesture. The sound/image relationship is used to accentuate and draw attention to textures, while supporting a contemplative musical form.

Oliveira (2018) points out that in both sound and image, energy is a consequence of movement. It is in constant transformation. The interaction between energy and what causes its release is similar to the gestural interaction between sound and image (Oliveira 2018). One gesture may inflect or trigger another one, terminate or bifurcate a flux of images and sound or, when successful, compose a discourse of sound and visual information that carry meaning, however diffuse or personal. Energy may be maintained, accumulated or converted, localised or diffused (Oliveira 2018). Sound and image moving together are energy through gestures and textures, shaping our perception of time and creating an alternate audiovisual experience.

## Meaning and imagination

### Connotative and energetic meaning

I will discuss two kinds of meaning, as they relate to the natural environment: the *connotative* and the *energetic*. Similar types of meaning are discussed in Lehrer (2011) but my approach to the subject is slightly different – it goes beyond the purely musical aspect (in the conventional sense which mainly concerns rhythm and harmony) and does not directly address neuroscience studies.

The relationship between connotative and energetic meaning will help distinguish the codependence of narrative and abstraction, and will, in time compose a *meta-narrative* form of story-telling. In this meta-narrative form, the implicit meaning is provided by both the matter-centric imagination and the energy deployed by the matter. Connoted and energetic meaning are intertwined to form an arc carrying several emotions, representations and feelings. These meaningful connections are understood from the subjective perspective of the viewer-listener. The intention of the composer is not to control this. Implicitly or explicitly, the viewer-listener will make sense of these meanings.

The *connotative meaning* of a recognisable object includes the feelings and ideas that we may associate with that object. For example, a bird, a river or a tree usually refer to the real world of experiences. Our perception of the physical world is concerned by factors beyond the visual and aural recognition.

In *Vagues*, there is a short scene presenting a black frame and a seabird sound. A natural seabird transmits known sound, which is associated with the sea. A seabird is

a real *object* within a range of physical shapes and colours. If a seabird is heard, most subjects will readily identify it and move on to explore other levels of meaning in the seabird. The subject will likely have personal experiences with seabirds, perhaps that of holidays spent by the sea or a passage on a ferry boat.

Moreover, the meaning depends on the relationship between all components of the work. It depends on the chain of sounds and images presented which will elevate the first impression of *something else*. In the context of *Vagues*, the seabird is obviously related to the water environment because various images of water are shown previously. According to this chain of relations, the bird may, for example, become a vector of freedom, alert or escape. Be that as it may, the cognitive relationship with the object has moved beyond physicality and stimulus. And the sense is thus established – it resides outside the object and inside experience, and of course, experience may vary from one individual to another.

*Energetic meaning* arises from abstraction and movement. It refers to colours, form, kinetic/morphologic characteristics, to the musical and its propulsive properties, and mostly, to the various relationships enacted by sounds and moving imagery. It emerges from the energy found in the aural and visual materials recorded, edited and manipulated.

### Our brain is the screen

About moving imagery, the philosopher Gilles Deleuze affirms in an interview given in *Les Cahiers du Cinéma* (Bergala 1986) that "our brain is the screen – that is to say, ourselves". I start from this statement to argue that our brain is the screen where the invented world – the work – unfolds. We don't see its exterior envelope; we live it from the inside, immersed in it. This immersive experience unfolds when our brain accepts this self-referential organisation and signs a form of cognitive contract. We willfully abandon everyday reality to involve ourselves in fantasy, dreaming wide awake. On moving imagery, Thomas Zummer writes:

> Optical devices, says Gaston Bachelard, provide us images to dream with, and cinema's flickering sensibilia constitute perhaps the most replete and consuming instance of an interface of dreaming. Still, we are less unwitting spectators than willing collaborators in this artificial dream.
>
> (Zummer 2001: 72)

Any videomusic work proposes an invented place, the reality of which we, as viewer-listeners, contribute to defining. Through an informed acceptance of the artifices that make up that *place*, we construct meaning. The construction of meaning confronts our present experience of a work with the ensemble of our previous experiences of a similar aesthetic or cultural nature. The credibility of what is proposed

depends on the coherence of the fictional universe we participated in defining. If only to ourselves, it must, ultimately, make sense.

But how does one create meaning with works mainly built from movements of natural matter? Likewise, where does meaning come from when there is an absence of explicit narrative? Intentionality, mental imaging, metaphors and symbolism are all part of the answer, and they are predominantly formed by each individual experience.

## *Intentionality*

In his study *Musical Intentionality: Between Objects and Meaning*, Lee explores how intentionality structures the ways in which aspects of musical materiality relate to musical meaning. The author examines some of the basic structures of intentionality presented in Searle's general theory (1983) and recalls that intentionality "denotes those aspects of conscious mental states that are directed at, are about, or represent states of affairs beyond themselves" (Lee 2016: 34). According to Lee, any "conscious mental state that has directedness – or 'aboutness' – to something beyond itself might be called an intentionalistic state" (Lee 2016: 34). Owing to the intrinsic subjectivity of mental representations, intentional contents and their objects are represented under unique aspects. On that point, Lee argues:

> The capacity for intentionality to represent the same object under different aspects enables a kind of "translation" across different domains of experience. In terms of musical intentionality, it is the phenomenon of aspectual representation that enables relations to hold between the two different levels of intentionality: the embodied/material domain and the conceptual domain.
>
> (Lee 2016: 49–50)

If we consider water as pure matter, using chemistry's knowledge of molecules: it is $H_2O$ (two atoms of hydrogen and one of oxygen). But water is not ordinarily experienced in this term. Rather, it is most commonly experienced as a substance with properties that far exceed its internal features. This way of approaching matter converges with Bachelard's ideas concerning the imagination of matter. In *Water and Dreams: An Essay on the Imagination of Matter*, Bachelard writes:

> I always experience the same melancholy in the presence of dormant water, a very special melancholy whose color is that of a stagnant pond in a rain-soaked forest, a melancholy not oppressive but dreamy, slow and calm.
>
> (Bachelard 1983: 7)

With this poetic metaphor, the author points out how our experience with water is closely related to movement:

> A being dedicated to water is a being in flux. He dies every minute; something of his substance is constantly falling away. [. . .] Water always flows, always falls, always ends in horizontal death. In innumerable examples, we shall see that for the materializing imagination, death associated with water is more dream-like than death associated with earth: the pain of water is infinite.
>
> (Bachelard 1983: 6)

Located in movements and organised into musical gestures and textures, intentionality in my work is revealed by structural elements such as dynamics, rhythm, kinetic energy, colour, timbre, tone and grain. Aural and visual components are composed and composited to express, reflect or suggest feelings, thoughts, expectations and reactions.

The received meaning of such work is elicited from the organisation of gestures and textures and the way the materials relate to each other. The reception also involves the experience that a viewer-listener historically entertains with the matter presented. Often, the mental imagery directly links sound and moving image to tactile impressions, conceptual thoughts and all other kinds of sensory experiences. Humans need meaning and will construct it internally from the stimuli presented, in a mind-space associated with the mental image.

## Mental imaging and audiovisuality

Following Bergson (see Deleuze 1966), an *image* is defined by Deleuze as the *set* of what appears (Deleuze 1986). In its cinematic manifestation, this set is a constant flux between intersecting parts in relation to a *whole* (Deleuze 1986).

The *mental image* takes on relationships, symbolic acts, intellectual feelings and is wrought with the thought of a new and direct relationship (Deleuze 1986: 203). According to Deleuze (1986), mental images are *thought-figures* that emerge from a chain of relations. As aural and visual movements of matter and objects unfold, the chain of relation corresponds to what *appears* to us. In other terms, *images* act and react on other *images*, providing meaning that is beyond the audiovisual content itself. Action, perception and affection are built in an interconnection of relationships. It is this chain of relationships that constitute the *mental image* (Deleuze 1986: 204).

The useful part of Deleuze's idea is that perception is largely based on relations between individual *objects*. A sound associated with an image adds its own contribution to the idea of the mental image. In this context, the relationship between seeing and hearing is central to the process of mental imaging. Further, the relationship

between all of our senses is connected in our mind. The relationship between seeing, hearing and feeling is thus at the heart of the process of mental imagery.

In her article *On Stan Brakhage and Visual Music* (2008), Maryline Brakhage explains the concept of "physiological relationship between seeing and hearing in the making of a work of art in film" evoked by Stan Brakhage. According to the filmmaker, the organisation of colours, lines, shapes and sounds "weaves a complexity of sensory truths to which we respond with our whole nervous system and deeply known physicality of being, as the sources of that knowing interact as felt response within the intricacies of mind" (Brakhage 1982, cited in Brakhage 2008).

A mental image is associated with a mind-space where our full body is engaged.

A mental image is a mind-space where we can hear, see, feel and act out our perceptions. A mind-space is where we can construct sense.

### Metaphors and symbolism

To discuss meaning, we must pay attention to the way a viewer-listener talks about her/his experience with the work. Indeed, *metaphorisation* and reception processes are strongly linked.

According to Delalande (1998), who has studied metaphorisation in a purely sonic context, metaphors are constructed by a listener when s/he attempts to describe sounds. These metaphors happen at two levels. First, a listener can imagine descriptive metaphors to label different types of sound (related to the morphology of the sound), such as *muted blow*, *splashing*, *impact*, *scraping* (Delalande 1998: 39). When related to actions, these sounds act on each other, and, in a symbolic way, act on the listener. For example, *wind in your hair*, *blows to the stomach* or *nails on a blackboard*. Secondly, metaphors can be articulated into narratives or complex images in a more personal way (Delalande 1998: 27): *like swimming in the waves*, *like walking in the sand*. The metaphors used will likely differ from one person to another. The *story* of this non-story is the fuzzy affect that rises in the listener's mind and body. As is the same with videomusic.

Ultimately, videomusic provides a musical experience enacted by both visual and aural materials. A visual gesture or texture reflected in the sound, or vice versa, is a metaphor. In *Vagues*, the high-pitched sound of the violin has nothing to do with the water splash seen. But the energy is mutually reflected, giving a meaning that goes beyond the simple relation between the movement of the water splash and the sound presented with it. The sound becomes the metaphorical meaning of the image. This meaning may be alarm, accident, fear, etc. There are many possible interpretations.

My practice focuses on the idea that the sound/image coupling becomes a symbolic link that articulates human experience with movement and matter. This approach, rooted in an observation of the natural environment, became particularly important in the composition of *Vagues*.

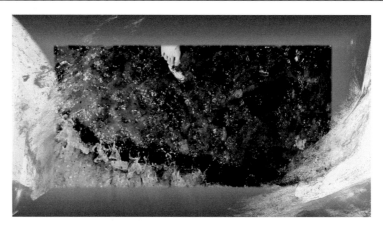

**Figure 16.6**   Still from *Vagues*. My foot in the water.

The meta-narrative arc is partly guided by the poem *The sea*, by Pablo Neruda. Here is an excerpt:

> *I need the sea because it teaches me,*
> *I don't know if I learn music or awareness,*
> *if it's a single wave or its vast existence,*
> *or only its harsh voice or its shining*
> *suggestion of fishes and ships.*
> *The fact is that until I fall asleep,*
> *in some magnetic way I move in*
> *the university of the waves.*
>                                    (Neruda 2003: 3)

Inspired by the three last lines of the excerpt, the final scene of *Vagues* presents a symbolic element: a foot in the water (see Figure 16.6). In literature, water symbolises life, purity, growth, birth and rebirth, among other things. This final scene may reflect one of these symbols, influencing the way meaning is constructed for the whole work. I recorded this video with the intention to capture just the water waves. My foot appeared in the shot by accident. This occurrence defined my work on meaning and led to my personal way to address it.

## Note to the reader

Many of the ideas presented here are the result of conversations, lectures and exchanges with Prof. Jean Piché, who sketched them early out. The author is indebted to his foundational contributions to the field.

## Note

1 See the Appendix for information on video links.

## References

Bachelard, G. (1983) *Water and Dreams: An Essay on the Imagination of Matter* (trans. from French by E. Farrell). Dallas: Pegasus Foundation.

Bergala, A., et al. (1986) Le cerveau, c'est l'écran: Entretien avec Gilles Deleuze. *Cahiers du Cinéma*. (380). pp. 24–32.

Brakhage, M. (2008) On Stan Brakhage and Visual Music. *Vantage Point* [blog], 31 January. Available online: https://vantagepointmagazine.wordpress.com/2008/01/31/on-stan-brakhage-and-visual-music/ [Last Accessed 10/11/19].

Delalande, F. (1998) Music Analysis and Reception Behaviours: Sommeil by Pierre Henry. *Journal of New Music Research*. 27(1–2). pp. 13–66.

Deleuze, G. (1966) *Le bergsonisme*. Paris: Presses Universitaires de France.

Deleuze, G. (1986) *Cinema 1: The Movement-Image* (trans. from French by H. Tomlinson; B. Habberjam). London: The Athlone Press.

Godoy, R.I.; Leman, M. (2010) *Musical Gestures: Sound, Movement, and Meaning*. New York: Routledge.

Gritten, A.; King, E. (eds). (2006) *Music and Gesture*. Burlington: Ashgate.

Hatten, R.S. (2006) A Theory of Musical Gesture and Its Application to Beethoven and Schubert. In: A. Gritten; E. King (eds.) *Music and Gesture*. Burlington: Ashgate.

Kastner, J. (2012) Introduction: Art in the Age of the Anthropocene. In: J. Kastner (ed.) *Nature*. Cambridge: The MIT Press.

Lee, M.C.-Y. (2016) *Musical Intentionality: Between Objects and Meaning*. PhD, Cornell University.

Lehrer, J. (2011) The Neuroscience of Music. *The Wired*. Available online: www.wired.com/2011/01/the-neuroscience-of-music/ [Last Accessed 10/11/19].

Neruda, P. (2003) The Sea. In *On the Blue Shore of Silence: Poems of the Sea* (trans. from Spanish by A. Reid). New York, NY: HarperCollins.

Oliveira, J.P. (2018) Gesture Relationship between Sound and Image. *L'espace du son*. Bruxelles, Belgium, 26/10/18.

Schafer, R.M. (1977) *The Tuning of the World: Toward a Theory of Soundscape Design*. Philadelphia: University of Pennsylvania Press.

Searle, J.R. (1983) *Intentionality: An Essay in the Philosophy of Mind*. Cambridge: Cambridge University Press.

Smalley, D. (1997) Spectromorphology: Explaining Sound-Shapes. *Organised Sound*. 2(2), pp. 107–126.

Whalen, Z. (2004). Play Along. An Approach to Videogame Music. *Game Studies*. 4(1), pp. 1–31.

Wishart, T. (1996) *On Sonic Art*. Amsterdam: Overseas Publishers Association.

Zummer, T. (2001) Projection and Dis/embodiment: Genealogies of the Virtual. In: C. Iles (ed.) *Into the Light: The Projected Image in American Art, 1964–1977*. New York: Whitney Museum of American Art.

## Film/Media

The Band Concert 1935 [FILM] dir. Wilfred Jackson. Walt Disney Productions.

[Videomusic] dir. Myriam Boucher. Unpublished.

*Reflets* (2015) is available at www.routledge.com/9780367271466

*Kabir Kouba* (2016) is available at www.routledge.com/9780367271466

*Vagues* (2017) is available at www.routledge.com/9780367271466

# Constructing visual music images with electroacoustic music concepts

Maura McDonnell

## Introduction

Each visual artist and every music composer have their own forms and means of expression, techniques and methods for creating the visual part of a visual music work. In this chapter, I will examine a method I developed and continue to use for creating visual music images for fixed media presentations that is influenced by *musique concrète* techniques and electroacoustic music composition. The processes and musical activity of creating sounds and timbres through recording, gathering and manipulating sound results in a musical output – the music composition. The music composer creates the sound material *and* the music composition. I apply similar techniques to crafting visual music images, where the processes and activity of creating images and visual material through recording, gathering and manipulating images results in the visual composition. In this method, the visual music composer creates the visual material *and* the visual composition. There are three main components of this method that are related to electroacoustic music and these are concept, process and listening. In terms of concept, the method is a way of conceiving of images as being similar to sound. In terms of process, this method relates to the processes of operating on images that originated in applying *musique concrète* techniques that are adapted and applied to image manipulation and image editing processes. Listening deeply and attentively to the sounds and the temporal evolution of the sounds sounding in the chosen music piece is a fundamental aspect of this method. Listening is involved throughout the process of constructing and composing the images and in the process of encountering the final visual music art work.

The final visual music work in a fixed media form is based on the chosen music that has been listened to in a rigorous manner. The music serves two purposes, it belongs to an essential part of the composition of the visual material and images and it becomes the soundtrack of the visual music work.

## Material origins

This method originated in an experimental short video, titled, *Dazzling and Blinding* that I made in 1997 where I set myself the task of experimenting with working with the manipulation of digital images and found video footage in the computer for the purposes of then re-using the manipulated images as source images for moving image compositions. I conceived of the image as being a malleable material that could create infinite visual permutations of form, texture, light, dark, colour and image content through digital manipulation processes. This conception of image as a malleable material came directly from working with sound in the computer when using *musique concrète* techniques to create electroacoustic music. The processes and methods of working with the arrangement, organisation and manipulation of sound were applied to the processes and methods of working with images. In this experiment, I discovered that when the music part in the form of the soundtrack was attached to these images, an exciting thing happened, the two parts created something aesthetically satisfying that emerged from the synthesis and synchronicity of the visual and music 'material' – what I started to name as a visual music. In the early days of this arts practice, I found it hard to explain what was the most pertinent aspect of music that I was exploring in my method and process of working with images. I knew what I was not doing, such as not focusing on the musical note or pitch; the melody or the harmonic structure of music. Nor was I engaging in trying to visualise the theoretical basis of music, or to create an accurate visual representation of the physical nature of sound. Yet I insisted that this was a visual that was extensively and essentially engaging with 'music' in a consistent and highly organised manner. Music was thus an essential part of the process of making the visual and it was an essential component of the work of art. It seemed to me that what I was doing was focusing on the 'sounding' of the music and also extending my conception of sound as an endlessly manipulative and malleable material in my conception of the image. Cinema and video art technologies provided the technical means by which the images could be presented side by side with the music, but in the beginning of my arts practice they did not inform the aesthetic or methodology of working and conceiving of visual music images. Later in my practice, it became apparent to me that the aesthetic that best fit the final images in the visual music work that I created was that of abstract visual art. This seemed to me to demonstrate a logical and further development of early twentieth-century abstract painting, absolute film, lumia art and kinetic light play art in particular. Through the accompanying research that I undertake for my arts practice and teaching, I have found that there are many other historical precursors to the evolution of a visual music practice, but such a historical account will not be dealt with in this chapter. Techniques for working with the manipulation of images that were devised from *musique*

*concrète* and electroacoustic music composition not only came from methods and processes of operating on sounds but also came from the activity of listening to the behaviour and activity of the sonic material of the sounds. When listening to sound for the purposes of composition, an attentiveness to the musical potential of sonic materials is at work. This attentiveness to the sound as sound was extended into a form of listening to the sonic material of the sounds in order to inform visual ideas, what could be called a form of visual sonic listening. The musical, sonic material and acoustic characteristics of the sounds suggest visual ideas that are then crafted into complex multi-dimensional visual surfaces. To see and hear the visual music work, in a fixed media presentation, speakers and video projectors are needed. Through the speaker and the video projector the visual music experience and the visual music work is thus constituted, comprehended and properly appreciated.

### Chapter overview

The chapter is divided into two main sections. The first section titled 'Contexts' will focus on highlighting some of the pertinent issues from history that provide an art historical context to the discussion of my methods used in composing visual music. This serves the purpose of placing visual music in an art-historical continuum. When I devised methods for creating images for a visual music art work, I was not fully aware of the many instances of artists, musicians, scientists and technologists that had already engaged in exploring aesthetic relations between the visual arts and music. I, rather, like many contemporaries and authors in the present and the past, discovered a visual music art through my own artistic activities and use of what was at the time new technologies for working with sounds and images in the computer. As my practice evolved, so too did my research into the historical and contemporary precursors relevant to the field of visual music expansion. Thus such research increasingly informs my practice. The second section of the chapter titled 'Sounding visual techniques' will elaborate on the specific techniques that I devised for creating visual music images. 'Sounding visual' was a term I used early in my practice to denote my understanding of the importance of sound and its sounding in my visual composition methods, and it was also the title of a website that I used to have that documented my work.

## Contexts

### Sonic themes for visual art

That music and visual art mutually influence each other in terms of compositional approaches to working both with the material and the means of each art is a strong and consistent feature for many artists creating their art works. For example, to

name but a few, Morton Feldman (1926–1987) was guided by the colour fields of Mark Rothko's (1903–1970) paintings in his conception and creation of blocks of sound; Franz Liszt (1811–1886) compared the vague impressions of a narrative and poetic image for and from the music to how a cycle of paintings is taken in by the eye (Liszt 1857 in Bonds 2014: 212). The composer and painter Mikhail Matyushin (1861–1934) believed in the inevitability of synthetic art and created 'musical-painting' compositions (Galeyev 2005). The Russian symbolists saw the spirit of music in all the arts (Rosenthal 1983). Paul Klee (1879–1940), František Kupka (1871–1957) and other painters interpreted the language and structure of music polyphony and the fugue in articulating a method for constructing the relationships of forms. The contemporary intermedia composer and pianist Jaroslaw Kapuscinski composes with sound and images, has used music counterpoint to structure images and has composed music for a series of paintings by Piet Mondrian that he also animated (Kapuscinski 2001). Oskar Fischinger (1900–1967), László Moholy-Nagy (1895–1946), Norman McLaren (1914–1987) were interested in the pictorial forms of sound when recorded onto the optical track of a filmstrip and, for a time, explored the possibilities of creating images and sound that were based on the same ornamental shape. Sonia Delaunay (1885–1979) and Robert Delaunay (1885–1941), and many other painters of the twentieth century, were influenced by the colour-tone analogies that connected the organisation and classification of colour to musical tones and their mathematically analogous proportioned intervals. The list goes on, and continues into much contemporary practice. In terms of a visual art, the forms and structures of music, as well as the methods in composition and the means of expression in music, can be the basis from which a language of visual composition arises. Many painters who were interested in exploring music's potential for their visual art were also musicians; this, however, was and is not a necessary requirement for being influenced by music in visual art. Much twentieth-century visual art in painting and film was described as 'a visual music' (McDonnell 2019: 1) by commentators and critics of the time who were ostensibly external to the creation of the work yet observant of this sonic theme arising in painting, film and the visual arts.

## Music in its sounding

It was, nonetheless, Fischinger who identified another feature of music beyond music's formal patterns, structures and musicological language that could be a main source of influence for the crafting of visual forms in visual art. This was the acoustic characteristics of music, that is to say, how music sounds. Fischinger pre-empted a fundamental feature of much contemporary visual music art, which starts with the characteristics of sounds that are grasped through listening. What is listened to and observed becomes the building blocks for the conception of visual forms. Walter

Schobert (2003) remarks, "unlike the other pioneers [non-narrative filmmakers of the 1920s], Fischinger 'consistently based his work on sound'" (237).

Fischinger's *Studie* films (1929–1934) *except for Studie Nr. 1* consist of remarkable experiments with 'hand-drawn charcoal-on-paper films' (Moritz, 2004: 26) and examples of abstract films that are synchronized closely to music. Several of the *Studie* films: *Studie Nr. 2, Studie Nr. 3, Studie Nr. 4* and a version of *Studie Nr. 5* were released by the Electrola EG gramophone record company (ibid. 22) as sound on disc films. Later *Studie* films had optical soundtracks (Gardiner 2007). Fischinger, who was already interested in the mathematical and acoustical basis of music, was able to explore music from its 'recorded' acoustical space more closely. The gramophone record and its playback through the speaker both enabled and provided a way of coming to know a music piece through its acoustical sounding. As a listener to a gramophone record, the artist now has non-linear access to the acoustic music performance, and so, can come to know the music, if so desired, in repeated soundings. Herein, a new type of knowledge of the music ensues that is based on listening, memory and becoming familiar with the sounds of the music piece. Cobi van Tonder refers to this as a music piece's 'consciousness' and describes that coming to know the sound world of a music piece is more than acknowledging notes or musical patterns, rather,

> I was mesmerized by the complex beauty and mystery of what I heard: it felt like the piece had some kind of consciousness of its own. [. . .] It was something that wasn't there in the notes, in the interlocking patterns, but rather an image that appeared because of the patterns.
>
> (van Tonder 2016: 2)

It would be so much more difficult to ask an ensemble of live musicians to playback repeatedly short phrases of music, or to stop abruptly and skip to another section repeatedly in order to 'freeze' the same type of acoustic knowledge of the music sounding. The music score, if one is available with the music, can of course assist further analysis, but it is the acoustics of music sounding that provide an embodied cognitive and phenomenological knowledge of the music in question. It is this knowledge and the artist's imaginative interpretation of this knowledge that can be used to influence the crafting of visual elements for the visual part of a visual music piece. In the final work, the music part becomes the soundtrack. A feature of these *Studie* films is the tight synchronisation of the music sounding *with* the movements, motions and transformations of the various types of *visual* forms in each film. Fischinger explains the acoustic influence in exploring the relationship between music and image in his *Studie* films, noting that,

> this time it will not, as hitherto, be music that is transposed into pictorial form; that was just the beginning, a makeshift effort. Now I am going to start exploring in greater depth the mathematical order and optical laws of the absolute

image. Since these laws are in keeping with acoustics, the result will be a space-music. The process – set out in a precise timetable – will involve tracing musical values and curves on graph paper. Then, at every phase of the work, I will play the relevant phrase. It is my aim to make absolute film theatre-worthy. For I am firmly convinced that there is still much that is new and beautiful to be discovered in this area.

(Fischinger 1930 quoted in Goergen 2013: 44–45)

Technologies for the playback of sound that have developed subsequently, such as the record player, the CD and the digital audio file, provide evermore ease of access to the playback and listening to sound. Technologies for the playback of sound and images together such as in various forms of camera and computer applications also provide an accessibility to listening to sound while watching the unfolding of images at the same time. As the technology for presenting sound and images together continued to develop, recorded-sound remained central. That is to say, the soundtrack is more than just a recording of a music performance, but the totality of the audio being presented, including sounds that have been generated synthetically with technology, manipulated sounds, as well as mixtures of recorded, synthetic and processed sound. A visual music artist engages with the recording as a whole, in its capacity to act as both the creative ground of the animation and as the actual soundtrack of the work. The distinction between diegetic and non-diegetic sound in narrative cinema is not a fundamental aspect of sound in early absolute film cinema or in contemporary visual music. Rather, recorded sound is the ground of a visual music exploration and construction. The activity of listening and composing with sound for its sonic characteristics is paralleled in the activity of creating visuals that have been grounded on these sonic characteristics. This is particularly the case for a visual music artist attending to the playback of an electroacoustic music soundtrack.

### Music extended listening

Listening to recorded sound, without focusing on the source of the sound, is a fundamental tool of *musique concrète* techniques and of the other new music composition approaches of the twentieth century, such as tape music, computer music and electroacoustic music. For Pierre Schaeffer, the *écoute réduite* (reduced listening) to the musical potentiality of musical acoustic qualities found in the sounds themselves was *a music compositional method in itself*. Schaeffer collected the sounds that had various forms of musical interest to be accessed again, later, for contemplation of their music compositional potential purposes. This process of storage, categorisation, non-linear access, playing back and repeated listening contributes to the method of composition. This potentiality of the sound becoming musical material in a composition can only happen through listening to it and coming to know it. This type of listening is also at work when identifying what is of compositional interest

in the music for the crafting of a visual composition consisting of animated visual elements and animated images that will also be aligned in time to the music through the synchronising of the images to the soundtrack in the final rendition of the work. Fischinger's listening to the music of the soundtracks is embodied in the figures and forms and their animation over time in his *Studie* films. Most of the soundtracks of these films were recordings of classical music and tonal music performances. It does not matter, nonetheless, what style, category or genre of music is listened to when paying attention to its acoustic and musical qualities for the crafting of visual forms. The acoustic characteristics of sounds sounding occur in all sounds and in all music sounding. What one attends to and what one crafts in visual form can be a musical motif in one instance, or it can be the sudden appearance of a fast rhythmic sequence on a violin or it can be the long duration of a rumbling sound from a highly processed sound recording. It can also be the pace of the changes of musical passages, or the pace of changes of the timbral sounds. It can be the attack of the sound or the decaying part, or it can be a sensed movement or trajectory that the sounds suggest for the listener. Thus the spectromorphological qualities of the soundtrack can be attended to as much as the more abstract compositional structures underpinning the composition.

Listening, then, is a fundamental feature of most visual music design. An extended form of listening takes place which could be called visual listening. In visual listening, the artist attends to the acoustic characteristics of sounds of the chosen music through repeated listening to the soundtrack. The soundtrack is both the creative ground for creating the visual part and is present in the final visual music work. What is attended to in the soundtrack by the artist is a number of things: the music composition as a whole in its structural unfolding; what the artist identifies as being of importance in the sonic material and what are the visual ideas arising from this listening to the music composition and the sonic material of the sounds sounding. A music work, in its acoustical sounding, can provide an infinite amount of possibilities for the crafting of dynamically transforming visual forms. The sounds can suggest trajectories, motions, curves, shapes. The unfolding of the sounds in these expressive ways, therefore, can be applied not just to music but to visual elements too.

### The surface is alive and limitless

The surface of the canvas or of the projected area for film and video is both the place and the space in which the acoustics and musicality of the sounds are extended visually into the visual music work. Both the Suprematist painter Kazimir Malevich (1879–1935) and the filmmaker Hans Richter (1888–1976) exploited the significance of the surface itself as a formal structuring device in their visual art work. Richter conceived of the area of the screen as a formal element in itself as well as

in its relationship to the other formal elements operating in the screen. Malevich went further, configuring the surface of a painting as being an alive living entity in itself. According to Malevich, the canvas, and what is represented on it, is "a window through which we discover life" (Malevich quoted in Golding 2000: 74). In the paintings from his white phase, the use of white suggests an infinite space. He writes about the limitlessness of white for the viewer. "The rays of vision are caught in a cupola and cannot penetrate the infinite. The Suprematist infinite white allows the beam to pass on without encountering any limit" (ibid.). Furthermore, the new abstract forms in the painting also have their own life and they live in the surface. In his manifesto he writes, "any painting surface is more alive than any face [. . .] a surface lives, it has been born. It is the face of the new art. The Square is a living royal infant" (ibid.: 62).

The surface is not a static thing; it acts, rather, as a vast limitless infinity. There are endless possibilities for defining how that surface will appear and what will exist in it. The surface can be spacious as much as be spatial, it can be weightless as much as be gravitational, and it can have multiple perspectival viewing and entry points. It can act as a groundless abstract entity, but it is full of potential. That is why some artists call the works of art in which the visual and music intertwine in the surface 'a world', and many visual music artists and composers would agree (McDonnell 2019). The visual elements in this surface can sometimes appear to have a weightless quality to them; at other times, they can suggest figure ground relationships or solidity. Cubist, Futurist and Abstract painting dismantled the material of the object as the subject matter for painting and drew our attention to the new reality of painting manifested in the area of the given surface of the work. Painters render the expressive possibilities of light on the surface of the canvas surface using pigments. When moving, image surfaces are rendered by means of electric light. The surface provides us with a new type of physical canvas that is crafted and presented by means of the physical representation of light. The aesthetic possibilities for the configurations of colour, light, intensity and darkness become light-based visual elements that can be used by the artist in the crafting of that surface. They provide artistic and expressive possibilities. However, in visual music works, the surface also comes from the actual physical rendering of light. The moving image surface is a new type of surface medium. The moving image in visual music is a continuation of the evolving role of the surface and in particular the role of the surface in the tradition of abstract painting. When abstract visual art content is created with light as its fundamental material basis, the sensory impression for the viewer is further engaged with the qualities and quantities of light and the colours that are formed through the interaction of light. The very technological intervention of capturing, reproducing and playing back images through light needed to display the image brings with it *new aesthetical qualities* to the composition of the visual music surface.

## Similar divisions in technical-led content making and composition methods

The three classic divisions of electronic music composition, *musique concrète*, *elektronische Musik* and 'tape music' (Emmerson 2018) as well as the category of computer music are all replicated in various visual compositional methods based on technical and medium-specific processes for creating the visual content of visual music works. There are *concrète* methods, where the sources of the images come from camera recording of natural scenes and objects. These images are used as new source material but then changed and transformed through image-editing and processing through the mediation of electronic video and computer technologies. I used this method initially when creating my first visual music work in 1997 and named the method of generating visual material and images as being a 'visual form of *musique concrète* technique' – this was my way of describing, whenever asked, what I was doing and had produced. Joseph Hyde uses the more succinct term 'visual *concrète*' to describe a similar method and technique for creating visuals in some of his art works (Hyde 2012). Indeed, the editing and manipulation of recorded images and found footage images is one common method for creating the visual part of a visual music work in many artists' works today. There are also electronic and digital synthesis methods for generating visual material for images in visual music works. These source images are created from the ground up, utilising the mechanism and technology of the video signal or the screen technology image format to create images from units of visual information coming from these technological representations. In *elektronische Musik*, the synthesis techniques are approached in this way: "a combination of an atomistic additive approach starting from 'elementary particles' – sine tones, impulses – was complemented by a subtractive route based on the filtering out of frequencies from noise bands" (Emmerson 2018: 251). Video signals were manipulated by video synthesis artists from the late 1960s (Collopy 2014), and there has been a continuous development of video synthesis techniques for generating visual content for presentation with music in contemporary practice. The computer facilitates a range of synthesis techniques for generating images. For example, images can be generated from very small shapes, called particles and these particles can be controlled in how they appear, group, move and behave in a spatialised three-dimensional image space environment. Images can be also be generated from data visualisation, visualisation of mathematical processes such as fractals, simulations of real world processes, such as chemical reactions, diffusion, etc. Images can be mixed together and can be related to each other through code. Every dot of light that is used to generate the images surface of the work can be accessed and manipulated. Most of the images for a visual music work – regardless of how the content is made either through manipulating recorded images or synthetic images – use the medium of video to output the steady stream of moving images necessary to project the

images onto the viewing surface and into the acoustic space of the performance or screening. In electronic music, the speaker makes the music audible and acoustic. In the visual part of the visual music work, the video projector makes the visual art visible and visual. Jean Piché names his art, where he crafts moving images that are projected with his electroacoustic music compositions, as being a *'video-music'*, grounding the art in the main means for presenting it. Video, as well as film of course, are important aesthetical contributors to the language of visual music. Both of these moving-image-based arts and technologies are inherently part of the legacy and language of crafting images synchronised in time with soundtracks. Computer music as 'a descriptor of means' (Emmerson 2018) for generating sound and music is replicated in computer video, which can generate images and visual art.

With every new development in music technology, music-making methods and composition techniques, there are interestingly parallel developments in the visual arts influenced by such changes, and vice versa. Such was the case with the advent of new cinema and music technologies of the twentieth century. There are numerous examples of such parallel developments that have resulted in mutual influencing as a result of technological developments. Two examples this that will be discussed in the following two sections demonstrate how the soundtrack could be utilised to create a visual accompaniment, in which the visual accompaniment is itself emulating the technological processes involved in creating the soundtrack. One example is what I call Cinema *concrète*, a term used by Pierre Schaeffer when interviewed about his direction of research-led projects. He led a research team of filmmakers to work with the *musique concrète* compositions as the soundtrack. Another example comes from the collaborative work between Barry Truax who worked with the computer graphic artist Theo Goldberg. Goldberg created computer videos using Truax's music as the soundtrack. Both authors acknowledged the computer technology underpinning their means of creating art. Many contemporary composers seek a visual element in their concert performances for both classical and electroacoustic music performances, which they obtain either through collaboration or through their own efforts.

### *Cinema* concrète

Pierre Schaeffer (1910–1995) writes about the *ars-relais* (the linking, indirect and/or relay arts[1] (1941–1942) that exists between recording images in cinema and recording sound in radio, observing that there is a "common intermediary point and connection between the recording of images in cinema and the recording of sound in radio for the arts, art practices and aesthetics" (quoted in McDonnell 2019: 157). Schaeffer was influenced by cinematic techniques and was also instrumental in facilitating actual creation of new cinematic experimental films with *musique concrète* music. From 1960 to 1974 Schaeffer was involved in the direction of several research-led groups, such as ORTF (Research Department of French Television Broadcast) and

the GRM (*Groupe de Recherches Musicales*) research services and in this capacity facilitated the making of these experimental films by filmmakers employed in the INA-FR with *musique concrète* compositions from the GRM studio to be used as soundtracks for the films. These films were initially conceived as being for television broadcast. A team of artists, composers, filmmakers, television producers worked on these audiovisual experiments (McDonnell 2019; Sonore-visuel.fr 2016). Example filmmakers follow. The filmmaker Piotr Kamler created films set to the music of François Bayle, Bernard Parmegiani, Robert Cohen Solal, Ivo Malec, Luc Ferrari and Iannis Xenakis. The filmmaker Jacques Brissot created films to the music of Pierre Schaeffer, Luc Ferrari, François-Bernard Mâche and Iannis Xenakis. The filmmaker Raymond Hains (1926–2005) created the film *étude aux allures* (allures study) to the music of Pierre Schaeffer's titled *étude aux allures* music composition (1958). Schaeffer remarked on the freedom in the images and sounds and in the audiovisual relations that were based on kinship rather than on mathematically contrived relations (Schaeffer in *Le contrepoint du son et de l'image* in *Arts sonores*, n.d.a). Schaeffer did not expect filmmakers to make precise synchronised sound to visual relationships but was interested in what linked the two together in terms of technique and process and that this new kind of cinema was based on the images and sounds speaking the same language (Arts sonores, n.d.b). In an interview with the actor Jean Desailly for a television programme 'Discorama' (1959), Schaeffer explains his idea of the acousmatic as applied to cinema, suggesting that there could be a new cinematic form that is both technologically and theoretically similar to *musique concrète* (Ina.fr n.d.a; McDonnell 2019: 200). Christian Gosvig provides a short paraphrase of Schaeffer's conversation with Desailly, in which Schaeffer declares his intention to support and "develop a form of cinema that could be called '*concrète*' as a visual counterpoint to *musique concrète* and explains how he tries to apply his idea of the acousmatic to cinema" (Gosvig 2011).

## Computer video – material connections

The intermediary points that occur between the sounds and images were facilitated by the technologies of film and video and were especially facilitated by the multi-sensory basis of computer communications. The computer makes the representation of sound and images into the same material: data. Similar processes such as analogue to digital conversion and vice versa are applied to data and output to the peripheral devices of screens and speakers. An early example of computer video and computer music being brought together for a mutual presentation in a similar mode of a related art based on related artistic processes were the computer graphic works of video artist Theo Goldberg and the computer music of composer Barry Truax's from 1987–1992 (Truax 2011). Goldberg notes that the correlation between music and visual structures are aided by the computer (1986).

### Electroacoustic music and visuals

Although the filmmaker Walter Ruttmann had already noted in 1919 that the new art form of film "will give rise to a totally new kind of artist, one whose existence has only been latent up to now, one who will more or less occupy a middle ground between painting and music" (Ruttmann in Schobert 1989: 102), with the advent of electroacoustic music as a field of compositional practice, many electroacoustic music composers have turned to an inclusion of a visual element for the presentation of their work and prepared a visual for projection acting as an extended and integral part of the music as well as collaborating with visual artists to create this visual projection layer for their music. There are, however, also many forms of collaborations between music composers and visual artists, and visual artists are also interested in exploring their video projection art works with music, and so, they work with the electroacoustic music as the soundtrack, originating idea and ground of their visual work.

## Sounding visual techniques

### Exploring visual music

My entry into a visual music form of expression for creating visuals for moving images and music was from the perspective of musicianship, music composition methods, *musique concrète*, digital signal processing, sound synthesis, algorithmic music composition and music technology as well as from a life-long amateur interest and practice in painting and drawing. The knowledge about the physical nature of sound, the electronic and digital representations of sound and the spatial and acoustic characteristics of sound were used to experiment with creating new sounds, using various methods of creating and crafting sounds for music composition from *concrète*, sound synthesis and algorithmic methods. However, an unexpected outcome, one that is common to many electroacoustic music composers who create a visual projection of moving imagery for their music, was that this kind of constructionist approach to building both the content and the form of a music composition was also inspiring visual ideas for my visual art. Several experiments were done with pastels on paper to create visual forms and visual spaces that captured in visual forms the richness of the acoustical and perceptual nature of a sound.

The method sought to experiment with understanding how a visual element could operate in the visual art space of the area of the paper surface. Of particular interest also was musical timbre. The different parts of a unit of timbre – its attack, steady state, decay in terms of both harmonic pitched sounds to inharmonic sounds – were of interest. So, too, were the 'behaviour' of musical sounds, such as its harmonics, the bursts of noise in space, and how a sound to the ear can tell us about the space

we are in the mixture of source sound, direction and reflections. These kinds of behaviours were emulated in how I approached the composition of a visual surface on paper. Of interest also was what is behind the surface, and how all the interacting layers of various snippets and fragments of form and colour can blend together to present the overall impression of a multi-faceted, multi-layered, multi-temporal complex moving visual art surface.

## Similarities in technology and technique

Later, while working with soundtracks for video in the computer and learning how to convert analogue video recordings to digital computer video in 1996, I continued to be inspired by knowledge of sound and of its acoustic characteristics. I saw the potential of developing further these visual ideas related to knowledge about sound on paper, into a temporal form through digital video processes. The inspiration from sound and timbre in electroacoustic music could be experimented with more significantly with the addition of access to time and more specifically video channel timelines that the computer video editor facilitated. The visual elements of lines and colours could now be animated and brought to 'life', they could have movement and rhythm and much more. The skill-set to do this was difficult at first, but the will and sonic inspiration was there to do it. The video and photo editing software were conceived of metaphorically as if they were sound editors. The interface was similar, the editing process was similar, the operative techniques were similar, the digital data nature of both sounds and images was similar. Psychologically, it felt like the playing field had been levelled between music and visual art, where both had become a free-form material that could be moulded into either sound or images, depending on one's skill level with manipulating data in the computer. Vibeke Sorensen (1998) notes a similar thing in the liquid architecture concept she uses to describe the sensory spaces created with sound and animations combined. Computer sound editors enable one to access and operate on the sound non-linearly such as to cut, copy, paste, superimpose, mix sounds into each other, with interesting musical results, often transforming the very nature of the sound heard and thus creating a new acoustical sound. Sounds could be slowed down, sped up, reversed, have filters, reverberation and various effects applied. Video and photo editors enabled similar access to images (e.g., cut, copy, paste, superimpose, blend, merge, filter, reverse, time stretch, speed up, and slow down). The editing and processing of recorded images results in a new technique for creating images – a visual form of *musique concrète* technique. The recorded image, when it becomes a complete new composition of colour and form after extensive image manipulation techniques, loses its linkage to its source recording and source image. The source then acts as a colour palette for the visual music composer as a paint brush might act for a painter. The sources are the material of the art-making. The material that the source becomes can be

moulded into endless permutations of forms and colours. In these early experiments, I was looking for interesting visual characteristics to use and with which to experiment in the manipulation and processing of all the source images. The final image result that ensued from this process was seen as a complete image in the area and boundary of the screen and video projection, it was a unique surface. As Malevich said, "a surface is born" (Golding 2000: 6).

## Concrète methods

The main tool of image-making is the gathering together of a library of images from various and multiple sources. Found footage, recorded video, photographs scanned and digitised, drawings and paintings digitised were all gathered together. What was gathered were only images and image content that were of interest and had some artistic potential. Potentialities sought in the images gathered were things like the patterns created on a surface, the reflection of light, the contrast of light and reflection, colours, relationships between colours, spaciousness, complexity, density, sparseness, spatial relations between objects, interesting formations and such like. Many hundreds of such items were gathered and organised. It was at this stage of creating this library of images, I noted the similarity of approach again to *musique concrète* methods in the selection of sounds and the building of a sound library and the subsequent transformation and processing of these sources using digital image and video editing and effects techniques. That is why the rather long-winded phrase of 'a visual form of *musique concrète*' was initially used to describe both the techniques and the method of visual composition.

## Extended listening and visual sonic listening

The technical techniques of *musique concrète* were initially of interest. It soon became apparent, however, that it was the sounds themselves and how one listened to these sounds through loudspeakers that determined the visual forms and temporal evolutions of these forms for a visual music composition. The music sounding is how the music becomes known. An extended form of listening takes place where one comes to know the sounds in a music composition with a view to creating a visual work with the music. The listening entails a type of attention that is focused just beyond auditory concerns to a concern for the visual potential of a sound's qualities, characteristics and behaviour in the composition. This visual listening attends to the sonic details of a music composition, capturing what is of interest in sound events, what part of the sound transforms, changes, fades away or suddenly disappears, what direction do sounds go, how long do they last, how do they interact with other sounds, what types of patterns and groupings of sound can be identified and what sounds belong (better and best) together.

This kind of extended and visual sonic listening is similar to how an electroacoustic music composer will listen to the sonic results of their sound-making and sound gathering and adjust and transform and mould the sounds into the final mix of the composite sound for their composition. At all stages, listening is the key component of the composition process, so too it is with visual music. The acoustic space of the sounds are visually extended into the visual art work. Both acoustic and visual spaces converge in the visual music expressive work. It is not just about a visualisation of music's qualities and quantities, although of course it can be and at times it seems to be, but it is about this occupation of extended spaces in which the visual space acts in the acoustic space and the acoustic space acts in the visual space. The visual music artist crafts these actions through the manipulation of visual material. Like sound, a visual form could change its state in time. It could start of as a snippet of colour, then morph into a larger shape, then split into tiny grains of colour and yet still keep a kind of visual identity, as if all these parts and partials belonged to the one formation.

## Complex surfaces

The surface is where all the visual elements are put, crafted, sought and organised into coherent parts and wholes, and with reference to Malevich's conception that the surface itself is alive in an abstract painting. The surface, nevertheless, is even more alive in a visual music work because the animation of visual elements brings a liveness quality to the visual elements of the visual composition. Visual elements have their own life in which they fade-in and fade-away, or dramatically enter and leave the space, or transform and change and mutate, or separate and merge and so forth. Without really realising it at the time, what attracted the author to working with digital video images was not the assembling and organising a sequence of shots but in having access to every point of light or square or dot of colour in the surface area of the frame. So, rather than having to paint the preferred colours and forms 'onto' a surface to build up the final image, the recorded image or the found footage or the scanned painting provides the artist with an image that is already given as a visual object and can be made, through the layering, separating and merging of colours and through manipulation and craft, into temporal animated forms and surfaces.

## Discussion – example work – Digital Alchemy (2018)

The visual music works *Silk Chroma* (2011), *Duel Tones* (2016) and *Digital Alchemy* (2018) were screened at SOUND/IMAGE colloquiums at University of Greenwich, London, in 2015, 2017 and 2018 respectively. This section will discuss briefly the work *Digital Alchemy* in light of the visual music contexts and methods of visual composition just outlined in this chapter by way of an example of a method of composing visual music images for a soundtrack recording of a music composition.

I was invited by the composer Cobi van Tonder to compose a visual music visual for a fixed media version of her micro-tonal music composition *Gala* which she composed in 2016. The ideas and musical intent in the music composition were not known *a-priori*, the visuals, rather, were crafted by the author by way of a concentrated listening and attention to the electroacoustic music impression of the music by way of its sounds. Later van Tonder's inspiration and methods were examined (van Tonder 2016).

The following sub-sections consist of the component parts of the method described that I devised to craft the visual music visuals and are listed as follows: extended listening – qualities of musical sound of interest; extended listening – visual ideas from sounds sounding; from *concrète* to complex electric visual; the multi-dimensional surface; emergent forms; and final surface.

## Extended listening – qualities of musical sound of interest

There were various qualities and features of the music of *Gala* that was of interest. Some of these were musical features in terms of the musical events such as motifs and rhythmical musical passages, others were more to do with characteristics of the sounds and sonic and musical stimuli that suggested movements, direction, events, textures, colours. For example, in listening to the music, I heard tiny snippets of sound that coalesced to suggest long timbres that drifted in and out of pitched tones. These snippets were attended to, but, with repeated listening, that also suggested a temporal transformation of pitch, rhythm and timbre in an upwards direction. The music was slow moving and the listening resulted in an impression that the whole piece consisted of one long evolving timbre. There was no sense of starting and stopping of any sound but a sense of tiny transformations of sound character within this long duration timbral sound. It was as if the content of this long-evolving sound were drifting into and out of consciousness. At times the sounds had sections in which the sounds were a little painful to listen to, like the stretching of multiple harmonic combinations and high pitches that had gone too far for comfortable hearing. Then the sounds seemed to come back to a place of equilibrium and settle down into a quiet recession and fade-out to the end.

## Extended listening – visual ideas from sounds sounding

The sounds suggested drifting lines of colour, colours moving together and colours moving apart. The overall screen area for the visual composition was conceived of as being a complete whole animated and alive surface that does not fundamentally change in terms of form but remains intact throughout the piece. What I intended was that the surface could emulate the kind of drifting sensation that can happen before one's eyes when they are closing when about to go to sleep, or when closed for

**Figure 17.1**  *Digital Alchemy* (2018) – the surface with multi-dimensional colour block areas.

meditation. The colours of gold, ochre and pink were suggested by the micro-tones of the music that operated as if they were part of one entity – this living and alive surface (see Figure 17.1).

There were two overall arching movements suggested by the sounds from beginning to end and that was of upwardness and a sideways drifting. Colour blocks of micro-motions and changes were suggested and these were to appear as if they were going upwards and sideways suggested by the perception of trajectories and paths from the music and there was to be a sensation of these motions echoing each other in time. The morphing and temporal evolution of the tiny fragments of sound were to appear as tiny snippets of micro-motion colours and various intensities and darknesses of hue and these were to appear in various directions. There was a sensation of pitch at times and this suggested an ordered balanced geometric figure. Several rough sketches of visual elements and their placement in the space of the area of the video surface were created. In a way, this drawing of visual ideas was a form of visual language creation for the sounds heard in this composition. A rough map was drawn of the placement of pitches in the work in order to obtain an overall sense of the range of pitches in the work. A dramatic moment where the music seems to break apart from its normal trajectory was thought through for possible visual equivalents.

### *From* concrète *to complex electric visual*

One source image of a still photograph of a lightbox with panels of various coloured glass in orange, olive green, lemon and white was used to create the visual material of the work. It was used as the initial starting point for the creation of the images, and

**Figure 17.2** *Digital Alchemy* (2018) – complex electric visual and the emergence of intense forms on the visual surface.

thus, it acted like a material foundation. Timelines of various durations were created for sections of the soundtrack. Image manipulations were carried out in these timelines by means of effects, masking and colour-blending techniques and many of these manipulations were keyframed over time to create complex transformations of the effects and thereby creating motions, movements, changes over time of the image material. Keyframing the various effects and image manipulations created motions, changes in appearance of visual elements and resulted in new colours and form to take shape and emerge in the surface (see Figure 17.2).

A library of timelines using these methods were created. Thus the manipulations of the initial source image became the source footage for new timelines to which more manipulations were carried out, to what I call a move from a *concrète* to a complex electric visual construction. The new images consisted of bursts of intensities of light that are facilitated by the fact that I was using a computer screen–based surface to create the visual surface. The images seemed to buzz as if they were emulating electric pulses traversing across the surface, creating motions and variations of light intensity.

### The multi-dimensional surface

These timelines were autonomous independent motion surfaces. Each surface comprised motions and changes of the image material. Surfaces were then copied and layered on top of each other, each layer having more effects applied until desired micro-motions and animations of colour and texture emerged. Surfaces were subsequently created that matched cue points in the soundtrack. The complex layering

process of multiple surfaces created various temporal, spatial and depth results. The surface is now not just a one-dimensional space and time entity but with this type of process of composition and construction, the surface is the accumulation of layers of multi-dimensional space and time entities. Each surface contributes to the final whole surface through various forms of blending and mixing the colour information of each pixel of each surface. In this way, colours come forward and forms emerge as a result of this process. The mixing happens at the two levels of each pixel point and at each frame at each point in time. A sense of depth and a complex space can be achieved, but the depth that ensues is not one that is mimicking how objects appear in the natural world; it mimics, rather, how depth in music can be replicated with music technology by copying the samples of a selected duration audio file and copying and mixing that sample into the selected portion at a slight offset in time, creating reverberation sonic results. When one extends this technique in audio by, for example, copying and mixing multiple portions of an audio segment into a selected portion, one creates a new sound. This copying, mixing and layering surfaces with selected layers of images is akin to this audio technique.

A geometric figure was created, animated and experimented with, in relation to the chosen section of music (see Figure 17.3). The visual composition progressed to the combination of many motion surfaces that lasted for the duration of the music composition and these were worked and re-worked using colour blending, masking, keying effects and colour correction filters to create the desired blend of colour and micro-motion of fragments of colour and form and until the colours of rose gold, gold and pink emerged. The final surface after this process of construction was aligned to the duration of the whole music composition.

**Figure 17.3**  *Digital Alchemy* (2018) – emergence of form and the construction of a geometric figure.

## Emergent forms

There was no *a-priori* visual forms or structures planned, except for the visual impressions and ideas that came from listening to the music. These vague general ideas, however, did guide the whole process of experimentation and working of the image material. It was as if, with these guides in mind, the eye was attending to what could be found as a result of the experimental processes. The technique of combining and layering multiple complex surfaces results in many unexpected but often quite wonderful results. It nearly always results in the emergence of new forms in places and positions in the surface that work really well with the overall concept. A complexity of motion results and a complexity of changes to colour and forms and their trajectories and behaviour in the surface takes place. In this visual composition the final surface did not emerge until a few weeks of this experimental activity.

## Final surface

The final surface ended up being very much in line with the initial visual listening to the music. It is characterised as being one whole entity that takes over the full area of the screen and does not change in structure or content much over the entire duration of the work. There are two oblong shapes set into the surface and offset from the sides and the centre. These stay in position throughout, but do undergo some transformations of their inside area over the composition (see Figure 17.4). I

**Figure 17.4** *Digital Alchemy* (2018) – two vertical lines offset from the centre act as an anchor for the overall surface.

perceived these two oblong shapes as a way to anchor the surface and give the viewer something solid to hold onto in the experience of the surface. Two major points of interest in the music were worked with intricately. One, a rapidly rising and hurried pitched section of the music is aligned to the appearance and animation of the geometric figure and tow, one of the oblong bands suddenly appears to break with the surface and undergoes an upwards trajectory movement yet keeping its position within the space of the oblong, this was aligned to a stretched upward pitch section in the music. As the piece nears the end, this broken-apart surface stops and rests in its usual position. The piece fades out to its end.

## Conclusion

### *Sounding visual*

An overarching concept that could describe the method that I take in the crafting of visual music works is a form of sounding visual. Sounding referring to the sounds, the act of listening, the acoustical action of sounding through soundtracks and loudspeakers and the present continuous nature of the temporal aspect of the music when it sounds in time. The sounding, then, is directed towards making all these aspects visual in whatever manner and means that an artist might like. Soundtrack listening is one of the vital tools which a visual music artist has today and is a fundamental starting point for the creation of a visual music expression. Such listening is less about understanding the fundamental theoretical basis of the musical material in the music, or about understanding music for music's sake. It is, rather, a form of excavation listening, a digging out of what is interesting and a thinking about ideas for the visual composition. Fischinger and Schaeffer used the soundtrack as the starting point for the composition of an animation and both were aware of the acoustical power of listening to sounds via a loudspeaker. Even if the visuals and music are composed by the same author, the soundtrack is often the starting point in contemporary visual music practice, as it is for the author. At some stage, the soundtrack will become part of the compositional ground to finalise visual animations. My process of crafting imagery for music started out from the perspective of experimenting with methods of translating *musique concrète* techniques into the domain of video and from the perspective of music composition. Such techniques led me into devising a method of creating visuals for music that is based solely on listening to the sounds of the music through the final recording of a music performance, or the final soundtrack of an electroacoustic music composition. The music in its listening is aimed towards the crafting of a multi-layered, multi-temporal surface to which time, depth and forms emerge. The surface lives in the music and vice versa.

## Note

1 The translation of '*des ars-relais*' differ. Bizzaro (2011: 2) translates it as 'linking arts' or 'indirect arts' and Palombini (1993) translates it as 'relay-arts'.

## Bibliography

Arts sonores. (n.d.a) *Artsonores*: Raymond HAINS, *Etude aux allures. Ina.fr*. Available online: https://fresques.ina.fr/artsonores/fiche-media/InaGrm00805/raymond-hains-etude-auxallures.html [Accessed 09/12/18].

Arts sonores. (n.d.b) *Artsonores*: Jacques BRISSOT, *Objets animés. Ina.fr*. [online]. Available online: https://fresques.ina.fr/artsonores/fiche-media/InaGrm00807/jacques-brissot-objets-animes.html [Accessed 09/12/18].

Bizzaro, N. (2011) Pierre Schaeffer's Contribution to Audiovisual Theory. *Worlds of Audio Vision*. Available online: http://www-5.unipv.it/wav/pdf/WAV_Bizzaro_2011_eng.pdf [Accessed 09/12/18].

Bonds, M.E. (2014) Liszt's 'Program' Music. In: *Absolute Music: The History of an Idea*. Oxford: Oxford University Press.

Collopy, P.S. (2014) Video Synthesizers: From Analog Computing to Digital Art. *In IEEE Annals of the History of Computing*. 36(4). pp. 74–86.

Emmerson, S. (2018) Introduction: Music Practice-Reaching Out with Technology. In: S. Emmerson (ed.) *The Routledge Research Companion to Electronic Music: Reaching Out with Technology*. Oxon and New York: Routledge.

Galeyev, B. (2005) Mikhail Matyushin's Contribution to Synthetic Art. *Leonardo*. 38(2). pp. 151–154.

Gardiner, I. (2007) Oskar Fischinger. In: *Music, Sound & the Moving Image*. Liverpool University Press. pp. 117–118.

Goergen, J. (2013 [2012]) Oskar Fischinger in Germany 1900 to 1936. In: C. Keefer; J. Guldemond (eds.) *Oskar Fischinger (1900–1967): Experiments in Cinematic Abstraction*. EYE Filmmuseum and Centre for Visual Music.

Goldberg, T.; Schrack, G. (1986) Computer-Aided Correlation of Musical and Visual Structures. *Leonardo*. 19(1). pp. 11–17.

Golding, J. (2000) *Paths to the Absolute: Mondrian, Malevich, Kandinsky, Pollock, Newman, Rothko, and Still*. Princeton, NJ: Princeton University Press.

Gosvig, C. (2011) A Concrete Cinema? *Curating the Moving Image* [blog]. Available online: https://web.archive.org/web/20120315133207/2011.curatingthemovingimage.org/blog/2011/03/16/3075/ [Accessed 06/12/17].

Hyde, J. (2012) *Musique concrète* Thinking in Visual Music Practice: Audiovisual Silence and Noise, Reduced Listening and Visual Suspension. *Organised Sound*. 17(2). pp. 170–178.

Ina.fr, I. (n.d.a). Pierre Schaeffer à propos de la musique concrète. *Ina.fr*. Available online: www.ina.fr/video/I05028438 [Accessed 08/12/18].

Kapuscinski, J. (2001) [1998] Basic Theory of Intermedia: Composing with Sounds and Images. In: *Monochord. De musica acta, studia et commentarii*. Vol. XIX. pp. 43–50. Torun: Adam Marszelek Publications. Available online: http://www.jaroslawkapuscinski.com/pdf/composing-sound-images.pdf [Accessed 08/12/18].

Keefer, C., Guldemond, J. (eds.). *Oskar Fischinger (1900–1967) Experiments in Cinematic Abstraction*. EYE Filmmuseum and Centre for Visual Music.

McDonnell, M. (2019) *Finding Visual Music in Its Twentieth Century History*. PhD Thesis, Trinity College, Dublin.

Palombini, C. (1993) Pierre Schaeffer, 1953: Towards an Experimental Music. *Music & Letters*. 74(4). pp. 542–557.

Rosenthal, B. (1983) The Spirit of Music in Russian Symbolism. *Russian History*. 10(1). pp. 66–76.

Ruttmann, W. (1919 [1989]) Painting with Light. In: W. Schobert (ed.) *The German Avant-Garde Film of the 1920's/ Der Deutsche Avant-Garde Film Der 20er Jarhre*. Goethe Institut München.

Schobert, W. (ed.). (2003 [1989]) *The German Avant-Garde Film of the 1920's: Der Deutsche Avant-Garde Film der 20er Jahre*. Goethe Institut München.

Sonore-visuel.fr. (2016) *Cycle 'Écoute voir: musique concrète et cinéma, le service de la recherche' | Sonore Visuel*. Available online: www.sonore-visuel.fr/fr/evenement/cycle-ecoutevoir-musique-concrete-et-cinema-le-service-de-la-recherche [Accessed 08/12/18].

Sorensen, V. (1998) Global Visual Music Jam Session. *Talk at Intel*, November. Available online: http://visualmusic.org/text/inteltalk.html [Accessed 08/12/18].

Truax, B. (2011) Computer Graphic Works. *Theo Goldberg & Barry Truax*. [DVD] Cambridge Street Publishing CSR-DVD 1101.

van Tonder, C. (2016) *Commentary on the Portfolio of Compositions*. PhD Thesis, Trinity College, Dublin.

# Technique and audiovisual counterpoint in the *Estuaries* series

Bret Battey

## Introduction

An estuary is the outlet of a river where it meets the tide. Fresh water meets salt water in complex dynamics, varying with the flow of the river and forces of the tide. Continuity, fragmentation, instabilities and transformations intertwine.

We find a continuum, here, between the distinct streams, the mixing, and their ultimate combining. Consider a poetic comparison between this intertwining stage and musical counterpoint. Individuality and interdependence co-exist: multiple identifiable musical lines intertwine. The horizontal (harmonic) and linear (melodic) define each other. Contrary motion and consonance "serve the morphological task of unification and reconciliation amidst the contrapuntal drive for independence" (Levarie and Levy 1983: 125).

Extending the metaphors further, my *Estuaries* series of audiovisual compositions have served as an intertwining of several streams of exploration. Specifically, through *Estuaries 1* (2016), *Estuaries 2* (2017), and *Estuaries 3* (2018),[1] I aimed to achieve the following:

- Develop and apply a new abstract-animation technique based on the visualisation of direct-search optimisation processes.
- Explore and refine further potentials of variable-coupled map networks (VCMN) – embodied in my Nodewebba software – as a generative-music tool.
- Assess the potential for VCMN to help generate coherent audiovisual counterpoint.
- Gain further insights into the formation of "fluid audiovisual counterpoint".

These will be discussed following in this order. Thus, the initial discussion is technical, describing some innovative tools and approaches to sound and image generation. Attention then shifts towards the aesthetic. This culminates in a detailed consideration

of a selection from *Estuaries 3*, showing how technological means and aesthetic viewpoints worked together to establish elements of a fluid audiovisual counterpoint.

I suggest on one hand that controlling sound and image simultaneously with VCMN – an event-based generative process that is not perceptually informed – has limited capacity to consistently generate convincing audiovisual counterpoint, fluid or otherwise. On the other hand, I demonstrate that such an approach can effectively generate *some* viable solutions in this vast domain, thereby serving to stimulate creative solutions and new insights into potential audiovisual relationships.

## Visual technique: the OptiNelder filter

### *Introduction*

The OptiNelder filter is a custom image-processing algorithm developed for the *Estuaries* series. It visualises the search paths of direct-search optimisation agents applied to an input image.

Mathematical optimisation refers broadly to finding best solutions to mathematical problems. The goal is to find the input values that will return the minimum or maximum output for a given function. Ideally, one can optimise through solving equations, but sometimes this is not possible. In these cases, other means must be used. One class of approaches uses iterative processes whereby a trial solution is tested and the results inform a new potential solution. These are called direct-search methods (Lewis et al. 2000; Kolda et al. 2003).

From an artistic perspective, we might find it clarifying to conceive of the potential outputs of a mathematical function as forming a terrain – a contoured landscape. Optimisation, then, entails finding the inputs to the function that will return the lowest or highest point in that landscape. A direct search will typically do so by exploring that terrain step-by-step, using what is discovered at any one step to infer a likely best direction (uphill or downhill) to search in the next step. This way, ideally, the process will eventually find its way to the top of the highest peak or to the bottom of the lowest valley.

The core hypothesis driving the development of the OptiNelder filter was that visualising aspects of a direct-search process could generate artistically useful images. This might occur through optimising a mathematical function or by using an actual image or video input as the search terrain. Artistic interest might be found in several aspects: (i) in the temporal behaviour exhibited by a direct searcher as it iterates, (ii) in the compound figures that would arise through the accumulation of shapes in the path of a searcher, (iii) in the changes of the search behaviour if/when the search terrain itself was altered, and (iv) the combined effect of visualising many search agents simultaneously. Thus, the interest was not in quality optimisation *per se*. Instead, the intent was to visualise direct-search

processes to provide a gamut of artistically distinctive and malleable shape-vocabularies, textures and behaviours.

## Optimisation, visualisation, and artistic applications

Unsurprisingly, published research to date on visualisation of direct-search processes is aimed at understanding, describing and refining the performance of such processes, rather than artistic visualisation. Generally, the intent has been to reveal the search path of the algorithm on the problem terrain to support analysis (for example Stanimirović et al. 2009). Another key issue is 2D or 3D visualisations of higher-dimensional problems (such as in Dos Santos and Brodlie 2004).

However, some precedents for the artistic application proposed here exist in the literature on swarm-based artistic visualisation. For example, Greenfield and Machado (2015) provide an overview of ant-colony-inspired generative art. Swarm-based multi-agent systems have been used to create non-photorealistic rendering based on multiple source images (Love et al. 2011; Machado and Pereira 2012). Bornhofen *et al.* use biological metaphors such as an energy model with food chasing and ingesting to create abstract images, plant-like structures, and processing of input images (2012). Choi and Ahn combine the classic BOIDS algorithm with a genetic algorithm to create stylised rendering of photos (2017).

The OptiNelder technique takes this multi-agent approach from swarm processing, with each agent being an instance of a classic direct-search algorithm – the Nelder-Mead method. One or more Nelder-Mead agents search an input image for the darkest or brightest points, displaying their search paths in the process. The colours extracted from the images at the points of the search process are used when drawing the search path. (However, since the Nelder-Mead agents do not share state information with each other, OptiNelder cannot be considered an example of swarm processing in the normal sense of the term.)

## The Nelder-Mead simplex method

The Nelder-Mead simplex method is a classic direct-search approach (Nelder and Mead 1965). Since its introduction, it has developed and retained strong popularity and can be found in many numerical analysis tools (Lewis et al. 2000). Nelder-Mead seemed a strong choice for this project, in part due to this technical ubiquity: code implementations and documentation are readily available. Further, given the shape vocabulary used in its search process, it seemed likely that it could provide visually novel complex accumulations of simple shapes.

In short, the method involves addressing a problem of $n$ dimensions (variables) by first creating an initial simplex shape of $n + 1$ points. For example, for a two-variable problem, this simplex will have three points, forming a triangle. Given what the function values at these points imply about the downward direction in the problem terrain

(if minimisation is the goal), a new simplex is specified. This process is iterated until exit criteria are met, it is hoped – though not necessarily – by converging on a solution.

At each step, the new simplex is formed by either a reflection, expansion, contraction or shrinkage of the evaluated simplex. These operations "probe" around the simplex with simple rules to determine the points of the next simplex. Coefficients control this behaviour, referred to in the original paper as $\rho$ for reflection, $\chi$ for expansion, $\gamma$ for contraction, and $\sigma$ for shrinkage. Formal definitions of the algorithm are readily available, such as from Wright (1996). I have developed a somewhat simplified description aimed at helping artists and non-specialists understand its behaviour and the effect of the coefficients, available at http://BatHatMedia.com/Research/neldermead.html

## Implementation

The OptiNelder filter currently uses an input image as the "terrain" on which Nelder-Mead agents seek maxima or minima. In the implementations thus far, this has entailed searching for brightest or darkest points in an RGB image. This is a two-dimensional problem: a point $x$, $y$ in the image returns a brightness value. In our terrain metaphor, bright points are high in the landscape and dark points low. As the agents search, the simplex points and/or the simplexes themselves are drawn, using colours extracted from the input image at the simplex points.

OptiNelder is a custom plugin filter for Apple's Motion 5.3 video-effects, animation and compositing tool. The code is Objective-C++, using Apple's FxPlug 3.1 SDK. This approach provides the advantage of combining refined time, editing and rendering controls of a modern visual-effects tool with custom-developed, OpenGL-accelerated effects, and easy manipulation of stills or movies to provide the visual input to the filter.

The plugin was built around the author's objective-C conversion of a C implementation of the Nelder-Mead algorithm by Michael Hutt (2011). The Hutt code implements constraints, which are needed to keep the search within the bounds of the image. It also creates a scalable equilateral simplex as the initial state, with sides one-unit long. This scaling is a necessary feature for this image processing application: one needs to scale the size upward to provide an appropriate start condition for the terrain, since one pixel in the source image is one unit.

The control parameters for the plugin fall into four main categories: placement and behaviour control, point control, triangle control and spline control. For the sake of brevity, only a key subset of these parameters is described next.

### Placement and behaviour control

The user determines the starting points of the search agents on the input image either through a grid (with the user specifying the number of rows and columns) or with positions determined through seeded randomness (with the user specifying total agent

count). In addition to the standard Nelder-Mead setup and the initial scaling factor mentioned earlier, the plugin also provides the capacity to rotate the initial simplex around the starting point. Variations in this starting angle can change the search path, ranging from subtle shifts in detail to an output that finds radically different end points. Users can also control the reflection, expansion, and contraction coefficients for the search process and set a maximum number of iterations before an agent stops searching.

Finally, a parameter can rotate the complete set of all simplexes in the search path around the starting point. This has nothing to do with the optimisation process, but it can serve aesthetic ends. It provides a way, for example, to gradually pull apart a coherent image formed of completed search paths – or gradually put it back together again.

## Point control

The point size and transparency can be specified separately for the agent start-point, the simplex corner points, and for the end-point of the search. The point sizes can be automatically scaled by their relative brightness. This latter feature can help provide variation in the points for a less mechanical-seeming visual result.

## Triangle control

One can enable colour fills for the simplexes and set the alpha (transparency) value. The colour fill of the triangle is created with an OpenGL interpolated fill between the colours of the three corner points.

## Spline control

The user can activate a spline curve that passes through the points of the simplexes. In particular, the filter uses a custom Objective-C implementation of Kochanek Bartels (KB) splines.[2] KB splines were originally created as a means for interpolating between animation keyframes (Kochanek and Bartels 1984). This means that they also serve in situations where one wishes to cast a smooth spline that is guaranteed to pass through a given ordered set of points. In addition, KB splines include controls for tension, continuity, and bias to provide results ranging from straight lines to very loose curves (see *ibid.* for details).

In the OptiNelder implementation, the user can determine whether the spline will be drawn and whether it will pass through points 1, 2 and/or 3 of each simplex in a search path. A "join spines" option determines whether a separate spline set is drawn for each Nelder-Mead agent path or a single spline is cast through the full set of paths of all active agents subsequently. Finally, this KB-spline implementation also allows for colour interpolation along the spline, so colours change gradually between those specified at the simplex points.

## Example

As the first piece in the series, *Estuaries 1* provides some of the simplest and clearest demonstrations of OptiNelder concepts. The primary input image is a Motion-generated circular gradient – from blue outside to white inside – with agents seeking the brightest points in that image. Throughout the work, agents are arranged using the grid-placement option.

In the 15-second gesture at the beginning of the work, the input is a radial gradient in the centre of the image (see Figure 18.1). OptiNelder begins with a single agent placed in the centre of the image, limited to one iteration – with the initial simplex gradually scaled up to reveal a single triangle. The triangle starts to rotate as the gradient moves left. This leftward motion of the gradient is an exponentially accelerating motion curve. During this leftward gesture, more agents are gradually added to the row and the Nelder-Mead iteration limit is increased to lengthen the search paths, which are tending to "reach out" towards the centre of the gradient. Thus, all of these elements work together to create a "throwing" gesture to the left side of the screen.

Watching this example in video form also reveals that the agent search-paths can be unstable and jump suddenly and unpredictably frame-to-frame as the source image undergoes gradual changes. This contributes to an essential aesthetic quality of *Estuaries 1*: the evocation of an unstable and awkward audiovisual semi-stasis that fractures and re-stabilises, seeking resolution.

## Discussion

The *Estuaries* series demonstrates a wide range of animated textures through the OptiNelder technique applied to both still and moving images. The diversity of possible behaviours, driven by an input image, proved amenable to supporting my ongoing interest to sculpt visual change in time in ways analogous to and interlinking with musical gestural and texture – such as the gesture described earlier.

The technique clearly functions in alignment with some of the strategies I have previously proposed for the generative artist (Battey 2016a):

- It provides a disciplined means to relinquish control to generate new ideas.
- It provides fruitful unpredictability if the artist is willing to dialog with the system to discover its potentials and limits.
- It can readily provide a perceptual complexity that lies between extremes or redundancy and randomness.
- It is arguably an example of creative "misuse" of a mathematical process to create unexpected and serendipitous visual outcomes.

As seen with the *Estuaries 1* example, one challenge of working with the OptiNelder filter is the difficulty of creating smooth, gradual transformation of the output

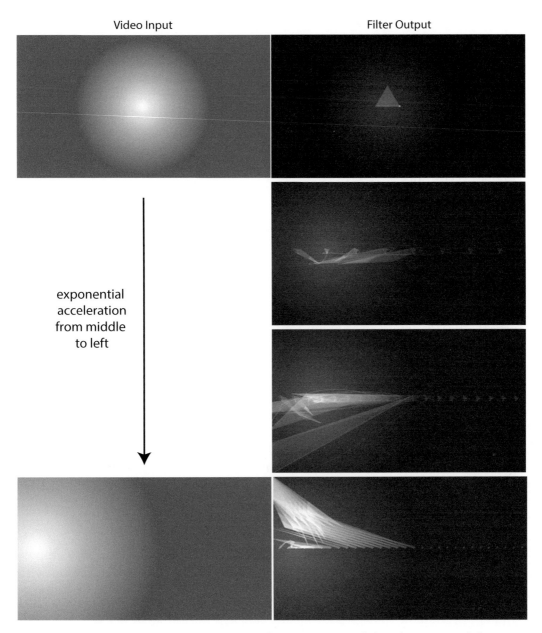

**Figure 18.1** Four frames from the beginning of *Estuaries 1*. A radial gradient moving left over 15 seconds provides the source image. The number of agents in the filter increases gradually, arranged in a row. Other parameters are modulated concurrently to provide an overall transformation that matches an underlying musical gesture.

image if any aspect of the search parameters or the search terrain is modulated. In *Estuaries 2*, with its focus on dense, canvas-filling textures driven by noisy image sources (water surfaces), the unpredictability of the paths simply becomes part of the noisy texture. In all of the *Estuaries* pieces, however, I struggled at times with this frame-to-frame nonlinearity. One solution, when this characteristic detracted from the aesthetic ends I was after, was to smooth the abrupt changes by applying extreme motion-blur effects after OptiNelder. In this case, the results of many different frames can blend together to create even more complex composites.

## Musical technique

With the *Estuaries* series, I have continued to develop my variable-coupled map networks (VCMN) approach to generate emergent behavioural patterns for music. In particular, I have been refining my *Nodewebba* software and gaining a greater sense of its potentials.

### VCMN and Nodewebba overview

In short, VCMN entails the linking together of iterative functions to create emergent behaviours. Each function (or "node") comprises Lehmer's Linear Congruence Formula (LLC) and a timing function to determine when it will next emit its state and iterate to a new state. LLC is a formula normally used to create pseudo-random numbers. However, when its variables are de-optimised, it can become a useful pattern generator, demonstrating behaviours ranging from stasis, decay/increase, simple iteration, compound iteration, and unpredictable self-similarity. By using the output of one node to set variables or timing of another node or nodes, more complex behaviours can emerge, including potentially perceptually interesting relationships between the nodes. Once feedback connections are considered, where nodes drive themselves or start paths of influence that ultimately come back to themselves, a wide range of possibilities emerge. The VCMN approach has been described in detail elsewhere (Battey 2004).

*Nodewebba* is software I developed to provide a GUI-based system for composing with a six-node VCMN system.[3] It ties all of the nodes to a metronome, with the timing of each node set as multiples of a small durational value (e.g. multiples of a 16th-note duration). A 2D matrix control allows for easy connection of node outputs and inputs. Node outputs can be mapped to various pitch-modes and instrumental ranges. The output can by synchronised to an external sequencer to record the MIDI output. Created in Max/MSP, Nodewebba can either run as stand-alone software or can be extended through interaction with other code developed in Max, with a set of global variables providing output and input to the Nodewebba system. Details can be found elsewhere (Battey 2016b).

### *Example: music in* Estuaries 3

A few specific points about the musical approach, with emphasis on *Estuaries 3*, are worth mentioning to frame the following discussion of audiovisual counterpoint.

The primary timbre approach in the *Estuaries* series entails driving samples of orchestral instruments via MIDI, but convolving these with tamboura samples (though piano sounds, not convolved, often provide a foreground function). Besides creating an extended decay tail on the samples, this convolution approach creates complex interaction between the pitches performed by an instrument and their alignment with the overtones of the tamboura. This is made more complex by having a different tamboura fundamental for each instrument. For example, in *Estuaries 1*, pizzicato violin is convolved with a tamboura pitched at F, while plate bells are convolved with a tamboura pitched at E. This creates spectral richness and complexity of temporal behaviour that transcends the original orchestral sources. Thus, the distance between the note events generated by the VCMN system and the perceptual result is significantly magnified.

All of the *Estuaries* works are unified in part through using a given set of 13 Messiaen-inspired chords as the core pitch material. However, each piece uses a different generative approach to create details and large-scale structure from those chords. In the case of *Estuaries 3*, each chord controls one portion of the piece. For each of these "chord-sections", the chord was turned into a pitch-mode definition that was loaded into the nodes in Nodewebba. (Note that a "chord section" does not necessarily correspond perceptually to what we might consider a large-scale section of the piece. As we shall see later, for example, the first counterpoint "section" of *Estuaries 3* comprises multiple chord-sections.)

Each chord section has a manual specification of overall duration, which nodes would be active, the pitch range for each node, and how many notes would form a "phrase" (after which a node would pause). A phasor running between zero and one across the duration of each section was mapped to control phrase length and rhythmic range, generally to provide higher density and activity towards the end of a section – often creating a sense of forward impetus.

Compressed Feedback Synthesis (CFS) is a sound synthesis approach based on software-based feedback loops controlled by automatic gain-control (Battey 2011). *Estuaries 3* includes CFS to provide a more continuum-based, rather than event-based, sound element. Nodewebba controlled aspects of the ongoing CFS process, including its fundamental feedback frequency (based on the first note of the chord for each section), the pitch-shift ratios, and frequency of ring filters. As with the convolution approach, the independence and unpredictability of the CFS process created behaviours that belie the simplicity of the VMCN-generated note-events that are shaping them.

Ultimately, these generative approaches provided initial materials, which were captured in a DAW and then subject to editing. Given this generative foundation for the music, could it also aid in the control of visual elements to create a complex but coherent audiovisual counterpoint?

## Audiovisual counterpoint, fluid and otherwise

Starting with my work on the *Luna Series* of audiovisual compositions (2007–2009), I have been slowly developing a concept of a "fluid audiovisual counterpoint". The term points to an artistic intuition about which I hope to gradually gain analytical clarity. My most extensive published exploration of the idea to date is my article "Towards a Fluid Audiovisual Counterpoint" (2015). Starting with the traditional music pedagogical framework of species counterpoint, the article considers whether and to what extent this could be a legitimate metaphor to apply to discussion of audiovisual counterpoint. From there it explores the idea of a counterpoint of gestures, moving beyond discrete note and visual events. It the considers the idea of fluid audiovisual counterpoint:

> A fluid audiovisual counterpoint, then, is a specialised instance of this gestural counterpoint, emphasizing even more the ebb and flow of alignment and non-alignment of tensions between relatively smooth articulation points in continuums, rather than discrete objects and instantaneous change.
>
> (*ibid.*: p. 31)

The *Estuaries* series explores this idea with the aid of "audiovisualisation" of VCMN activity. The audiovisual artist Ryo Ikeshiro proposes the word *audiovisualisation* to refer to the simultaneous sonification and visualisation of the same source of data.

> In audiovisualisation, the audiovisual relationship arises as a result of independent presentations of the same data in the audio and the visual media. They both relate directly to the underlying process. Furthermore, they relate indirectly to each other via their individual relationship to the underlying process.
>
> (Ikeshiro 2013: 61)

Audiovisualisation can be both a fascinating and problematic prospect – arguably something likely to prove difficult to achieve to a convincing standard, given the differences between visual and musical perception. How and to what degree and depth can music and image cohere if arising from a single underlying abstraction that is neither musical nor visual in its essence, nor perceptually informed?

My hypothesis was that VCMN could provide a way to explore the vastly multivariate problem-space of audiovisual relationships, including generation of solutions that might not have conceived of directly. Thus, it might generate some aspects of convincing solutions to audiovisual counterpoint, helping to create effective solutions in the short run which could also inform a theory of audiovisual counterpoint in the long run. This is to say that it was not expected that convincing counterpoint would be achieved fully through VCMN control. Indeed, as we shall see, a great deal

of editing of the audiovisualisation results were required to achieve results that I found perceptually convincing. Thus, this cannot be called audiovisualisation, per se. Instead we might call it audiovisualisation-assisted composing.

The clearest examples of VCMN-assisted counterpoint can be seen in the two counterpoint sections of *Estuaries 3*, which serve as the climax (4:00–5:55) and ambiguous close (7:30–8:30) of the work. The relative counterpoint clarity of these sections, including discrete visual objects within the image, provide a clear dramatic contrast to the more textural approach of the other sections. We will now consider this in more detail.

### Estuaries 3 *example*

Technically, the approach involved exporting node data from Nodewebba to set keyframes in Motion to control OptiNelder and the visual elements fed to it.[4] There was an immediate tension, here. The quality of fluidity requires emphasis on continuums and gestures, while VCMN, MIDI and the core sound-design approach of the series is naturally oriented towards discrete event triggers. I sought to overcome this event bias to some degree in some portions of the *Estuaries* series. Musically, as already noted, the use of convolution and the inclusion of the CFS instrument in *Estuaries 3* was also aimed at providing more continuous sonic elements. Further, when using Nodewebba to set visual keyframes, I used varying types of transitions between those keyframes to shape time between those events.

In the two previously mentioned counterpoint sections in *Estuaries 3*, for example, two thin, green vertical bars use primarily exponentially shaped motion between Nodewebba-determined keyframes. This creates a very strong point of arrival at the keyframe – a clear accelerating gesture landing on and highlighting a discrete event-point.

In contrast, orange and white membranes in the background (provided by the "Membrane" generator in Motion) have smoother motion curves through keyframes. In this latter case, the keyframes become articulation points (in the sense used in the quotation about fluid counterpoint), rather than events. They provide moments of relative stability in a continuous flow of motion.

Similarly, the simplex starting-angle of the OptiNelder filter is often modulated with smooth motion curves, providing a fluid, detailed paralleling or dialog with elements of the other musical and visual elements. Arguably, the interplay between the various continuums-based motion and the clear event/arrival motions provide some of the fascination and complex coherence in these sections of *Estuaries 3*.

We can look at 4:51 to 5:56 in *Estuaries 3* for some examples of how these musical and audiovisual elements work together hierarchically to create elements of gestural and fluid counterpoint. To aid in this discussion, a video excerpt of this section of *Estuaries 3*, with time code superimposed, can be found at https://vimeo.com/356157209. Figures 18.2a and 18.2b provide a notation-reduction of key

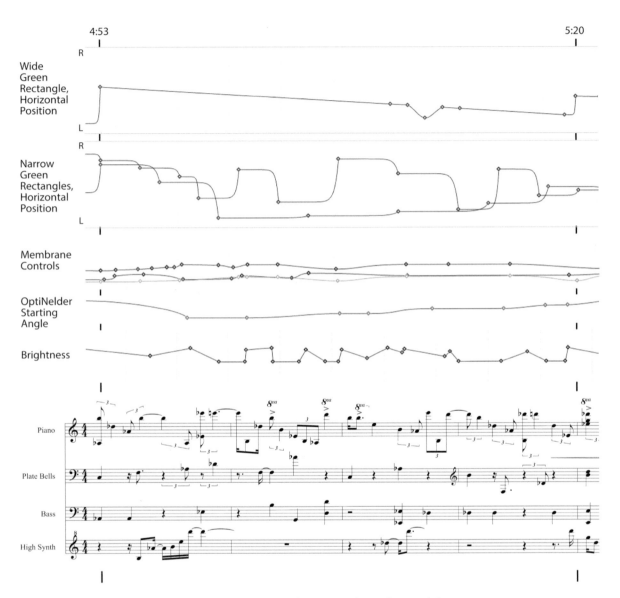

**Figure 18.2a and 18.2b.**   *Estuaries 3* excerpt: Music elements and visual control data.

Note: The musical notation at the bottom provides a simplified pitch and rhythm notation of prominent musical elements. Above that, the figure displays Motion keyframes and time controls for prominent visual objects and processes.

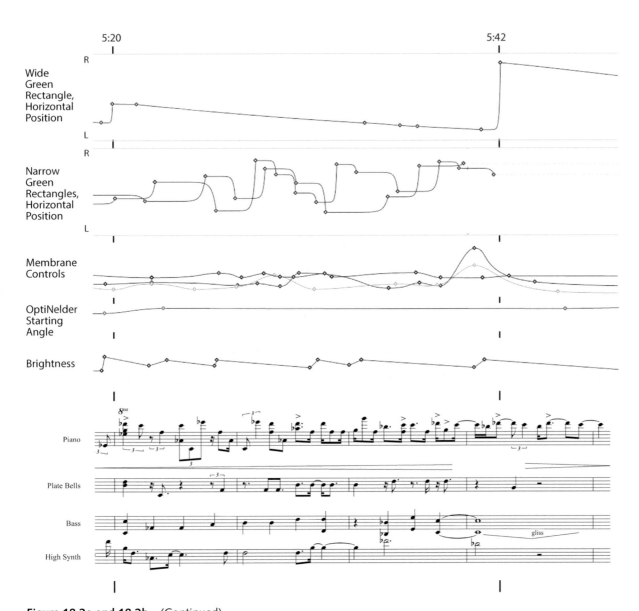

**Figure 18.2a and 18.2b**    (Continued)

aspects of the musical texture and the keyframe controls of some of the primary elements in the visual texture.[5]

The span shown in Figure 18.2 covers two chord sections. The first runs from 4:53 to 5:20, and the second from 5:20 to the resolution of the whole counterpoint section at 5:42. Thus 4:53, 5:20, and 5:42 are the highest-level structural points of this excerpt. The Max phasor associated with each chord section was mapped to the horizontal position of the wide green vertical bar. As a result, it gradually moves from right to left over the time span of a chord section. It moves quickly with exponentially accelerated motion back to a rightward position at the start of each new chord section, providing a heavily emphasised arrival point. Note that this jump to the right is of lesser magnitude at 5:20 then at 5:42. That is, the larger leap is reserved to demark the strongest point of arrival: the resolution of the whole section.

From 5:10–5:12, there is one deviation from this, where the wide green bar smoothly and momentarily accelerates to the left and then back to the original linear trajectory. This was actually an error in the data transfer for Max to Motion, but I felt that it provided an effective fluid response to the "high synth" gesture occurring at this point, and also prepared the perceptual downbeat at the start of measure four. I perceive a passing of gestural energy between elements here: brightness, Opti-Nelder starting angle and membrane controls modulate together in parallel with the high-synth gesture. Hierarchically, these elements provide shifts in the details of the visual texture rather than changes in the higher-level organisational elements (such as positions of the rectangles), thus paralleling the decorative or ancillary-gesture nature of the high-synth element. These visual modulations stabilise on the high note of that gesture. That high note is also the starting point of the left-and-return deviation-gesture of the wide-green rectangle. This gesture in turn is "answered" by a narrow-green line accelerating to the left and joining the wide-green line, with the sounding of a plate bell.

The keyframes for the narrow green rectangles were derived from the data that also generated the plate bells and bass notes. In this case, the exponentially accelerated horizontal motion of a green rectangle culminates in a note, providing a kind of visual anticipation of the note event. However, I often heavily edited the actual horizontal-location value of the keyframe to create horizontal alignments of these rectangles with other graphical elements, particularly in ways that might aid in the balance or cohesion of the image or provide emphasis, such as by having two elements landing in the same location.

As examples of the former, at 4:53 the left-most thin-green line aligns with the right-most edge of the orange membrane; at 5:04, the left-most thin-green line aligns with the third fold (from the left) of the orange membrane. As an example of both balance and emphasis considerations working together, at

5:06 the right-most thin-green line has leapt a considerable distance to a position right on the edge of the orange membrane, corresponding to a musical point of relative emphasis – the accented note shown at the start of measure three. As an example of horizontal positions corresponding to create emphasis, at the chord-section change at 5:20, the wide-green line leaps to the position of the left-most thin-green line.

Compositionally, from a high-level structural perspective, the details of each chord-section should contribute on the whole to the culmination of that chord-section and preparing the transition to the next. We can see how smooth articulations of a continuum can contribute to this by looking at the membrane behaviour in the build of tension to 5:42. At 5:31, I manipulated the membrane keyframes to result in a horizontal line appearing mid-screen in the white membrane. This provides a strong, momentary sense of visual stability corresponding to the accented note in measure six. This note initiates a period of higher note density and considerably higher pitch ambitus building to 5:42. During this passage, the membrane oscillates up and down in an accelerating fashion. This culminates at 5:36–5:45, where the membranes for the first time fold up on top of themselves in many layers, evoking a sense of previously pent-up energy expressing itself in an almost spring-like build of tension and release – paralleling the musical energetic profile building to the peak note of the section (5:42). This can also be seen in the keyframe data in Figure 18.2, with the relatively large upward change in one of the membrane controls begins to pull back just before the final rightward-leap of the wide-green rectangle.

The elements described in these examples all entail the interlinking of detail, mid- and high-level organisation through coordination of both event-points and continuums. Audio and visual events, gestures, and fluidity work together in interdependence to shape our experience of time. This passage originated in audiovisualised relationships established from a VCMN origin. I then interceded, sometimes significantly, to clarify the counterpoint, create or refine gestural linkages between the mediums, establish visual alignments for emphasis, and shape tension contributing to mid-scale audiovisual structures.

## Conclusion

The *Estuaries* series, and *Estuaries 3* in particular, have served my intent to help develop and clarify the idea and practice of gestural and fluid counterpoint. VCMN and Nodewebba helped in this process. However, as expected, using VCMN for audiovisualisation did not generate useful audiovisual counterpoints in these works so much as much as serve as starting point and source of surprise from which I

could work heuristically to create counterpoint solutions that I found perceptually satisfying.

The OptiNelder filter, besides demonstrably providing a wide range of visual potentials, also served the search for a fluid counterpoint. First, the creation of the input to the filter (choice of video or structuring of images from basic elements like rectangles and membranes) could readily be used to determine high- to mid-level structural features. OptiNelder processing would then contribute more towards detail elements of the structure, as shown in the *Estuaries 3* example.

At the same time, OptiNelder supported a dialog between event/object focus and continuum focus. In the *Estuaries 3* example, an initial scene comprising discrete objects (rectangles and membranes) was "blurred" through OptiNelder processing – intermingling the boundaries of discrete objects and providing overall textural features that could be expressively modulated.

The fluidity of some materials in the *Estuaries 3* example (textures, membranes, and their articulations) may function in the counterpoint in part due to the clarity provided by their interplay with relatively discrete points of arrival (notes, objects, exponential-movement preparing/anticipating events) in other materials. This raises questions for further consideration: to what degree can one move towards purely fluid materials and maintain enough clarity in articulation to have a sense of ordered relations? How "light" can articulation of a continuum be and still provide sufficient perceptual impact to establish counterpoint?

In the *Estuaries 3* passage examined, there are many note-to-motion correspondences. These help glue the mediums together perceptually but are of the simplest kind of relationship that could be established. The question of when image and sound events/gestures can be timed independently – or to what degree there can be independent audio or visual "voices" (in the counterpoint metaphor) is still difficult to assess. In the *Estuaries 3* example, independence among parts could be high as long as careful attention was applied to structural hierarchy and relative perceptual weight of events: more important temporal events were reinforced by alignment of multiple parts, and could be emphasised by wider leap in approach (be that a musical leap or a visual leap). Between such events, relationships can be freer. This is not a surprise; it is a basic principle of traditional Western musical counterpoint.

The range of artistic possibilities in audiovisual counterpoint remains immense – and perhaps ultimately resistant to a comprehensive formal explanation. From that perspective, audiovisualisation-assisted composition provides one valuable means for exploring this range and generating creative outcomes. In this case, sensitive artistic perception remains essential for guiding selection and adaptation of algorithmically generated materials to achieve the delicate task of balancing unification and independence of materials.

## Notes

1 Online versions of the works can be found at https://vimeo.com/202629040, https://vimeo.com/216727482, and https://vimeo.com/264837797 respectfully. Do note that the high level of detail and frame-to-frame change in many portions of these works cannot be accurately represented in current streaming formats.

2 The project's KB-spine code can be found on Github at https://github.com/bbattey/KochanekBartels Spline

3 Nodewebba can be downloaded at http://BatHatMedia.com/Software/Nodewebba/

4 Technical information on how I transferred Max-generated data to Motion XML can be found at http://bathatmedia.blogspot.com/2019/08/using-midi-and-max-to-generate.html

5 In Figure 18.2, I do not provide a vertical value indication for membrane controls, OptiNelder starting angle, or brightness, since absolute value indications are not as important here as relative value changes. I am also not describing the details of the Motion membrane generator, since that level of detail, too, is not essential to investigating the perceptual organisation of the excerpt.

## Bibliography

Battey, B. (2004) Musical Pattern Generation with Variable-Coupled Iterated Map Networks. *Organised Sound*. 9(2). Cambridge University Press. pp. 137–150.

Battey, B. (2011) Sound Synthesis and Composition with Compression-Controlled Feedback. *Proceedings of the International Computer Music Conference*, Huddersfield, UK.

Battey, B. (2015) Towards a Fluid Audiovisual Counterpoint. *Ideas Sónicas*. 17(4). Contro Mexicano para la Musica y las Artes Sonoras. pp. 26–32.

Battey, B. (2016a) Creative Computing and the Generative Artist. *International Journal of Creative Computing*. 1(2–4). Inderscience Publishers. pp. 154–173.

Battey, B. (2016b) Nodewebba: Software for Composing with Networked Iterated Maps. *Proceedings of the International Computer Music Conference*, Utrecht, Holland.

Bornhofen, S.; Gardeux, V.; Machizaud, A. (2012) From Swarm Art toward Ecosystem Art. *International Journal of Swarm Intelligence Research*. 3(3). IGI Global. pp. 1–18.

Choi, T.J.; Ahn, C.W. (2017) A Swarm Art Based on Evolvable Boids with Genetic Programming. *Journal of Advances in Information Technology*. 8(1). Engineering and Technology Publishing. pp. 23–28.

Dos Santos, S.; Brodlie, K. (2004) Gaining Understanding of Multivariate and Multidimensional Data through Visualization. *Computers & Graphics*. 28(3). Elsevier. pp. 311–325.

Greenfield, G.; Machado, P. (2015) Ant- and Ant-Colony-Inspired a Life Visual Art. *Artificial Life*. 21(3). MIT Press. pp. 293–306.

Hutt, M. (2011) *Nelder-Mead Simplex Method* [C-code]. Version 1 March. Available online: https://github.com/huttmf/nelder-mead [Last Accessed 18/09/27].

Ikeshiro, R. (2013) *Live Audiovisualisation Using Emergent Generative Systems*. PhD Thesis, University of London, Goldsmiths.

Kochanek, D.H.U.; Bartels, R.H. (1984) Interpolating Splines with Local Tension, Continuity, and Bias Control. *Computer Graphics*. 18(3). ACM SIGGRAPH. pp. 33–41.

Kolda, T.G.; Lewis, R.M.; Torczon, V. (2003) Optimisation by Direct Search: New Perspectives on Some Classical and Modern Methods. *SIAM Review*. 45(3). SIAM. pp. 385–482.

Levarie, S.; Levy, E. (1983) *Musical Morphology: A Discourse and a Dictionary*. Kent, OH: The Kent State University Press.

Lewis, R.M.; Torczon, V.; Trosset, M.W. (2000) Direct Search Methods: Then and Now. *Journal of Computational and Applied Mathematics*. 124(1–2). Elsevier. pp. 191–207.

Love, J.; Pasquier, P.; Wyvill, B.; Gibson, S.; Tzanetakis, G. (2011) Aesthetic Agents: Swarm-Based Non-Photorealistic Rendering using Multiple Images. *Proceedings of the International Symposium on Computational Aesthetics in Graphics, Visualization, and Imaging.* 1. pp. 47–54.

Machado, P.; Pereira, L. (2012) Photogrowth: Non-Photorealistic Rendering through Ant Paintings. *Proceedings of the Fourteenth International Conf. of Genetic Evolutionary Computing.*

Nelder, J.A.; Mead, R. (1965) A Simplex Method for Function Minimization. *The Computer Journal.* 7(4). Oxford Academic. pp. 308–313.

Stanimirović, P.; Petković, M.; Zlatanović, M. (2009) Visualization in Optimisation with Mathematica. *Filomat.* 2. Faculty of Sciences and Mathematics, University of Nis, Serbia. pp. 68–81.

Wright, M.H. (1996) Direct Search Methods: Once Scorned, Now Respectable. In: *Pittman Research Notes in Mathematics Series: Numerical Analysis 1995.* Harlow, UK: Addison Wesley Longman. pp. 191–208.

# Exploring Expanded Audiovisual Formats (EAFs) – a practitioner's perspective

**Louise Harris**

## Introduction

> [A] certain situation is stated. Certain elements with that situation remain constant, others precipitate the destruction of themselves by themselves. Recurrently as a result of the cyclic movement of repose, disturbance and repose, the original situation is restated.
>
> (Riley 1968)

This chapter documents and discusses the work of a contemporary audiovisual artist, based in UK academia, and considers some of the interests and preoccupations that have led to her developing two recent pieces along a particular research trajectory. It considers the author's understanding of the perceptual experience of the work and the compositional intentions underpinning this. It offers some jumping-off points for considering how *site*[1] has implications for both the composition and exhibition of two, very different, Expanded Audiovisual Format (EAF) works. It also considers how the author's preoccupation with creating a balance between control and unpredictability, and the manifestation of what Riley describes as 'repose, disturbance and repose' (1968) has shaped the audiovisual trajectories of the works discussed here. Ultimately, this chapter offers starting points – ways of thinking about the compositional, material, spatial and perceptual concerns of developing work in expanded formats, which have the potential to be applicable across a range of audiovisual practices.

## Expanded Audiovisual Formats (EAF)

The best place to begin this discussion is with a consideration of the nature of Expanded Audiovisual Format (EAF) works. Initially, I utilised the term to encompass works that sought to move away from the ubiquitous single-screen,

stereo-speaker format so prevalent in screen-based audiovisual modes. However, as time has gone on, and my work for EAF has developed, it has become clear that developing work for EAF involves interrogation not only of the exhibition format of the work, but of broader spatial and material considerations in their conception and exhibition. For the purposes of this discussion, the definition of EAF used is as follows:

> Works for Expanded Audiovisual Format (EAF) are those that seek to explore the possibilities of expanded exhibition formats from both a sonic and visual perspective simultaneously. These might include, but are not limited to, multiscreen, fulldome or projection mapping in combination with multichannel, multidirectional or ambisonic sound. Expanded Audiovisual Format works might also involve site-specific reconfiguration of both sonic and visual materials based on available exhibition spaces, or the design of an expanded audiovisual work for a specific architectural space.

The majority of my work with EAFs developed in response to external possibilities or limitations and represents a methodology for working within these conditions. This initially began with the composition of *pletten*. In the early stages of composition, I found myself torn between two distinct visual renderings I had envisaged for the piece; one showing the visual system 'from a distance', the other, a close-up of the internal workings of that system.

Faced with this issue, questions began to arise concerning the dominance of single-screen audiovisual work. Certainly, almost all screen-based audiovisual content is delivered for this format, and as a consequence we tend to expect audiovisual work in this mode of delivery. Further, the desire to work within the confines of a single video channel has historically reflected a preoccupation with what could be perceived as the 'ideal' audiovisual experience for viewing my work. Concerns over "composing with auditory and visual media simultaneously to create works in which the sound and image function as part of a unified, cohesive system – what John Whitney described as a 'complementarity' (1994: 2) and Bill Alves has subsequently referred to as the 'digital harmony of sound and light' (2005: 1)" (Harris 2016: 2) meant that the fixed, somewhat rigid nature of these works were an essential aspect of this attempt at cohesion – an attempt to limit additional demands on the audioviewer's sensory experience. *pletten* presented an initial encounter with stepping outside and away from this preoccupation, experimenting with alternative and expanded formats, and this exploration continued through *ilsonilus:1* (2015), a work initially envisaged for four-screen or cylindrical visual projection with 8-channel audio and later presented in fulldome format.

In late 2015, *pletten* and *ilsonilus:1* formed part of *Auroculis*, a digital release of a number of my works on the web label *deepwhitesound*. As part of the release, the site's curator wrote the following comments on the work:

> *Auroculis* is a collection of video works that serve as translations of digital audio compositions. Harris' visual-aural explorations into synaesthetic experience made possible through digital technologies hint at a mimicry of the generative process of looking. The result of her investigations are works that rely on projection, location and duration for full contextual consideration. Here she presents in digital download several fixed examples of this process, a mere glimpse at the potentiality of immersive visual music through expanded cinema installation.
>
> (Amorin 2015)

Looking again at these comments, certain descriptors struck a particular chord. Firstly – that the works might rely on 'projection, location and duration for full contextual consideration', which will be considered in more detail later, and secondly, that the works offered a glimpse 'of the potentiality of immersive visual music through expanded cinema installation'. Having not considered these works as being in any way akin to 'expanded cinema' previously, in light of explorations with fragmenting and disrupting a previously fixed visual space the use of the term 'expanded' became intriguing. Writing in the *Audiovisual Breakthrough*, Adeena Mey considers the "dialectics of ideation and materiality through which a work comes into being", suggesting that "in fact, expanded cinema seems to suggest that categories are dynamic and that the dynamics of art practices themselves always create new relationships between ideas and materialities" (Mey 2015: 46). Certainly, in working with EAFs, there is considerable dialogue between ideation and the physical materiality and experience of the work, and there is a fluidity to this dialogue that will be considered in the case studies that follow.

One of the concerns historically underpinning my approach to fixed audiovisual composition has been a preoccupation with the confines of the audiovisual frame. Chion remarks that "what is specific to film is that it has just one place for images" (1994: 67), yet contained within that one place there is the implication of the existence of the physical world beyond the confines of that frame; this is something that I have sought to explore in my own single-screen audiovisual work. Often, the visual component has been intended to give a snapshot of a larger whole, suggesting an environment that extends beyond the confines of the frame, as though the screen presented the opportunity to look through a window into an unfamiliar visual environment. This has led to some interesting negotiations of the resistance between physical, virtual and embodied space within installation

works in particular. There is an inherent tension between the inhabited, physical space of the environment in which the work is installed and in which the audience is present, and the more 'virtual' projected audiovisual environment inhabiting it. These two spaces might be argued to exist differently from one another; although they are situated in the same physical location, one is physical, present and inhabited; a comprehensible and continuous space, whilst the other is virtual; delimited and, in a sense, discontinuous. Through considering the nature of the embodied space relevant to the exhibition of works for EAF, some of these tensions manifest differently. The preoccupation with the confines of the frame become less central, because the frame itself is more fluid, existing differently with each iteration of the work – this is true of *Alocas* in particular. There is something very attractive about this, offering the possibility to reconsider the work with each installation, presenting an alternative engagement between physical and virtual spaces in each subsequent iteration.

Writing for eContact, Andrew Hill and Jim Hobbs describe their own explorations of expanded formats as an extension of Youngblood's (1970) ideas on expanded cinema, alongside what they describe as the expanded sonic practices prevalent in electroacoustic music, seeking to "investigate where approaches from experimental film and electroacoustic music performance might be brought together" (2017: 1).

References here to Youngblood, as well as Hobbs and Hill's own approach, help to effectively situate the use of the term 'expanded' in the context of EAF. The ethos of the works presented in this chapter very much resonates with Youngblood's ideas on expanded cinema – being a 'process of becoming' and allowing the artist to 'manifest his consciousness outside of his mind'; additionally, considering the works from the perspective of EAF is concerned both with method of production and workflow, and how this ethos is communicated and shaped through this consideration of production and exhibition, resonating with Hobbs and Hill's approach to collaboration in this expanded context. Whilst the *expansion* in the context of EAF refers first to the way in which the work is conceived and realised, both sonically and visually, it is also an important manifestation of the nature of the work as an aesthetic object.

Through developing the two works addressed in this chapter it has become apparent that there are other aspects of EAF work that are important to the development of works for EAF; namely whether they are developed for a specific physical space (site-specific) or whether they are developed with an ideal space in mind, but adaptable to a variety of contexts – a format described in this chapter as *site-adaptive*. Both of the works presented in this chapter have been developed using a similar compositional process, which will be discussed later, but represent a site-adaptive (*Alocas*) and site-specific (*Visaurihelix*) embodiment of that process respectively.

## Site-specific/site-adaptive

Most useful in the exploration of these terms – as suggested previously – is the work of Joanna Demers, and her attempt at disambiguating the concept of *site* within the context of site-specificity:

> The terms at play in discussions of music and site are *space, place*, and *location*. *Space*, according to Lefebvre (2000) refers to large-scale sites that could be physical, mental, or cultural in nature and either imaginary or real. . . . *Place*, according to Castells (2000) refers to sites that are local and governed by interpersonal, ecological, or political relationships. . . . By *location*, I mean the sheer physical placement of listeners and sound objects. . . . When talking about these terms together, I employ the word *site*, which can refer to acoustics, source origins, or cultural associations of sound. In short, the aim . . . is to delve into works that regard sound as *situated*, as inextricably bound to a particular spot or trajectory, whether real or imagined, physical or metaphysical.
>
> (2010: 3)

In both of the case studies presented herein, the audiovisual component of the works could fruitfully be considered through the lens of *site* – site encompassing space, place and location – ultimately creating an audiovisual experience which is situated, if not physically located, in a particular site.

However, within each work this concern is manifest differently, with the term 'site' referring to different concerns in each work and with the subsequent designation of 'adaptive' or 'specific' further defining their relationship with space, place and location.

## Case studies

### Alocas – *a site-adaptive EAF work*

*Alocas* is a dual screen, 4.1 channel audiovisual installation work completed in 2017. There are a number of aesthetic considerations central to its composition, relating to shape and form and how these are manifest sonically and visually. The initial genesis of the work was a consideration of the relationship between timbre and circular form (note, this is the intuitive underpinning of the initial formal considerations of the work – not intended as a primer on DSP!). Specifically, the work begins from the premise that, broadly construed, a sine wave at a particular frequency can be visualised as circular in form, and that the timbre of that pitch played on an instrument – a flute in the case of *Alocas* – might be visualised as a fragmented and granular manifestation of that circular form. Consequently, the combination of these two sounds

together are visualised in the work as a series of particle systems in the left[2] screen which present both circular forms and more chaotic, granular versions of those forms through forces of attraction exerted on the particles within each system. This can be seen throughout the work, but is perhaps most visible at the outset, with each particle system beginning as a tight circular construction before progressing outwards into a constantly shifting, more granular circular form somewhat reminiscent of movements seen on Chladni plates.

The right video channel of the work is conceived as almost a microscopic representation of the left. Specifically, it is governed by the same physical behaviours as the first, but the particles are attached to one another, are significantly larger and are rooted in one spot, creating particle chains that appear to move organically with significant changes in the sound material. Their more fluid movement has been likened by audioviewers to microscopic organisms that can be seen moving in water, but they retain their relationship to, and coherence with, the circular forms on the left screen through the individual forms that comprise the particle chain and the nature of their direct, often parametric, relationship to the sound materials in the work.

The central sonic material in *Alocas* is constructed around 12 frequencies, moving sequentially through a series of pitch clusters – these are defined algorithmically in Max and played through a series of cycle~ objects, for a pre-defined maximum time limit and with Max choosing when to move from one cluster to the next within certain parameters. The work is palindromic, with regard to the central pitched material – the pitch clusters move through their defined sequence over a period of 5 minutes and then move back in reverse – giving the work a feeling of expansion or unfolding to the central point, both sonically and visually, and subsequent contraction (repose, disturbance and repose). The audio of the work is 4.1, and the pitch clusters in the work involve very closely (< 5 Hz) pitched sine waves which cause beating relationships throughout; having presented this work in a range of different spaces, it has become clear that the audibility and effect of this beating varies enormously dependent on the specific physical space in which the work is presented, something which was intended at the composition stage but was largely theoretical until the work had been exhibited in diverse spaces.

Further compositional intervention in the synthesised material through, for example, the inclusion or foregrounding of flute recordings and other sound materials, or an altering in the nature of sound processing, are governed by the initial dry run of the visual system for the duration of the work – in this case 10 minutes. The visual system for both channels has some element of chaotic behaviour built into them – they are able to, for example, alter their levels of attraction, or the behaviour of the particles within each system, within certain parameters. The first run of the system, without audio input, elicited a series of these unpredictable behaviours; the timings of these were then noted and used to define the points in the synthesised audio material at which intervention would take place. Unlike the initial generation

of the material, this happened over the full 10-minute duration, so the timings of these interventions are not palindromic.

*Alocas* utilises a process for audiovisual composition that can be described as *algorithmic aleatoricism*, and it would be useful here to spend some time describing and discussing this term as it relates to both *Alocas* and *Visaurihelix*. The term can be applied to both the process underpinning the composition of both the sonic and visual materials in these and other recent works, and also the way in which the works are manifest and experienced in diverse physical and architectural spaces.

To fully flesh out this approach to developing materials for both of these works, it is best to begin with definitions of the terms *algorithmic* and *aleatoric* as they apply to composition. Unsurprisingly, each of these terms has been defined in variously specific and broad ways in a huge range of contexts, so presented here is one for each term – for algorithmic, Alpern's succinct definition of algorithmic composition as "the process of using some formal process to make music with minimal human intervention" (1995), and Paul Griffiths's similarly brief presentation of the term 'aleatory': "A term applied to music whose composition and/or performance is, to a greater or lesser extent, undetermined by the composer" (2001: 1).

Considered side by side in this way, these two definitions might almost be seen as somewhat interchangeable; indeed, structuring mechanisms such as using dice have been described as being both aleatoric and algorithmic. Consequently, for this context Meyer-Eppler's presentation of aleatory processes is perhaps more instructive – "a process is said to be aleatoric . . . if its course is determined in general but depends on chance in detail" (1958: 55).

In *Alocas* and *Visaurihelix*, techniques such as the mapping of visual structures to sonic outcomes are done algorithmically in max; visual structures are used as the basis for defining changes in pitch or the emergence of rhythmic motifs over time. However, these materials are subsequently shaped and intervened with through a process that is somewhat chance-based – the visual systems developed for the work are able to enact certain behaviours at certain points, and the timing of these points in the initial rendering of the visual material determines when compositional intervention – such as changes in voicing, pitch, rhythm, processing – in the sound materials take place. This allows either the appearance of other materials, or the nature of the processing of the sound materials, to be somewhat based in chance; in this way, the course of the work is determined in general, but the fine detail of aspects such as processing or motivic foregrounding is left somewhat to chance.

The term 'algorithmic aleatoricism' also reflects the nature of the chance-based intervention as, itself, somewhat algorithmic – being defined by the chance behaviour of an algorithmic system. The term also effectively describes the relationship between the sound and visual materials – in some ways very tightly controlled

and rule-driven, and in others more left to chance. This compositional strategy has been used as a way of both controlling, and not controlling, the audiovisual outcome of the two works presented here; having a clear sense of the overall compositional design – the course of the work and how it will develop – but allowing some of the fine detail to be left to both chance and rules-based procedures. At present, this is a very fruitful trajectory suggesting considerable further promise for development and has afforded the development of works that both look and sounds as desired, yet also afford the ongoing exploration of reciprocal audiovisual relationships with a certain amount of unpredictability. Further, there is significant resonance in both *Alocas* and *Visaurihelix* between the original compositional intention and the ultimate exhibition format, in that the physical manifestation of the work in specific architectural spaces might be seen as a reflection of this algorithmic aleatoricism.

*Alocas* is an example of a *site-adaptive* work – it is conceived for 4.1 audio with dual-screen visuals, ideally with the visual screens placed opposite one another in a small, very dark space. The intention is that the screens are large and close to the audience, allowing the audioviewer to engage in the complex visual structures in significant detail, whilst also being unable to really see everything that is happening visually at once. The 4.1 audio contains beatings and phase cancellations that alter dependent on the shape/size/resonance of the room in which the work is exhibited, alongside where in the room the audience is situated – consequently the audiovisual experience of the work is constantly shifting. The work has been most effectively realised at the Steven Lawrence Gallery in Greenwich, as part of the 2018 SOUND/IMAGE exhibition – for which a bespoke physical structure was built for the exhibition of the piece.[3] It has, however, also been screened numerous times in concert format (most recently at the Centre for Contemporary Art [CCA] in Glasgow) and exhibited in single-screen format with 4.1 audio. Being adaptable to a range of spaces and formats requires the relinquishing of a certain amount of control by the composer over the outcome of the work – however, this could be seen as a further *expansion* of the possibilities of the work itself, and is in many ways complementary to the ethos of the work in presenting a range of audiovisual possibilities and experiences through subsequent reconfiguration.

In *Alocas*, then, the work effectively exists in a fixed format (two video channels, 4.1 audio), but the manifestation of that work in a physical space – how it will behave in that space, how an individual will respond to it and, indeed, even how many individuals are in the room with the work at any one time – has an unpredictable impact on the audiovisual space; the basic rules are in place, but the fine details are left to chance. Designing site-adaptive EAF work involves not only having an ideal exhibition format in mind, but being adaptable to a range of circumstances and contexts, and allowing the work to speak differently in each of these, as it would speak differently to each audioviewer in turn.

## Visaurihelix – *a site-specific EAF work*

> There should be fantastic buildings for musical and sound productions. Not just a lot of speakers, but a really extraordinary architecture that you find your way in, that evolves.
>
> (Maryanne Amacher, in Handelman 2010)

*Visaurihelix* was commissioned by the Lighthouse and Cryptic as part of Sonica 2018 and the Mackintosh 150 celebrations. Designed and constructed for the Mackintosh Tower at the Lighthouse – the former water tower of the Herald Building in central Glasgow – the work consisted of a 32-minute, 6.1 channel linear audiovisual composition played on speakers spread throughout the Mackintosh Tower, with visuals projected on a custom-built, octagonal plinth positioned at the base of the tower, and an interactive sonic element consisting of struck copper rods, reminiscent of a Glockenspiel, suspended over the void of the helical staircase. The work is an audiovisual exploration of Mackintosh design and, specifically, of five Mackintosh buildings in and around Glasgow – Scotland Street School, Hill House, The Mackintosh House, The Lighthouse and House for an Art Lover. It consists of five, 6-minute movements, each exploring a different Mackintosh space and design motif.[4] All of the colour palettes in the visuals of the work are derived from Mackintosh stained glass panels found in each of the five buildings, and the sounds utilised, outside of the electronically generated materials which are mapped to the visual structures chosen for each movement of the work, were also all recorded within these five Mackintosh buildings.

Unlike *Alocas*, *Visaurihelix* is *site-specific*, being designed for and exhibited in a specific, highly unusual architectural space. Here, the visuals placed in the octagonal structure at the base of the tower become progressively more distant as the audience move up the tower, and become increasingly obscured by the copper rods, reminiscent of Mackintosh geometric forms, suspended across the void of the helical staircase. Consequently, although there is a very direct, generative relationship and considerable synchresis (Chion 1994) between the sound and visual materials in the work, this becomes less legible as the audience ascends through the space, and indeed this relationship is somewhat fragmentary from the outset, with the visual environment – on the octagonal structure in the base – being physically distant from the sound materials spatialised linearly throughout the 50-metre tall tower.

Conceiving and developing material for *Visaurihelix*, particularly with regard to the linear spatialisation, was challenging – without a 50-metre vertical structure in which to test out possibilities, one had to imagine how certain materials would sound when placed linearly in the space. However, again this was an aspect of the expanded and aleatoric nature of the work – the ultimate outcome, though important, was somewhat unknown and unpredictable, needing to be approached from a conceptual

and theoretical perspective as opposed to a concrete one. The fragmentation of the sonic and visual spaces in the tower, again, afforded an expanded perspective on the audiovisual outcome of the works – though very directly linked, their physical dislocation and presentation in differing physical and perceptual spaces presented a unique challenge and required a relinquishing of control which historically would have been unthinkable in my fixed media work.

The site-specific nature of the work is such that it could not really exist elsewhere – its resonance with Mackintosh, his buildings and the 150-year celebrations created a very specific cultural space that could not easily be replicated. The fixed audiovisual component of the work is for single channel video, at 1:1 aspect ratio, with 6.1 audio, so could quite reasonably be exhibited in fulldome or IMAX format with multichannel sound. Whilst this would present a different kind of expanded audiovisual experience, it would not be the site-specific experience of the original version of the work – rather, a site-adaptive version and, with regard to the *cultural* site-specificity, an entirely different piece.

Finally, to return to the Bridget Riley quotation earlier in this chapter, the unfolding of the sonic and visual materials in both *Alocas* and *Visaurihelix* exemplifies the idea of 'repose, disturbance and repose' that has been a key feature of, on reflection, all of the non-performative audiovisual works I have developed through my career. The development of sonic and visual systems that begin at rest, move through more active and, often, disruptive audiovisual gestures and return to a state of rest represents a cyclic compositional form that, unknowingly, has been a feature of all of my fixed works to date. Interestingly, the utilisation of stark colour contrast and simple geometric forms generating more complex visual environments, which has been a hallmark of my own visual style, is also something that can be seen extensively in the work of Riley and as a huge admirer of her work that influence can be very clearly seen. It is interesting to reflect on the prevalence of both these formal concerns and the ideas underpinning them as manifest in my own work, and the extent to which this has exerted unconscious influence over the development of my audiovisual compositions.

## Site: space, place, location

In describing the development of these works, I realise I have to some extent ridden roughshod over the preoccupations with space and spatial composition that is central to the practice of a large number of electroacoustic composers and sound artists. Evoking Maryanne Amacher earlier in this chapter was perhaps a little mischievous in this regard – whilst being a huge admirer of her work, Amacher's approach to working spatially and my own are somewhat different. Indeed, as Stefani and Lauke (2010: 251) note:

> The need for extended periods of development to create site-specific sound works of any sophistication was also emphasised by Maryanne Amacher. . . .

> To produce the location-based installations for my major works, intensive acoustic and auditory research in the space is required. Usually a residency of one month is needed for my investigations, depending on the size of the space and the number of rooms.
>
> (Amacher 2009)

A period of development lasting several months is unrealistic for most composers . . . but even one or two days of working in a space . . . should make a significant difference to the quality of musical results. This text proposes that techniques for acousmatic spatialisation will function most effectively when developed "on location". . . . Despite the fact that there may be some potential transferability of materials and practice developed for the work to another location, such works are a product of one listening space; a musical counterpart to that environment.

My exploration of site-specific and site-adaptive works for EAF approaches the composition of these works in a somewhat different way to that advocated earlier, and might be more along the lines of that expressed by artists such as sculptor David Nash: "I keep my mind on the process and let the piece take care of itself" (2001). In the case of *Alocas*, the concern is with the construction of audiovisual materials that almost 'carry on regardless' of their physical location, looking and sounding different with each iteration and for each audioviewer's individual trajectory through the work. In *Visaurihelix*, the nature of the building as a public gallery space rendered testing in the space impossible, creating ambiguity over the final outcome of the work up until the moment of installation. It was also borne in mind that a 50m tower ascended via a spiral staircase is physically affecting to the audience in a range of different ways (audience feedback documented vertigo in numerous cases, some exacerbated by the installation and others alleviated by it), and it is impossible to accommodate these in the composition process. Spatial considerations therefore became a little secondary, setting aside what the composer might consider as 'the ideal', as the audience's physical experience of the space varies so widely.

Both *Alocas* and *Visaurihelix* are fundamentally concerned with *space*, in the Lefebvrian sense – they involve both real (physical) and imaginary (audiovisually projected) spaces which are situated, which evoke mental spaces for the audioviewer and which are inextricably bound to cultural institutions for their playback or exhibition. In the case of *Visaurihelix*, for example, the mental and cultural spaces evoked through the associations with Mackintosh may be quite specific and present for certain audience members, yet entirely illegible for others. They have a place (Castells 2000: 26) – they are part of an interpersonal relationship between the composer, the venue/place of exhibition and the audioviewer. They also have a location, and in the case of *Visaurihelix*, for example, this location is multifaceted, consisting

not only of the physical location of the work within the Mackintosh tower, but also the location of the sound materials recorded in other Mackintosh locations and presented in the work, displacing and diffracting those locations and bringing them into the internal space of the installation.

Through delineating the two works presented here as site-specific and site-adaptive, I am once again returning to notions of *process* and *concept* – in Demers's more inclusive definition, site-specific art could be considered as "any art that *in some manner* . . . addresses the topics of site and location" (2010: 4, My emphasis), under which banner both *Alocas* and *Visaurihelix* could comfortably sit. However, they are fundamentally different in how they are conceived, how they respond to the notion of site and how they are approached as expanded format works. Therefore this designation feels more constructive.

## Summary

This chapter has explored conceptual approaches to space, site and audiovisual experience in two recent Expanded Audiovisual Format (EAF) works – one site-specific (*Visaurihelix*) and one site-adaptive (*Alocas*). It has described how these works engage with the concept of *site*, how they consider the nature of space and how they utilise algorithmic aleatoricism in the generation and shaping of materials. It has also expressed some of the author's conceptual and compositional ideas, concerns and preoccupations in developing these works, and attempted a definition of Expanded Audiovisual Formats (EAFs), alongside the terms 'site-specific', 'site-adaptive' and 'algorithmic aleatoricism', which are fruitful for the author as an audiovisual composer and which may be fruitful to other artists working in similar or related ways.

Ultimately, in writing this chapter I have been able to reflect on the development of these works and where they sit in the trajectory of my practice research, both to date and ongoing. Fundamentally, there are two central concerns at play here. Firstly, the possibilities of working with Expanded Audiovisual Formats – being able to either design audiovisual work for a specific architectural space, or adapt existing work to a particular space, affords a range of possibilities in both the development and exhibition of audiovisual materials which is somewhat unpredictable and can uniquely shape an audioviewer's experience. Secondly, both compositionally and in the realisation and exhibition of these works, I have become concerned with finding a balance between control and unpredictability. I discuss this earlier in the consideration of algorithmic aleatoricism but would suggest that this balance between defining aspects of the work and leaving others to chance might manifest itself in the complete approach to the work, not just the development of materials. To return again to Meyer-Eppler, it might be appropriate to conclude that my approach to

developing these works for EAF is "determined in general but depend on chance in detail" – that is, that whilst fundamentally certain components of the work are fixed, or exist in a relatively fixed form, the manifestation and experience of these works is entirely site-, context- and audience-dependent.

## Notes

1 In this context the word *site* will be taken from the definition offered by Joanna Demers in her 2010 book *Listening through the Noise: The Aesthetics of Experimental Electronic Music.* This will be discussed in more detail later in the chapter.
2 I will describe the screens as left and right in this discussion, as this is how they are presented in single-screen playback and in the fixed, online versions of the work.
3 This can be seen on my website: www.louiseharris.co.uk/work/Alocas/
4 Further details of the work, including pictures and video documentation, can be found here: www.louiseharris.co.uk/work/Visaurihelix/

## References

Alpern, A. (1995) *Techniques for Algorithmic Composition of Music.* 95. p. 120. Available online: http://hamp.hampshire.edu/adaF92/algocomp/algocomp.
Alves, B. (2005) Digital Harmony of Sound and Light. *Computer Music Journal.* 29(4). pp. 45–54.
Amacher, M. (2009) Music for Sound Joined Rooms. Available online: www.maryanneamacher.org/Amacher_Archive_Project/Entries/2009/10/24_music_for_sound_joined_rooms.html.
Amorin, D.B. (2015) Available online: http://deepwhitesound.com/dws167/.
Castells, M. (2000). *The Rise of the Network Society* (2nd ed.). Oxford: Blackwell.
Chion, M. (1994) *Audio-Vision: Sound on Screen.* Columbia University Press.
Demers, J. (2010) *Listening through the Noise: The Aesthetics of Experimental Electronic Music.* Oxford: Oxford University Press.
Griffiths, P. (2001) Aleatory. *The New Grove Dictionary of Music and Musicians.* 2.
Handelman, E. (2010) *Maryanne Amacher: Interview by Dr Eliot Handelman.* Available online: www.colba.net/,eliot/amacher.htm.
Harris, L. (2016) Audiovisual Coherence and Physical Presence: I Am There, Therefore I Am [?]. *eContact!.* 18(2).
Hill, A.; Hobbs, J. (2017) (I) Magesound (S): Expanded Audiovisual Practice. *eContact!.* 19(2).
Lefebvre, H. (2000) *La production de l'espace* (4th ed.). Paris: Éditions Anthropos.
Mey, A. (2015) Expanded Cinema by Other Means. *The Audiovisual Breakthrough.* pp. 42–61.
Meyer-Eppler, W. (1958) Statistic and Psychologic Problems of Sound. *Die Reihe.* 1. pp. 55–61.
Nash, D. (2001). *David Nash: Forms into Time.* London: Artmedia Press.
Riley, B. (2009). *The Eye's Mind: Collected Writings 1965–2009.* London: Thames & Hudson.
Stefani, E.; Lauke, K. (2010) Music, Space and Theatre: Site-Specific Approaches to Multichannel Spatialisation. *Organised Sound.* 15(3). pp. 251–259.
Whitney, J. (1994) To Paint on Water: The Audiovisual Duet of Complementarity. *Computer Music Journal.* 18(3). pp. 45–52.
Youngblood, G.; Fuller, R.B. (1970) *Expanded Cinema.* New York: Dutton. p. 340.

# Making a motion score
## A graphical and genealogical inquiry into a multi-screen cinegraphy

Leyokki

## Introduction

This chapter aims to study the act of making meaning through motion. It starts with a concept – cinegraphy; a movie – *#wreckOfHope*, 2016; and a new form – a motion score – as a specific form of representation and inquiry. It will unpack the process of making a motion score and explore how this can reveal interesting leads toward the act of writing through motion. This chapter should be considered therefore, a path, a line of flight, more than a pure demonstration.

### Cinegraphy, music and narration

The word *cinegraphy*, based on the same etymology as cinema, means to "write through motion". The expression was particularly used in early cinema by the French avant-garde of the 1920s. At this time, movies were silent, and cinema had to build its own language; it had to invent in the language. Cineasts, such as Germaine Dulac and Jean Epstein, invented a new lexical field on this same root: cinegraphy (*cinégraphie*), cineologist (*cinéologue*) and cinegram (*cinégramme*) (Dulac 1994: 26).

Germain Dulac, in particular, decided to put the emphasis on the relation between cinegraphy and music. She called this "visual symphony" (*symphonie visuelle*) (Dulac 1994: 96) and spoke about "the measure, cadence, visual orchestration" ("*mesure, la cadence, l'orchestration visuelle*", Dulac 1994: 113). Through this operation, Dulac intended to free cinema from the growing influence of novel and theatre. It was actually a way to discover a specific language, or rather, a specific way of creating meaning.

If cinema could be seen as writing through motions, it could signify that motion, in itself, could bring meaning or a specific form of narration. And, as the constant reference to the musical paradigm points out, this meaning could have something

to do with the musical meaning, a meaning that is not based on words or story. Cinegraphic meaning was not supposed to lead to a precise signification, but to a feeling of understanding. An understanding that would be called blurry, obscure, even sometimes esoteric; an understanding that, as Adorno wrote of music, "reaches the absolute immediately, but in the same instant it darkens" (Adorno 1993: 404).

In this chapter, cinegraphy represents a form of movies that expresses narration and a meaning through motions, rather than through representative figures. Such a form of narration and meaning might be considered somewhat close to music. Therefore, we shall introduce conceptions of musical narration alongside those from other forms. In an article of 2011, the narratologist Raphaël Barroni proposed a definition of the plot, as a play on tensions and resolutions: a broad definition that tends to abolish the distinction between plot and musical sequence. The tension tenses toward a telos, and, following his definition, we could use the mechanisms of "suspense, curiosity and surprise as the basis of narration".

### A movie as a starting point

Inspired by these explorations, in 2016 we made a movie called *#wreckOfHope*. This short movie is built from a painting, the *Sea of Ice*, by Caspar David Friedrich (1823–1824), and a music score, the last of the *Four Romantic Pieces* by Antonín Dvořák (1887). At this time, we were inspired by the idea of a 'visual study': "a study of an already created image through the means of the image itself" (Brenez 1998: 313). We wanted, then, to make a movie without any words or characters and only driven by images and sounds.

The movie shows a split-screen of four panels, where each panel presents a perspective on a 3D representation of the painting. These views are in motion, like movements of a camera around a 3D model, but each one seems independent, or slightly delayed in comparison to the others. The movie itself appears, then, out of variation and of the agency of these motions together. We could describe the movie as being constituted by five sequences:

  I  The original painting fading into its 3D representation.
 II  A first agency of four panels, going into loops, before breaking into a flickering between multiple agencies.
III  Emphasises the relation between the two panels in the centre.
 IV  Silent, where the texture and colours of the 3D model have changed into white; the four panels are never together shown, and this part looks like a rhythmic play between the appearance and the vanishing of the panels.
  V  Return to a full four-panel agency, slightly delayed but together.

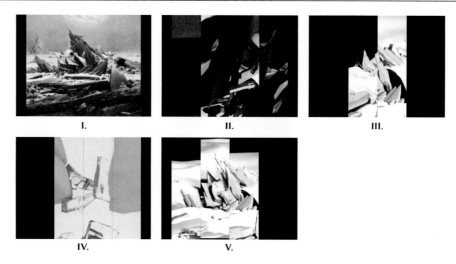

**Figure 20.1** A still frame from each of the five sequences.

*#wreckOfHope* is a play of motions, built upon a musical metaphor of cinegraphy. If our project is successful, from this musical notion in which the motion leads the meaning or the narration, then we should be able to make a motion score, a notation of the motions in the movie; and to deduce from these motions the narrative patterns or meaningful effects.

Such a motion score would us help to distinguish between the different agencies of motions that are at stake in the movie, but also to give an overview, through its development, of the evolution of motions within the film.

### Motion score

As per the definition of *cinegraphy*, we will be focussing in this chapter on visual motion, and leave the possibility discussing sonic motions for another study. However, while we will not engage in a detailed exposition of auditory movement, the interaction between music and visual motions will be at stake numerous times, and the motion score itself visualise both visual motions and music on the same page. Further, it is important to note the terms 'motion' and 'movements' are applied interchangeably under the common term 'motion' within this chapter.

Motions can designate, either motion of characters inside the frame, of camera, or changes of parameters of the full frame inside – such as the opacity or the saturation. Every material element is an object which can be animated. They are conceived from the point of view of the maker, an animator – the one who interprets the score. As in musical practice, someone with the score, should be able to make the movie again, within the same margin of interpretation as could be expected from a musical interpretations.

This practice abolishes the distinction, usually made in cinema, between production and post-production. Articulation is related to a succession of values, whether this value concerns the position of a character into the space, the percentage of the saturation of the image, the strength of a force that distorts a field of particles or a body or the position of a field of vertex that are shaping this body. The challenge of this project is that if all elements of the movie can be apprehended on the same level, we will need to devise unique ways to write them, in order to express them clearly in the score.

So, to the *process* of making a motion score. We follow a three-part structure corresponding to: idea, experiment, review.

1   The first part is dedicated to a prelude to the motion score: what are the motions considered and how were they thought? We will focus here on the genesis of our movie, and to see how the motions were conceived and thought.
2   The second part will reply to the question – how to represent such motions? – by looking at different referent models of score and notations, borrowed from cinema, music and dance.
3   The last part will deal will the results and limits of such a motion score, in other words: how motion can conduct narration? In detail, we will focus on the questions of readability, relations between images and sound and the relation between motion, texture and shape.

## Genesis: dealing with motion

We must first to distinguish the forms of motions that we are dealing with. Exploring compositional practices in creating the movie helps us to describe the forms of the motions, how they were made and conceived and their relation toward music and time.

Five versions of the movie were made during editing. First, by putting two sequences on top of the unworked music. An installation of the two basic split screens was then made with the sound of cracking icebergs. Second, where the music was now modified: cut, mixed with noises and disturbed by a flanging at the end. Third made with the presence of flickers. Fourth, one without the sequence between the silence and then finally the completed end version. All these versions are available online: www.routledge.com/9780367271466

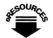

### *Making motion*

#### *Motion of the view*

The project started from the painting by Caspar David Friedrich, the *Sea of Ice*, from which we constructed a 3D model.

From this 3D model emerged two basic descriptive motions. These animations were made by placing the 3D camera in circular motion around the scene: the first follows a horizontal movement, the second a vertical one. In both these movements, the camera has a double constraint: to follow the path of the motion, and to track the centre of the scene, so that the point of origin is the same as the one of the painting. At this time, a lot of different renders where made with different textures: white, transparent, black and white. Different motions were also experimented with, but only simple ones: horizontal, vertical and diagonal.

From the global animation, the split screen was conceived. Split screens had been previously employed in a previous movie – *Leaves of Maple*. This results in two main sequences, corresponding to two directions of movement – vertical and horizontal – that, with a slight delay, could build an endless motion.

What is striking to note at this point is that the only thing in motion is the camera. The whole movie is made of changes in the direction and speed of the motions of the camera, and the appearance and vanishing of different panels. The texture of the scene is the only parameter not dependent on the camera that will change. It will do it only once and briefly. The movie is thus first defined by the act of showing.

### Thinking motion

The initial stages of composition were quite linear. Every step continued from the previous one, building sequentially upon it. At the editing stage, the 3D images were considered as footages or rushes, i.e. images that cannot be retaken if they don't match, images that we have to deal with. The footage elements could be modified through editing – cutting, varied speeds and split screens – but their inner motions would remain consistent. Each step thus took the form of a type of sedimentation, where features would become locked as steps become firm layers. The only layer to remain fluid is the last one: the editing and compositing will alternate between different assemblages of panels and vary them, either as a global frame or as individual ones. This leads us to see, in the editing process, how the motion was thought and apprehended.

### Relation between motions

The motion of the camera is simultaneously split into four panels. Each one is independent, sometimes they follow the same motion, slightly delayed, and sometimes they just show completely different motions. However, they always compose a new form of unity, inside the frame of the screen. This unity is maintained by the fact that each panel appears as a surface: the 3D camera uses a virtual long lens (120 mm in the composition), thus compressing the space. The panels appear very flat, and some motions may even appear in a different form, for example as a tracking shot when in reality they are in rotation.

In this way the agencies of these panels were merged together. The actual editing – and this was a surprise when looking back at the timeline – uses what is usually called "precomposed" layers or a "nested sequence". To quote Adobe, "Precomposing layers places them in a new composition, which replaces the layers in the original composition. The new nested composition becomes the source for a single layer in the original composition" (Adobe 2019). This operation allows treating a whole sequence, or an assemblage of split screens, as one new footage.

The whole movie, with the exception of the first scene which shows the painting, is a play of these assemblages. The split-screen appears at the centre of the movie, and thus, more than a play of motion, the film acts as a *play between motions*: built on the balance between the motions within each panel.

## Motion shapes

Each agency of the panels was a way to *reshape* the initial figure. In this view, the whole movie is a play of deconstruction and reconstruction of the painting. The adjacency of motions act as a means of figuration.

The figurative element was usually *implied* by the motion. Each panel was composed with pre-existing motion in the footage – i.e. in the first export of the circular motion. The inner motion of each panel followed the rules of the 3D world, where the only precise point of view was the one of the painting. The colours shown when the camera is looking down, from the top of the scene, are not edited individually for this specific shot but are simply a new perspective on the disposition of elements and lights that were designed and made for the original front view.

Editing and compositing further engages in a *play with the scales* of the images, between the individual and global view of the panel. This technique, possible through "nested composition", gives an interesting view on how the editing was thought through. Even if the footage has its inner motions and time, the play of the editing process is to create sequences that 'work' effectively both as a panel and as a frame of four panels. The edit alternates between these two levels. It deals sometimes with a full panel – in which case, the relation between the figures and their motion matters more than the actual figures generated by the juxtaposition. On the other hand, sometimes focusses on many panels within the frame. This hesitation between a global and a focused view is at stake in the view of the maker, first.

## Narration of readability

Inside this play of scales and of shapes, how is the narrative constructed? If plot is a play of tension and resolution, it leads us to the question: how was tension made?

Our footage and sequences deal only with a question of the view – the perspective of the camera – in a 3D world where nothing else moves, the tension cannot

be articulated through variation in form (though there is one variation in texture). Instead all tension needs to be constructed through: the readability of the image. Indeed, the capacity to read the image, i.e. to see it and to understand its shapes and motions, is the main vector of tension and resolution in the work.

This readability creates what we could call an 'inner time', the time of its readability, relative to its inner motions. For a specific motion and a specific shape, there is a time that corresponds to the period needed to see and recognise what is in the image. This recognition can also be negative – the recognition that there is nothing to see – or one of distortion – that it is blurry – but these are still valid 'recognitions' of what is to be seen. Readability is built by the relation of the panel themselves, as a relation of different motions and images to read. The split-screen seems, thus, to be an essential part of the narration, because the scheme of tension and resolution will occur between these split-screens; at the opposite of a movie like Gance's *Napoleon*, the split screen doesn't act as an extension of the screen or as a contrasted effect, between a close-up and a long shot, but as the main motor of narration itself.

The editing is therefore a play inside this readability, balancing the pre-existing motion and its possible speeds and starting points.

### Non-diegetic synchronisation

The music and the sound arrived after all the images were already prepared and they have no diegetic relation to the image. There is obviously nothing in the movie that could be the source of the music. The music can thus be regarded as "pit music", to invoke the distinction made by Michel Chion (1994: 80). As "pit music", the sound "can cast the images into a homogenizing bath or current" that "temporally and spatially overflows the limits of shots on the screen" (Chion 1994: 47).

Despite this acousmatic form of the sound, the music and the images are indissolubly linked, and the edit relies upon significant "points of synchronisation", as defined by Chion: "a salient moment of an audiovisual sequence during which a sound event and a visual event meet in synchrony" (Chion 1994: 58). It is therefore important to elaborate how the figurative plot, at stake in this movie, is developed at the crossing between the visual and the sonic inner narrative.

### Organic growth

The second sequence of the movie – from 0'37" to 2'59" – which ends with a flicker between multiple agencies was developed in three stages: in the first, fourth and fifth versions of the editing.

In earlier versions, it was only a loop of four panels. In the fourth version, the presence of loops appears without flickering – or, rather, it was just one frame repeated, separated by exactly one black frame. At this point, the loop was purely

metric: it was just a gap of one frame between every frame of sound. Indeed, the flickering appears as a continuity of the loops in a more condensed form: where the loop deals with a musical sentence or the visual equivalent, the flicker impacts on the level of the frame, the shortest loop possible. At this time, in the fourth edit, the only possibility seemed to be the silence: after the shortest loop, it had to stop. The new image, the blended one, was then freely conveyed, i.e. without being connected to other images.

In the next edit, however, the idea of making loops crossed through the image, and as the four panels were creating one global frame, this frame could be looped and repeated. On the other side, to release the tension of the visual repetition by the appearance of a new image – the blended diagonals – provided the occasion to do the same for the sound: to release the tension by escaping the loop, in a way that would not erase the memory of its loop but build upon it. In other words, to transform the digital sound of the artificial repetition through a clicking sound that would accompany the new start of the music and act as a reminiscence of the loop before. This highlights the important combination of both sound and music within the film.

This evolution in the editing process might be called an *organic growth*, because it derivates from the component themselves. The flickering sequence emerged from the interaction between image and sound, and the idea to distort the image in the same way the sound might be. At the same time, this growth relies upon the use of an image that does not relate directly to the other – the blended one. The final image appears as a layer that emerges from the interaction between image and sound, as well as the glue that consolidates the change of mode of figurability.

So we can assert, the movie was made of motions, mainly motions of camera: the motion score will have to describe these. These motions were blended together into a sedimentation process, constituting panels. Together, these motions create shapes, which are seen as the result of the motions rather than their condition. Therefore, the motion score might then need to reflect these adjustments, more than the actual shapes. Finally, the editing process was modulated in relation to both the readability and relation to music. In this context, the making of movie can be seen as an organic growth articulated by the relation of music and the visual elements evolving. This process formed a key factor in the final development of the work and the motion score must therefore show this relation by demonstrating the evolution of the sound and the image.

## Making the score: writing motions

How do we write motions? What existing models are there? How can we pull some elements together?

First we will examine how images and the process of editing can be notated within in cinema, in storyboard and timelines. Our second step focusses on music, exploring the question of the representation of instruments and notes. While finally, we will take inspiration from the writing of choreography and Labanotation to write the actual motions.

### Cinema: storyboard and timeline

The storyboard appears as the first model of notation in film. It presents in graphic the composition of the many different shots of a movie and how they should look. The storyboard is a succession of drawings, occasionally captioned with indications about dialogue, the script or technical information – such as the lens or the position of the lights. It sits at the crossing between illustration and a technical-document.

The challenge of the storyboard is that it provides a representation of fixed states. Even while motion can be implied between two drawings, or sometimes through the use of arrows inside the drawing or with a schematic nearby the drawings, it is difficult for such a form to represent a film that is entirely built upon motion, in which the shapes and forms within the film only appear as the consequence of motion. Instead, we need to look for a form that can deal with the continuity of action.

Film provides another model that might help us: the timeline of the editing software. In non-linear editing software, such as Adobe Premiere, Final Cut or Avid, timelines usually look the same: we have a certain number of tracks, each containing one or multiple shots, notated as blocks. A timeline is to be read from left to right and from top to bottom. One shot on top of another is supposed to replace it or be blended with it depending on its opacity and the implementation of masks.

This form is closer to a partition. The tracks look like instruments and follow the same direction of reading. It gives us a precise indication of the duration of each rush and of their possible transitions. Furthermore, it can give us precise information on a huge number of parameters, such as the opacity or every parameter that is actually changing on the global layer, such as a decrease in saturation, or the presence of a mask. In addition, it is the only actual material we have on the editing of the movie. Figure 20.2 gives an example of the timeline of *#wreckOfHope*.

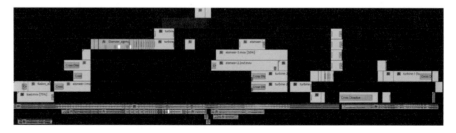

**Figure 20.2**   An example of the timeline of *#wreckOfHope*.

However, the timeline form has two flaws. First, the parameters, such as saturation or masks, are usually not shown directly in the timeline but in another window. Second, this form gives no information about the motions that actually happen inside the panels, the intraframe movement. We still have to find a form that will help us describe these motions together.

## Music: stave

What elements can we take from musical notation?

The first thing we draw from the musical score is the idea of stave. To convert the tracks of the timeline into staves related to object or effects – camera or changes of opacity, saturation, etc. – might help us to write out the changes within all these parameters. In the context of this movie, the form that makes more sense is to relate these staves to each panel. We will write, then, four bands, one for each simultaneous motion of the camera. Figure 20.3 gives an abstract example of this form.

This form of stave can even resolve the problem of nesting sequences. We saw, during the first part about the making of motions in the movies, that the editing uses precomposed or nested sequences. At some point, in the movie, these nested sequences are themselves used as layers, the image shows a blend of two four-panel agencies together. We could then use the stave to write one four-panel agency, or multiply the staves to show all panels separately.

For now, it raises a major question on how to treat these sequences. On one hand, the motion score gets a lot more complex by the notation of all these layers. On the other hand, a nested composition obfuscates the visibility of the motions: this solution seems rather unlikely for a project that emphasises on 'writing motion'.

This question is resolved when we look at the relation between precomposition and time. We saw that nested compositions can be used as a simplification of space:

Four-panel frame                                                   Stave-like design

**Figure 20.3**   Abstract example of the form.

four panels can be considered as one layer. On the other hand, they are also a simplification of time: they allow and enable the possibility of loops. In the flickering sequence, flickers appear at the end of multiple loops, both sonic and visual. And these loops are actually taken from different points in the previous sequence. It would be rather complex to refer to all these points in time. The solution is to write these loops as new motions. The possibility to play it as actual new motion, or as a loop, will be left to the appreciation of the player, as something similar to fingering in music.

Moreover, to use a stave to represent each camera, or each panel, raises the question of the comparison between object and instruments.

In our introduction, we underlined the relation between cinegraphy and music; during that early period of filmmaking, artists and filmmakers such as Hans Richter, Oskar Fischinger or Viking Eggeling were also reflecting on the idea of making a score between music and cinema. In an article named *Easel – Scroll – Films* Richter comes back to their experiment and notates: "Our research led us to make a large number of drawings as transformations of one form element or another. These were our 'themes,' or, as we called them, 'instruments,' by analogy with music" (Richter 1952: 79). In their view the instrument and the theme are mixed up.

However, these early abstract animators were dealing with abstract forms in a second space. The main motions elaborated are ones of appearance-disappearance and of warping – changing the shape. As we saw in our first part, in our case, the impact of the 3D world led us to a conception of the distortion of this shape as implied by the motion of the camera. Therefore, our distinction between the instrument – camera – and the theme – the painting – might be clearer.

## Notes as variations

We have now a design where each track of the time – or, rather, each object or parameter – is represented by a stave. However, depending of the nature of the element, if it is an object or a parameter, we will represent their variation differently.

The case of a parameter, such as opacity or saturation, seems to be the easiest one. Its values can fit on a scale of 0 to 100 per cent. Therefore, we can attribute a stave with only two lines to these parameters, the bottom line being 0 and the upper being 100. The variation of these values will then be shown by filling or not the block delimited by these staves. To pinpoint which parameter is concerned, we will add a symbol. This symbol will denote the content it refers to. Figure 20.4 gives an example of a few symbols.

On the opposite, objects, that are freely moving into a potential infinite space, should have another form of notation. We found this form in the Labanotation.

CONTRAST     OPACITY     SATURATION

**Figure 20.4**   Examples of symbols.

## Dance

### Labanotation

Kinetography or Labanotation was invented by Rudolf Laban to notate choreography. The strength of this form is to focus on the making, rather than on the final scenes, or in Pino Mlakar's words, "it's based on the movement flow, rather than on the positions" (Knust et al. 2011 [1979]: 19). This idea resonates clearly with our will to put the emphasis on motion, rather than on actual images.

In Labanotation each character is represented by three lines in a stave-like design rotated 90 degrees: the lines are vertical, read from bottom to top. Between these lines the parts of the body are represented: legs in the centre and arms on the borders. The motion of each of these parts is then described through symbols, giving information on the height (up or down) and the direction (left, right, in front, behind) (see Figure 20.5). The whole Laban staff is then written above the musical stave and allows a direct reading of both music and choreography.

### Adaptions for 3D movie space

The Labanotation gives us a basis upon which we can build our own notations of motions, positions and rotations in a 3D space. In order to notate our own motions, we need also to add another piece of information to these motions: the point of focus.

The camera is an object that possesses a gaze, so it is important to have a hint of where it is looking. In the current composition this is easy, as the camera always targets the centre of the scene. However, the starting position is different for each panel: sometimes it starts in front of the painting, sometimes from under the scene, or sometimes it even concatenates a few shots with different positions – as during

Figure 20.5    Representation of different movements in Labanotation.

Figure 20.6    Symbols of Labanotation orientated in a 3D space.

the loop sequence. So that this might be taken into account we will add a symbol describing the orientation of the camera toward the scene at the beginning of a shot. We will use the symbols of Labanotation, orientated in a 3D space, as in Figure 20.6. An extract of the motion score for the flickering sequence can be seen in Figure 20.7.

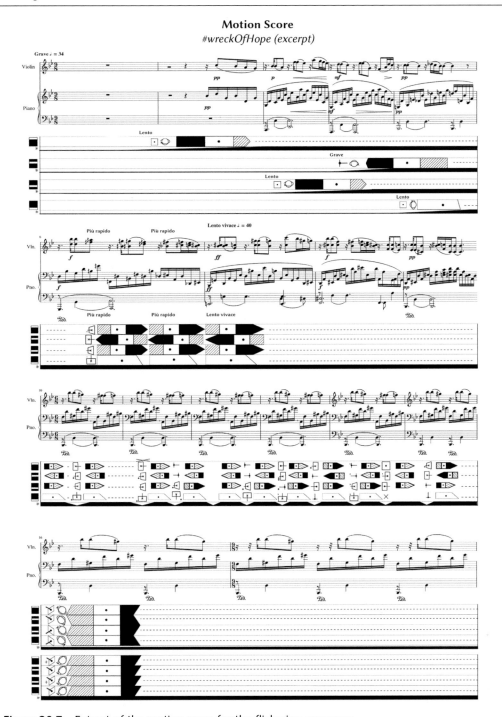

**Figure 20.7** Extract of the motion score for the flickering sequence.

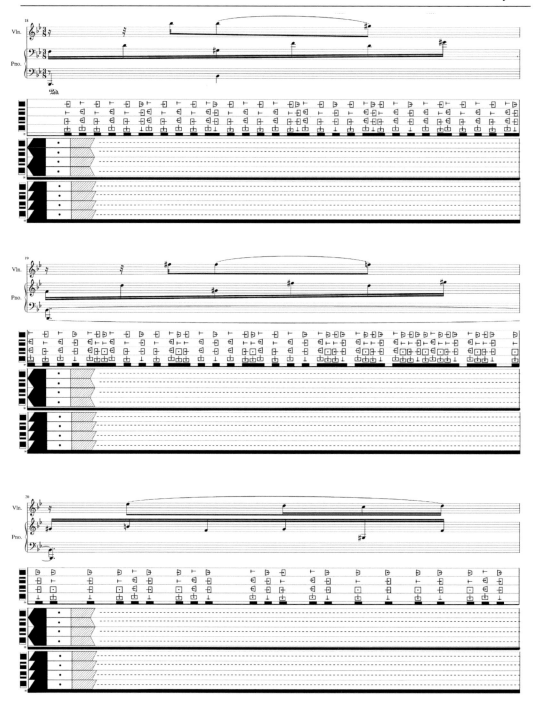

**Figure 20.7** (Continued)

## Motion and narration: motion and feelings

Now that we have developed a form for our motion score, we can focus on the question of the narration, to elaborate how motions build this narration and associated feelings.

Focussing on three sequences in which the role of the motion seemed to be particularly significant, we study these sequences in increasing complexity. We will begin with the third sequence of the film – built on two panels – before exploring the narrative strategies of the second sequence. Finally, we will analyse the fourth sequence – the silent one – in which the limits of the motion score are tested.

### *Sequence three – motion and perception: visual stretch*

Within the third section of the film the form we are dealing with is two simple motions. However, the motions appear incompatible, because they are radically opposed. As explored previously, the gaze of the viewer is usually in motion between the different panels. Thus the viewer must switch radically between different movements. This effect is exacerbated by the fact that the panels seem to form a flat unity and sometimes it is difficult to see whether the image is made up of one surface or of different panels. The lines themselves seems to form a continuity that is opposed to the paradoxical motion, as is shown in Figure 20.9. Our eye hesitates between focussing on each individual object and a peripheral view that will encompass these panels.

This hesitation between the scales of seeing – either inside a panel or at the scale as the global frame – might be described as *a visual stretch*. Stretch refers to the quality of this visual tension, a form of elasticity in representation. As the stretch goes on, the object of perception widens to one global object.

The effect of this stretch impression begins to fade when the screens no longer relate: for example when the lines and texture of one screen do not prolongate into the second, as at 3'24". The visual stretch could thus be qualified as the relation between the different motions and the visual coherence of these motions into the screen.

**Figure 20.8**  The juxtaposition of a vertical circular motion and a horizontal one.

**CONTINUITY OF LINES
BETWEEN THE PANELS**

**Figure 20.9**   Paradoxical motion.

The prolongation of the visual stretch seems to provoke a feeling of expansion, something like a breath in. This expansion can be related to this feeling of widening perception, and it stops when our perception reaches the limit at which it must make a binary choice between the local and the global view.

The music at this point seeks to emphasise this feeling, a rise in tension as the note goes higher adds to the impression of gradation we might have from the visual stretch.

This impact of the melody is also extended by the use of a slight delay effect on the music, which makes the notes resonate and adds to the impression of an increased physical acoustic space. The music and the visual converge in the production of this impression of expansion.

With the appearance of the other panels the tension decreases on all levels: the visual stretch lowers, and there is therefore a less coherent impression of the global frame, the melody stops and the music is actually relayed by the sound of the turbine, a deep and warm repeated sound.[1]

### Sequence two – telos, additive structure, trigger and relay

The second sequence, represented by Figure 20.7, starts with the successive appearance of each panel. In the movie, we have the following order: 1-3-2-4.[2] This order is not linear. Moreover, panel number 2 shows a very dark image, and its appearance is actually delayed, creating something the sequential impression of: 1–3 – (2) – 4.

The appearance of each panel is introduced by music, with each panel corresponding with a different musical sentence. These play as points of synchronisation, highlighting the connection between images and sounds and this entire sequence is structured with the music – creating a modality of suspense and expectation at the appearance of new panels – while at the same time the order of appearance maximises curiosity and surprise.

Regarding visual stretch, we can notice that the different panels do not follow the same motion. Panels 1 and 3 follow a vertical move going upward, panel number 2 has a vertical move in the opposite direction – starting from under the scene – and the last panel is in the opposite plane, the horizontal one. The continuity of panels 1 and 3 is disturbed by the resistance of panels 2 and 4. The movement scattered through the four panels is thus difficult to follow. We retrieve here a form of visual stretch. However, the complexity of the relations between four panels – and not two – tends to diminish the tension; the impression of visual stretch is less apparent than in the third sequence.

The four panels continue their motion for a few seconds before being accelerated as a whole, along with the music.[3] At this point, the movie begins to follow what we could call an 'additive structure'. This expression is taken from minimalist musical practice; Keith Potter has explained how Philip Glass works with additive and negative processes: each musical figure is repeated with the addition or subtraction of one cell or harmonic group (Potter 2000: 297). This form emphasises the fluid aspect of the flow of the music, as each cell is being repeated with one slight change. In the same manner, each new element in this sequence seems to bring change in only one domain, respectively: fade-in (first panel), order of appearances (second), direction of motion (third), sense (the fourth), speed with dissonance (acceleration), speed with consonance (second acceleration). This seems to create a gradation, or at least an accumulation, that could go on forever.

The appearance of a singular loop at 1'49" – bar 10 – breaks this gradation. The sequence, both visual and musical, is strictly repeated, putting the narration in stasis. It thereby creates an accent at this particular moment. From the combination of accent and stasis, the movie creates a desire for surprise, a will-to-change that could be interpreted as suspense, or at least as a climax.

The trigger comes from the image. A new image – the superposition of two diagonal movements around the scene – bar 16 – appears. However, the music is still looped. There is a second trigger when the music starts again. But at this moment, the image and the sound are both effected by a flickering. We have here a system of *narrative relay* between image and sound: the trigger is delayed by the fact that one component still creates a tension.

The very end of the sequence arrives a few seconds later, when image and sound crystallise themselves around a clear form: without a gap for the music and the flickering panel for the visual.

In this section, the relation between the visual and the sound builds the narration in a system of narrative relay. The tension brought on one level, e.g. visual, is modulated by the continuity of the sonic level, until a point of inversion: the music goes into loop while the image seems to continue its motion. The intertwined nature of their relation builds, emphasised by the presence of regular points of synchronisation, guiding the evolution of the visual and sonic narrations.

### Sequence four – visual rhythm and motions of texture

The fourth sequence, shown in Figure 20.10, is defined by the absence of sound and a radical change of materiality of the scene. All the blocks are transparent in a white background, constructing a form of suspension, from the absence of sound and also by the change in visual texture, which is much brighter than the rest of the scene. These two contrasts evoke a new feeling of curiosity.

This suspension is unlike the 'breath in' as in the second sequence – that was more a feeling of inspiration, expansion; here, it is a suspension as a stop in the movie.

The quality of attention is emphasised.

Moreover, this sequence works in a different way to the rest of the movie. The time interval between the image is reduced and the panels are often separated by a black screen, implying a very low potential for visual stretch. At the same time, the high contrast in the image looks like a variation of black and white with only glimpsed perspectives of the detailed scene.

The expectation and tension in this scene comes from the rhythm of apparition/disappearance of the panels, rather than from any inner motions within the images. The motion appears, in actuality, as an expectation of the transition from white to black. This sequence is built around an almost symmetrical structure, starting and ending with the panel 2–3 shown (white), and crossed by the impression of 'out of frame' when three panels are put together and the fourth is black (panels 2, 3 and 4 first, then its symmetric 1, 2, 3). Such a sequence seems to emphasise its structure through patterns and rhythms, echoing the music within earlier sequences, filling in the empty musical space.

**Figure 20.10**   Fourth sequence.

It is in the face of this sequence that our motion score seems to find its explicit limits. The motion of the texture takes precedence over that of the camera. The sequence plays with white and black screens, but some dark screens are not due to an absence of image, but due to the motion of the camera into a point where there is no light. If we wanted precisely to describe the visual motions in this sequence, we should really add another stave or layer, corresponding to the brightness of the screen.

For example, at the 3rd bar the camera of the panel 2 goes under the model, where there is a 3D equivalent of 'water', with different proprieties of roughness and reflection. The image is nearly black, but we can still see glimpses of light through reflection. The image is very noisy and the reflections appear more as motions of texture than properly defined shapes. As a viewer, we have the rhythmic element of the black and white alternation, but, at the same time retain an impression of the circulating motion.

In other words, the rhythmic element of this sequence is balanced out by the subtle motion still perceptible in the texture of the visual grains. This texture oscillates between its presence as a textured form, and as pure 'texturality' when the shape does not make sense anymore, reaching the limit of a 2D world. In this way, the readability is also constructed by this play of shapes, rhythm and texture.

Thus, we have examined first, how the motion itself, through the idea of visual stretch, could create a tension in the image. This tension, by the tension between different levels of perception, builds a feeling of expansion.

Analysis of the second sequence led us to explore the relations between sound and image to reach the idea of a narrative relay. We also saw how the visual could bring its own suspense, through the mechanisms of successive opening and loops.

While finally, our analysis of the fourth sequence brought us to apprehend the rhythmic play of the film as a vector of narration. This sequence showed, also, that in this rhythmic play, the motion score should be dubbed by a texture score, in order to show correctly the evolution of the visual.

## Conclusion

To do *cinegraphy* is to actually write with motions, shapes and texture. We saw during the process of making the motion score, the multiple interfaces of the relation between motion, figures and narration. This inquiry led us to describe the camera – and therefore, the view – as the main element in motion. This view, split into four panels, was immediately related to a question of figurability, as the different agencies of these panels reshape the painting. These new shapes were both made and discovered as a consequence of the motion of the camera. The figurability, linked to the question of its readability, formed the basis of editing. This editing, in some places, took the form of an organic growth, when the visual motion found echoes and relayed into the sonic level.

We explored the writing of the score, which takes inspiration from dance and music as well as cinematographic tools – such as timelines and storyboard – and

follows a stave-like design, where the parameters are instruments. In the case of our movie, these parameters were essentially the cameras – we understood the panels as different cameras – and the opacity of the different panels.[4]

From the motion score, we focussed on three particular sequences in which the motions take particular shapes. The basic form, where two panels are moving on opposite directions, highlights the presence of what we called a visual stretch, a tension in the readability of the image. This tension is increased as the motion in the 3D space – the one inside one panel – is contradicted by the unity that seems to appear in the surface of the global frame. If we wanted to go further – but that would be the start of another chapter – we could suggest the presence of something close to the sublime, this old aesthetic category in which the tension between our imagination and representation provokes an intense emotion. The tension between these two categories, usually related to our encounter with infinity, could be indeed linked to the one between the local and global perception of the frame, when these two seem incompatible, as it is with our visual stretch. The third sequence helped us to define the relation between visual motions and music, on a more global level, to the point where narrative relay from one to another, and a form of double trigger could be recognised as taking place. The tension, at the basis of our scheme, is driven both by the visual readability and the sonic narration.

When the music stops in the fourth sequence, it initially appears like a rhythmic study. However, the obvious rhythm of the alternants between the white and the black screen was questioned by the texture of the image. The motion score itself would need to show the evolution of the texture to be more accurate about the questions of figurability and narrativity.

Each of these parts was thus, an elaboration of the concept of making as a reshaping of the figure. To twist our hermeneutic circle, the narrative strategies and their genesis both warp the figures as they build matter and plot and resonate with the establishing of the motion score. The motion score, on its own, shapes the movie in an allographic form, as it tries to describe the work in the way it was conceived of by its creator. The hermeneutic becomes constructive, creating figures as it explains others.

The circulation of the figure gravitates, then, around its relation to the tool that shapes it. The non-linear editor preconfigures our relation to motion, just as the 3D software reconfigures our relation to time and space. The making of the software, or instrument, that will allow us to play the motion score might touch the depth of a motion-matter, at the risk of its darkening.

## Notes

1  We wanted also to place the painting in the context of an auditory turbine, as an echo of the presence of the Turbine Hall in the contemporary world – from the Behren's Turbinenfabrik quoted in Rancière's *Aisthesis* to the actual Turbine Hall at the Tate Modern.

2 Let us give a number to each panel, 1 being the extreme-left and 4 the extreme-right.
3 The accelerated music increases in pitch and for representative purposes – to fit the motion score with the musical score – we included quarter-tone notes. The sequence is accelerated again and reaches an equal tempered notch – whereby the score no longer needs to use quarter-tones.
4 However, while our motion score fully elaborated the visual, it represented musical elements in traditionally notated form. Another exercise, for another study, could be to delve further into the idea of motion, and to experiment with something like a vector score. In such a form, the melody could be written through vector, going up and down, and the same could occur for the visual, allowing thus to think the complementarity of sonic and visual motions – and, maybe, their interchangeability.

## Bibliography

Adobe. (2019) Precomposing, Nesting, and Pre-Rendering. In: *After Effects User Guide*. Available online: https://helpx.adobe.com/after-effects/using/precomposing-nesting-pre-rendering.html [Last Accessed 30/06/2019].

Adorno, T.W. (1993) Music, Language, and Composition. Trans. S. Gillespie. *The Musical Quarterly*. 77(3). Oxford University Press. pp. 401–414.

Baroni, R. (2011) Tensions et résolutions: musicalité de l'intrigue ou intrigue musicale? *Cahiers de Narratologie*. (21). Available online: https://journals.openedition.org/narratologie/6461 [Last Accessed 30/06/2019].

Brenez, N. (1998) *De la figure en général et du corps en particulier. L'invention figurative au cinema*. Paris and Brussels: De Boeck Université.

Chion, M. (1994) *Audio-Vision*. New York: Columbia University Press.

Dulac, G. (1994) *Écrits sur le cinéma (1919–1937)*. Paris: Editions Paris Expérimental.

Knust, A.; Challet, J.; Challet-Haas, J. (2011 [1979]) *Dictionnaire usuel de cinétographie Laban (Labanotation)*. Coeuvres-et-Valsery: Ressouvenances.

Potter, K. (2000) *Four Musical Minimalists: La Monte Young, Terry Riley, Steve Reich, Philip Glass*. Cambridge: Cambridge University Press.

Richter, H. (1952) Easel-Scroll-Film. *Magazine of Art*, February.

4 Romantic Pieces, Op.75. (1887) [SCORE] Antonín Dvořák - T. B. Harms Company.

The Sea of Ice [Das Eismeer]. (1823–24) [PAINTING], Caspar David Friedrich, Oil on canvas, 96.7 cm × 126.9 cm (38 in × 49.9 in), Kunsthalle Hamburg, Hamburg, Germany.

*#wreckOfHope*. (2016) Leyokki. [FILM]. Available online: http://vimeo.com/leyokki/wreckOfHope [Last Accessed 30/10/2019].

# The human body as an audiovisual instrument

## Claudia Robles-Angel

## Context – brief overview

In the mid-1960s biofeedback methods were incorporated by composers in their performances in order to create what Rosenboom describes as "a self-organizing, dynamical system, rather than a fixed musical composition" (Rosenboom 1997: 74). This dynamic was attainable by measuring physiological parameters of subjects through diverse interfaces used in the aforementioned methods, which were developed by psychologists in order to help patients to reduce stress levels. The way in which composers such as Alvin Lucier, David Rosenboom and Richard Teitelbaum utilised these physiological values introduced a new form of modifying music in real-time through diverse physiological parameters of the human body related to the nervous system.

Biofeedback methods in art (more specifically in music) were introduced for the first time to audiences in 1965 with the piece *Music for Solo Performer – for Enormously Amplified Brain Waves and Percussion* by Alvin Lucier using electroencephalogram (EEG) equipment belonging to the US Air Force with technical support by physicist Edmon Dewan (Lucier et al. 1995: 442). Further works followed; for example Richard Teitelbaum's *Organ Music* and *IN TUNE*, both created in 1968, where the composer uses EEG signals mainly to control voltages in the Moog synthesiser (Teitelbaum 1966–74: 35). Another remarkable example is David Rosenboom's *On being invisible II* (1994/95) (Rosenboom 1997), which adds light, video and slide projectors to the usage of EEG. This work influenced and inspired artists in the second half of the 1990s (such as Mariko Mori and her work *Wave UFO*) to create not only music compositions but also audiovisual works, the latter comprising installations as well (Robles 2011: 421). It is not by coincidence that such developments in music took off at the end of the 1960s. Dr Joe Kamiya, who was studying alpha and beta brain states in the second half of the 1960s, reported in 1969 that "one could

voluntarily control alpha waves – a feat that was previously believed impossible" (Schwartz and Andrasik 2003: 9). With his research, Kamiya gave a vital impulse to the usage of the EEG-biofeedback method, most commonly known as Neurofeedback (Robles 2011: 421). Other biomedical signals were experimented with at that time too; for example Rosenboom's *Ecology of the Skin* (1970–1971) includes heart signals, and experiments by Manfred Eaton at ORCUS (research centre in Kansas City, US) who introduced diverse biomedical signals including respiration, galvanic skin response (GSR), blood flow and electrocardiography (ECG) among others (Rosenboom 1997: 12).

According to Tom Blum, the usage of biofeedback in the arts was influenced by the peace movement of the 1960s, attracted by Eastern philosophies and meditation practices such as Yoga, Zen meditation, etc., and driven by a message of self-awareness and a humanitarian ideal. There was therefore an active proliferation of pieces during the mid-1960s, which include collaborative work amongst many other artists from a large list comprising names such as Nam June Paik and John Cage. These experimentations decrease in the second half of the 1970s according to Blum, influenced by a post-war effect in which those goals were not anymore so important and were replaced by "a nihilistic punk movement, and the fantasy of plugging into psychophysical systems" (Blum 1989: 87).

But biofeedback in art did not disappear completely. At the end of the 1980s (1987/89) another important development in the field took place when Benjamin Knapp and Hugh Lusted at Stanford's Center for Computer Research in Music and Acoustics (CCRMA) developed the *Biomuse*, an interface that measured diverse biomedical signals and converted them into MIDI data.

The usage of biofeedback methods in the last fifty years has experienced substantial change, due to the rapid evolution of new technologies in the same period. The consequence of this is that nowadays we can find in the market a wide range of small and wearable interfaces for affordable prices, including also self-built and open source. As usual with such advances, these technologies have become clearly affordable and accessible to the broader public, to a point that, for example, it is possible nowadays for everyone to possess a mobile EEG interface connected with a smartphone to monitor their brainwaves, something unthinkable at the time pioneers started using brainwave activity in art. This accessibility has produced a substantial increase in the creation of artworks based on both music/sound and visual arts using brainwaves and other biomedical signals in the past two decades.

Although there are many examples of the usage of Brain Computer Interfaces (BCI) in music and in visual art, there are however many less examples using GSR interfaces. Good examples of the latter are Lynn Hughes's and Simon Laroche's installation *Perversely Interactive System* (2004) which introduces a GSR interface for biofeedback methods by Canadian Thought Technologies, and Michaela

Palmer's *Excitations* (2009), a series of works combining GSR data with heart beat and pulse rate, using sonification processes which translate stream of data into sound frequencies and musical notes.

The examples and the research presented by the author in this chapter are driven by the power of the organic body and its internal imperceptible fluctuations to produce an audiovisual outcome. It can be therefore inferred that the real-time performances and installations described in this chapter fuse visual elements with music and/or sound in a synaesthetic unity, where it is not possible to refer to the human body in terms of being exclusively a musical instrument nor a visual instrument, but instead, a combination of both. Furthermore, these works and the research behind them propose that our body is not obsolete, contrary to Stelarc's position (Stelarc. org), but that instead, it has yet to be perceived in its full range of possibilities. Hereby it is vital to remark that the usage of interfaces to measure the internal body fluctuations is conceived in these works as a bridge, a means that helps to perceive the human body in a different manner and not as an extension of the body.

## What is an audiovisual instrument?

In order to define the concept of audiovisual instrument, we should start by asking the question: what is an instrument? According to the Cambridge Dictionary Online, an instrument is "a tool or other device, especially one without electrical power, used for performing a particular piece of work". From this definition it can be inferred that instruments are usually referred to as tools to achieve a precise task: whether medical, optical or musical instruments, their purpose is what makes them a particular instrument with a particular function.

In regard to music, the Lexico dictionary describes a musical instrument as "an object or device for producing musical sounds". From a musical point of view, there are several other definitions applicable to musical instruments. According to Tellef Kvifte, one of the most-cited definitions is Hornbostel's, in which "everything must count as a musical instrument with which sound can be produced intentionally" (von Hornbostel 1933: 129; Kvifte 2007: 84). Hornbostel's definition is further amplified with its classification based on the characteristics of how the instrument's vibrations originate (von Hornbostel and Sachs 1961):

1  *Idiophones* in which sound is produced by the vibration of a solid material such as stone or wood.
2  *Membranophones:* sound is produced by the vibration of membranes such as drums.
3  *Chordophones:* sound is produced by the vibration of strings.
4  *Aerophones:* sound is produced by the vibration of air.

Due to a lack of proper and/or accurate definitions, an analogy in regard to instruments used for visual purposes is unfortunately not so straightforward to find; most common definitions consider the term *visual instrument* as those used in maritime ships or aircraft such as radars, affording the visualisation of processes not visible otherwise. Whilst the history of musical instruments demonstrates that the first instruments date from between 37,000 to 63,000 years ago, focusing specifically on the history of *visual music*, one of the first visual instruments was built by Arcimboldo in the late 16th century, the *colour harpsichord*, which produced light and music simultaneously. The colour harpsichord was based on Pythagoras's theory of a "direct correspondence between musical and the rainbow spectrum" (Lucassen 2019: 2). Lucassen adds that this instrument was used by Arcimboldo only for experiment purposes and not to perform in front of audiences. More than 100 years later, in 1725 Louis-Bertrand Castel introduced the *Clavecin pour les yeux* (Ocular Harpsichord) "designed to produce a music of colours" (Franssen 1991: 15), and which, along with Newton's theory of correspondence between light and sound, was the inspiration to the development years later of the *colour organs*, instruments representing sound in a visual form and which consisted of a keyboard for coloured light that could project colour in synchronicity with music (Peacock 1988: 401). One of the best-known examples of *colour organ* was Rimingston's, whose instrument was used for the premiere of Scriabin's synæsthetic symphony *Prometheus: The Poem of Fire* in 1915, in which the respective colours were notated in the score (Moritz 1997); another important example of *colour organ* is the Clavilux by Thomas Wilfred, with the first model built in 1919. Many experiments with combinations of image and music followed. Examples of this are *Lichtspiel Opus 1* (1921) by experimental filmmaker Walter Ruttmann, the series of *Studies* (1929–34) by Oskar Fischinger – complemented by Fischinger's own writings and film experiments with *Ornament Sound*, focused on creating films with synthetic sound whereby drawn ornamental patterns were photographed onto the film's soundtrack area (Fischinger 1932) – and the *Five Abstract Film Exercises* (1943–1944) by the Whitney brothers.

The concept of *Visual Music* offers further clarification, which according to Evans is a "time-based visual imagery that establishes a temporal architecture in a way similar to absolute music. It is typically non-narrative and non-representational" (Evans 2005: 11).

Amongst the most common visual elements in audiovisual music are videos, photos and 3D graphics. Additionally, this chapter includes light as a further visual element to the former list, albeit not following the same aspects already mentioned about *colour organs*. Instead, the visual sections of one of the two main works related to this chapter (the performance *Mindscape* and its related installation *Web-Mindscape*) consist of Electroluminescent Light (EL) wires, which are cables made of a thin copper wire coated in a substance exhibiting of luminescence (phosphor), which produces light via electroluminescence in different colour variants when applying an alternating current.

Considering the aforementioned concepts of musical and visual instrument inserted in the context of this chapter and related to the interactive performances and installations presented in this chapter, we can now combine both into the term *audiovisual instrument*: a tool that produces and/or transforms in real-time both music/sound as well as visual elements. In order to fulfil its purpose, the audiovisual instrument requires connection to a machine (usually a computer) via interfaces such as MIDI controllers, joysticks, etc. enabling the communication between the performer (or visitors in the case of installations) and the audiovisual environment through the usage of diverse software packages. The term *interface* is usually understood as a bridge communicating between two different systems, as Peter Weibel explains: "Distinction constitutes the interface", where he considers that "the alphabet already is the first interface" (Diebner et al. 2001: 275). In the digital domain, *interface* is a device helping us to communicate with a machine, usually a computer or similar devices.

All of the interfaces included in this research allow for communication between human physiological parameters and a computer. Specific for the artworks described in this chapter, the interfaces used measure either skin resistance or brainwave activity. Their task is to quantify internal and normally imperceptible fluctuations of the human body, and to thereafter translate these values to a computer equipped with software responsible for sound and visual effects, which can understand the data sent by the interfaces. The interfaces act therefore as a communication-bridge between the organic body and the machine and a full description of the precise models included in the works is offered later in the chapter. The software in charge of interpreting this data and of creating the audiovisual environment is Max, a computer application originally conceived at IRCAM in the 1980s for interactive music purposes, and which has been extended to video and 2D/3D graphics in the past 20 years.

## Is the human body an audiovisual instrument after all?

Following closely the definitions mentioned in the former section in regard to musical instruments, it can be observed that some parts of the human body can also be considered under the general description of *musical instrument*; for example singing or hand clapping could be classified – according to Hornbostel's classification – respectively as *aerophone* and as *idiophone*. However, in these particular cases, the instrument is clearly circumscribed to precise areas of the human body. Tanaka and Donnarumma (2018) further describe the human body as a musical instrument in situations related to bio-signals; they consider aspects of body schemata, explained as "schemes used by the body to govern posture, movement, and the use of physical implements". They also conceive the human body "a malleable idea changing across cultural contexts and technological advancements", and that it is "open to become, integrate, or combine with an instrument".

It has to be noted, though, that the philosophical and artistic approach presented in this chapter considers the human body from a slightly different perspective

compared to those just mentioned, proposing that the internal electrical fluctuations circulating inside the human body are the precise elements that define it as a valid instrument for audiovisual purposes and consequently, not solely as musical instrument. From Einstein's theory of relativity to quantum mechanics/physics, science has demonstrated that the entire universe is made of vibrating particles (atomic and subatomic). In this sense, we can truly say that everything in the universe vibrates (livescience.com). As the human body is made of molecules and atoms, the conclusion must be that it vibrates too. Further, inside the human body, chemical reactions continuously produce electrical impulses and the nervous system is continuously sending signals between brain and body. We can deduce, therefore, that the human body is continuously vibrating without any external impulse, hence producing constantly diverse, non-audible frequencies. In the case of the brain, electrical impulses result through the communication between neurons producing electrical activity, which according to Buzsáki, the brain rhythms cover from approximately 0.02–600 Hz (Buzsáki 2018). These internal impulses and vibrations inside the human body such as brainwaves, heartbeats, etc. are the main focus of this research and those that make the human body a viable instrument to generate an audiovisual environment. The focus on these internal vibrations inside the human body are extremely close to a further artistic search in the author's work: on the one hand, how to make visible the invisible or audible the inaudible; on the other hand, how to perceive the imperceptible. While the first purpose serves as a means to display simultaneously imperceptible spaces or surfaces united to subtle sounds, none of which are obvious to perception in our daily life, the second shows a particular and deep interest in those internal signs of the human body that are usually imperceptible.

The works by the author included in this chapter show therefore how the human body (specifically hereby, its inner electrical impulses) is used as an audiovisual instrument by modulating in real time diverse sound and visual effects already programmed in Max, whilst Arduino is used only to control light structures. Such sound and visual effects make perceptible the imperceptible internal fluctuations of the human body. These signals are measured through diverse biomedical interfaces, such as, for example BCI or GSR. The next section explains these works in detail, including the type of interfaces used to measure the internal fluctuations of the human body for such purposes.

## The works *Skin* and *Web-Mindscape*: how the human body is used as an *audiovisual instrument*

Although this section focuses mainly on these two works, it is important to quote two former examples, as they both can be considered as the initiators of this research. The first example is the interactive performance/installation *Seed/Tree* (2005) for three Butoh dancers, immersive sound and multiple video panels, created during an artist-in-residence programme at ZKM (Centre for Media Art in Karlsruhe,

Germany). In this work two biomedical signals are used: the electrical activity in one of the performer's muscles, measured via an EMG interface and the auscultation of the heart sounds of a second performer using a stethoscope connected to a micro microphone and the breathing of a third performer. The sound of both heart as well as breathing is continuously modified by the muscular tension measured from the third dancer. With continued interest and research in the combination of bio-signals as audiovisual composition, the author started experimenting and researching other internal impulses of the human body. Consequently, in 2009 during an artist-in-residence at KHM (Kunst Hochschule für Medien in Cologne, Germany), the author created *INsideOUT*, an interactive performance incorporating brainwaves within an immersive space made of surround sound and two video projections. In this work, the performer's brain activity is measured via an open source BCI and the received data is used to modulate continuously the sound and images effects programmed in *Max*. These two pieces, for which a detailed description can be found in the proceedings of the NIME2011 (Robles-Angel 2011: 422), led the way to the two works on which this chapter focuses, and which are set out in detail in the next sections.

## 1   Skin *(installation and performance) using a GSR (Galvanic Skin Interface)*

After having experimented in the former works with biomedical signals in performances, and due to constant questions from the audience with regard to the 'hidden side' of the system, the decision was to create an installation in which not only a single performer, but also the audience are able to participate and to experiment by themselves with the interfaces, inviting them to create an audiovisual environment with their own internal bio-signals. The first version of this interactive installation was conceived and developed during an artist-in-residence in Cluj-Napoca (Romania) during the *Liquid Spaces – Dynamic Models of Space in Art and Technology* event in October 2012. The first version was designed for three video channels and stereo sound. In 2014 and by invitation of *Harvestworks* – Digital Media Art Center in New York City, an extended version for octophonic sound (8.1) was developed and which is the current and final version of the installation. Since then the installation has been presented several times, for example during the 2015 International Symposium on Computer Music Multidisciplinary Research (CMMR) in Plymouth (University of Plymouth, UK) and during the 2016 International Computer Music Conference (ICMC) in Utrecht, Holland (Tivoli – Vredenburg).

The interface used is a GSR, which measures skin resistance or electrodermal activity (EDA). This activity changes according to the sweat glands and these fluctuations indicate psychological/physiological arousal (e.g. stress or relaxation). According to Boucsein (2011: 4), the first experiment demonstrating the connection between sweat gland activity and current flow in the human skin was conducted by Hermann and Luchsinger in 1878. The GSR is very sensitive to diverse emotions and according to several tests carried out during the making of the piece, it reacts

rather rapidly to changes in the skin, reflecting the corresponding changes in the mood of the visitor, such as for example anger, anxiety or relaxation, each of which take just milliseconds for the interface to react. A fundamental consideration therefore is that, given the type of work, for an installation which invites different types of audiences/visitors to test it (including presentations in different countries), the choice of GSR interface required must be simple and easy to use. For this reason, the interface finally chosen is a model by the Canadian firm Thought Technology Ltd., which meets such criteria, including a strong resemblance with a computer mouse.

During the exhibition, visitors are invited to sit in the middle of the surround sound space and use the hand-held interface in order to transform the immersive audiovisual environment with their own emotions, basically projecting either levels of stress or relaxation.

The sound environment of this installation is created by the sonification of the skin conductances or sweat gland activity data translated into frequencies by the GSR2 interface. These frequencies are used as original sound material, which is further transformed with diverse DSP effects programmed in Max, such as for example, filters, granular synthesis and spatialisation movement in the eight audio channels. All of these effects are mapped in order to accentuate the current emotion state, which can be either arousal due to high skin conductance levels (and therefore high-pitched frequencies with a chaotic sound environment created by the multiplicity of grains and a twitchy movement of the sound in the space), or, otherwise, a peaceful sound environment due to low skin conductance.

For the visual part, these internal states are translated as follows: for high levels of arousal, an unstable projection of multiple images move randomly within the three screens; for low levels, a blue visual environment fills the whole space. The transition from stress to relaxation is visible through a blue line that appears in the middle of the screen, which grows broader, the higher the relaxation. Hence, ideally a full relaxation state is visually represented with a full blue screen (see Figures 21.1 and 21.2).

The audiovisual environment mirrors therefore the subject's internal emotional states. Further details about this work can be found in the ISEA 2017 Proceedings (Robles-Angel et al. 2017: 724). A short documentation of this installation can be watched online (Video 21.1).

The performance version of this work follows a precise composed dramaturgy inspired by the skin's moulting process of reptiles such as, for example, snakes. It starts with an extreme close-up tour into the performer's body, showing a real-time feed of their own skin through the introduction of a microscopic video camera. Similar to the installation, the performer interacts with a GSR2 interface measuring skin moisture changes in real-time, which are triggered by changes in their emotional states. The sound environment is composed considering the entire interdisciplinary character of the piece involving moving image, sound and body performance. To

**Figure 21.1**
Source: Skin © Claudia Robles-Angel/VG Bild und Kunst.

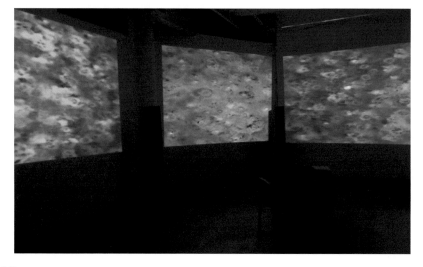

**Figure 21.2**
Source: Skin © Claudia Robles-Angel/VG Bild und Kunst.

this purpose, the first 8 minutes of the performance are dedicated to the creation of a dramatic situation of the shedding of the skin, in which the sound composition utilises pre-recorded sounds without any effects added in real-time. Thereafter, the performer starts using the GSR interface, whereby the sound produced by the interface is amplified and the audiovisual effects already programmed in Max start

to be continuously modified by the performer's emotions on the stage. For this to be possible, the performer must attain a constant modification of inner emotional states. A short documentation of this performance can be watched online (Video 21.2).

## 2 Web-Mindscape *(installation and performance)* using a BCI *(Brain Computer Interface)*

This interactive installation was developed during an artist-in-residence invitation in Holland in 2016 thanks to a grant offered by the IK Foundation. A beta version was exhibited at the IK during that year as a work-in-progress, which should be considered a test version. It has been presented in several venues thereafter including the International Symposium on Electronic Art ISEA 2017 in Manizales, Colombia, and ISEA 2019 in Gwangju, South Korea. The initial main purpose of the installation was to make visual and audible the impact of the large profusion of social media on our inner states, inviting visitors on the one hand to reflect upon this fact and on the other hand, to create an audiovisual environment originating from their own mental states. Thus, the installation creates a site-specific immersive audiovisual environment joining disparate aspects such as social media networks, sound, brainwaves and visual elements.

For this installation the internal fluctuation measured is the brain activity via a BCI (Brain Computer Interface).

In the installation *Web-Mindscape* the interface used is the *EMOTIV Insight*, developed for health and well-being purposes which "consists of only 5 polymer sensors that absorb the humidity from the atmosphere, thus it does not require the application of gel or saline solutions which is therefore more appropriate and practical for its usage in art installations" (Robles-Angel et al. 2017: 725). The *EMOTIV Insight* connects via Bluetooth to the computer and has its own software that helps the user to check the connection of the electrodes to the scalp during the set-up process (pictured in Figure 21.3).

**Figure 21.3** *EMOTIV Insight* software during the set-up process.
Source: Photo by Claudia Robles-Angel.

In *Web-Mindscape* visitors are invited (one at a time) to interact with the audio-visual environment (light and sound) by using the *EMOTIV Insight* interface, which reads their brain activity. Thereby, they are confronted to messages from a social media network (in this case, Twitter). The tweet messages are turned into audible sound, and the computer measures thereafter the cerebral activity of the visitors and analyses their emotional reactions to both the environment and the tweets, transforming this data into visual and audible signals, which reproduce how the subject's inner self is influenced by the outer environment and at the same time, having an impact on the installation's audiovisual environment.

The sound section of the work consists of a surround soundscape (8x independent audio channels), which changes depending on the information coming from the visitor's brainwaves. There are two main sound sources: the first is an ocean field recording attached to a dynamic filter, activated when the participant is in relaxation state, whereby the filter's cut-off frequencies vary according to data received from the participant's brainwave values; the second source consists of texts received via Twitter converted into sound by a text-to-speech algorithm inside the Max patcher. Once converted, this synthetic voice is used as sound material to which diverse sound effects are applied, such as for example, Granular Synthesis. The parameters of the sound effects are modified by the subject's brain activity and this sound is activated when the subject's relaxed condition is altered (Excitement State), which creates a sonic environment made of words as whispers, and which increases its level of complexity in a degree dependent on the data received from the brain activity.

The visual environment of *Web-Mindscape* is created by a light structure made by 32 electroluminescent wires (EL wires) as shown in Figure 21.4. This wired structure

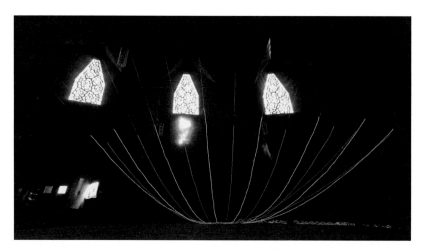

**Figure 21.4**  *Web-Mindscape* at St. Gertrud Church Cologne © Claudia Robles-Angel/VG Bild und Kunst.
Source: Photo by Volker Adolf.

**Figure 21.5**   Electronic boards and EL wire used in *Web-Mindscape*.
Source: Photo by Claudia Robles-Angel.

is built according to the characteristics of the space. The participant is therefore immersed in a luminous structure, surrounded by light cables and sound, creating the immersive audiovisual environment. As EL cables glare when applied to an alternating current (AC), once the AC has been activated, the data of the subject's brainwaves from the EEG interface is utilised in order to turn on/off different cables and in different tempi.

There are 2 EL wire system boxes, each one consisting of an *Arduino* and two *El Escudo Dos Spark Fun* boards for 16 EL wires (see Figure 21.5) that are connected to the laptop and which are continuously receiving data from the Max patcher via USB. This electronic device was developed with technical support by Andreas Gernemann-Paulsen from the Department of Musicology at the University of Cologne, Germany. Further technical support was provided by Michael Lateo, Department of Electronic and Computer Engineering, Brunel University, London, UK.

Even though the *EMOTIV Interface* can be used appropriately for art installations, it presents unfortunately noticeable disadvantages in some cases, because it is difficult to connect to some subjects in most cases due to either plenty of hair or a dry scalp, both of which make it difficult to capture the signal. For this reason, in the performance version called *Mindscape,* the interface used is the open source EEG

from Olimex, for which a saline product and gel is applied; a detailed description of this interface can be found at the proceedings of NIME2011 p. 423.

In the performance *Mindscape*, the performer interacts via a BCI measuring her brainwaves with the immersive sound environment and the light structure (only one EL box) made by 16 electroluminescent (EL) wires in front of the performer with a 180° angle.

As mentioned earlier, for this performance the interface used was the OpenEEG from Olimex, the same used in the author's piece *INsideOUT* (2009) and the same the author used to perform Alvin Lucier's EEG's piece in a festival in Cologne in 2011. The main reasons why I continue using this interface are twofold: on the one hand, and from a purely technical point of view, because this interface can get a reliable connection with the scalp, allowing for a more precise measurement of the brain activity, even if it is not suitable for art installations (Robles-Angel et al. 2017: 724); on the other hand, and from the aesthetical point of view, as it is not wireless, the performer is directly connected to the computer as a visual metaphor of our reality nowadays in regard to becoming more and more attached to the machine. This results in an image of a performer hooked to a computer, with the body connected to and surrounded by light wires, isolated by the distance between her own body and the surrounding environment, which symbolises the desire of becoming a machine/cyborg that attaches artificial technologies to its own structure. Although the performer appears to be rigid on stage, her inner emotional states give continuously movement and transformation to the audiovisual environment through the measurement of her brain activity. A short documentation of this performance can be watched online (Video 21.3).

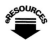

As it can be observed in all of the previously mentioned works, the organic body and its internal fluctuations is the instrument that modifies in real-time the sonic and visual elements of the immersive space.

## Conclusion

This chapter introduced the concept of the human body acting as an audiovisual instrument for artworks (either performances or installations whereby sound and visuals are equally represented) inviting visitors/audiences to perceive the imperceptible fluctuations inside the human body. This concept is developed and explained in two artworks by the author. Although dependent on interfaces that read and measure the values of such fluctuations, this chapter demonstrates that such interfaces do not pursue the purpose either of being or of acting as an extension of the body (in contrast to positions by other artists such as Sterlarc,

Tanaka and Donnarumma). By exteriorising the aforementioned imperceptible fluctuations inside the human body, works using it as an audiovisual instrument pursue the goal of arousing interest and even curiosity about the perception of events that go beyond our day-to-day perception, and instead force our senses to perceive inner imperceptible micro-movements in our own bodies in the form of an audiovisual environment. The body is therefore the tool that allows for such an environment to exist. Either in installations or performances, the works described in this chapter reflect the constant intention of the author to create immersive spaces by inviting visitors and audiences not only to dip into the audiovisual environment but also to participate with their own imperceptible physiological manifestations (e.g. either with their brainwaves, skin's moisture, muscle tension, heartbeats or other bio-signals).

Using the human body as an audiovisual instrument is a way to recover the *organic body* in a digital era, it is a way to get the power of our body back, as the philosopher Consuelo Pabón, following Deleuze philosophy concluded: "It is not about moral wars to conquer power; it is about molecular wars to recover the power of the body, the power of life that steals the biopower, wherever it comes from" (Pabón 2014: 38).

# References

Blum, T. (1989) Reviewed Work(s): Biofeedback and the Arts: Results of Early Experiments by David Rosenboom. *Computer Music Journal*. 13(4). The MIT Press, MA. pp. 86–88.

Boucsein, W. (2012 [2011]) *Electrodermal Activity* (2nd ed.). Springer Verlag.

Buzsáki, G. (2018) Neural Oscillation. *Encyclopaedia Britannica*. Available online: www.britannica.com/science/brain-wave-physiology [Last Accessed 15/06/19].

Cambridge Dictionary Online. *Instrument*. Available online: https://dictionary.cambridge.org/dictionary/english/instrument [Last Accessed 11/06/19].

Diebner, H.; Druckrey, T.; Weibel, P. (eds.). (2001) *Sciences of the Interface*. Tübingen: Genista.

Evans, B. (2005) Foundations of a Visual Music. *Computer Music Journal*. 29(4). Visual Music. MIT Press, MA. pp. 11–24.

Fischinger, O. (1932) Klingende Ornamente. *Deutsche Allgemeine Zeitung, Kraft und Stoff*. No. 30, 28 July. Selected statements translated into English. Available online: www.centerforvisualmusic.org/Fischinger/SoundOrnaments.htm [Last Accessed 13/06/19].

Franssen, M. (1991) The Ocular Harpsichord of Louis-Bertrand Castel. *The Science and Aesthetics of an Eighteenth-Century Cause Célèbre: Tractrix, Yearbook for the History of Science, Medicine, Technology and Mathematics*. 3.

Kvifte, T. (2007) *Instruments and the Electronic Age* (2nd ed.). Oslo: Taragot Sounds.

Lexico Dictionary Online. *Instrument*. Available online: https://www.lexico.com/definition/instrument [Last Accessed 13/06/19].

Livescience. Available online: www.livescience.com/33816-quantum-mechanics-explanation.html [Last Accessed 15/06/19].

Lucassen, T. (2019) *Color Organs*. Available online: www.researchgate.net/publication/228363257_Color_Organs/citation/download [Last Accessed 13/06/19].

Lucier, A.; Gronemeyer, G.; Oehlschlaegel, R. (1995) *Reflections: Interview, Scores, Writings 1965–1994*. Köln: Musik Texte. p. 442.

Moritz, W. (1997) The Dream of Color Music, and Machines That Made It Possible. *Animation World Magazine*. 2(1). Available online: www.awn.com/mag/issue2.1/articles/moritz2.1.html [Last Accessed 13/06/19].

Pabón, C. (2014) Construcciones de cuerpos. In: *Expresión y vida. Prácticas en la diferencia*. Bogotá: ESAP. pp. 36–79. Available online: https://issuu.com/mondritos/docs/consuelo_pab__n_-_construciones_de_ [Last Accessed 13/06/19].

Peacock, K. (1988) Instruments to Perform Color-Music: Two Centuries of Technological Experimentation. *Leonardo*. 21(4). pp. 397–406.

Robles, C. (2011) EEG Data in Interactive Art. *Online Proceedings of the ISEA 2011*, Istanbul. Available online: http://isea2011.sabanciuniv.edu/paper/eeg-data-interactive-art [Last Accessed 13/06/19].

Robles-Angel, C. (2011) Creating Interactive Multimedia Works with Bio Data. *Proceedings of the 11th International Conference on New Interfaces for Musical Expression*, Department of Musicology, University of Oslo, Oslo, Norway. pp. 421–424.

Robles-Angel, C.; Scherffig, L.; Birringer, J.; Seifert, U.; Schmidt, L. (2017) Bio-Medical Signals in Media Art. *Proceedings of the 23rd International Symposium on Electronic Arts* (ed. J.J. Arango, A. Bubarno, F.C. Londoño; G.M. Mejía). pp. 720–729.

Rosenboom, D. (1997) Extended Musical Interface with the Human Nervous System. *LEA Electronic Monographs, No. 1*, ISAST. Available online: http://leoalmanac.org/resources/emonograph/rosenboom/rosenboom.html#PART2 [Last Accessed 13/06/19].

Schwartz, M.S.; Andrasik, F. (2003) *Biofeedback: A Practitioner's Guide*. New York and London: The Guilford Press. p. 9.

Sterlarc.org. Available online: http://stelarc.org/?catID=20317 [Last Accessed 13/06/19].

Tanaka, A.; Donnarumma, M. (2018) The Body as Musical Instrument. In: Y. Kim; S.L. Gilman (eds.) *Oxford Handbook of Music and the Body*. Oxford: Oxford University Press. Available online: www.hz-journal.org/n21/tanaka.html [Last Accessed 11/06/19] and www.oxfordhandbooks.com/view/10.1093/oxfordhb/9780190636234.001.0001/oxfordhb-9780190636234-e-2 [Last Accessed 11/06/19].

Teitelbaum, R. (1976) In Tune: Some Early Experiments in Biofeedback Music (1966–1974). In: D.V. Rosenboom (ed.) *Biofeedback and the Arts, Results of Early Experiments*. Aesthetic Research Center of Canada Publications. pp. 35–51.

Von Hornbostel, E.M. (1933) The Ethnology of African Sound-Instruments. Comments on 'Geist und Werden der Musikinstrumente' by C. Sachs. *Africa*. 6(2). pp. 129–157.

Von Hornbostel, E.M.; Sachs, C. (1961) *Classification of Musical Instruments* (trans. from the Original German by A. Baines; K.P. Wachsmann). *The Galpin Society Journal*. (14). Galpin Society. pp. 3–29.

# Sound – [object] – dance
## A holistic approach to interdisciplinary composition

**Jung In Jung**

## Introduction

The origins of interactive dance can be traced back to John Cage and Merce Cunningham's collaboration *Variations V* of 1965, yet vigorous research on developing wearable or camera-based motion-tracking sensors has only been conducted by a larger number of composers since the 1990s. As a consequence, debates and criticisms regarding the usage of technology in the dance technology community have been directed towards artists who were "eager to work with newly arising digital tools", but who had "little understanding of the inner workings of electronics or computer code", which in turn created trivial works (Salter 2010: 263–264). This is a critical point of view; however, I find it not entirely fair towards the artists. The increasing accessibility of Max/MSP,[1] with its graphical interface, and user-friendly tools like Isadora[2] have attracted composers and artists who are new to programming, enabling them to create interactive artworks. These are creative users who are not necessarily software developers. I argue that the problem is not lack of knowledge of the technology, but a lack of investigation into novel mediums that the artists did not primarily practice within. A more appropriate critical question asked by Chris Salter is how could the use of motion-tracking technology "enlarge dance as a historical and cultural practice" and what kind of aesthetic impact could it have on spectators who were not privy to the process of mapping movement data to the resulting media? (2010: 263).

In gesture-driven music, when interactivity is considered a crucial element that has to be demonstrated to the audience, it can easily restrict interactive dance to the folly of mere demonstrations of technology. Thus, it results in trivial works. Scott deLahunta (2001) argues that in the field of computer music the process of new musical instrument learning has been assumed to be a form of dance training. Julie Wilson-Bokowiec and Mark Alexander Bokowiec (2006: 48) point out that mapping

sound to bodily movement has been described in utilitarian terms, that is, "what the technology is doing and not what the body is experiencing". According to Johannes Birringer (2008: 119), developing interactive systems with this utilitarian perspective requires performers to learn "specific physical techniques to play the instruments" of the outcome media. Dancers find it hard to think of these as they do the "intuitive vocabulary" that they have gained through their physical and kinaesthetic practice. Discussions about creating musical instruments are still valuable to the development of interactive systems. However, I find that this narrow focus on the gestural or postural articulation of technology misses the aesthetic concerns in creating choreography with dancers.

To direct and frame my own compositional practice, I have shaped the following research questions: (1) How can interactive systems guide collaboration by encouraging dancers to use their intuitive vocabulary, not just demand that they learn the technological and musical functions of the interface? (2) Once I have considered the sounds to be used in a piece, how should I direct dancers to create choreography as well as sound composition with my interactive system? To answer the first question, it was necessary to investigate the choreographic composition process. To answer the second question, I applied the interactive technology in collaboration with my dancers. In the following sections, I will elaborate this compositional process developed with my collaborating dancers and applied in two works *Locus* and *The Music Room*. For this particular research, I decided to work with professionally trained contemporary dancers; as my contextualisation is strictly based on contemporary dance technique.

### *Physical restriction as a core choreographic method*

"Choreography has gone viral", argues Susan Leigh Foster (2010: 32). She writes that since the mid-2000s the word has been used as "general referent for any structuring of movement, not necessarily the movement of human beings". The word "choreographic" has been used to describe the process of paintings, sculptures and installations, such as Allan Kaprow's movement score *18 Happenings in 6 parts* and Bruce Nauman's *Green Light Corridor*. These works were focused on certain movements of the artists or viewers, and were, therefore, choreographed. More recently, the artist Ruairi Glynn presented his kinetic sculpture *Fearful Symmetry* as a choreographic idea at the conference *Moving Matter(s): On Code, Choreography and Dance Data* in 2017. The reason this kind of movement from non-dancers and non-human movement has come to be recognised as "choreographic" is because dance has changed dramatically since the mid-twentieth century to eliminate virtuosic movements. For example, the Judson Dance Theater choreographers deliberately incorporated everyday movements such as walking, running and sitting into their work (Au 2002: 161, 168). In his essay *Notes on Music and Dance*, Steve Reich (1973: 41) writes that the Judson group choreographers have embraced "any movement as dance", equivalent to John Cage's idea that "any sound is music".

Yet, for my collaboration with dancers, I thought it more appropriate to understand how choreographers think of choreographic movement rather than what choreography ultimately is. Movement art pioneer Rudolf Laban sees choreography as a "continuous flux" of movement that should be understood alongside both "the preceding and the following phases" (Ullmann 2011: 4). Laban's dance notation shows movement "trace-forms" through directional symbols inside the kinesphere[3] rather than specific postures. This inspired me to think about what principally stimulates which movement.

I found the contemporary dance choreographer William Forsythe's composition approach interesting because he extended Laban's notion of the kinesphere. In his lecture video *Improvisation Technologies*, Forsythe demonstrates possible movement variations depending on a newly given axis without stepping away from the first position; the axis of movement is no longer the centre of the body. For instance, he shows as a normal scale of the kinesphere the entire body in a cubic space, and then creates a smaller scale to isolate his left arm to make arm movement variation. Furthermore, Forsythe asks his dancers to imagine objects or geometric lines to create movement with or around, which he calls "choreographic objects" (Forsythe n.d.). Re-orientating physical perception with these imaginary spaces and objects is Forsythe's core movement creation technique. Forsythe provides inputs at "the beginning of a movement rather than on the end" and "in the process, discover[s] new ways of moving" (Forsythe and Kaiser 1999). Similar to Forsythe, choreographer Wayne McGregor proposes that his dancers imagine an object as well as use other sensations such as colour or music to compose choreography. Another technique McGregor uses is to provide dancers with a physical problem that they have to solve through movement. For example, dancers are asked to "picture a rod connected to their shoulder, which is then pushed or pulled by a partner some distance away" (Clark and Ando 2014: 187). McGregor describes these ways of creating movement phrases with specific physical conditions as a "physical thinking process" (McGregor 2012).

What is interesting from both Forsythe and McGregor's methods is that rather than freely improvising to seek new movement they restrict their physical condition with imagined objects and space. In order to actively stimulate and engage dancers to create choreography with the interactive system, I decided instead to provide a visible and tactile motion-sensing device that primarily challenged performers to dance, and to let these movements create the sounding results. Subverting common conventions in which motion-tracking or motion-sensing devices are applied as a mere interface for preserving the freedom of the dancer's movement – connecting the presupposed musicality of movement data to the output – I decided to replace the mental imagery described by Forsythe and McGregor with actual physical restriction using the cables of the Gametrak controllers (Figure 22.1). In this way, the Gametrak provides a technological restriction that governs my sound composition and movement creation as both an interface and a physical limitation that has to be accounted for by the dancers.

**Figure 22.1**   Sketch of two dancers tethered with the cables of the Gametrak controllers.

Amongst interactive musical instrument and dance collaborations, I find the work *Eidos: Telos* (1995) by Forsythe and the Studio for Electro-Instrumental Music (STEIM) composer Joel Ryan the most interesting, even though it was developed in the 1990s, at the very beginning of the period of experimentation in interactive musical synthesis with computers. Across the stage, a net of massive steel cables was set to be amplified by contact microphones and in turn become a large-scale sonic instrument when plucked by the dancers. The choreography was composed around the steel cables; there was a moment when one dancer danced in front of the steel cables and a group of dancers danced behind the cables in lines. The stage lighting was set to become dimmer when the dancers stood behind the cables. Later, a dancer in a black costume held a panel and scratched the cables while moving to the left and right sides of the stage. The instrument was "audio scenography: the replacement of visual scenography with a continually transforming audio landscape" and showed "the shifting of dance music composition in Forsythe's work towards the design of total acoustic environments" (Spier 2011: 57–58). The instrument created simple and modern-looking scenography without superfluous technological aesthetic – which Forsythe usually seeks in his other works – and acted as the work's core compositional as well as dramaturgical strategy. Similarly, I wanted to include the symmetrical lines created by the cables of Gametrak controllers as part of visual scenery as well as to provoke dramaturgy. But in my works the cables were connected to my dancers' bodies, which affected their ways of moving more intimately.

## Locus

While searching for case studies in dance and technology collaboration, I found that McGregor worked with cognitive scientists to seek connections between creativity, choreography and the scientific study of movement and the mind (deLahunta 2006). The scientists observed how McGregor and his dancers developed choreography from mental imageries and helped break the dancers' movement habits by shifting the perspectives by which these imageries were approached. What interested me about this collaboration was that the choreography itself came about as the result of technological adaptation rather than a representational event such as a sound or image created with real-time movement data. One outcome to the collaboration was the choreographic composition tool *Mind and Movement* for choreographers and teachers, which includes image cards with related movement tasks to stimulate developing and structuring movement materials.

Inspired by the use of imagery for choreographic composition, I decided to include a real-time video composition that could be used as choreographic stimulus. The result is my composition *Locus*[4] based on three photographs I took in Manchester city centre (Figure 22.2). They were chosen because my main collaborating dancer Katerina Foti was interested in creating choreography inspired by the

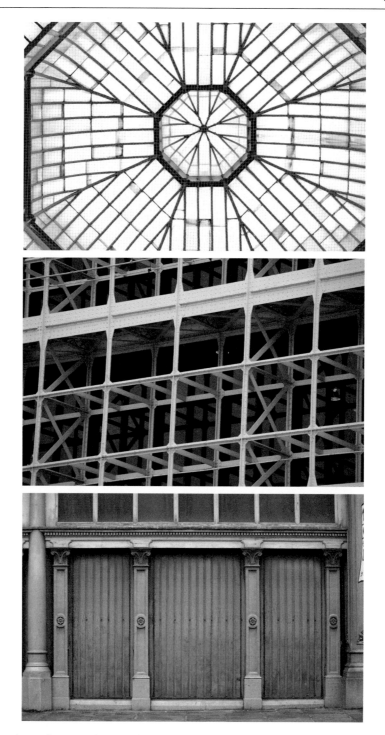

**Figure 22.2**   Three photographs used for *Locus*.

geometric shapes and lines in these architectures. I decided to place eight hacked Gametrak controllers in a cube shape – four above and four below – as shown in Figure 22.3, and locate the dancers in the middle so that the Gametrak cables could also create geometric lines when they were connected to the dancers' bodies.

I proposed using the Gametrak controllers as a visual stimulus and physical restriction to Foti and as she was aware of Forsythe's approach she was interested in the method. This was my first time composing an interactive music with physical restriction, and I decided to apply a methodology of improvisation to find the most suitable compositional approach. To begin the collaboration, I devised the interactive audiovisual work in three different parts. I fixed the overall framework of the piece but left the inner structures to be completed by the dancers. Different choreographic tasks were set for each part, and each part was constructed as the dancers executed the tasks.

The tasks indicated what to do with the Gametrak controller, as well as the duration and speed of movement, but the detailed body movements in response to these tasks were up to the dancers. For instance, the first part of the composition consists of three different audiovisual variations.

1   The first variation:
    • Tether the cables one by one slowly (total four each).
    • Continue this act until you hear the sound of 'gong' thirty times so that the next part starts.
2   The second variation:
    • Improvise as duet for 2 minutes.
    • Explore the movable space between and around each other's body.
3   The third variation:
    • Perform as solo for 1 minute each.
    • When the solo is finished, move to the side and detach three cables.

I did not aim to deliver a specific storyline with my audiovisual work, but I let the given materials be processed through my real-time synthesis engine so as to see what would be evoked during the composition process with the dancers.

To interrogate the use of the Gametrak controllers and the choreographic tasks with my collaborating dancers, I planned several steps to guide Foti and another dancer, Natasha Pandermali, towards gradually constructing a choreographic composition with my interactive sound synthesis before I revealed the specific choreographic tasks for each part of the composition. First, I asked the two dancers to tether four cables each to their bodies and to improvise to find out how to move within the restrictive conditions without any audiovisual work. Once they had got used to moving within the conditions, I then provided

more specific choreographic tasks section by section depending on the structure of the audiovisual composition. During this process, the dancers proposed how they would create choreography with my movement tasks and I selected promising materials. We repeated the proposing, selecting and modifying process several times until we completed the composition.[5]

Such an approach of proposing and selecting choreographic materials is a common in contemporary dance, as exemplified by the choreographers Forsythe and McGregor. While searching for the origin of this choreographic method, I found that some contemporary dance choreographers began using the so-called problem-solving concept in the 1960s as research in information theory and artificial intelligence awakened around that time (Rosenberg 2017: 185–186). This technique adopted improvisation as a choreographic compositional method. For example, the Judson Church group choreographer Trisha Brown "cast her dancers into what problem-solving theorists call a 'problem space' defined by an 'initial state, a goal state, and a set of operators that can be applied that will move the solver from one state to another'" (Rosenberg 2017: 186). This algorithmic process is also apparent in Forsythe's choreographic procedure *Alphabet* (Forsythe and Kaiser 1999) and McGregor's "if, then, if, then" process (McGregor 2012).

I also find similar algorithmic thinking in the electroacoustic composer Simon Emmerson's model of compositional process. Since electroacoustic music does not use traditional musical notation systems and materials, Emmerson (1989) proposes a new compositional model for contemporary music. The model consists of a cycle of actions: the composer does an action drawn from an action repertoire, which then has to be tested. After testing, accepted materials reinforce the action repertoire and rejected ones can be modified for the action or removed. Emmerson explains that research begins when one "tests" the action, and new actions need to be fed into the action repertoire to evolve the research further (Emmerson 1989: 136). Similarly, in my composition process I provide new actions with the Gametrak controllers, and my collaborating dancers "test" the actions and reflect on the next phase.

The reason that I decided to provoke the dancers to improvise with this special condition was to encourage them to resist their habitual movements. This is my method for employing directed improvisation, using a problem-solving technique as a compositional strategy, as well as to discover new ways of moving. Notoriously, Cunningham rejected improvisation because he resisted his instinctive preferences in order to create more innovative choreography (Copeland 2004: 80). However, I did not want to eliminate intuitive decisions from my dancers. My intention was to let the dancers contribute their movement knowledge and skills to the choreography beyond their own habits. In other words, this was my way of provoking a "physical thinking process" as McGregor (2012) calls it. The resulting movements would be what had been processed through the dancers' movement repertoire with my new inputs. Eventually, a composition is completed with multiple iterations of these actions.

After the first rehearsal of *Locus*, I interviewed Foti and Pandermali to ask about their experience working with my method. Foti mentioned that the tethered controllers limited her but also made her create movement because of the restrictions. Pandermali agreed and explained further about the restrictions: "We may put some restrictions to ourselves [when we dance], but it is like more mental. [. . .] But this time we were physically restricted [. . .] it is more [. . .] true. The movement comes from what we are allowed to do with the cables. [. . .] Now [the restriction] was strict, but at the same time, there was a completely new world to explore." I also found that the dancers were able to realise how they moved by listening to the sounds they created, and that also affected how they moved between themselves (Foti and Pandermali 2015).

My audiovisual work and choreographic tasks were neutral in terms of directing any narrative or emotions. I used abstract forms because I wanted the dancers to freely interpret and express the audiovisual work through their own movements. After creating *Locus*, I searched for other choreographic works that used abstraction so as to better reflect and understand my own method, and found works by the choreographer Alwin Nikolais. I found his compositional approach, which is often called "total theatre", very similar to mine. His focus is on creating interdisciplinary work using motion, light, sound and colour, rather than creating only movement phrases. His abstract dance performances have sometimes been accused of "neglecting the element of drama", but Nikolais has insisted that "abstraction does not eliminate emotion" (Au 2002: 160). His intention was to get away from storytelling, which was common in early modern dance. Instead, he has focused on motion as he believed that "motion is the art of dance" just as "sound is the art of music" (Nikolais 1974). He also used abstract electronic music because he thought instrumental music would activate another sense association with the performer of the instrument rather than only its sound (Nikolais 1974). The same kind of abstraction was adapted to dancers: Nikolais encouraged his dancers to use their minds rather than try to play a role. For instance, in his work *Tower* the dancers construct a tower by stepping on or hanging onto a metal structure without a storyline, "yet their motion helps build images that are fraught with emotional connotations" (Au 2002: 160).

Similarly, during the composition process of *Locus*, my collaborating dancers naturally developed a drama between themselves and the restrictive performance environment as they improvised more and more. When Pandermali was tethered with eight cables in the last part of the composition, for example, I suggested tethering one of the cables to her neck rather than to her limbs so as to increase the challenge for her (Figure 22.3). For this part, I made the cube images change their textures randomly with the three photographs and the interactive audiovisual synthesis was disabled. The non-controllable audiovisual set and Foti's contrasting free and fast movements provoked Pandermali to express struggle with her movement within the extremely restrictive conditions compared to other parts of the composition.

**Figure 22.3**   Live performance of *Locus* at Electric Spring Festival 2016 in Huddersfield. Dance artist: Natasha Pandermali.

Source: Jean François Laporte, Electric Spring 2016, © University of Huddersfield.

Also, Pandermali confessed to me that she sometimes made more of a struggling gesture than the actual physical situation demanded. Foti explained that although the choreographic task was functional, the dramaturgy could evolve by way of the restrictions not letting them move in familiar ways. "By searching the unfamiliarity, we ended up having our own special vocabulary for our movement which connoted an untold story" (Foti 2018).

## The Music Room

Inspired by Laban's notion of kinesphere, I wanted to create with my interactive system a work that dealt with the size and shape of the space of the kinesphere. In my previous works, I have used Gametrak controllers to make the dancers more aware of the space of the kinesphere. For example, when a dancer was no longer able to move one part of his or her tethered body, he or she was provoked to think about and move other body parts. In other words, the tethered parts of the kinesphere were restrained. However, I wanted to create a new work that somehow more clearly demonstrated the invisible kinesphere around the body.

I looked at the possible movement trace-forms drawn in the book *Choreutics* and planned how to map my sound composition using Laban's dance notation. I also recreated the trace-forms in 3D space in vvvv.[6] However, the more I worked in this direction, the more I felt that it was a mere representation of Laban's drawings of movement theory. Eventually, I came up with an idea of adding a double enforcement for the dancers by restricting the size of the performance space alongside the use of the Gametrak controllers as a new challenge. Since the kinesphere is a 360° space, I wondered how it would affect a dancer's perspective when it was cut into quarters (Figure 22.4). This led me to create a piece that had to be performed at the corner of a room.

**Figure 22.4**  The kinesphere is cut into quarters.

I read Laban's book *A Life for Dance* (1975), which consists of his commentaries on his works. I wanted to know his background so that I could understand why he created such a movement theory. In the chapter "The Fool's Mirror", Laban wrote about how much he was afraid of the fact that movement could be captured as still images with a camera and lose its physical quality. Perhaps this was behind the basic idea of his choreutic theory as seeing movement as constant "flux". In the chapter "Illusions", Laban wrote about how he had struggled to lead his dance troupe during the post-war period without enough financial support and food. Although Laban did not have a hall for rehearsals and had to use meadows instead, this was the period when he further developed the idea of pure movement art with his pupils by dancing in silence without music. While I was reading about choreutic theory, I often wondered why Laban had been obsessed with creating "unity" or "harmony" in movement, which sounded like another way of "controlling" rather than freeing from tradition. However, the more I got to know about his experience in the community with his pupils, the more I came to understand that his goal was not to teach a unified style of dance, but to introduce the most basic principles of human body movement. Therefore, anyone could perform with any kind of movement style. I find Mark Jarecke's introduction to Laban's work helps to understand this approach: "Laban looked at dance outside traditions as Kandinsky and Schoenberg did to art and music" (Jarecke 2012).

For *The Music Room* (Figure 22.5),[7] I wanted to recreate a specific scene I had read in the chapter "The Earth", not as a literal translation but trying to take an

**Figure 22.5** Live performance of *The Music Room* at Vivarium Festival 2019 in Porto. Dancer/performer: Katerina Foti.

Source: João Pádua, Vivarium Festival 2019, © Saco Azul and Maus Hábitos.

excerpt of the story. Laban's story recounted joyful moments of his childhood as he adventured in the mountains, feeling the majestic earth, and how he incubated his creative ideas inspired by these adventures in the music room of his grandparents' house by playing a piano. I was drawn to the story in particular because it reminded me of childhood vacations at my own grandparents' house in the mountains. There was a stream right next to my grandparents' house, and I swam every summer with my cousins. Visiting my grandparents' house and playing in nature was definitely one of the most joyful memories from my childhood. It may sound banal or primitive, but it was no doubt simple and true happiness. In *The Music Room*, therefore, I wanted to create a piece with the most basic principles for creating sound and movement of all my works so far.

I used a piano sound because of Laban's story, although I do not usually use musical instruments in my sound compositions. I do not feel it is right for me to mess around with musical instruments since I am not a player. While hesitating to use piano, I remembered what Morton Feldman said:

> My concern is: what is its scale when prolonged, and what is the best method to arrive at it? My past experience was not to "meddle" with the material, but use my concentration as a guide to what might transpire. I mentioned this to Stockhausen once when he had asked me what my secret was. "I don't push the sounds around."
>
> (Feldman 2000: 142–143)

This inspired me to set the core choreographic task for this piece: *Once you trigger sound, let the sound be played out until it lasts before you move again.* In other words, the dancer needed to concentrate on when to move according to the length of sound she had triggered, and the triggered sounds unfolded by themselves according to the intervals created by the dancers. The dancer was not attempting to respond emotionally, but had to think about creating stillness until the note decayed. Here, the sound composition also worked as another restriction for the dancer. As a consequence, this relationship evolved the dramaturgy through a tension between the dancer and the piano notes. Based on this idea I played some chords I liked on a piano and listened to the overtones and lengths of resonance. I then recorded each note from the chords until the sound naturally decayed. Finally, I loaded the recorded piano notes in Max using poly~ objects to be triggered randomly.

I set up four Gametrak controllers – two on the ceiling and two on the floor. Based on Laban's notation system within the kinesphere I initially mapped the sound to be triggered when the dancer held her limbs towards forward, right forward, left forward, high forward, high right forward, high left forward, deep forward, deep right forward and deep left forward, because these were the possible directions of movement while standing at the corner of a room. For the first rehearsal, I asked my collaborating dancer Foti to stand in the corner of the room and to tether the cables of the Gametrak

controllers onto each of her limbs. Then I asked her to move her limbs one by one. I thought this would be an effective introduction for the audience to demonstrate the fact that each of her limbs were triggering sound as she moved. However, Foti said that where I had mapped the sounds was not natural for her dance style. Laban wrote his theory in the early 1900s, just as modern dance started to be established as a form. He thus used the centre of the body as the axis in his notation system, in relation to traditional ballet principles. But in current contemporary dance practice the axis of the body is instead grounded, following the natural relationship between gravity and the body. When Foti tried to move only one arm, it was not a problem. However, she felt very awkward moving only one leg in the standing position.

After we went through the entire composition twice, Foti suggested leaning against the wall behind her for the very beginning part rather than free standing. She explained that moving only one part of her limb while standing could be one way of applying a restriction to her, but it did not feel natural based on how she had been trained. Therefore, for the third rehearsal she tried the beginning part while crouched down to see how she could move her legs from that position. Eventually, we decided to start the composition with the dancer sitting down and holding the column behind her. In this way, she could fix her hands holding the column more naturally while moving her legs and, in return, not accidentally trigger sounds with her hands. I mapped the piano notes again according to this position.[8]

Once we had established the right position from which to begin the composition, the choreographic ideas for the next parts came very quickly. In the fifth rehearsal, the dancer also tried upside down positions leaning her legs against the wall. This was another interesting position in which she could fix her hands so as not to trigger unwanted sounds. In the end we no longer cared about Laban's well-structured notation system within the cube-shape kinesphere, but designated our own positions that were more suitable for Foti's style of dance.

I decided to present this piece as a dance film to show the intimate relationship between the body, the space and my choreographic sound composition with the viewpoints that I wanted to show. I experience dance by looking primarily at the "effort" of movement, not only its outline. That effort provokes or relates to certain emotions, which I find to be quite a different way of expression from acting. I tried to capture the effort of moving with my rules and the space as a "hidden feature" of the choreography just as Laban highlighted the intimate relationship between space and movement in his choreutic theory (Ullmann 2011: 3–4).

## Conclusion

In creating my sound compositions I have sought ways to integrate interactive technology into the choreographic process. I have therefore studied some choreographic methods to understand how contemporary dance works are structured. *Locus* was where I tested whether my compositional approach was convincing for

my collaborating dancers. Throughout this piece, I observed how restriction affected the dancers' awareness of their bodies and the performance space. For me, the later work *The Music Room* was the best-demonstrated piece in terms of using restrictions with interactive sound synthesis. Here the sound triggered by the dancer also restricted her movement, creating stillness, and the corner of the room became a physical enforcement that restricted the size and shape of her kinesphere.

With this compositional method, I was sometimes asked whether my role had become that of a choreographer as well. However, my intention was to introduce the collaborative model from the field of contemporary dance to the field of computer music and to adopt it into my compositional process for sound. Therefore, it is hard to clarify the roles of composer, choreographer and performer in the traditional sense. This compositional approach came about because I wanted to create a sound and dance collaboration in which each collaborator could contribute their expertise to the creative process, rather than one medium determining the other. Therefore, the Gametrak controllers were used not only as an interface but also as a common medium in which to think and work on the compositional process together. Both abstract sound and choreographic ideas were bridged through a concrete object – co-opting the affordances of the restrictive motion-tracking technology – to successfully conduct this interdisciplinary collaborative composition. Ultimately, not just the technological integration, but the holistic collaborative compositional cycle can be considered as an interdisciplinary compositional act.

## Notes

1 Cycling '74, www.cycling74.com/
2 TroikaTronix, https://troikatronix.com/
3 Laban defines kinesphere as "the sphere around the body whose periphery can be reached by easily extended limbs without stepping away from that place which is the point of support when standing on one foot" (Ullmann 2011: 10).
4 By Jung In Jung, Available online: https://vimeo.com/141275226
5 The composition process is documented as a video. Available online: https://vimeo.com/343061554/ 1b9da94db1
6 vvvv, https://vvvv.org/
7 By Jung In Jung, Available online: https://vimeo.com/273755878/26dcf4a5c3
8 The composition process is documented as a video. Available online: https://vimeo.com/343064818/ 649ce20eee

## References

## Book

Au, S. (2002) *Ballet and Modern Dance* (2nd ed.). London: Thames & Hudson.
Copeland, R. (2004) *Merce Cunningham: The Modernizing of Modern Dance*. New York and London: Routledge.

Feldman, M. (2000) *Give My Regards to Eighth Street: Collected Writings of Morton Feldman* (ed. B.H. Friedman). Cambridge, MA: Exact Change.

Foster, S.L. (2010) Choreographing Your Move. In: S. Rosenthal (ed.) *Move Choreographing You: Art and Dance since the 1960s*. London and Manchester: Hayward Pub.

Laban, R. (1975) *A Life for Dance*. London: Macdonald & Evans.

Reich, S. (1973) Notes on Music and Dance. In: *Writings about Music*. Halifax: The Press of the Nova Scotia College of Art and Design.

Rosenberg, S. (2017) *Trisha Brown: Choreography as Visual Art*. Middletown, CT: Wesleyan University Press.

Salter, C. (2010) *Entangled: Technology and the Transformation of Performance*. London and Cambridge, MA: The MIT Press.

Spier, S. (2011) *William Forsythe and the Practice of Choreography: It Starts from Any Point*. London: Routledge.

Ullmann, L. (2011) *Choreutics*. Hampshire: Dance Books.

## Journal article

Birringer, J. (2008) After Choreography. *Performance Research*. 13(1). Routledge. pp. 118–122. doi: 10.1080/13528160802465649.

Clark, J.O.; Ando, T. (2014) Geometry, Embodied Cognition and Choreographic Praxis. *International Journal of Performance Arts and Digital Media*. 10(2). Routledge. pp. 179–192. doi: 10.1080/14794713.2014.946285.

deLahunta, S. (2001) Invisibility/Corporeality. *NOEMA*. Available online: https://noemalab.eu/ideas/essay/invisibilitycorporeality/ [Last Accessed 12/02/18].

deLahunta, S. (2006) Willing Conversations: The Process of Being between. *Leonardo*. 39(5). The MIT Press. pp. 479–481. doi: 10.2307/20206301.

Emmerson, S. (1989) Composing Strategies and Pedagogy. *Contemporary Music Review*. 3(1). Taylor & Francis Group. pp. 133–144. doi: 10.1080/07494468900640091.

Forsythe, W.; Kaiser, P. (1999) Dance Geometry. *Performance Research*. 4(2). Routledge. pp. 64–71. doi: 10.1080/13528165.1999.10871671.

Wilson-Bokowiec, J.; Bokowiec, M.A. (2006) Kinaesonics: The Intertwining Relationship of Body and Sound. *Contemporary Music Review*. 25(1–2). Routledge. pp. 47–57. doi: 10.1080/07494460600647436.

## Personal communication

Foti, K. (2018) Personal communication, 15 October.

Foti, K.; Pandermali, N. (2015) Personal communication, 7 September.

## Website

Forsythe, W. (n.d.) *Choreographic Objects*. Available online: www.williamforsythe.com/essay.html [Last Accessed 18/06/19].

## Video

Jarecke, M. (2012) *Introduction to Laban's Space Harmony* [Lecture]. Available online: www.youtube.com/watch?v=p-B_E3loAto&t=15s [Last Accessed 02/06/18].

McGregor, W. (2012) A Choreographer's Creative Process in Real Time. *TED Global*. Available online: www.ted.com/talks/wayne_mcgregor_a_choreographer_s_creative_process_in_real_time?utm_campaign=tedspread–b&utm_medium=referral&utm_source=tedcomshare [Last Accessed 12/02/18].

Nikolais, A. (1974) Interviewed by James Day for *Day at Night*. PBS, 29 November. Available online: www.youtube.com/watch?v=atmek4ra-UU [Last Accessed 27/05/18].

## Attended conference

*Moving Matter(s): On Code, Choreography and Dance Data, Fiber Festival*. (2017) Amsterdam, Netherlands.

## Artwork

*18 Happenings in 6 Parts* (1959) by Allan Kaprow.

*Eidos: Telos* (1995) by William Forsythe, Thom Willem and Joel Ryan, Frankfurt Ballet Company.

*Fearful Symmetry* (2012) by Ruairi Glynn.

*Green Light Corridor* (1970) by Bruce Nauman.

*Improvisation Technologies* (2011) by The Forsythe Company and ZKM.

*Mind and Movement from the Project Choreographic Thinking Tools* (2013) by Wayne McGregor | Random Dance.

*Tower* (1965) by Alwin Nikolais.

*Variations V* (1965) by John Cage, Merce Cunningham, David Tudor, Gordon Mumma, Carolyn Brown, Barbara Dilley.

# Son e(s)t Lumière

## Expanding notions of composition, transcription and tangibility through creative sonification of digital images

**Simon Cummings**

A word that is often used when discussing music is 'intangible'. As we are not able to see or touch sound in the same way we can with the visual or plastic arts, there is a tendency to regard music as being a distinct, even separate, art form. However, there are of course many means available to manifest sound and thereby reduce this inherent intangibility. Oscilloscopes, VU meters, wave editors and spectrum analysers all provide unique ways to peer 'under the hood' of sound and understand better its inner intricacies and nature. For composers, especially those utilising recorded or electronic sounds, such means are an invaluable aid to the creative process, enabling us to shape and sculpt materials in great detail.

The act of visualising the 'intangible' in this way is not only an aid to creativity but is also an act of creation in and of itself. Visual artists, particularly in the last couple of centuries, have often been inspired by musical works. Henri Fantin-Latour created a series of lithographs in the 1870s in tribute to the music of Hector Berlioz. Marc Chagall's ceiling at the Paris Opera contains elements inspired by no fewer than fourteen operas, including Mozart's *The Magic Flute*, Mussorgsky's *Boris Godunov*, Ravel's *Daphnis and Chloe*, Tchaikovsky's *Swan Lake* and Wagner's *Tristan and Isolde*. Tom Walker's *The Mystic Image* is an ambitious sequence of paintings inspired by Charles Tournemire's fifteen-hour cycle of organ music *L'Orgue Mystique*. German architect and designer David Mrugala, whose work is largely rooted in generative art, has created pieces that visualise examples of pop and electronic music – through, for example, a real-time analysis of their dynamic or pitch content – as well as more abstract forms such as the rising frequencies of a sine tone sweep and astronomical data recorded by NASA.[1] Creative visualisations of this kind are not limited to sonic sources. Data scientist Martin Krzywinski is well known for the striking, attractive visualisations he has made of, among other things, irrational numbers – most famously, π – created with the primary aim of transforming data into something beautiful.[2]

It is generally less common for such methods as these to be practiced the other way round, utilising visual sources as the means to musical ends. Conceptual artist James Whitehead (who works under the name JLIAT) took inspiration from the imagery in film footage of US nuclear tests in the Pacific to create his four *Bikini tests*. Part of Whitehead's ongoing exploration of the definition, nature and interpretation of noise, these works artificially recreate the sonic experience of the nuclear tests, Whitehead imagining "the scene, beach, waves, slight breeze, then the aircraft . . . followed by the explosion".[3] To the uninformed listener, one could plausibly believe these pieces to be authentic field recordings, and whether or not they are viewed in conjunction with the film, the *Bikini tests* constitute what we might call a 'creative sonification' of the film footage.

Clarence Barlow's fascination with links between sound and image has led to many compositions where visual sources are sonified. The two movements of his 1998 piano work *Kuri Suti Bekar* are each derived from what Barlow describes as 'sonic translations' of images related to the work's dedicatee, Kristi Becker: her name written in Japanese Katakana script and a scanned photograph of her face. More ambitiously, in his *Le loup en pierre* (2002), composed for the two organs in St. Peter's Church in Leiden, the opening of the work is derived from a sketch of the church that Barlow mapped to the keys of the organs in order to sonify the image (Figure 23.1).

**Figure 23.1** Clarence Barlow – *Le loup en pierre*: overview of pitch-mapping from the image to the two organs.

Yet more intangible, sound artist Christina Kubisch's music uses otherwise invisible electromagnetic waves as the basis for sonification. In works such as *La Ville Magnétique* (2008) and *Seven Magnetic Places* (2017) part or all of the musical material is derived from recordings made from converting these signals into sound. Throughout her career she has extended this process to real-time acts of composition in which listeners wear magnetic induction headphones to make the electromagnetic waves audible. Her numerous 'Electrical Walks' involve the following of a pre-planned route around various town and city centres, and her most recent work *Weaving* (2019) is a gallery installation piece picking up waves from nearby sources in downtown Oslo (Cummings 2019b).

In more conventional audiovisual works the hierarchical relationship between its visual and musical aspects is often one of, at best – from the perspective of the music – equal significance. Jaroslaw Kapuscinski describes his work as "sculpting audiovisually" to the end of creating "structurally integrated intermedia works, in which sounds and images are given equal importance and are developed either simultaneously or in constant awareness of each other" (Kapuscinski 2008: 11'15"). However, even when the relationship is nominally equal, it is not uncommon for the visual to take precedence. Ryoji Ikeda's *formula* and *datamatics [ver. 2.0]* are two cases in point: presented cinematically, the large screen unavoidably places increased emphasis on the visual.[4] While the majority of Ikeda's output is not audiovisual, almost all of his albums sonically imply a fundamental connection to, or even a derivation from, complex datasets that could be similarly visualised. Likewise, Christian Ludwig's pioneering 'oscilloscope music' can only be appreciated fully when viewed – as the name implies – through an oscilloscope, revealing the visual component created by the sound. Indeed, it could be argued that in this context the music, though highly engaging on its own terms, is ultimately at the mercy of the visual, being carefully composed in order to create interesting visual patterns and images. Further still, composer Nell Shaw Cohen has written of her suspicion of creating sounds "with an abstract or imperceptible connection to their source material". She has therefore instead sought to subjugate the role of music, conceiving it "expressly for the purpose of illuminating, commenting upon, and conversing with visual art" (Cohen 2015). As such, it is vital to the concept of Cohen's pieces that the associated visual art is clearly displayed to the audience.

Instances of works in which this hierarchy is reversed – where the sound is of greater importance than any associated visual source – are very much less prevalent. They tend to be presented more as scientific rather than artistic creations, with reduced emphasis on their status as music than on being the product of a process. The clear implication in such instances is that they should be regarded as being more creatively passive: sound as the product of research rather than sound as a creative work of musical art.

This is well exemplified by works originating in datasets. Carsten Nicolai's 2008 album *Unitxt* concludes with a collection of miniature tracks created by converting the content of data files, from familiar programs such as Microsoft Word, Excel and PowerPoint, into short-lived streams of rapidly shifting noise. Though fascinating in their own right, the very short durations of these pieces lends them the distinct impression of being tiny 'novelties' tacked onto the end of the album. Astronomical data sent back by the *Voyager I* and *II* probes has been regularly sonified since the late 1970s. Originally developed by Frederick L. Scarf as a means to make science more tangible to the public (Fisk 1989), these recordings have been collected and released on various occasions. The most extensive of these is the *Voyager Space Sounds* album series by Jeffrey Thompson which, quite apart from under-emphasising its musical qualities, even downplays the recordings' scientific aspects, instead marketing them as a New Age holistic 'remedy'.[5]

Music that employs sonification with more demonstrable creative intent has tended to inhabit the periphery of compositional practice. Prominent examples, such as the Oramics system by Daphne Oram and Iannis Xenakis' UPIC – both techniques turning pre-drawn designs into sound data – have failed to acquire significant followings and are largely regarded as individual oddities. In the digital age, software developments in this area have produced modern equivalents of the Oramics and UPIC models (IanniX[6] and HighC[7] are both designed as direct descendants of the latter), rendering image data into sonic parameters. These programs have been similarly marginal, and in many cases are essentially the product of a single individual, including Rasmus Ekman's Coagula,[8] Kenji Kojima's RGB MusicLab,[9] Michael Rouzic's Photosounder,[10] Nicolas Fournel's Audiopaint[11] and Olivia Jack's browser-based PIXELSYNTH.[12]

All of the aforementioned musical examples use abstract sources as the basis for their sonification. Use of specific, identifiable images to create sound material is relatively rare. One particularly well-known example is by British musician Richard D. James (better known as Aphex Twin), whose 1999 EP *Windowlicker* features two such sonified images. The title track includes a brief spiral at its end, acting as a transition into the following track, the title of which is generally referred to as 'formula'.[13] One of James's most avant-garde creations, 'formula' culminates with an episode created from an image of his own grinning face (Figure 23.2). The sonic effect is deliberately unexpected and jarring; hitherto, 'formula' has been heavily beat-based and regular, but during this concluding episode becomes suddenly and unsettlingly abstract and amorphous.

Comparable in approach is Venetian Snares's 'Look', created from photographs of cats owned by its composer, Aaron Funk (Figure 23.3). The final track on Funk's 2001 album *Songs About My Cats*, the soundworld created by this sonification is once again completely distinct from the mixture of drum and bass and synthetic instrumental music that precedes it.

**Figure 23.2**    Spectrogram of the conclusion of Aphex Twin's 'formula'.

**Figure 23.3**    Spectrogram of Venetian Snares's 'Look'.

Similar but less striking instances can also be found in isolated tracks by Plaid, who used a sequence of interconnected number threes in '3 Recurring' (1999), and Nine Inch Nails, who inserted the appearance of an ominous hand (referred to as "the Presence") in their 2007 song 'The Warning'.

A more substantial example can be found in the soundtrack to the 2012 video game *FEZ* by Rich Vreeland, who composes under the name Disasterpeace. The game includes a number of secret elements, and Vreeland mirrored this by embedding various shapes and images – including the photograph of Neil Armstrong's footprint on the moon, a human eye, the portrait by Greta Kempton of US president

**Figure 23.4**   Spectrograms of the sonified images found within the audio of Disasterpeace's *FEZ* soundtrack.

Harry S. Truman, Salvador Dali's painting *Crucifixion (Corpus Hypercubus)*, a smiley face and a QR code containing a sequence of numbers – within the opening or closing moments of many parts of the soundtrack (Figure 23.4).

In contrast to the previously discussed examples, where the use of sonification was contextually highly distinct and conspicuous, Vreeland keeps these images secret from the listener by rendering them at an almost inaudible level. They can therefore only be clearly discerned by viewing spectrograms of the audio.[14]

This is indicative of the broader fact that, in all of these examples, sonification is arguably employed principally as a playful gimmick that seeks less to create material with significant compositional potential than to present the listener with a strange sonic novelty. This is reinforced by the fact that the use of these sonified images is restricted to a very brief, either highly contrasting or virtually undetectable, appearance within a single composition. Furthermore, the technique is not explored anywhere else in their respective artists' output. While Vreeland's *FEZ* soundtrack uses it more extensively, as discussed its results are not intended to be clearly audible. As such, sonification is utilised as a form of mischievous sonic steganography, akin to the practice of backmasking on vinyl records by numerous bands from the 1960s onward,[15] or otherwise hidden messages such as the Morse code contained within Mike Oldfield's *Amarok*.[16] The relatively trivial creative attitude towards sonification in these examples is echoed by Madeline Mechem's journalistic response to them; the conclusion of her otherwise ostensibly enthusiastic and encouraging overview

of the technique advises potential listeners, "Don't listen to the sound files – unless you just enjoy weird, dial-tone-like static sounds" (Mechem 2015).

Attempts to obviate the unconventional nature of such sonified images have tended to be articulated by a simplified retreat to the conventions of historical tonality, restricting the output to traditional pitches, scales and modes. In their research into image-based composition, Wu and Li were guided by how "pleasant" or "smooth" the results sounded, eschewing chromaticism in favour of the "stability and popularity" arising from 'melodic anchoring' within the tonal hierarchical confines of major scales (Wu and Li 2008: 1346–1347). Maria Mannone's so-called Tridimensional Music takes a similarly simplified approach, heavily quantising both its pitched and rhythmic elements in her transformations of images into sound (Mannone 2014). Such basic approaches to sonification have attained minor popular interest and appeal, culminating in the naïve, optimistically named 'Glorious Midi Unicorn' by YouTuber Andrew Huang (Mufson 2017).

My own work with sonification, while methodologically related to some of these aforementioned examples, is ultimately distinct from them. My primary interest in this area is to create self-contained musical compositions that are fundamentally informed, and both macro- and microstructurally determined, by an intermedia relationship with existing visual stimuli, articulated – at least, initially – via sonification.

Sonification is a natural development and extension of my existing approach to composition, which in the early stages involves a great deal of previsualisation. A major aspect of my compositional research is the use of discretely defined musical behaviours (Cummings 2017), and these are invariably designed via sketches in which their small- and large-scale activity is visualised. These sketches illustrate an overview of the nature of the behaviour in relation to an implied x/y-axial arrangement, where the x-axis acts as a timeline above which the behaviour's details are shown. Figure 23.5 shows three such visualisations used in the composition process of my large orchestral work *Cloud Triptych* (2016).

Sonification was first utilised in my work in *Triptych, May/July 2009* (2009).[17] Inspired in part by the triptychs of Francis Bacon, the piece was composed as a homage to my late father, and as such I had wanted to 'embed' him into the firmament of the music in some tangible way. To that end, I experimented with designing the time-pitch structure of the work's three movements using modified versions of

**Figure 23.5**   Visualisation sketches of musical behaviours used in *Cloud Triptych*.

**Figure 23.6**   The original photograph of my father together with the two modified versions used to create *Triptych, May/July 2009*.

a digitised photograph of his face (Figure 23.6). One version focused on sparseness, intended to create a vague and elusive soundworld for the outer movements 'Figment' and 'Vestige', the other on saturation, designed to generate a complex noise environment which forms the basis for the work's central panel, 'Icon'.

The immediacy of creating an equivalence between light distribution across an image and sound distribution over time establishes the image as a kind of 'graphic score'. Daphne Oram saw her own work using the Oramics system as comparable to this. Furthermore, Oram regarded having such a complete sonic overview of a composition as this as highly beneficial, noting that it "gives an easily comprehended, permanent, visual account of the music" (Oram 1972: 102). In his work with what he calls 'phonographics' (a 16-synth microtonally tuned MIDI system), French composer Vincent Lesbros has echoed this sentiment, particularly with regard to the capacity such image-sound equivalences afford the composer to devise and organise both large- and small-scale musical details: "Graphical representations of sound offer a global view, and thus help organise a composition's temporal structure. One advantage of such a representation is that a simple zoom on the score image becomes a bridge between the macrostructure and the microstructure of the composition" (Lesbros 1996: 59).

Since 2014, I have been exploring further the creative possibilities of sonification in an ongoing series of electronic *Studies*. While these build on my previous work with both sketched behavioural visualisations and sonified images, they were especially inspired by examples of Op art and pattern-based generative art, in particular the work of Bridget Riley and David Mrugala.

*Study No. 1* (2014)[18] was the product of experimenting with Riley's 1964 work *Blaze* (Figure 23.7). In order to clarify the work's dense zig-zag arrangement, these were alternately separated to the left and right channels. Interestingly, the resulting

**Figure 23.7** Bridget Riley's *Blaze* and the sonogram of *Study No. 1*.

network of concentrically spiralling sliding bands produced a curious aural effect akin to the optical illusion in the original artwork, with pitches shimmering or juddering against each other either within a single channel or apparently moving between channels. This uncanny effect – an example of what might be termed 'Op music' – was unexpected and, even when subsequently scrutinised, is hard to explain.

Encouraged by the results of this piece, several subsequent studies also utilised radial designs, based on pieces by David Mrugala (Figure 23.8). These were approached in a similar way to *Study No. 1*, exploring how concentric layers clarify, obfuscate and otherwise impinge on each other (*No. 3* [2015] and *No. 4* [2014]) or directing shafts of tapering pitch towards and away from a central point, in the process accreting varying quantities of noise (*No. 5* [2014] and *No. 6* [2017]).[19]

One of the key musical aspects that these early studies clarified was the importance of positioning within the stereo field. The sonifications were created using the program Coagula, which assigns a stereo position to each pixel according to its RGB light value, on a continuum from red (left) through yellow (centre) to green (right). Therefore, to create the material for these pieces, the images were first edited such that their values were either purely red and green (as in *Study No. 1*) to create a hard, polarised stereo, or including yellow in order to introduce a third, central, channel to the stereo field.[20]

This discrete positioning has been harnessed as an integral element in the structure of many of the studies. *No. 9* (2015),[21] another radial design based on an image by David Mrugula, features a gradual progression from mono (centre) to stereo (left/right) as its frequency range expands and contracts, engineered through a colour gradient from yellow to red/green. *No. 10* (2016)[22] sets up a polarised left/right environment within which a separate, abstract idea occupies the centre channel. *No. 24* (2017)[23] does the opposite, using the faintest parts of Jeffrey Earp's circuit diagram-like image 'Downtown Dreaming' as the basis for an austere centre-channel backdrop. Left/right stereo chords, created from the more vibrant parts of the image,

**Figure 23.8** Generative images by David Mrugala and the sonograms of *Studies No.4* (top) and *No. 6* (bottom).

extrude outward from this. Experiments have also been made with a few of the *Studies* in four- and eight-channel arrangements, or using a wider variety of RGB colour combinations to enable more fine positioning within the stereo field. At the opposite extreme, several of the *Studies* are monaural pieces, exploring the extreme intimacy arising from the use of just a single channel.

That these *Studies* exhibit engaging compositional structures and unifying behaviour has been aided in part by the use of images that possess an overall quasi-symmetric design with consistent elements. However, images that are more abstract and unpredictable in character have also been explored. *No. 2* (2014)[24] is based on David Lemm's 'One', which was specifically chosen for its diverse combination of straight and curved lines, large amorphous forms and scattered minutiae. When sonified, these elements become extended drones, bursts of noise and sporadic pitch chatter (Figure 23.9).

*No. 8* (2015)[25] is a composite study in which two images, one geometric and one abstract, are superimposed. The abstract image, by Justin Lincoln, becomes akin to a series of fireworks being set off within the hollowed-out centre of a fierce wall of noise, based on another of David Mrugala's geometric generative images. The juxtaposition in *No. 10*[26] is more combative, the abstract element – sonified from a painting by Zachariah Rieke – being designed to aggressively complicate and confuse an

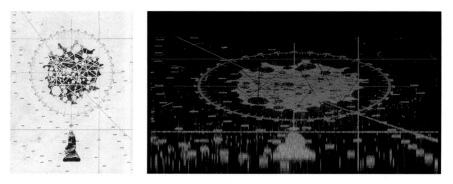

**Figure 23.9**    David Lemm's 'One' and the sonogram of *Study No. 2*.

already disintegrating pattern of rhythmic and behavioural order, created from a geometric image by Refik Anadol (Figure 23.10).

More recent *Studies* have explored the potential of larger-scale, ambient-influenced structures. *No. 16* (2016)[27] uses an untitled painting by A. J. Fusco as the basis for a 13-minute journey through semi-fixed drones. At different rates these drones gradually expand and contract, in the process obfuscating their pitch content and merging to form complex, noisy but resonant epicentres. *No. 19* (2016)[28] undergoes a conceptually similar but altogether less-defined process, using an image by Victoria Burge to navigate an abstract procession through large-scale shifts in registral emphasis and timbral quality. A woodcut by Lee Ufan was used as the starting point for *No. 22* (2016),[29] emerging from a dense wall of noise into a spacious world where extruded pitches float freely beside each other. In this environment, the music establishes a 'steady state' (Cummings 2019a), producing a continual slow shift in the nature of its harmony. Though all three of these studies contain or attain high points of intensity, they are fundamentally restful, even peaceful works, in which the beauty of their slowly evolving materials is allowed to linger and dominate the composition. With a dramatic interplay of pitch and noise these pieces exhibit the unique combination of quasi-stasis and gradual flux that typifies ambient music (Figure 23.11).

When composing *Study No. 1*, the urge to impose my compositional 'voice' onto the raw output created from the sonified Bridget Riley image was strong. Ultimately in that case and some others, the urge was resisted. This was in part an acknowledgement of the fact that the process had already involved considerable creativity, in terms of choosing a potentially suitable image and then editing it in preparation for sonification. This was done in conjunction with often extensive trial-and-error experiments to understand better the sonic implications and 'language' of the image, in order to discover the most compositionally appealing combination of duration, frequency range and stereo positioning.[30] In many of the later *Studies*, the sonifications have

**Figure 23.10**   Source images and the sonograms of composite *Studies No. 8* (top) and *No. 10* (bottom).

**Figure 23.11**   Source images and the sonograms of *Studies No. 19* (top) and *No. 22* (bottom).

been merely the first step in a longer composition process, providing material to be subsequently worked on further. But in all cases they have highlighted the fundamental importance of personal creative thinking to the musical success of this practice.

However, research in sonification has often sought to introduce notions of objectivity. This has primarily focused on establishing associations or even parallels

between visual elements and musical parameters. Alan Wells has suggested a correlation between colour and harmony (Wells 1980), José Luis Caivano between luminosity and loudness (Caivano 1994), while Woon Seung Yeo and Jonathan Berger's work with sonification has led them to propose a parallel between human image perception and the method by which an image is sonified (Yeo and Berger 2005).

Away from the field of research, from the perspective of music composition, correlations of this kind are inherently problematic. The term 'sonification' aptly describes one particular aspect of this creative process, but other terms – some musical, some not – are equally relevant. The act of creating a musical rendition of a non-sonic original is a clear form of *transcription*, while the appropriation and repurposing of extant material is suggestive of *arrangement*. Furthermore the transformation of an image into sound data can be likened to *conversion*, and the intermedia movement from one discrete art form to another is an example of *translation*.

Regardless of which terms are used, their accompanying processes can certainly be automated, though the mechanisms and criteria for those processes must by necessity be subjective, the product of imagination, interpretation and creativity. In a musical context, therefore, efforts to obviate creative input and make sonification 'objective' seem entirely incongruous. Kapuscinski and Sanchez's work developing the *Counterlines* intermedia setup led to the same realisation. They concluded that, while "there are many parameters in music that can be represented in numbers", their algorithmic mapping method was "maybe logical but not very expressive. Such techniques can reveal interesting, musically relevant, and at times highly sophisticated information but it is always reductionist and serves better the purpose of analysis than creation" (Kapuscinski and Sanchez 2009: 225). Bob L. Sturm's work sonifying ocean buoy data reached a similar verdict. Drawn by the "inherent beauty and characteristic qualities of the sonifications" to explore composing with them, Sturm found that "expressive large-scale structures do not come from within the datasets. The responsibilities of the sonification artist are much different than those of the composer. It takes a creative hand to fix the material into effective musical forms. The sound material provides only a palette of colours and sensations with which to paint" (Sturm 2005: 148). Martin Krzywinski, similarly considering how data can be made beautiful, states that, "I think that comes down to the individual artist. There are objective aspects of what people find attractive, but then there's also the personal expression. This is what I like to see, and this is what I create, and this is how I express myself. And you may like it or you may not, like any other artist. [. . .] My approach is to keep working at it until I no longer think it's ugly. I don't quite know how to make it beautiful, but I know when it's still ugly to me, and I just keep plugging away at it until that sense stops" (Krzywinski 2014: 11'45").

In conclusion, it is worth briefly considering the implications of image appropriation on originality. To what extent is a composition that has been substantially created through sonification an original work of art? Due to the considerable

subjectivity of the overall process and the complex crossover of implications arising from its multifaceted identity as a work involving elements of transcription, arrangement, conversion and translation, together with the plethora of creative decisions that are unavoidably required at every stage, it is easy to argue that compositions of this kind are highly original. This is consolidated by the fact that the connection between the music and the image from which it sprang is broken, or at least rendered moot. It is by no means obvious that such compositions began life in the form of a visual image.

With the image absent – not only not visible but, potentially, its existence not even implied – such sound materials therefore no longer exist merely as sonifications but transcend their origin. They are thus perceived via what Pierre Schaeffer described as 'reduced listening' (Chion 2009: 30), and thereby become conventionally acousmatic. As such, the sonifications can be regarded as something of a parallel to the Schaefferian *objet sonore*, being "perceived as a whole, a coherent entity, [. . .] which targets it for itself, independently of its origin or its meaning. [. . .] It is a sound unit perceived in its material, its particular texture, its own qualities and perceptual dimensions" (Chion 2009: 32). Heard in their own right in this way, sonified images act as not so much a sound object as a *sound structure*. These structures help visualise, make tangible and articulate a composer's large- and small-scale creative intentions, thereby becoming the basis for original, personal and powerful works of sonic art.

## Notes

1 David Mrugula, thedotisblack, http://thedotisblack.com/tagged/audiovisual [Last accessed 10/03/20].
2 Martin Krzywinski, Science + Art, http://mkweb.bcgsc.ca/pi/ [Last accessed 10/03/20].
3 James Whitehead, email to author, 31 October 2018.
4 Ryoji Ikeda, *Datamatics*, www.ryojiikeda.com/project/datamatics/ [Last accessed 10/03/20].
5 Dr Jeffrey Thompson, *NASA Voyager I & II Space Sounds*, https://scientificsounds.com/index.php/store/nasa-space-sounds [Last accessed 10/03/20].
6 IanniX: A Graphical Open-Source Sequencer for Digital Art, www.iannix.org/ [Last accessed 10/03/20].
7 HighC, https://highc.org/index.html [Last accessed 10/03/20].
8 Coagula: Industrial Strength Color-Note Organ, www.abc.se/~re/Coagula/Coagula.html [Last accessed 10/03/20].
9 RGB Musiclab, www.kenjikojima.com/rgbmusiclab/ [Last accessed 10/03/20].
10 Photosounder, https://photosounder.com/ [Last accessed 10/03/20].
11 Nicolas Fournel, Audiopaint, www.nicolasfournel.com/?page_id=125 [Last accessed 10/03/20].
12 Olivia Jack, PIXELSYNTH, https://ojack.github.io/articles/pixelsynth/index.html [Last accessed 10/03/20].
13 The given title of this track, as shown on the *Windowlicker* artwork, is $\Delta M_i^{-1} = -\alpha \Sigma_{n=1}^{N} D_i[\eta] [\Sigma_{j \in C[i]} Fji[\eta-1] + Fext_i[\eta^{-1}]]$. The track can be viewed with its spectrogram online: www.youtube.com/watch?v=wSYAZnQmffg [Last accessed 07/11/19].

14  It is worth noting that, while the effect of sonification in Aphex Twin's *Windowlicker* is conspicuous, the fact that sonification had been used did not come to light until over two years after the EP had been released, when a listener discovered the image of Richard D. James's face by accident. See Kahney (2002).

15  Perhaps the most controversial instance being Judas Priest's 'Love Bites', which resulted in (unsuccessful) litigation brought against the band due to being the supposed subliminal cause of a fan's subsequent suicide.

16  The code contains a message, directed at Virgin Records' founder Richard Branson, that reads "FUCK OFF RB".

17  Simon Cummings, *Triptych, May/July 2009*, https://simoncummings.bandcamp.com/album/triptych-may-july-2009 [Last accessed 07/11/19].

18  Simon Cummings, *Study No. 1*, https://simoncummings.bandcamp.com/track/study-no-1 [Last accessed 0410/03/20].

19  Simon Cummings, *Study No. 3*, https://simoncummings.bandcamp.com/track/study-no-3; *Study No. 4*: https://simoncummings.bandcamp.com/track/study-no-4; *Study No. 5*, https://simoncummings.bandcamp.com/track/study-no-5; *Study No. 6*, https://simoncummings.bandcamp.com/track/study-no-6 [Last accessed 10/03/20].

20  This general division of the soundstage into Left–Centre–Right has become a fundamental aspect of the *Studies*. Though they can be easily presented via a two-channel speaker arrangement, many of them are essentially three-channel works.

21  Simon Cummings, *Study No. 9*, https://simoncummings.bandcamp.com/track/study-no-9 [Last accessed 10/03/20].

22  Simon Cummings, *Study No. 10*, https://simoncummings.bandcamp.com/track/study-no-10 [Last accessed 10/03/20].

23  Simon Cummings, *Study No. 24*, https://simoncummings.bandcamp.com/track/study-no-24 [Last accessed 10/03/20].

24  Simon Cummings, *Study No. 2*, https://simoncummings.bandcamp.com/track/study-no-2 [Last accessed 10/03/20].

25  Simon Cummings, *Study No. 8*, https://simoncummings.bandcamp.com/track/study-no-8 [Last accessed 10/03/20].

26  Simon Cummings, *Study No. 10*, https://simoncummings.bandcamp.com/track/study-no-10 [Last accessed 10/03/20].

27  Simon Cummings, *Study No. 16*, https://simoncummings.bandcamp.com/track/study-no-16 [Last accessed 10/03/20].

28  Simon Cummings, *Study No. 19*, https://simoncummings.bandcamp.com/track/study-no-19 [Last accessed 10/03/20].

29  Simon Cummings, *Study No. 22*, https://simoncummings.bandcamp.com/track/study-no-22 [Last accessed 10/03/20].

30  Or, as in many cases, in order to learn that the image was unsuitable to be used as the basis for a composition.

# Bibliography

Arblaster, S. (2016) The Noise of Art: Pixelsynth Can Turn Your Images into Music for Free. *Music Radar*. Available online: www.musicradar.com/news/tech/the-noise-of-art-pixelsynth-can-turn-your-images-into-music-for-free-638423 [Last Accessed 25/06/19].

Barlow, C. (2008) Musica Visualis: On the Sonification of the Visual and the Visualisation of Sound. *Proceedings of the Systems Research in the Arts and Humanities Symposium*. pp. 38–42.

Ben-Tal, O.; Berger, J. (2004) Creative Aspects of Sonification. *Leonardo*. 37. pp. 229–233.

Caivano, J. (1994) Color and Sound: Physical and Psychophysical Relations. *Color Research & Application*. 19(2). pp. 126–133.

Chion, M. (2009) *Guide to Sound Objects: Pierre Schaeffer and Musical Research* (trans. J. Dack; C. North). Available online: www.ears.dmu.ac.uk.

Cohen, N.S. (2015) Music Inspired by Visual Art. *New Music Box*. Available online: https://nmbx.newmusicusa.org/music-inspired-by-visual-art/ [Last Accessed 24/06/19].

Cox, C. (2011) Beyond Representation and Signification: Toward a Sonic Materialism. *Journal of Visual Culture*. 10(2). pp. 145–161.

Cummings, S. (2017) *Cloud Triptych: An Exploration of Stochastic Movement between Discrete Musical Behaviours*. PhD Thesis, Birmingham City University/Birmingham Conservatoire.

Cummings, S. (2019a) The Steady State Theory: Recalibrating the Quiddity of Ambient Music. In: M. Adkins; S. Cummings (eds.) *Music Beyond Airports: Appraising Ambient Music*. University of Huddersfield Press.

Cummings, S. (2019b) Ultima 2019 (Part 2). *5:4*. Available online: http://5against4.com/2019/09/20/ultima-2019-part-2/ [Last Accessed 07/11/19].

Dachis, A. (2011) How to Hide Secret Messages and Codes in Audio Files. *Lifehacker*. Available online: https://lifehacker.com/5807289/how-to-hide-secret-messages-and-codes-in-audio-files [Last Accessed 07/11/19].

Fisk, L. (1989) Obituaries: Frederick L. Scarf. *Physics Today*. 42(9). pp. 116–118.

Huang, A. (2017) *Glorious Midi Unicorn*. Available online: www.youtube.com/watch?v=i3tiuGVDDkk [Last Accessed 07/11/19].

Ikeda, R. (2002) *Formula*. NTT Publishing.

Kahney, L. (2002) Hey, Who's That Face in My Song? *Wired*. Available online: www.wired.com/2002/05/hey-whos-that-face-in-my-song/ [Last Accessed 24/06/19].

Kapuscinski, J. (2008) *Composing with Sounds and Images*. Available online: www.youtube.com/watch?v=uyWYAcvwPOg [Last Accessed 25/06/19].

Kapuscinski, J.; Sanchez, J. (2009) Interfacing Graphic and Musical Elements in Counterlines. *ICMC 2009*. pp. 222–225.

Killham, E. (2012) The Fez Soundtrack's Hidden Images and How They Got There. *VentureBeat*. Available online: https://venturebeat.com/2012/04/23/fez-hidden-images/ [Last Accessed 24/06/19].

Krzywinski, M. (2014) *The Art of Data Visualization, Design & Information Mapping*. Available online: www.youtube.com/watch?v=mS8Q5_sZYH8 [Last Accessed 07/11/19].

Lesbros, V. (1996) From Images to Sounds, a Dual Representation. *Computer Music Journal*. 20(3). pp. 59–69.

Licht, A. (2009) Sound Art: Origins, Development and Ambiguities. *Organised Sound*. 14(1). pp. 3–10.

Mechem, M. (2015) How Musicians Put Hidden Images in Their Songs. *Mental Floss*. Available online: http://mentalfloss.com/article/61815/how-musicians-put-hidden-images-their-songs [Last Accessed 24/06/19].

Mannone, M. (2014) *Tridimensional Music*. Available online: www.youtube.com/watch?v=Kle1AzsljiE [Last Accessed 07/11/19].

Mufson, B. (2017) The Internet Is Freaking Out over This Song Made from a Unicorn Drawing. *Vice*. Available online: www.vice.com/en_us/article/nz9e98/andrew-huang-unicorn-drawing-song-incredible [Last Accessed 07/11/19].

Niinisalo, J. (2002) *The Aphex Face*. Available online: https://web.archive.org/web/20020604013443/www.tp.spt.fi/~cleth/projects/aphexface/index.htm [Last Accessed 24/06/19].

Oram, D. (1972) *An Individual Note of Music, Sound and Electronics*. Galliard Paperbacks.

Sturm, B.L. (2005) Pulse of an Ocean: Sonification of Ocean Buoy Data. *Leonardo*. 38(2). The MIT Press. pp. 143–149.

Walker, T. (1989) *The Mystic Image: A Cycle of Visual Meditations Inspired by the 51 Offices of L'Orgue Mystique of Charles Tournemire*. Self-Published.

Wells, A. (1980) Music and Visual Colour: A Proposed Correlation. *Leonardo*. 13(2). The MIT Press. pp. 101–107.

Wu, X.; Li, Z. (2008) A Study of Image-Based Music Composition. *IEEE International Conference on Multimedia and Expo*. pp. 1345–1348.

Yeo, W.; Berger, J. (2005) A Framework for Designing Image Sonification Methods. *Proceedings of ICAD 05: Eleventh Meeting of the International Conference on Auditory Display*, Limerick, Ireland, July 6–9. pp. 1–5.

Yeo, W.; Berger, J. (2005) Application of Image Sonification Methods to Music. *ICMC*.

## Music

Aphex Twin, *Windowlicker* (Warp, 1999).

Alva Noto, *Unitxt* (Raster-Noton, 2008).

Simon Cummings, *Studies Vols. 1–6* (Interrobang, 2016–18).

Simon Cummings, *Triptych, May/July 2009* (Interrobang, 2009).

Disasterpeace, *FEZ OST* (II, 2012).

Jerobeam Fenderson, *Oscilloscope Music* (Self-Released, 2016).

JLIAT, *Bikini Tests* (Self-Released, 2002).

Christina Kubisch, *Five Electrical Walks* (Important Records, 2007).

Christina Kubisch, *La Ville Magnétique/The Magnetic City* (Ville De Poitiers, 2008).

Nine Inch Nails, *Year Zero* (Interscope, 2007).

Mike Oldfield, *Amarok* (Virgin Records, 1990).

Plaid, *Rest Proof Clockwork* (Warp, 1999).

Venetian Snares, *Songs About My Cats* (Planet Mu, 2001).

# Audiovisual heterophony
## A musical reading of Walter Ruttmann's film *Lichtspiel Opus 3* (1924)

Tom Reid

## Introduction

In this chapter I discuss my new musical score for Walter Ruttmann's short, abstract film *Lichtspiel Opus 3* (1924), composed in 2014. During the first section I consider Ruttmann's artistic background and relationship to his peers, Hans Richter and Viking Eggeling. The film's spatio-temporal characteristics and inner relationships are closely scrutinised. Overall, Ruttmann avoids montage in favour of a more evolutionary, evenly proportioned time character; meanwhile, the choreographic elements, varied repetitions, strong formal contrasts and fluid rhythmic patterns all appear to spring from the same structural impulse as music. I wanted to use a 'musical' reading of the film images as the starting point for a score which functioned as a marker of the film's 'musicality'. Initially, however, I was unsure of how to practically realise this 'analytical' ideal without lapsing into sterility and slavish predictability. My compositional approach was ultimately enriched and transformed through stimulating, productive encounters with the multimedia theories of Nicholas Cook and the music of Conlon Nancarrow, in which contrasting layers of rhythmic activity are clearly discernible, almost like a musical 'split screen' effect. Subsequently, I developed a research method for interrogating and 'performing' Ruttmann's abstract film text musically, by reading it as a set of musical instructions, or 'score'. This formed the starting point and material basis for a multi-faceted, polyphonic musical response, which illuminates formal detail and structure while simultaneously contributing additional layers of movement and meaning. The in-depth audiovisual analysis in the third section presents detailed case studies from the film and score. The chapter ends with some further reflections on the project; the overall approach is defined as 'audiovisual heterophony'.

## *Walter Ruttmann and the spatio-temporal characteristics of* Lichtspiel Opus 3

Many abstract (non-narrative, non-representational) films from the silent era claim an analogy with music. German animations such as *Rhythmus 21* (Hans Richter 1921/4), *Symphonie Diagonale* (Viking Eggeling 1924), and *Lichtspiel Opus 3* (Walter Ruttmann 1924) reject montage, in favour of spatial subdivisions and a 'polyphony' of visual elements. Hans Richter and Viking Eggeling sought to use musical processes and forms as purely technical models, for plotting and co-ordinating simultaneous visual movements over time, with every action 'producing a corresponding reaction' (Richter 1957: 64). By contrast, Ruttmann was a more 'emotive' artist and less of a theorising personality. However, he was an accomplished cellist, having studied music as well as visual art at the Academy of Fine Arts, Munich, and the influence of Kandinsky can be clearly discerned in his mode of painterly abstraction. His first film, *Lichtspiel Opus 1*, is probably the earliest surviving example of abstract cinema, resembling as it does a painting in motion (Elder 2008: 120). The work has also been likened to a dance choreography.[1] However, Richter was critical of the work's impressionistic tendencies (Richter 1949: 222–223) and another contemporary reviewer commented on its 'troubling bent towards cuteness' (Elder 2008: 124). While movements are controlled in an assured and 'professional' manner, gestures are often not particularly interrelated or differentiated. The later films in Ruttmann's *Opus* series are more aesthetically accomplished and structurally sophisticated, with dynamic contrasts between different types of shapes and movement occurring amid 'stark architecture' and 'complex musical structures' (Elder 2008: 124). Ruttmann pulled stylistically closer to his peers without sacrificing his spontaneity, verve and slicker animation style.

Overall, the formal time-structure of *Lichtspiel Opus 3* is repetitious and very sectional, demonstrating Ruttmann's apparent concern for periodicity and corresponding units of similar duration. The film has an 'organic' unity akin to composed music, as visual gestures and sequences are recalled and transformed throughout. Ruttmann often subdivides the screen like a grid; forms and movements are arranged diagonally, layered, grow, merge, break apart and reciprocate one another in many sequences. However, these visual elements are more than merely functional units, unlike the slowly oscillating rectangular components in *Rhythmus 21* (Lawder 1975: 52). Put simply, the forms and movements have a strong aesthetic significance and identity in and of themselves; Ruttmann allows them a degree of autonomy as they 'dance'. Furthermore colour plays an important structural role in *Lichtspiel Opus 3*, providing additional differentiation between forms and movements; it is used as 'an element in choreography, almost like stage lighting' and there are even black 'visual silences' (Moritz 1997). Both these features also help to reinforce the film's large-scale sectional symmetries and contrasts.

*Symphonie Diagonale* has been characterised as the visual embodiment of a sonata form.[2] I find this particular musical reading of the film's time structure problematic; the formal contrasts between hard, angular elements and softer, curved lines are too subtle. The static, muted animation style (Le Grice 1977: 24) and lack of colour give the film a continuous, unbroken quality, particularly when viewed silently (as intended by Eggeling). This, along with the film's intricate, interrelated, 'imitative' style of textural patterning surely places it aesthetically closer to the 'seamless, almost uniform flow' of Baroque music (Rosen 1971: 43) and certain forms of atonal modernism (e.g. Webern) than to a Classical-Romantic aesthetic. By comparison, the formal contrasts in *Lichtspiel Opus 3* are much more clearly and dramatically presented, with conflicts between geometric and curved forms and between pumping 'pistons' and smoother gestures particularly prominent. As mentioned previously, the use of colour and visual 'silences' prevent the overall pacing from becoming too uniform. There are no sequences featuring curved forms until about a third of the way through the film (1'18.7") and these are mostly kept separate from the geometric, modernistic elements and 'aggressive' movements until the fast closing section (from about 2'59.0" to 3'20.0"). This is a vivid formal climax, in which many of the earlier forms and sequences are recalled and forcefully merged into one another, with rapid bursts of visual activity and densely layered shot compositions.

*Lichtspiel Opus 3* is especially notable for its rhythmic freeness and fluidity, which also contributes a great deal of energy and drama to the visual processes.[3] There are two possible 'musical' readings of this phenomenon, a 'romantic' and a 'modernist' one. The fluidity can be interpreted as a form of 'rubato' (flexible interpretations of the beat), found mainly in performances of Classical and Romantic music. Alternatively, it can be read as a series of written-out rhythmic accelerations and decelerations, relating to modernist techniques of musical composition. The former would seem to accord more with other elements in the film (the interaction of two 'themes', the apparent concern for corresponding units of similar duration) and in all probability is what Ruttmann was consciously emulating. However, the latter suggests a rhythm fixed in time and utilised as part of the compositional structure, as opposed to an improvisatory feature added on afterwards by a performer for purely expressive purposes; therefore, it is a more appropriate and useful analogy, regardless of Ruttmann's intentions.

### From a 'musical' reading of the images to a multi-faceted compositional approach

The main compositional research questions which arose at this stage were these: if the spatio-temporal characteristics of *Lichtspiel Opus 3* show evidence of having been systematically modelled after musical processes and forms, can I develop a method for interrogating the film musically and learn more about this phenomenon

through the act of musical composition? How might a new musical soundtrack function as a marker of the film's 'musicality', 'analysing' and commenting on the images while, at the same time, functioning as a multi-faceted musical composition, avoiding sterility and slavish predictability? In *Analysing Musical Multimedia*, Nicholas Cook argues that similarity is the *starting point* for a 'transfer of attributes' between two media, especially music and film. Meaning is created from a 'limited intersection of attributes', not 'complete overlap or total divergence' (Cook 1998: 81–82). Seeking to formulate and test new analytical strategies, he also makes a striking analogy between the interaction of musical elements (like pitches, rhythms) and the perceptual interaction between individual components in multimedia (Cook 1998: 24).

While it is possible to conceive of certain time-based notions, particularly 'rhythm' and 'counterpoint' functioning in a broadly similar way across different media, obviously musical and abstract film processes cannot be measured by exactly the same standards, and subject to precisely the same criteria in practice; there will always be subtle perceptual and behavioural differences, which intrude. However, it is at least theoretically possible to envisage an intricate audiovisual fabric, in which there are not only significant 'internal' relationships within each separate medium (i.e. between pitch and rhythmic material, or visual forms and motion) but also meaningful connections and interactions between pitch and visual forms, rhythm and visual motion, musical texture and visual shot composition and so on. Over time, relationships between these elements may be set up and subsequently changed, or even abandoned; nothing stays fixed by necessity or design. Given that the most significant aesthetic, structural and behavioural characteristics of *Lichtspiel Opus 3* include spatial subdivisions, the 'polyphony' of visual elements (overlapping, interrelated and reciprocal movements), varied repetition, formal contrasts between 'hard' and 'soft' elements and a fluid approach to rhythm, I determined that ideally the music should seek to emulate these characteristics as far as possible without compromising its own structural integrity. However, it should also contribute additional layers of movement and meaning, enriching and enlivening the audiovisual texture, without expressively overwhelming the film. Reconciling these competing objectives represented the main technical challenge of the project.

As I searched for a flexible, rhythmic, dynamic musical style with roomy textures, capable of accommodating and articulating multiple musical perspectives without becoming weighed down by them, I found myself drawn to the music of Nancarrow. In Nancarrow's player piano studies, time is 'manipulated into something that can exist in multiple ways at once' (Murcott 2012: 2). This is particularly apparent in a piece like *Study No. 21* (also known as 'Canon X'). The apparently simple combination of an accelerating lower line and decelerating upper line creates a highly distinctive and uncannily powerful effect. There is an air of permanent flux, of formal imbalance and unresolved tension. Temporal ambiguity dominates the entire piece; it is impossible to 'reconcile' the two separate layers of activity, or determine a

'central' pulse. Most importantly for my purposes, the fast, busy texture allows room for contrasting musical materials to operate simultaneously, in a clearly audible way; there are multiple 'points of entry' for the listener. The organisation of the musical texture is perhaps analogous to a split-screen effect.

There are a number of additional characteristics which make this style of music aesthetically appropriate for my purposes. Firstly, a piece for player piano (or electronic sequencer/MIDI) can execute impossibly fast rhythms and agile melodic runs, meaning that it has the potential to keep pace with and 'catch' rapid visual patterns very precisely. During a discussion on Nancarrow's player piano studies, Paul Griffiths refers to the 'joys and comedies of heavy loads lightly carried', explicitly linking this phenomenon to cartoons and animation more generally (Griffiths 1995: 101–102). Secondly, while the textures in many of the player piano studies are full of elaborate pitch patterning and harmonic dissonance is by no means avoided, the fast tempi and predominance of percussive, staccato attacks mean that the perceptual focus generally shifts from the vertical to the horizontal. The music is not typically weighed down by dense, introspective harmonic activity; much of it 'moves too quickly for harmony to register' (Gann 1995: 12). Instead, Nancarrow almost always foregrounds rhythm and polyphony; these are elements which are intrinsically musical, but less *exclusive* to music than harmony and pitch functions. By way of illustration, the overlapping, rapidly 'echoing' visual flourishes and fluid visual rhythms which occur in *Lichtspiel Opus 3* could be regarded as a very approximate visual analogue of his imitative textures and irregular rhythmic patterning. Finally, while Nancarrow's work is abrasively modernist in many ways, it does not completely reject the past. The composer often relied on an ancient device (canon) in order to produce his futuristic-sounding musical textures (Gann 1995: 109). He also restricted himself to the 12-note equally tempered scale and a percussive piano timbre. The player piano studies often feature pulsating materials, developmental structures and even triads (although obviously these elements are abstracted and divorced from their usual context).

I sought to apply similar techniques in an audiovisual context, assembling a multi-faceted musical commentary which draws attention to and meaningfully interprets the spatial subdivisions, polyphony of visual elements and fluid visual rhythms of *Lichtspiel Opus 3*. I began by treating the visual patterns as a set of instructions, or 'score', which I 'performed' by composing a fragmentary single line of music, meticulously subordinated and synchronised to the picture with the aid of a click-track. I tried to 'catch' as many visual details as possible. This very close, imitative reading was subsequently transformed, becoming the structural bedrock and material basis for a multi-faceted, polyphonic musical response. The finished piece seeks to illuminate detail and articulate structure, for example through shadowing, punctuation and temporal partitioning. However, there are also layers which intensify, even exaggerate visual gestures, superimpose additional rhythmic complexity and move

at their own pace. This technique facilitated maximum compositional control, while maintaining contact with the picture at all times and enabled the conception of a flexible formal outline at an early stage in the compositional process.[4]

The instrumentation features a combination of live performers (piano, vibraphone) with pre-recorded electronic audio parts (sampled piano, harpsichord sounds). Both performers receive a click-track via headphones and the electronic parts are routed through loudspeakers. The electronic (MIDI) parts help to lock in the choreographic, synchronised gestures more tightly than human instrumentalists would be able to by themselves. They also ensure that the complexity of the musical rhythms and their sometimes confrontational relationship with the picture are intensified rather than softened. While the music has an improvisatory, humorous sensibility, with allusions to jazz rhythms and a 'waltz' figure in the middle section, the end result is nervously playful rather than 'pretty'. Musical patterns originally prompted by the visuals are gradually reworked according to their own, independent logic and woven back into the semi-autonomous polyphonic fabric of the music.

Pitch centres are important, strengthening musical unity and directionality. However, there is an increased concern with melodic variation – melodic patterns are constantly fragmented and inwardly re-shaped, which invites the viewer to examine the images more critically, drawing attention to transformations which occur within them. The bassline in the first two bars of the piece contains two significant motivic patterns (separated by the barline, in Musical Score Example 1, Figure 24.1). The second pattern (in the second bar) can be interpreted as a re-ordering or inward re-shaping of the first; the two have many notes in common. The semitone is the most common interval and the tritone is also structurally significant.

Throughout the piece, both of these patterns are further reduced, re-shaped and split into fragments, which are often inverted (this can be clearly seen in the later musical score examples; I have drawn boxes around some of the more significant recurrences, placements and transformations). However, the patterns are also recalled in their original form from time to time. The accented, syncopated rhythm of the first pattern gradually becomes a distinctive figure in its own right. The harmonic language is post-tonal but I have avoided extremely dissonant sonorities such as cluster chords. In bars 6–7 (Musical Score Example 2 in the following section), the first pattern is harmonised with major and minor thirds [0,3,4]; the second with a

**Figure 24.1**  Musical score example 1.

whole tone sonority [0,4,6]. While the music often 'toughens' the film, it was impor-
tant to avoid heavy-handedness.

Meanwhile, the ensemble writing features an increasing amount of differen-
tiation and tension between the expressive, soloistic piano part and the electronic
lines, in an effort to make them more stylistically distinct from one another. This
polarisation is intended as a musical commentary on the film's formal contrasts,
the conflict between 'hard' and 'soft' elements. The piano part's hairpins, abrupt
dynamic changes, trills and tremolo are juxtaposed against the more thoroughly
mechanical qualities of the electronically sequenced lines. Trills and tremolo have
an 'uneven' and unpredictable quality in the hands of a real pianist; when notated
and played back on a score-writing programme like Sibelius they just sound like
electronic pulsation, unless the composer intervenes. While this instrumental set-up
contributes an additional layer of meaning to my musical reading of *Lichtspiel Opus
3* and makes the separation between certain musical lines more audible, it can also
be read as a more general comment on the forced marriage between live (music) and
pre-recorded media (film) which commonly occurs in a silent film concert setting.
Applying these ideas within the musical ensemble is a further extension of the con-
cept. The theorist Marion Saxer observes:

> Composing music to a film is always a kind of collaboration with a machine.
> Film as a completely technical medium has its own terms of use and char-
> acteristics. Not only the composer, but also the film as a medium, composes.
> Hence one could speak of a sort of distributed agency between the film and
> the composer.
>
> (Saxer 2014: 203)

In this piece, it might be said that the film 'plays' the live musicians via the electronic
parts and the headphone click-track. The last few bars have quite an arresting effect,
as the electronic parts take over, swamping the musical texture with increasingly
rapid, impossible-to-play patterns as the live instrumentalists drop out.

### Audiovisual analysis: case studies

I worked from a video of the restored film, taken from the commercial DVD release
*Berlin: Die Sinfonie der Grosstadt* and *Melodie der Welt* (*Berlin: Symphony of a Great
City and Melody of the World*), dir. Walter Ruttmann, 1927/1929 (Munich Film
Museum 2008). The duration of the film is 3'20.0". Two audio recordings of my
piece are available to listen to on the companion website for this book. The first is a
completely electronic (MIDI) recording (Video 24.1), created using sampled instru-
mental sounds and the second is a 2017 live concert performance by the Riot Ensem-
ble, featuring the two performers (Adam Swayne and Jude Carlton) playing along to

pre-recorded audio, as intended (Video 24.2). The score is exactly the same for both versions. There are six musical score examples in the audiovisual analysis which follows, with corresponding video clips online. Sibelius timecode references and important visual movements and rhythms are indicated with arrows. I have also drawn boxes around some of the more structurally significant and rhythmically disruptive musical patterns, in order to make the analysis as clear as possible.

The music begins at 10.0"/bar 6, as the 'III' graphic reaches its full size, with an energetically syncopated chordal texture (the preliminary part of the title sequence is left silent). The film begins properly at 14.0"/bar 8, with a procession of tall, overlapping, oscillating blue rectangles positioned on the left of the screen, over a dark background. As they are re-oriented diagonally towards the centre of the shot, their movement becomes increasingly fast-paced and erratic. The music increases the intensity of this opening sequence with a disorientating, abruptly introduced 'surge' of polyphonic activity in bars 8–10. Pulsating rhythmic and melodic patterns are layered at different speeds and overlap one another. I have drawn boxes around some

of these overlapping patterns in Musical Score Example 2 (10.0"/bar 6 to 20.0"/bar 11), which is shown in Figure 24.2 (Videos 24.3 and 24.4).

In Musical Score Example 3 (22.5"/bar 12 to 32.5"/bar 17) (Figure 24.3), a snaking arrow traces a diagonal path across the screen, merges into a rectangle and fades to black. This 'melodic phrase' occurs four times (indicated by diagonal arrows in the score) (Videos 24.5 and 24.6). With each repetition there is an increase in 'dynamic' intensity and volume (indicated by the steeper gradient of each line), as the arrow travels further across

**Figure 24.2**  Musical score example 2.

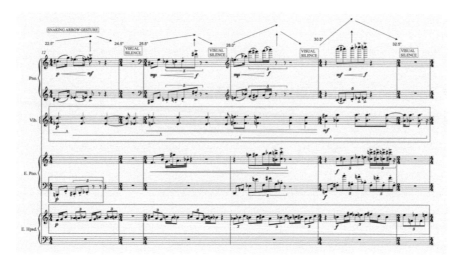

**Figure 24.3** Musical score example 3.

the screen and the rectangle increases in size, finally breaking apart from the central shape and morphing into a trapezoid. This creates quite an expressive, dramatic effect even when the film is played silently. The music punctuates and embellishes these fluctuating visual intensities, increasing the already quite strong momentum and directionality of the sequence. It does so by repeating and elongating an ascending figure in the bass and using melodic variation, localised heterophony, spasmodic rhythmic ornamentation and ascending harmonies, with a new pitch centre in each bar. The flurry of musical activity ceases each time the screen fades to black with a 'visual silence'; only the vibraphone continues with its soft, irregularly pulsating dyads. Meanwhile, the counter-melodies in the electronic harpsichord part, derived from the bassline in bar 8 (see Musical Score Example 2), are initially placed where they are for purely musical reasons and subject to inward re-shaping, although they gradually intrude on and overwhelm the surrounding parts, contributing additional intensity and disruptive power.

In the visual sequence beginning at 33.5"/bar 18, a square appears to rapidly advance and 'flash', resulting in an incisive visual 'pulse.' This creates 'ripples' at a fairly regular tempo; the screen 'vibrates'. In Musical Score Example 4 (Figure 24.4), the music exactly imitates the rhythm or 'metre' of this visual gesture in the bassline (Video 24.7). The pattern (indicated with the downward arrows in bars 18–20, electric piano lower stave) runs 3/8+3/8+3/8+4/8+3/8+3/8+4/8. Building on this irregular foundation, the music also creates a gesture analogous to the 'ripples' with a hocketing technique, as the vibraphone dyads are placed a semi-quaver behind the bass. Meanwhile, earlier figures are recalled and elaborated on melodically in the upper parts.

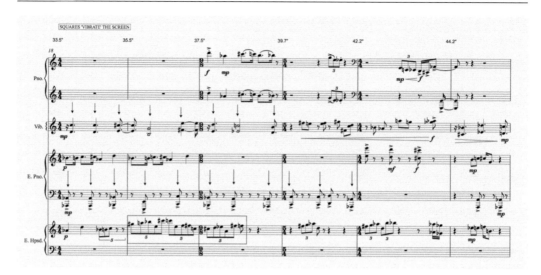

**Figure 24.4** Musical score example 4.

In bars 19–20 the melodic elaboration in the harpsichord line (a familiar pattern derived from the opening bars) proceeds at its own pace again (quintuplets/crotchet 150); this superimposed rhythmic complexity is somewhat 'indifferent' to both the bassline and visual 'pulse' and has a purely decorative function. Overall, the music continues to suggest multiple rhythmic perspectives here, while simultaneously emphasising formal continuities.

At 1'01.7"/bar 32 there is a split-screen effect and a pulsating, very machine-like sequence begins. Again, there is a close synchronicity between the two media, as a major seventh aggressively punctuates the downward motion of each 'piston' (indicated in Musical Score Example 5 [Figure 24.5] with the downward arrows) (Videos 24.7 and 24.8). This musical attack sharply intensifies the visual gesture; it seems less forceful when the film is played silently.[5] In between each punctuation, free melodic elaboration continues in the surrounding parts, with individual notes sometimes 'catching' the smaller, upward-moving rectangles (indicated with the smaller arrows). After each punctuation, the pitch centre changes. First the music 'modulates' up a tritone from G to C sharp, then down a third to A. These three pitches form the pattern [0,4,6], which relates to the whole tone sonority in bars 6–7. This cyclical harmonic movement briefly superimposes a dynamic forward motion onto the visual sequence which it does not possess when played silently, making the visual repetitions seem more varied. Slightly later, the musical pulse begins to become submerged as quintuplets and septuplets smudge the texture, and free melodic elaboration starts to take over. The music becomes more independent, and briefly takes some 'time out' to rework material according to its own internal structural principles while the visual repetition continues.

**Figure 24.5** Musical score example 5.

**Figure 24.6** Musical score example 6.

Musical Score Example 6 (beginning at 1'18.7"/bar 41) (Figure 24.6) sees the first proper appearance of curved lines/shapes in the film (Videos 24.9 and 24.10). In the music, there is an increase in rhythmic dissonance and layered complexity, from 5:4 in the first half of the bar, to 7:6:5:4 in the second. These superimpositions are brief further examples of temporal ambiguity, overlaid onto the visual patterns here in order to increase energy and dynamism. The tentative, fluctuating melodic pattern at crotchet 105 (septuplets) in the middle of the bar connects the two rhythmic textures in a somewhat unstable manner, during the visual 'silence'. Then, at 1'23.7" the shot

composition changes, as the screen is split diagonally from the lower left corner to the upper right. Curved figures 'climb' up the central dividing line. Their movement begins to accelerate and becomes more irregular and fluid at 1'28.7"/bar 44:3, then decelerates around 1'31.7"/bar 46. Also, from about 1'30.7", the diagonal line begins to 'wilt', morphing into a curved form. This is one of the moments in the film when its rhythmic freeness and fluidity are most strikingly apparent; the energy and irregularity of the music help to accentuate it.

However, since the change in shot composition at 1'23.7" is not especially dramatic or striking when viewed silently, the music (bar 42) marks the sectional break here much more decisively. The transition to the quintuplet dyads sounds like a tempo change (to crotchet 150) and the pitch centre drops down a major third, from C to A. There is a sudden decrease in the dynamic level and the texture becomes slightly more vertical, dominated by the quintuplet dyads. The role of the music here might be characterised as analogous to a change in stage lighting, or even a 'jump cut'; an act of temporal partitioning which helps to articulate the film structure more clearly. While many of the instrumental lines subtly track the upward movement in the picture, the descending major thirds in the harpsichord part, which begin momentarily before the sectional break, add decorative contrary motion, a kind of reverse shadowing. As in previous sections, this contributes further to the multi-layered effect and prevents the music from becoming sterile or predictable.

Finally, in Musical Score Example 7 (beginning at 2'11.7"/bar 58) (Figure 24.7), a curved figure emerges and begins to 'dance', with slow, jerky but evenly recurring rotations (indicated with the upward/downward arrows) (Video 24.11). This is the most 'anthropomorphic' gesture in the whole film so far, yet it can be traced back to the earlier

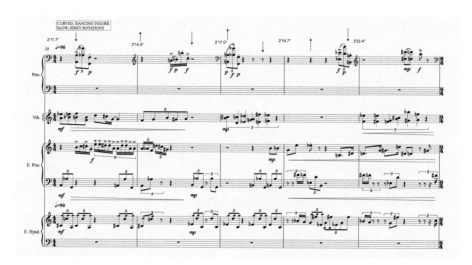

**Figure 24.7**  Musical score example 7.

movements of curved forms from 1'23.7". The music undergoes a tempo change/metric modulation here (from crotchet 120 to 90) and there is also an implied metre change as the stuttering, lopsided, waltz-like figure emerges (notated as triplets). The surrounding parts gradually disrupt the more 'vernacular'-sounding dance gestures. The pitch centres alternate between F, G and B. This forms the trichord [0,2,6], another whole tone grouping similar to [0,4,6], the trio of pitch centres familiar from the earlier 'piston' sequence (Musical Score Example 5). Like before, this cyclical harmonic movement makes the visual patterns seem more dynamic and less repetitive than they are when played silently. The recurring musical device also suggests a formal association with the earlier sequence. Therefore, this passage is an example of the music not only intensifying and enlivening visual gestures but also implying structural parallels and connections between contrasting sections, contributing additional cohesion to the film overall.

The purpose of this audiovisual analysis has been to demonstrate how the compositional ideas outlined in the earlier sections of this chapter are made to work in practice. The piece continues in a similar vein; from 2'59.0" the tempo of both the film and music become much more frantic, as earlier visual and musical material is restated and rhythmically compressed. At 3'02.2" and from about 3'09.4" to the end, the geometric and curved elements in the film are decisively merged together for the first time. In the music, fast, dotted rhythms and frenetic electronic flourishes confront one another in a frenzied climax.

## Conclusion: audiovisual 'heterophony'

Reading *Lichtspiel Opus 3* as a musical score reveals and elucidates the film's unusual blend of influences from different media and historical periods. Ruttmann's abstract moving image aesthetic looks backwards and forwards at the same time, retrospectively embodying a tension between tradition and modernity. His rejection of montage technique in favour of a more evolutionary, evenly proportioned and organic time character distances *Lichtspiel Opus 3* from the more famous examples of 1920s non-narrative cinema, such as *Ballet Mécanique* (Léger and Murphy 1924) and *Le Retour a la Raison* (Man Ray 1923), which are unmistakeably futuristic by comparison.[6] However, as my analysis has shown, the visual elements in his work are frequently geometric and contrasting, with movements recurring at an uneven pace, running the whole gamut from fluid to spasmodic, metronomic to irregular. Modernist themes and 'hard' imagery are by no means neglected in *Lichtspiel Opus 3*.

A device such as counterpoint is a thoroughly institutionalised element within music; yet its deployment in an approximately analogous way within abstract moving images, as pulsating visual patterns which overlap, interrelate and reciprocate one another, remains a relatively 'avant-garde' concern. Perhaps this merely serves

to reiterate the point made near the beginning of the second section of this chapter: there will always be subtle perceptual and behavioural differences between music and abstract film, even when their spatio-temporal characteristics spring from the same impulse. However, I would argue that my musical reading of the film images in *Lichtspiel Opus 3* points away from these apparently irreconcilable differences, drawing the two media closer together without degrading them. By taking influence from Nancarrow's formal techniques and also combining live performers with electronically sequenced parts, I have been able to creatively reinterpret Ruttmann's complex visual rhythms and choreographic structures, articulating and elaborating on their modernist qualities without completely obscuring their connection to more traditional, developmental classical music structures and 'romantic' performance traditions.

Moreover, I have sought to create and demonstrate a working model of film music, which allows room for precisely synchronised musical gestures and relatively self-governing musical textures to co-exist. Superimposed, clearly discernible layers of contrasting rhythmic activity make it possible to create a *polyphony* of musical perspectives. This is not a 'universal' theory of film music; there are other, more narrative-based contexts in which formalist devices like these might obfuscate rather than reveal or enhance. Yet, in bringing the insights and methods of later musical thought to bear retrospectively on *Lichtspiel Opus 3*, my music has explored new modes of mediation between historical moving images and contemporary classical music. The internal relationships of both media interact and overlap, resulting in a set of dynamic interrelations across sight and sound.

Like many practitioners and theorists before me I have often been attracted to the term 'audiovisual counterpoint.' Obviously the music for *Lichtspiel Opus 3* is very polyphonic when taken by itself. As frequently discussed, the film has sections which include overlapping, interrelated movements. However, the relationship between the film and the music cannot be described as 'counterpoint' as the two media are not, strictly speaking, completely independent of one another. Rather, they represent different versions of one another, played at the same time. Heterophony is defined as the 'simultaneous performance of a melody and a variant of the same melody' (Bowman 2002: 78). Therefore, 'audiovisual heterophony' would, perhaps be a more precise description of the multimedia texture captured in my score for *Lichtspiel Opus 3*. This relates back to Nicholas Cook's theory of multimedia, cited earlier: similarity is the *starting point* for a 'transfer of attributes' between two media (especially music and film). However, it is only a starting point, no more. Meaning is created from a 'limited intersection of attributes', not 'complete overlap or total divergence' (Cook 1998: 81–82). My compositional approach is both precise and flexible, demonstrating that a close audiovisual relationship need not compromise the structural and aesthetic integrity (and autonomous potential) of the musical soundtrack.

## Notes

1 See Leonard Adelt '*The Filmed Symphony*' (quoted in Elder 2008: 124).
2 According to Bengt Edlund (quoted in Ahlstrand 2012: 221): 'It has an ingeniously developed imaginative sonata form with a wealth of imitative work. Diagonals and sharp angles play a visually dominant role and contrast with softer visual motifs.'
3 Ruttmann always envisioned his films to be shown with music; *Lichtspiel Opus I* had a specially composed score by Max Butting, although its style is somewhat conservative. This may further explain his fluid rhythmic sense, although the later films in the series were not always presented with specially prepared music. (See Moritz 1997 for more information.)
4 The experimentation with a closer match in terms of moment-to-moment rhythmic synchronisation has the additional advantage of differentiating my approach from the one taken by Hanns Eisler, evident in the 2008 Munich Film Museum reconstruction of his 1927 score for *Lichtspiel Opus 3* ('Prelude in the Form of a Passacaglia'). See Heller (1998: 541–559) for more information.
5 It has been observed that visual activity, taken by itself, lacks the percussive 'edge' of sounding rhythm; it has no transient bite. However, when coupled with sounds, visual rhythms 'spring forward from the screen with a quite remarkable immediacy, vitalized, dynamic and organic'. (Cook 1998: 117).
6 They are 'more pictorial and less self-consciously motivated by an analogy with traditional music forms' (Rees 2009: 28).

## Bibliography

Adorno, T.; Eisler, H. (1947) *Composing for the Films*. New York: Oxford University Press.
Andriessen, L.; Schönberger, E. (1989) *The Apollonian Clockwork: On Stravinsky* (trans. J. Hamburg). Oxford: Oxford University Press.
Bowman, D. (2002) *Rhinegold Dictionary of Music in Sound*. London: Rhinegold Publishing Ltd.
Cook, N. (1998) *Analysing Musical Multimedia*. Oxford: Oxford University Press.
Cowell, H. (1930) *New Musical Resources*. Cambridge: Cambridge University Press.
Eisenstein, S. (1975) *The Film Sense* (trans. J. Leyda). New York: Harcourt Brace.
Elder, R.B. (2008) *Harmony and Dissent: Film and Avant-Garde Art Movements in the Early Twentieth Century*. Ontario: Wilfrid Laurier University Press.
Gann, K. (1995) *The Music of Conlon Nancarrow*. Cambridge: Cambridge University Press.
Griffiths, P. (1995) *Modern Music and after*. Oxford: Oxford University Press.
Lawder, S.D. (1975) *The Cubist Cinema*. New York: New York University Press.
Leeuw, T.D. (1977) *Music of the Twentieth Century* (trans. S. Taylor). Amsterdam: Amsterdam University Press.
Le Grice, M. (1977) *Abstract Film and Beyond*. London: Cassell & Collier Macmillan Publishers Ltd.
Marks, L.E. (1978) *The Unity of the Senses: Interrelations among the Modalities*. New York: Academic Press.
O'Konor, L. (1971) *Viking Eggeling: Artist and Film-Maker, Life and Work*. Stockholm: Royal Swedish Academy of Letters, Histories & Antiquities.
O'Pray, M. (2003) *Avant-Garde Film*. London: Wallflower Press.
Rees, A.L. (2011) *A History of Experimental Film and Video*. London: BFI & Palgrave Macmillan.
Rogers, H. (2013) *Sounding the Gallery: Video and the Rise of Art-Music*. Oxford: Oxford University Press.
Rosen, C. (1971) *The Classical Style*. London: Faber and Faber.

## Chapters in books

Ahlstrand, J.T. (2012) Berlin and the Swedish Avant-Garde. In: H. Berg (ed.) *A Cultural History of the Avant-Garde in the Nordic Countries 1900–25*. New York: Rodopi. pp. 201–229.

Elsaesser, T. (1987) Dada/Cinema? In: R.E. Kuenzli (ed.) *Dada and Surrealist Film*. New York: Willis Locker & Owens. pp. 13–28.

Hughes, E. (2008) New Technologies and Old Rites: Dissonance between Picture and Music in Readings of Joris Ivens's *Rain*. In: R.J. Stilwell; P. Powrie (eds.) *Composing for the Screen in Germany and the USSR: Cultural Politics and Propaganda*. Bloomington, IN: Indiana University Press. pp. 93–106.

Moritz, W. (1997) Restoring the Aesthetics of Early Abstract Films. In: J. Pilling (ed.) *A Reader in Animation Studies*. Sydney: John Libbey.

Rees, A.L. (2007) Frames and Windows: Visual Space in Abstract Cinema. In: A. Graf; D. Scheunemann (eds.) *Avant-Garde Film*. New York: Rodopi. pp. 55–77.

Rees, A.L. (2009) Movements in Art, 1912–40. In: S. Comer (ed.) *Film and Video Art*. London: Tate Publishing. pp. 26–46.

Richter, H. (1949) Avant-Garde Film in Germany. In: R. Manvell (ed.) *Experiment in the Film*. London: The Grey Walls Press. pp. 219–234.

Richter, H. (1957) Dada and the Film. In: W. Verkauf (ed.) *Dada: Monograph of a Movement*. New York: George Wittenborn, Inc. p. 64.

Saxer, M. (2014) Paradoxes of Autonomy: Bernd Thewes's Compositions to the *Rhythmus-Films* of Hans Richter. In: C. Tieber; A.K. Windisch (eds.) *The Sounds of Silent Films: New Perspectives on History, Theory and Practice*. Palgrave Studies in Audio-Visual Culture. Hampshire: Palgrave Macmillan. pp. 192–208.

Velguth, P. (2006) Notes on the Musical Accompaniment to the Silent Films. In: S. MacDonald (ed.) *Art in Cinema: Documents Toward a History of the Film Society*. Philadelphia: Temple University Press. pp. 151–155.

## Journal articles

Bordwell, D. (1980) The Musical Analogy. *Yale French Studies*. (60). Cinema/Sound. pp. 141–156.

Heller, B. (1998) The Reconstruction of Eisler's Film Music: Opus III, Regen and the Circus. *Historical Journal of Film, Radio and Television*. 18(4). pp. 541–559.

## Online resources

McDonnell, M. (2003) *Notes for Lecture on Visual Music*. Available online: www.soundingvisual.com/visualmusic/visualmusic2003_2004.pdf [Last Accessed 16/03/16].

Murcott, D.; Kelly, J. (2012) *The Music of Conlon Nancarrow: Impossible Brilliance - Festival Programme*. Available online: https://static1.squarespace.com/static/51372358e4b09e6afa7c7ffa/t/5512e9eae4b039d26a9136f8/1427302912261/Impossible+Brilliance+Programme.pdf [Last Accessed 13/3/20].

## Filmography

*Ballet Mécanique* (1924) [FILM] dir. Fernand Léger; Dudley Murphy. Kino Video/Douris Corp.
*Le Retour a la Raison* (1923) [FILM] dir. Man Ray. Kino Video/Douris Corp.
*Lichtspiel Opus 1* (1920) [FILM] dir. Walter Ruttmann. Munich Film Museum.
*Lichtspiel Opus 3* (1924) [FILM] dir. Walter Ruttmann. Munich Film Museum.
*Rhythmus 21* (1921/4) [FILM] dir. Hans Richter. Kino Video/Douris Corp.
*Symphonie Diagonale* (1924) [FILM] dir. Viking Eggeling. Kino Video/Douris Corp.

## DVDs

*Avant-Garde: Experimental Cinema of the 1920s and '30s*, Films from the Raymond Rohauer Collection, dir. Various (Kino Video, Licensed by the Douris Corp, K402 DVD, 2005).

*Berlin: Die Sinfonie der Grosstadt* and *Melodie der Welt* (Berlin: Symphony of a Great City and Melody of the World), dir. Walter Ruttmann, 1927/1929 (Munich Film Museum, 2008).

# Index